A CATALOGUE OF THE DRAWINGS BY

CAMILLE PISSARRO

IN THE ASHMOLEAN MUSEUM, OXFORD

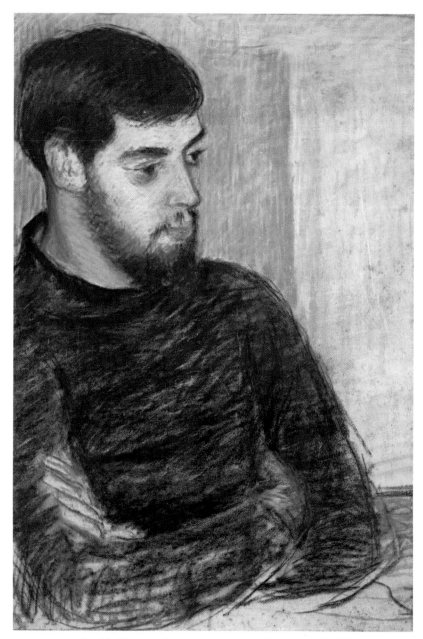

Camille Pissarro, *Portrait of Lucien Pissarro (1865–1944)*.
Pastel. 552 × 376 mm (sight)

A CATALOGUE OF THE DRAWINGS BY

CAMILLE PISSARRO

IN THE ASHMOLEAN MUSEUM, OXFORD

RICHARD BRETTELL

CHRISTOPHER LLOYD

Oxford, University. Ashmoleon Museum

OXFORD
AT THE CLARENDON PRESS
1980

Oxford University Press, Walton Street, Oxford OX2 6DP

OXFORD LONDON GLASGOW
NEW YORK TORONTO MELBOURNE WELLINGTON
KUALA LUMPUR SINGAPORE JAKARTA HONG KONG TOKYO
DELHI BOMBAY CALCUTTA MADRAS KARACHI
NAIROBI DAR ES SALAAM CAPE TOWN

Published in the United States
by Oxford University Press, New York

British Library Cataloguing in Publication Data
Pissarro, Camille
 A catalogue of drawings by Camille
Pissarro in the Ashmolean Museum, Oxford.
 1. Pissarro, Camille 2. Ashmolean Museum
—Catalogs
 I. Title II. Brettell, Richard
III. Lloyd, Christopher IV. Ashmolean Museum
741.9′44 NC248.P/ 79-41042
ISBN 0-19-817357-1

*Text printed in Great Britain
by Butler & Tanner Ltd.,
Frome and London
Plates printed, and bound
at the University Press, Oxford
by Eric Buckley
Printer to the University*

For Carol and Frances

Camille Pissarro a été un des plus grands peintres de ce siècle et de tous les siècles. Il laisse une œuvre considérable, variée, puissante, charmante, d'un haut caractère classique. Peintures à l'huile, aquarelles, gouaches, eaux-fortes, lithographies, et des dessins, des dessins, des dessins . . . Feuilleter ces cartons bourrés de notes, de projets, d'études sommaires ou poussées, suivre, au jour le jour, cette pensée toujours active, toujours en train de création, rien de plus émouvant, et aussi rien de plus instructif.

Octave Mirbeau. Preface to *Catalogue de l'Exposition de l'œuvre de Camille Pissarro*. Galeries Durand-Ruel. Paris, April 1904.

Je ne sais pas d'art qui puisse engager plus d'intelligence que le dessin. Qu'il s'agisse d'extraire du complexe de la vue la trouvaille du *trait*, de résumer une structure, de ne pas céder à la main, de *lire* et de *prononcer en soi* une forme avant de l'écrire; ou bien que l'invention domine le moment, que l'idée se fasse obéir, se précise et s'enrichisse de ce qu'elle devient sur le papier, sous le regard, tous les dons de l'esprit trouvent leur emploi dans ce travail, où paraissent non moins fortement tous les caractères de la personne quand elle en a.

Paul Valéry, *Degas Danse Dessin*, Paris, 1938

Preface

In writing this catalogue the authors have incurred a number of major debts. We would like, in particular, to record our gratitude to the following scholars and colleagues for their interest, encouragement, and sympathy during the preparation of the text: Mme Janine Bailly-Herzberg for her tireless help in seeking out, together with M Claude Bonin and Mme Madeleine Oustry, grandchildren of Camille Pissarro, specific items of biographical information; Mr Alfredo Boulton for his close inspection of the drawings executed while Pissarro lived on the island of St. Thomas and during the visit to Venezuela, and also for his kindness in obtaining photographs and catalogue entries for the drawings now in Caracas; Mr David Chambers for checking details about the Eragny Press; Miss Judith Chantry of the Department of Western Art, the Ashmolean Museum, Oxford, for her patience and technical expertise in examining the paper, watermarks, and media of many of the drawings in the collection; Dr Mark Gerstein for information on the fans and related drawings; Mr Christian Neffe for his generosity in supplying photographs and information about Pissarro drawings in his possession; Mr Christopher Parsons for details of the Emile Gavet sale; Mr Martin Reid for his advice over the drawings done while Pissarro was in England; Professor John Rewald, the doyen of Pissarro scholars, for discussing the overall size of Camille Pissarro's corpus of drawings; Mrs Barbara Shapiro for discussing the drawings related to Pissarro's prints; Mr Ralph Shikes and Dr Paula Hayes Harper for items of biographical information gleaned while they were working on their biography of the artist; Martha Ward for generously sharing her knowledge of Pissarro's Neo-Impressionist phase. Many of these scholars are also acknowledged in the catalogue entries, but rarely was their help limited to single drawings or to single problems.

One of the writers benefited enormously from the opportunity of working through the whole collection with Professor Robert Herbert during his most successful tenure of the Slade Professorship in Oxford in 1977–8, and with Mr David Alston. Their comments are acknowledged in the entries, but that is a poor return for the rich experience of seeing the collection again through fresher and sharper eyes.

Two debts of a wider kind should also be recorded. Mr John Bensusan-Butt and his brother, David, generously gave us access to their homes on numerous occasions to inspect drawings and related material. These visits were a constant pleasure, and, if it was a relief to them, at least for the writers it was source of deep regret that as our work drew to a close so these visits had to be discontinued. Mrs Anne Thorold has served Pissarro studies particularly well, having, firstly, calendared and sorted out the whole of the extensive archive in the Ashmolean Museum, and, secondly, cheerfully and utterly selflessly lent assistance at all times in several different ways,

not least in typing a preliminary draft of the manuscript. The final typing was under-
taken by Mr Paul Adams and we are most grateful for the care and patience with
which he accomplished this difficult task. Our transcriptions from the letters of
Camille and Lucien Pissarro were diligently checked by Miss Elizabeth Cope, and
by Mrs Christopher Lloyd, both of whom came to our rescue during the final stages.
The arduous task of photographing the collection fell to Mr Michael Dudley of the
Ashmolean Museum, who, with his customary skill, achieved excellent results.

In addition, the staffs of numerous museums all over the world have been pestered
for details and for photographs of works of art in their possession or under their
care, and our thanks go to those who granted our requests. Mr Rupert Hodge of
the Witt Library was, as ever, helpful and generous with his time and interest, and
Mme Edda Maillet, Secretary-General of Les Amis de Camille Pissarro at Pontoise,
also supplied us with photographs and information.

Lastly, it is important to acknowledge the pioneering work of Mrs Lullie Huda,
who has been closely associated with the Pissarro family for a number of years. Only
a portion of Lucien Pissarro's collection of his father's drawings was presented to
the Ashmolean Museum in 1950. In fact, it seems that in numerical terms approxi-
mately half came to Oxford at the behest of Esther Pissarro, the widow of Lucien
Pissarro, whilst the other half was retained by the family. At the time of Esther Pis-
sarro's gift before her death in 1951, Mrs Lullie Huda was allotted the task of sorting
out all the drawings, placing them in categories, and establishing a chronology. This
must have been a daunting task, but so well did Mrs Huda carry out this preliminary
work that she in effect built the foundations on which the present catalogue is based.
Furthermore, Mrs Huda has been on hand to answer our queries and to verify some
of our suppositions.

The collaboration between the two writers for the purposes of compiling this cata-
logue was assisted by financial support by their respective universities. Grants from
the University Research Institute, University of Texas at Austin, and from the Whit-
ing Fellowship administered by Yale University, facilitated Dr Brettell's travelling
both in America and Europe, and a grant from the Zaharoff Fund administered by
the Curators of the Taylor Institution at Oxford University enabled Mr Lloyd to
undertake research in Paris in 1976.

Oxford, July 1980

List of Acknowledgements

The authors are grateful for permission to reproduce the following: Figures 1, 2, 5, 12, Oxford, Ashmolean Museum; Figures 3, 10, Caracas, Banco Central de Venezuela; Figure 4, New York, The Metropolitan Museum of Art; Figures 6, 7, and 8, Paris, Musée du Louvre (Cabinet des Dessins); Figure 9, London, The British Museum (Department of Prints and Drawings); Figure 11, Upperville, Virginia, Collection of Mr and Mrs Paul Mellon; Figure 13, Tokyo, Bridgestone Museum of Art; Figure 14, Caracas, Private Collection; Figure 15, Dallas, Museum of Fine Arts (Munger Fund Purchase); Figure 16, Philadelphia Museum of Art (John G. Johnson Collection; Figure 17, London, The Courtauld Institute of Art (Witt Library); Figures 18, 19, England, Private Collection.

Contents

Catalogue

Indexes

List of illustrations
to the introduction

Introduction

I

The Collection: its origins and significance*

In 1944 Camille Pissarro's eldest son, Lucien, died in England where he had spent most of his life since 1883. In 1892 he had married a young Englishwoman, Esther Bensusan, who, on her husband's death, assumed full responsibility for that part of the Pissarro family collection that had been accumulated in England. Esther Pissarro presented the bulk of this collection to the Ashmolean Museum in 1950, when the first instalment was transferred from her house, The Brook, at Stamford Brook in the western suburbs of London. It was her aim to donate the collection to an institution that was prepared to keep it intact and to recognize it as a family collection with all the difficulties of presentation that this might entail. The Ashmolean Museum was not the most obvious place to fulfil these terms, as there was only a limited representation of Impressionist works hanging in the galleries at that time, but the University of Oxford was willing and, fortunately, was able to comply with Esther Pissarro's wishes. The transference of the collection by instalments continued in 1951, the year of the benefactor's death, and was completed in 1952.

The amassing of Pissarro material in Oxford did not cease in 1952, however, for Lucien Pissarro's daughter, Orovida, supplemented this original gift, notably by a representation of her own work and by further archival material relating to her father, until the time of her own death in 1968. In this way, and by further gifts from Esther Pissarro's nephew, Mr John Bensusan-Butt, the desire that the onus should be placed on the familial aspect of the collection as a whole, and that there should not be undue emphasis on Camille, has been honoured.[1]

At the time when the benefaction was being negotiated, it was remarked by Anthony Blunt that 'no serious student of the Impressionist movement would be able to disregard this collection.'[2] Yet, although it has been readily available to students since 1950–2, it has remained comparatively little known, and whole sections of it are unpublished. Some figures, which the limits of the present catalogue must restrict to Camille Pissarro alone, will perhaps help to redress the balance. On the completion of the gift in 1952 the Ashmolean Museum had come into possession of ten paintings by this major Impressionist painter, over four hundred of his drawings, almost a complete set of his prints, and in addition seven hundred letters

* Only four of the drawings in the present catalogue come from sources other than that of the collection of Lucien Pissarro (Nos. 191, 234, 243F, and 343).

[1] For a tabulation of the contents of the Pissarro collection in Oxford see A. Thorold, 'The Pissarro Collection in the Ashmolean Museum, Oxford', *Burlington Magazine*, cxx (1978), pp. 642–5.

[2] Reported in a letter of 17 November 1949 in the files of the Department of Western Art, Ashmolean Museum.

written to his son, Lucien. Of these parts of the collection, the pictures had been included in the official *catalogue raisonné* of Camille Pissarro's paintings compiled by Ludovic Rodo Pissarro and Lionello Venturi in 1939; the prints had been published by Loys Delteil in 1923; and some of the letters had been issued in an edition prepared and edited for publication in 1943 by John Rewald with the assistance of Lucien Pissarro.[3] The drawings have occasionally been exhibited, but they have never been fully catalogued, and it is with this section of the Pissarro collection in Oxford that the present catalogue is concerned.

The size and quality of the collection of drawings by Camille Pissarro in Oxford emboldens one to make some large claims for it. There can, for instance, be few, if any, collections of drawings by an Impressionist painter that are larger, and it is highly likely that it is the largest collection of drawings by a single Impressionist artist in the world. As such, it constitutes an introduction to Camille Pissarro that is comparable with an inspection of the Notebooks of Edgar Degas in the Bibliothèque Nationale, Paris.[4] Apart from adding considerably to our understanding of Pissarro as an individual artist, such a collection also prompts one to consider the role of drawing for the Impressionists as a group.

It should be borne in mind that, by virtue of its provenance and of the system of *partage* operating at the time of Camille Pissarro's will of 1903, the collection of drawings in Oxford only represents a fraction of the total number of drawings by his hand. An undated list of drawings and prints entitled *Liste qu'il est impossible d'évaluer en ce moment à Eragny*,[5] which was most probably compiled in 1903 by Lucien Pissarro on his father's death, provides us with the following numerical information:

> 58 dessins
> 52 pastels
> 57 dessins rehaussés
> 1709 croquis
> 11 académies
>
>
>
> 22 albums de croquis
> 112 croquis Travaux des Chàmps que j'empreinte
>
>
>
> 47 dessins à la presse

This list gives a total of approximately two thousand five hundred drawings, assuming there to be about twenty pages to each sketchbook, left in the studio at Eragny

[3] For full details of these various publications and for the various abbreviations used in the text of the Introduction see Abbreviations below (pp. 91–2).

[4] T. Reff, *The Notebooks of Edgar Degas*, 2 vols., Oxford, 1976.

[5] Ashmolean Museum, Department of Western Art, Lucien Pissarro box file xxxvii, Picture Lists. It is possible that this list was drawn up at the time of the death of Julie Pissarro, Camille's widow, in 1926, but this is unlikely, because of the drawings connected with *Travaux des champs* and the other drawings described as *à la presse*, which suggest work in progress, a state of affairs that is perfectly valid in 1903 in the case of *Travaux des champs*, a joint project undertaken by Camille and Lucien Pissarro (see Introduction pp. 66–85).

on the artist's death. Presumably there were also several hundred drawings that were no longer in the artist's possession or were assembled elsewhere. The total number of Camille Pissarro's drawings, therefore, may amount hypothetically to as many as three thousand, a total which John Rewald regards as a conservative estimate.[6]

The observations made in the subsequent sections of this Introduction to the catalogue are based upon a close examination of the drawings in the Ashmolean Museum, as well as upon those drawings in public and private collections to which the writers have been granted access. By the time that the material has been gathered for the publication of a corpus of Camille Pissarro's drawings, it may be necessary to refine, or adjust, some of the conclusions or temporal divisions that are discussed below. Yet, owing to the fact that the collection in Oxford has drawings from all periods of Pissarro's working life, it has been possible to describe, in outline at least, the main changes in his style of drawing and on a wider basis to discuss the role of drawing for his art taken as a whole.

The account of Pissarro's drawings which forms the basis of this Introduction falls into sections. In that entitled Evolution of style (II) a chronological analysis has been attempted. It will be seen that there is a certain unevenness in the chronological divisions, although in the present state of knowledge the writers believe that these do represent valid shifts in style. Some of these divisions are fairly long, spanning periods of as much as fifteen years, whilst others are of much shorter duration, sometimes reduced to a mere three years. On the other hand, some of the divisions, particularly the early formative ones, have clear boundaries, whilst others, particularly those of the 1870s, are less clearly demarcated. There are, regrettably, very few external aids for the dating of Pissarro's drawings. Few of the sheets are actually dated by the artist himself (see Index 4) and references in his correspondence, or in the catalogues of exhibitions held during his lifetime, are not usually sufficiently detailed to allow exact identification. Yet a surprising number of the drawings do relate directly to dated or datable paintings listed in the official *catalogue raisonné*, and around these drawings others have been grouped on the basis of style. Every attempt, however, has been made to avoid giving drawings arbitrary dates and frequently in the entries comparative material has been cited, so that the reasons for a suggested date can be followed. Later sections of the Introduction, Individual aspects of drawing (III) and The role of drawing (IV), discuss such matters as subject-matter and function. Both these aspects assume great importance in the study of Pissarro's drawings in that they reflect changes in approach to his work that are as helpful in understanding his methods of drawing as the formal or textural qualities of the drawings themselves. The student of Pissarro's drawings has, therefore, to balance out these factors when examining each sheet and nothing demonstrates more effectively the complexity of Pissarro as an artist than the necessity to adopt this dual approach to his drawings.

When viewed in the context of Impressionism, Camille Pissarro's graphic *œuvre* is formidable. In numerical terms, it is at least four times larger than Manet's

[6] Letter to the compilers from John Rewald dated 4 December 1977.

published graphic *œuvre* and almost twice as large as that of Cézanne,[7] whereas the surviving drawings of Sisley, Renoir, and Monet, in so far as they have been studied at all, seem comparatively rare in comparison with those by Pissarro. Only a comparison with Degas is justified. Camille Pissarro himself remarked in a letter to Lucien written on 24 February, 1895, '*Non, je reste avec Sisley, comme une queue de l'impressionisme*', and, indeed, it is true to say that until now Pissarro studies have lacked the intensity that characterizes research on other major Impressionist painters. Examination of Pissarro's drawings, however, reveals a far more fascinating artist than has previously been imagined.

II
Evolution of style

(a) 1852–1855

It is ironic that the brief period of Pissarro's working life spent away from France on the island of St. Thomas in the Antilles and in South America should be the most studied. Through the efforts of the Museo de Bellas Artes and the Banco Central in Caracas, as well as several private collectors, nearly two hundred sheets dating from this early period have been assembled in Venezuela. Together with the sheets in the Ashmolean Museum and the few others scattered in European and American collections, this provides a formidable group of early drawings. Therefore, it is hardly surprising that two pioneering scholars, John Rewald and particularly Mr Alfredo Boulton[8], should have submitted these early drawings to close examination, and their findings allow one to analyse the origins of Pissarro's style in some detail. In fact, we know more about the origins of his style of drawing than we do about those of Monet, Renoir, or Sisley.

The outline of Pissarro's movements during the years 1852–5 can be gleaned from documents and from his first biographers. Born on the island of St. Thomas in 1830, Pissarro was sent to school in France in 1842. He arrived back on St. Thomas from his school in Passy near Paris in 1847 and began to work in the family business. He met the Danish painter Fritz Melbye some time in May 1851 and left St. Thomas with him in November of the following year bound for Venezuela, where they stayed for two and a half years. Pissarro returned to St. Thomas in August, 1855, and finally sailed for France during the final months of 1855.

It is difficult to discuss the style of Pissarro's earliest drawings, or to measure the

[7] For Manet see A. de Leiris, *The Drawings of Edouard Manet*, University of California Press, Berkeley and Los Angeles, 1969. For Cézanne see A. Chappuis, *The Drawings of Paul Cézanne. A Catalogue Raisonné*, 2 vols., London, 1973, reviewed by T. Reff, *Burlington Magazine*, cxvii (1975), pp. 489–91.
[8] A. Boulton, *Camille Pissarro en Venezuela*, Caracas, 1966. J. Rewald, 'Camille Pissarro in The West Indies', *Gazette des Beaux-Arts*, 6th series, xxii (1947), pp. 57–60. Also J. Joëts, 'Camille Pissarro et la période inconnue de St. Thomas et de Caracas', *L'Amour de l'Art*, NS 20 (1947), pp. 91–6.

influence of Fritz Melbye, because none of the sheets done before his meeting with the Danish artist has survived. Yet there are numerous anecdotes from family sources and early biographies about Pissarro's propensity for drawing as a child. He apparently received some instruction from M. Savary, M. Marelle, and M. Poncet, who taught drawing in the school he attended at Passy. He is also reported to have spent a great deal of time drawing in the harbour of Charlotte Amalie on St. Thomas after returning from school in France, and it is clear that this was done in preference to the drudgery of office work in the small mercantile business that his family owned. We are also told that Melbye first noticed the young Pissarro because of the latter's facility as a draughtsman. These anecdotes suggest that even at this stage of his life Pissarro drew obsessively and that he had obtained some European training in that art. To this extent he was already a fairly proficient draughtsman before his meeting with Melbye, who was then able to provide him with a professional example which he could emulate.

The drawings dating from 1852 have a remarkable stylistic unity. Although Pissarro essayed a wide range of subjects and made drawings for a multitude of purposes in a variety of media, there are two major characteristics that are nearly always present. The first is the variable and broken outline, which is distinctly episodic in character and on which forms are composed of numerous separate lines rather than enclosed by continuously flowing contours. In the study of a young boy called Frederick David (No. 3 verso) Pissarro has defined the figure with an abundance of pencil lines of different lengths and varying strengths. The pencil delineates such features as the edge of the coat, the gleam of the buttons, the fold of the cloth at the right elbow, and the lobe of the boy's right ear, each with separate strokes. The idea of the whole figure seen as an enclosed form did not interest the young Pissarro, whose eye roved about with an agility and nervousness that corresponds with the outlook of contemporary artists such as Constantin Guys and Honoré Daumier who were then at work in Paris. Although it might be possible to argue that the constant need to redraw so many of the outlines might have resulted from the artist's relative inexperience, such an explanation does not account for those passages found in almost all Pissarro's drawings of this date that have a vibrancy and panache absent from the work of any ordinary student.

The second major characteristic of Pissarro's early drawings is the use of diagonal hatching. If the treatment of outline attests the acuity and independence of Pissarro's eye, the system of hatching lends the drawings their strength. Hatching exists on almost every sheet and dominates certain drawings to the extent that it might well be considered the hallmark of Pissarro's early style. The delicate hatching, which defines the foliage in No. 4 recto, or the bold hatching drawn across the face of the male figure in No. 17 verso, indicate the full range of this technique. It is of particular interest that Pissarro's hatching hardly ever creates an illusion of distance or space by introducing shadows in the manner of tonal modelling. Rather, the hatching is more applicable in the context of building up the structure of the pictorial surface. In this way, the hatching is analytical, as opposed to descriptive, and, in this

Figure 1. Samuel Prout, *Easy Lessons in Landscape Drawing contained in forty plates.* Plate 19. Lithograph. 170 × 247 mm.

respect, has a remarkable affinity with Cézanne's so called 'constructive stroke' of the 1870s.

Almost all scholars equate Pissarro's style of drawing with that of Fritz Melbye, whose own career is little known beyond the few paintings and drawings published by Boulton. Although it is impossible to deny the role which Melbye must have played in the early career of Pissarro, it can easily be over-emphasized. Melbye's surviving works reveal a tendency to over-elaborate which one seldom finds in Pissarro's drawings. The Danish artist relied on carefully delineated contours and on a traditional system of hatching. Indeed, direct comparison between the two artists leads one to suspect that in nearly every case Pissarro's own artistic instincts were already comparatively well developed before his association with the Danish painter and that one must look elsewhere for his main sources of inspiration.

Although it cannot yet be proved, one of the most important sources for the young Pissarro may have been the drawing manuals, topographical books, and popular illustrated periodicals to which he would undoubtedly have had access. As artistic sources, these branches of literature are still largely unstudied,[9] but they do include illustrations that share the principal stylistic and iconographic qualities found in

[9] J. Adhémar, 'Les lithographies de paysage en France à l'époque romantique', *Archives de l'art français in Société de l'histoire de l'art*, NP xix (1935–7), pp. 189–364, with a bibliography of published lithographs on pp. 284–364; M. Twyman, *Lithography 1800–1850*, Oxford, 1970. Also R. V. Tooley, *English Books with Coloured Plates 1790–1860. A Bibliographical Account*, London, 1954, reprinted 1973, and *Travel in Aquatint and Lithography 1770–1860 from the Library of J. R. Abbey. A Bibliographical Catalogue*, vol. ii, London, privately printed, the Curwen Press, 1956. For a brief survey

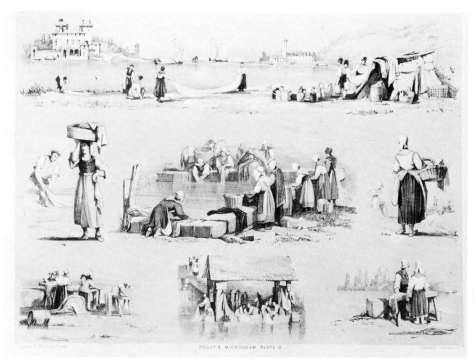

Figure 2. Samuel Prout, *Microcosm*. Plate 15. Lithograph. 247 × 343 mm.

Pissarro's drawings of this date. As an apposite example one might cite the drawing-manuals of Samuel Prout, with whose work, particularly *Easy Lessons in Landscape Drawing* (London, 1819) and the *Microcosm* (London, 1841), Pissarro's early drawings often have close affinities (Figs. 1 and 2).[10] It is perhaps significant that popular illustrated periodicals were also of considerable importance for Monet and other French artists of the mid-nineteenth century, thereby providing a precedent for the repertoire of gestures that forms one of the dominant characteristics of Impressionist painting.[11]

The most interesting aspect of Pissarro's draughtsmanship during the years 1852–5 is the speed with which it developed. The style moves dramatically from one

of drawing manuals see J. Friedman, 'Every Lady her Own Drawing Master', *Apollo*, cv (1977), pp. 262–7.

[10] See E. G. Halton, *Sketches by Samuel Prout in France, Belgium, Germany, Italy, and Switzerland*, London, Paris, New York, 1915, reprinted from *The Studio*.

[11] See D. Wildenstein, *Claude Monet. Biographie et catalogue raisonné, i, 1840–1881*, Lausanne–Paris, 1974, pp. 4–5; R. Walter, 'Claude Monet as a Caricaturist. A Clandestine Apprenticeship', *Apollo*, ciii (1976), pp. 488–93; M. Schapiro, 'Courbet and Popular Imagery. An Essay on Realism and Naïveté', *Journal of the Warburg and Courtauld Institutes*, iv (1940–1); L. Nochlin, 'Gustave Courbet's *Meeting*: A Portrait of the Artist as a Wandering Jew', *Art Bulletin*, xlix (1967), pp. 209–22; A. Coffin Hanson, 'Manet's Subject Matter and a Source of Popular Imagery', *Museum Studies. The Art Institute of Chicago*, 3 (1969), pp. 63–80 and, now, A. Coffin Hanson, *Manet and the Modern Tradition*, Yale University Press, London, 1977.

characterized by minuteness of form and immense detail, stemming from close observation, to a looser, more confident manner which exaggerates many of the features found on the earliest sheets. Indeed, the drawings done in 1854–5 on St. Thomas after Pissarro's return from Venezuela are totally different from those done before his departure for South America two years earlier. An early sheet, such as No. 5, has a limited range of tonal values, whereas a later one of a similar subject (No. 34) has a breadth of execution, a wide distribution of varied tones, and an appreciation of the structural possibilities of diagonal hatching.

This rapid development in Pissarro's style can be interpreted as a move away from Melbye, whose classically ordered landscapes had been an important directive for him during 1852–3. Melbye was quickly surpassed by the younger artist and a masterly sheet entitled *Camino de la Guaira à Macuto* (No. 32 recto), which was drawn in 1853, is virtually a parody of Melbye's compositional methods.

In a drawing of a panoramic view of Caracas (No. 18 verso), which can be directly compared with a sheet by Melbye, the forceful pencil work demonstrates a complete technical mastery of the medium. The pairing of the two sets of palm trees in the middle distance connects the strongly drawn foreground to the mountains seen emerging through the humid atmosphere. Both the compositional devices and the atmospheric effects have been perfectly realized with the pencil. Melbye's drawing of the same view of Caracas (Fig. 3), which was made in preparation for a painting,

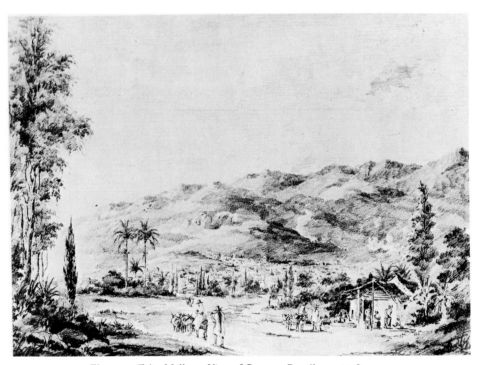

Figure 3. Fritz Melbye, *View of Caracas*. Pencil. 273 × 383 mm.

is awkwardly composed.[12] It is principally concerned with the individual forms within the landscape, as opposed to the composition as a whole. Melbye was obsessed by minutiae within the vast panorama before him. Pissarro, on the other hand, was not so much interested in the mountains, the sky, or the architectural features of the distant city, as in the immediacy, the quickening of impulse experienced before the motif itself. Already his concerns were compositional rather than descriptive.

The surviving drawings made by Pissarro during this first period can be divided into two groups. There are those drawn directly from nature and those made in preparation for specific compositions. The former group is dominated by single figure studies, various genre scenes, informal landscapes, and studies of the dense vegetation found in the forests surrounding Caracas. These drawings form the basis of the compositional studies, which were presumably created in the studio, mostly on large sheets of paper. The compositions themselves are often crowded with figures, usually posed rather stiffly, and positioned close to the picture plane.

The compositional studies, important as they no doubt were for the young Pissarro, are of less significance for us today. The drawings made from life are numerically superior, and they contain the germ of Pissarro's later development. Already the South American counterparts of the French peasants that he was to paint so consistently later find their way into his visual repertoire. The streets and suburbs of Caracas were explored with a detachment that anticipates Pissarro's paintings of the boulevards of Paris. The life of the ports of Charlotte-Amalie on St. Thomas and of La Guaira on the coastline of Venezuela was illustrated in a series of drawings which look forward to the port scenes of Rouen, Dieppe and Le Havre. The markets which came to fascinate Pissarro so much during the 1880s and 1890s were also observed in Venezuela. It is, therefore, true to assert that the two major subjects that were to absorb Pissarro for the remainder of his working life—peasant genre and landscape—were the most important aspects of his Venezuelan iconography. This is of crucial significance for our understanding of Camille Pissarro's art. When he arrived in Paris in 1855 for the closing days of the Universal Exhibition, it was no accident that he was attracted to the landscapes of Corot and the Barbizon school. His own aesthetic, which he had worked out for himself from a vernacular tradition of immense richness, prepared him more for the paintings of the Realists than for the historical and narrative compositions of Ingres and Delacroix, whose works dominated the Exhibition of 1855.

(b) 1855–1869

The drawings, which survive from the early years in France, lack the stylistic unity and clear sense of development that mark those done in South America between 1852–5. Pissarro's exposure in France to the successive tutelage of several major painters, notably Corot, Courbet, Daubigny, and Chintreuil, placed him in an entirely different position from the closely defined relationship that he had

[12] Both the painting and the drawing by Melbye are reproduced in Boulton, op. cit. 63.

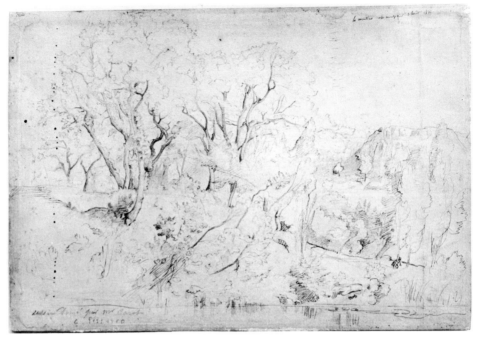

Figure 4. J. B. C. Corot, *Le Martinet près Montpellier*. Pen and ink over pencil. 337 × 502 mm.

experienced with the minor artist, Melbye. These diverse influences, to which others may be added, partly explain the varied nature of Pissarro's drawings dating from 1855–69.

An initial and apparently short-lived influence is that of the academic institutions, such as the classes of the École des Beaux-Arts and the Académie Suisse where drawing was still taught on a formal or quasi-formal basis.[13] Pissarro is known to have attended both these institutions and there are three sheets in the Ashmolean Museum that provide evidence for this (Nos. 35–8). Interestingly, the rough inventory of the contents of the studio at Eragny drawn up by Lucien Pissarro possibly in 1903 lists *11 académies*, which must presumably refer to drawings of this type.

After a brief interest in studio instruction Pissarro seems virtually to have abandoned figure drawing and to have concentrated upon the landscape of the *campagne de Paris*. The landscape drawings of this period, many of which are signed and dated, reveal not only a deep commitment to nature, but also an attempt to master the styles of several individual artists. Corot, whose pupil Pissarro so described himself in the Salons of 1864 and 1865, has often been considered to be the most important of his artistic mentors during this pre-Impressionist period. Certain sheets, like the

[13] See A. Boime, *The Academy and French Painting in the Nineteenth Century*, London, 1971, and also 'The Teaching Reforms of 1863 and the Origins of Modernism in France,' *Art Quarterly*, NS i (1977), pp. 1–39.

delicate study of a tree drawn in pencil (No. 58 recto), are clearly derived from Corot's example, although it is in a style that Corot had used somewhat earlier in his career. In fact, the clear pencil outlines and the crisply defined branches of the tree recall Corot's drawings dating from 1826–40, suggesting that Pissarro must have studied such drawings in the master's own collection, in addition to showing an interest in his current work. This fact is substantiated by the existence of a drawing by Corot dated 1836 once owned by Pissarro and now in the Metropolitan Museum of Art, New York (Fig. 4). Perhaps at this same time Pissarro acquired the drawing by Corot of a quarry that is now in the Ashmolean Museum having reached Oxford from an independent source (Fig. 5). Corot's later drawings and prints with their structural web of finely drawn lines, used to build up tonal value, seem to have had little effect on Pissarro between 1855 and 1869.

Although other sheets from this period indicate that Pissarro was affected by artists such as Diaz, Daubigny, and Rousseau, it is perhaps to the comparatively unknown painter Chintreuil, whom Pissarro knew as early as 1859, that we must turn in seeking a precedent for many of his drawings. There are several sheets made either by Chintreuil himself, or by his pupil Desbrosses, which bear striking stylistic and iconographic similarities to those drawn by Pissarro at this date. The *Liber Veritatis* of Chintreuil, whose precise authorship has long been held in doubt, but which

Figure 5. J. B. C. Corot, *The Quarry*. Pencil. 295 × 387 mm.

was certainly compiled during the final decade of the master's life, contains many sheets which are related to those drawings executed by Pissarro in Montmorency (Nos. 50–1), La Roche-Guyon (Nos. 52–3), Chailly (No. 60), and Nanterre (No. 61).[14]

However, the absence of any systematic study of French landscape drawings of the mid-nineteenth century makes generalizations about Pissarro's own development between 1855–69 difficult. If the published drawings of major artists with whom Pissarro worked may be considered representative, it is clear that he was not profoundly influenced by any one of them. Yet it need not necessarily follow from this that Pissarro continued to develop his style in comparative isolation, as he was forced to do before reaching France in 1855. Rather, it is best to describe this period of his life as one of experimentation. The drawings display a host of techniques and different modes of drawing. Some are in pure outline, others almost overloaded with detailed observation, and still others evince a new interest in broadly defined tonal values. These various drawings are executed in a corresponding variety of media, including pencil, pen, brush, chalk, and charcoal, sometimes used in combination and often on coloured papers. The purposes for which the drawings were made also vary considerably, extending from brief preparatory studies to elaborate compositional exercises. If the period divided between St. Thomas and Venezuela concentrated predominantly upon analysing subject matter, that in France between the years 1855 and 1869 shows a preoccupation with style and technique.

Yet, despite the profligacy of styles and techniques that abound in these drawings, it is possible to make some general points about Pissarro's development as a draughtsman between 1855 and 1869. There is, for instance, a shift in the medium from the pencil and pen favoured in 1852–5 to the softer and more variable media of chalk and charcoal used in conjunction with wash and coloured paper. This change in itself tells us a great deal about the development of Pissarro's artistic sensibilities after his arrival in France. It is reasonable to assert that the most important aspect of his new style is tonal value, which to some extent had already become apparent in some of the drawings made in South America. One particular sheet executed in Montmorency in 1857 (No. 50) and several related drawings done at La Roche-Guyon (Nos. 52 and 53) have inscriptions which provide direct evidence of Pissarro's new interest in tonal values. No. 52 is inscribed with value notations such as *1. forte lumière 2. lumière 3. ombre* and *4. ombre foncé*, a scheme that can be connected with an inscription that occurs on another sheet drawn at Montmorency (No. 50), which reads *étude à l'huile à faire*. These last sheets were clearly conceived as the first steps in a preparatory process, which began with the observation of tonal values and was then followed by colour studies done in oil. This was, of course, the method advocated by Corot in his famous remark to Pissarro, 'il faut avant tout étudier les valeurs.

[14] The *Liber Veritatis* is in the Fondation Custodia, Institut Néerlandais, Paris (inv. 1970. T.I.). For discussion of this and other drawings by Chintreuil, see *Antoine Chintreuil 1814–1873. Catalogue de l'exposition organisée par les villes de Bourge-en-Bresse et Pont-de-Vaux*, 1973, pp. 65–74. See especially those drawings numbered 190 and 429 in the *Liber Veritatis*.

Nous ne voyons pas de la même façon; vous voyez vert, et moi je vois gris et blond. Mais ce n'est pas une raison pour que vous ne travailliez pas les valeurs, car cela est au fond de tout ...'[15] This concern with tonal values, therefore, does provide an underlying unity to what at first seems to be a series of unrelated drawings. The informal studies of the period 1852–5 are replaced by large elaborately constructed drawings, which lack the panache and spontaneity of the earlier sheets. The compositions are more controlled and purposeful, indicating that draughting, rather than sketching, was Pissarro's principal concern between 1855–69.

A detailed examination of these first drawings done after Pissarro's arrival in France in 1855 reveals that, regardless of the painter's sympathy with those young artists who were to form the Impressionist group during the later 1860s and early 1870s, his own art was more closely tied to that of the Barbizon school and the painters who surrounded Corot. Pissarro does not seem to have been familiar with the important pictorial advances made by Boudin, Jongkind, and the young Monet until the very end of the 1860s. Nor did he, at this stage, share with Renoir a desire to learn from the great French painters of the eighteenth century, then being championed by the brothers Edmond and Jules Goncourt in their *L'Art au dix-huitième siècle*, published between 1856 and 1875. Apart from a single drawing and an etching of Montmartre,[16] Pissarro avoided Paris during this period, and the variety of styles in his drawings must be seen in terms of the habits of an itinerent student who was attempting to absorb the lessons of Corot, Rousseau, Daubigny, Chintreuil, and Courbet by looking over their shoulders as they worked *en face de la motif*. The drawings allude to a simple unpopulated rural world, such as that described so lovingly by Frederick Henriet in his various publications of the 1860s and 1870s.[17] It is, indeed, the mid-century attitude towards art and reality exemplified by Henriet's writings that forms one of the principal strands in Pissarro's somewhat eclectic style of this period.

(c) 1869–1873

The period 1869–73 must be treated separately for two reasons. First, there is Pissarro's move to Louveciennes in 1869, which allowed him to work in close proximity with Renoir, Sisley, and Monet, all of whom were painting in the Bougival, Louveciennes, and Marly region at that time. Direct contact with Monet in particular caused Pissarro to revise the method of landscape painting that he had learnt from the Barbizon school. He now began to divide his brushstrokes, to employ smaller patches of paint, and to become much more aware of the importance of colour for

[15] A. Alexandre, *Claude Monet*, Paris, 1921, p. 38, quoted by J. Rewald, *Histoire de l'impressionnisme*, French edn., Paris, 1955, p. 87.
[16] The drawing is reproduced by J. Rewald, *Camille Pissarro*, London, 1963, p. 53. The etching is L. Delteil, *Le Peintre-Graveur illustré. Vol. XXVII. Camille Pissarro. A. Sisley. A. Renoir*, Paris, 1923, No. 4.
[17] F. Henriet, *Le Paysagiste aux champs*, Paris, 1867, expanded edn., 1876.

the purpose of creating a composition, as well as for the description of natural pheno-
mena.

The second reason for treating the years 1869–73 separately is Pissarro's visit to
England in 1870–1 during the period of the Franco-Prussian War and the Paris Com-
mune. In England, Pissarro was exposed to the landscape tradition of Gainsborough,
Constable, Turner, and the Norwich school, as well as to the work of landscape artists
of other schools of painting such as the Dutch seventeenth century, as represented
in the National Gallery, London.[18] All these influences helped to initiate a period
in Pissarro's working life that is best described as 'classical' when he allied himself to
the broader spectrum of the European landscape tradition.

There are two ways in which the direct influence of Monet and the English school
altered Pissarro's style of drawing. The first can be observed in those sheets of studies
inscribed with colour notations and instructions about the literal fragmentation of
the surface into smaller areas of paint. The inscription, for instance, above a slight
study of a male figure on the verso of No. 68A refers to a landscape *vue attravers
une vapeur complètement transparent et les couleurs fondues d'une dans l'autre*. Another
drawing in pencil, executed on the route de Versailles near the painter's own house
at Louveciennes, is covered with detailed inscriptions describing the colours in
a sunset (No. 68B). Both these sheets mark a fundamental change from the artist's
approach to landscape as practised between 1855–69 and show Pissarro adapting
himself to Impressionist techniques and theories. Both his hand and his eye are now
more concerned with temporal effects. The drawings are intensely linear and
rhythmical, almost totally devoid of hatching, and in many ways related to Monet's
and Manet's exuberant style of draughtsmanship. The pencil and the pen predomi-
nate and are substituted for the crumbly media used during the period 1855–69.

The important stylistic change that occurs in Pissarro's paintings at the beginning
of the 1870s is easier to define with the knowledge of these drawings. He does not
seek to define solid forms by a system of closed lines. Those, for instance, that
represent the spire of St. Stephen's church at Dulwich (No. 68F) retain an autonomy
of their own and barely assume any architectural significance. The relative absence
of hatching in these same drawings results from a lack of interest in tonal values
and implies a new concern for rapidly executed drawings in pure outline.

The second distinctive feature of the drawings dating from 1869–73 is Pissarro's
adoption of watercolour. This was encouraged not so much by Monet as by Jongkind
and the English watercolourists of the first half of the nineteenth century. The role
of watercolour in Pissarro's art and its independent stylistic development will be
discussed in full in a later section (see pp. 28–33), but it is important to stress here
that the rapidity and fluency of the technique appealed to him and that the transient
qualities, as well as the reliance on colour demanded by this medium, helped him
to think in terms of Impressionist theory. There is also an important change in Pis-
sarro's ideas about landscape during this period, which is similarly connected with

[18] C. Lloyd, 'Camille Pissarro and Hans Holbein the Younger', *Burlington Magazine*, cxvii (1975),
pp. 722–6.

his adoption of watercolour. The surviving watercolours are usually compositional studies. However, they are quickly executed, loosely drawn, and rarely closely finished, in contrast with the paintings. The painter seems, in fact, to have retained a strictly hierarchical system of preparation for his paintings, a process that is surprising in the context of a movement that is often associated with spontaneity in front of the motif. For Pissarro, as for Manet, the oil sketch may by now have been elevated to the status of a finished picture, yet both artists continued to proceed systematically from drawing to watercolour and from watercolour to the final painting. A specific example of this progression is given in a later section in a discussion of the preparatory process used for P&V 108 (see p. 42), incorrectly entitled *Eglise de Westow Hill, Neige*.

The drawings of the period 1869–73 are not visually very striking. In this respect, they are dissimilar from the finished drawings dating from the period 1855–69. They represent an attempt to translate the chief characteristics of a motif with the minimum number of lines. Economy of means and conciseness of style are their principal virtues.

(d) 1873–1880

During the final months of 1873 Pissarro's art underwent a further change. He rejected the modernist subject-matter of Impressionism and began to take an intense interest in the human figure seen in a specifically rural context. Furthermore, with the assistance of Paul Gachet and later of Edgar Degas, Pissarro returned to print-making where he portrayed the same themes as in his painting. The exact reasons for these two developments are difficult to discover in the absence of primary sources. However, the correspondence with the critic Théodore Duret, which has survived in part, does help to explain why during this intensely experimental period Pissarro rejected a great deal of the style and the subject-matter traditionally associated with Impressionism. In a crucial letter written to Pissarro on 6 December 1873, Duret gave the painter the following advice:

Je persiste à penser que la nature agreste, rustique avec les animaux est ce qui correspond le mieux à votre talent. Vous n'avez pas le sentiment décoratif de Sisley ni l'œil fantastique de Monet, mais vous avez ce qu'ils n'ont pas, un sentiment intime et profond de la nature et une puissance de pinceau qui fait qu'un beau tableau de vous est quelque chose d'absolument assis. Si j'avais un consil à vous donner, je vous dirais: ne penser ni à Monet ni à Sisley ... allez de votre côté, dans votre voie de la nature rustique, vous irez dans une voie nouvelle, aussi loin et aussi haut qu'aucun maître.

Only part of Pissarro's reply to Duret, written two days later, has been published:

Merci de vos conseils, vous devez savoir qu'il y a longtemps que je pensais à ce que vous me dîtes. Ce qui m'a empêché longtemps de faire la nature vivante, c'est toute simplement la facilité d'avoir des modèles à mon disposition, non pas seulement pour faire le tableau

mais pour étudier la chose sérieusement. Du reste, je ne tarderai pas à essayer encore d'en faire, ce sera fort difficile car vous devez vous douter que ces tableaux ne peuvent se faire toujours sur nature, c'est à dire dehors. Ce sera bien difficile.[19]

The letter from Duret to Pissarro is confirmation of the fact that the artist attempted to undertake new themes at that time, and the reply from Pissarro implies strongly that the principal way in which he could explore the new possibilities of rural subjects would be in his drawings. In fact, Pissarro makes it clear in his reply that it was difficult for him to paint in front of nature *en plein air* and that a great deal of his work was now carried out in the studio. As a result, his graphic output increased substantially.

In contrast with earlier periods, studies of the human figure are now more numerous and these reveal above all else that Pissarro was attempting to find a standard method of drawing this most challenging of forms. There is some evidence that this search had already begun in Venezuela, but there is one sheet in the present collection (Nos. 58 verso), as well as another in the possession of Professor Charles de Tolnay in Florence, both dating from 1874–5, which show a radical development in the drawing of the human figure. The delineation of the figures on these two sheets of studies is best described as modular. The forms are built up with a series of short lines joining one another at sharp angles and the polygonal shapes that they assume are accentuated by the placement of the figures either parallel to the picture plane or at right angles to it. Indeed, this almost geometric method of drawing permeates the backgrounds of compositions, in addition to governing the figures, and is, in turn, related to the graphic work of Cézanne dating from this same period. The differences between this newly developed system of drawing and the figure studies from an earlier date can best be demonstrated by a direct comparison. In No. 68A recto, for instance, which dates from 1870 and was used in preparation for P&V 96, *La Route de Versailles à Louveciennes*, now in the Foundation Emil G. Bührle Collection, Zürich, the figure is defined by long, clear contours, which silhouette the form against the background. The peasant woman in No. 80, however, has no such autonomy. She exists within, and merges with, the structured confines of her setting.

The significance of the polygonal style in Pissarro's career and in the history of nineteenth-century French art is profound. When one examines in detail the surfaces of Pissarro's paintings dating from the middle of the 1870s, it is clear that his method of painting was now ordered and controlled in the same way as the lines in his drawings. This process of structuring the pictorial surface is also characteristic of Cézanne, who was later to explore its full implications. In view of the fact that both artists worked together closely during this period and were concerned with the same artistic problems, it is hardly surprising that both their paintings and drawings should to some extent resemble one another (see, particularly, Nos. 76–8, 80, and

[19] Both Théodore Duret's letter of 6 December 1873 and Pissarro's reply are in the Musée du Louvre, Cabinet des Dessins, Paris. Incomplete transcriptions of both the letters may be found in L. R. Pissarro and L. Venturi, *Camille Pissarro. Son art – son œuvre*, i, Paris (1939), pp. 26–7.

81). The purpose of this systematic method of drawing the human form was to allow its ready integration into an ordered composition, thereby solving the problem of tension between the figure and the background that had constrained so many painters of the second half of the nineteenth century in France, and was perhaps most closely studied by Cézanne in his late paintings of bathers.

Even though there are a large number of surviving drawings from the years 1873–1880, very few actually relate directly to finished paintings. In fact, the drawings differ from those of earlier periods in that they are so obviously exploratory rather than preparatory. It appears that Pissarro now began to draw compulsively, ceaselessly recording the figures and the landscapes before him, even if he did not intend to develop them further. Sketchbooks, often of small dimensions, are reserved for this task, and the artist seems to have used several contemporaneously. Many of the sheets from these sketchbooks (for example, Nos. 73C and 85A) have an immediacy and freshness shared by the drawings from the preceding period, only now they are independent graphic exercises. With these drawings, therefore, the spontaneity that characterizes Pissarro's initial phase as a draughtsman (1852–5) returns.

The lack of correspondence between the paintings and drawings dating from 1873–1880 also applies to the prints. At this time, Pissarro executed both lithographs and etchings, but neither the preparatory studies, nor the transfer drawings seem to have survived as they have for later periods. There are certainly stylistic affinities between the lithographs of the mid 1870s and the drawings in chalk and charcoal of the same date, but no other precise connections exist. The etchings, too, even though they are of the highest quality, form an independent group to which no drawings can be related except as regards a general similarity in style.

The artist who had the deepest effect upon Pissarro as a draughtsman between 1873–1880 was Jean-François Millet. It seems odd that Pissarro, who was preeminently Millet's successor in the depiction of rural life, should never have known him and that the paintings and drawings done after Pissarro's arrival in France in 1855 should show so little awareness of his achievements. It is apparent, however, that Pissarro did turn to Millet during the 1870s, and this came about for several reasons. First, there was a reference to Millet in Duret's letter of 6 December 1873, a section of which has been quoted above. The contents of that letter bear directly upon the subject-matter of Millet's paintings in the context of Pissarro's own work. Secondly, there was the sale of Emile Gavet's collection of drawings by Millet, which was held in Paris in 1875. This sale, and the exhibition which preceded it, gave Pissarro a unique opportunity to see Millet's drawings in abundance. Indeed, Pissarro's interest in peasant genre and his new preoccupation with the human figure must be seen in terms of Millet's example. In the prints made by Millet himself between 1852–69, as well as those executed after his work by A. Lavieille and others, the figure is built up with a series of short, slightly curved lines. It is a style that resembles Pissarro's own treatment of the human figure in his drawings of this date (for example, Nos. 85A recto and 85H verso), and, indeed, Millet's compositional methods would also have held a certain fascination for Pissarro at

this time with his preoccupation for the integration of the figure into a setting.[20] As far as one knows, Pissarro makes no reference to Millet in any of his letters dating from the 1870s, but, none the less, his paintings and drawings of the second half of that decade are conscious remakings and updatings of the subjects that Millet had treated earlier. The brief quotations from Millet (Nos. 85H verso and 87B verso) and the studies of the farmyard at Montfoucault are sufficient indications that Millet was a valuable source of inspiration for Pissarro in the evolution of his new brand of ruralism. It might, indeed, be the case that the important series of rural images created by Pissarro in 1875 were intended as a memorial to his famous forerunner, whose death occurred in that very year.

There is one strikingly beautiful pastel of a landscape in the Ashmolean collection (No. 86), which may be used to demonstrate how Pissarro transformed Millet's imagery. *The Pond at Montfoucault: Autumn* dates from 1874–5. It represents a motif that Pissarro painted and drew many times during the three painting-seasons that he spent at Ludovic Piette's farm in Brittany. Although the subject is one that could easily occur in Millet's *œuvre*, the style of Pissarro's pastel is notable for its mastery of colour, variety of handling, and optical brilliance, which not only anticipates Pissarro's own work of the mid 1880s but also the achievements of Gauguin and the Pont-Aven school, of which *Landscape of the Bois d'Amour at Pont-Aven—The Talisman* painted by Paul Sérusier in 1888 under Gauguin's direction may serve as an appropriate example.[21] The pastel by Pissarro is more anecdotal than Sérusier's landscape, but both have a similar subject and use of high-keyed colour. The pastel is applied to the surface of No. 86 in a variety of ways. The rugged branch of the tree on the left is drawn with a directness and simplicity that allows it a certain three-dimensional quality, whereas the pond, with its reflections of the sky and the autumn leaves, is smoother, owing to the fact that the pastel has been diluted in a volatile medium in the manner of Degas.

On a technical basis the main inspiration for Pissarro's pastel of the pond at Montfoucault was probably Degas, who had exhibited a pastel on the occasion of the first Impressionist Exhibition in 1874. That Degas advised Pissarro on the question of print-making is well known, and it is highly probable that his advice was not limited to recipes for etching grounds. The carefully controlled modulation between the different areas of pastel in No. 86, caused by diluting the medium, invests it with a quality that is quite unlike any of Millet's pastels, which are basically drawn with the purer pastel technique of the eighteenth century. Yet, paradoxically, the intensely traditional iconography of this particular landscape would be quite unexpected in Degas's experience. If, therefore, No. 86 owes its imagery chiefly to Millet and other French artists of the middle of the nineteenth century, its technique anticipates future developments in French art.

[20] Pissarro owned three prints by J.-F. Millet (L. Delteil, *Le Peintre-Graveur illustré. Vol. I. J.-F. Millet. Th. Rousseau. Jules Dupré. J. Barthold Jongkind*, Paris, 1906, Nos. 32–4, for which see *Collection Camille Pissarro, Troisième Vente*, Hôtel Drouot, Paris, 12–13 Dec. 1929, lots 258–9.
[21] Reproduced in colour by J. Rewald, *Post-Impressionism from Van Gogh to Gauguin*, Museum of Modern Art, New York, 1956, opp. p. 206.

(e) 1880–1890

The drawings executed during the last two decades of Pissarro's life are so diverse and complex that they cannot be easily treated in brief discussions of style alone. Indeed, it is virtually impossible to divide Pissarro's working life between 1880 and 1903 into periods which have any kind of consistency for the graphic media. Therefore the writers have chosen, in the first instance, to describe the major stylistic tenets of Pissarro's drawings in the periods 1880–90 and 1890–1903 very broadly and then to analyse in greater detail certain specific aspects which underlie these two periods (watercolour pp. 28–33; topography pp. 33–36; caricature pp. 36–38). This system is necessary for several reasons. First, it recognizes the fact that Pissarro's graphic production increased enormously in the period between 1880 and his death, an increase which is so important that one can safely say that as much as three-quarters of Pissarro's graphic *œuvre* was executed in these years. Secondly, the topical division of the remainder of the Introduction makes it perfectly clear that Pissarro's mature career was not developmental. Rather, he worked simultaneously in several styles and media, each of which had an independent history within his total *œuvre*. It is clear from a persual of the plates in this catalogue alone that uniformity of style was not even an aim of the artist. Pissarro appears to have cultivated diversity and for this reason can be considered amongst the most experimental draughtsmen of the late nineteenth century.

The artist himself regarded the first half of the 1880s as being the period in which he began to make a fundamental contribution to the development of French art. Significantly, the symbolist critics of the 1890s, writers such as Gustave Geoffroy, Georges Lecomte, and Octave Mirbeau, all stress the importance of the years 1880–90 when, in their view, Pissarro succeeded in unifying the different strands of his art and achieved a rewarding interaction in his paintings between the human figure and its setting without sacrificing one for the other. Although it is customary when discussing Pissarro's paintings to make a stylistic distinction between the early part of the 1880s and the last half of the decade when he embraced the theories of Neo-Impressionism, it is not necessary to do this for the drawings. There is, in fact, a continuity of style, which, while it accepts the theory of Neo-Impressionism, also totally ignores it. While he tended to use coloured chalks with greater frequency during his Neo-Impressionist phase of 1885–90, Pissarro's mode of handling chalk did not significantly change, and it is, therefore, false to make a distinction between those drawings made either before or after 1885. Indeed, it is easier to understand Pissarro's paintings during this decade by reference to the drawings, since they reveal his response to new developments in French art without any loss of individuality, as appears to have happened in the case of his divisionist paintings. In many ways, drawing was an antidote for Pissarro during a period in which he had many reservations about the theory of Neo-Impressionism, and an anodyne for the disappointment that he felt at the dullness of his own style of paintings, which is so often remarked upon in his letters. It might be said that the drawings serve as a

barometer by which to read Pissarro's anxieties about his own paintings, and, whereas in 1889 he completed only twelve canvases, a low point in the annual level of his production, no such interruption upset the flow of drawings. Indeed, Pissarro drew prolifically throughout this decade, and there is a large number of surviving sheets. From among them, two new interests can be seen emerging. These are the topographical drawings done in Rouen on his first extended visit to the city in 1883, and the caricature drawings, both of which will be discussed in separate sections below (see pp. 33–36 and pp. 36–38).

As in the preceding period figure drawing was Pissarro's main concern. An increasing confidence in the depiction of the human form is reflected in the greater variety of media with which he executed these drawings—pencil, chalk, pastel, ink—the last applied with both the pen and the brush. Pissarro also makes use of larger sheets of paper, and of sketchbooks of larger dimensions, among which may be included Sketchbook XV (No. 168), which contains some of Pissarro's most accomplished drawings. As the mid-point in Pissarro's working life, and as the epitome of his mature style of drawing, in that it summarizes what has gone before and foreshadows what is to follow, Sketchbook XV (No. 168) is valuable testimony. There are twelve sheets from this source in the Ashmolean Museum, and at least eight others have been found in other collections. The basic medium is black chalk, but it is often strikingly highlighted with watercolour, sometimes limited to a single wash, as in No. 168E, a study for the painting *La Charcutière* (P&V 615) in the Tate Gallery, London, which is delicately touched with a transparent light blue wash. Where a wash has not been enlisted, the black chalk has been utilized with the greatest possible freedom and vigour, as in No. 168F, where the contrast between the blank paper and the intensely dark striations creates a convincing effect of luminosity that is so characteristic of Pissarro's paintings of the 1880s. No. 168D and No. 168E, and possibly No. 168F, are compositional studies, but the sketchbook also contains independent studies of figures and animals all of the highest quality. The underdrawing of the two standing female figures in No. 168G, for instance, is in black chalk, but there is extensive modelling in grey and brown washes, particularly on the figure seen from behind, where the folds of the dress have been laid in with the brush, and then highlighted with gouache. These figures are notable for the sense of volume, referring back in this respect to those studies made in the 1870s, which is also the period of origin for the broken outlines of the bending woman in the right foreground of No. 168F, and the seated figure in No. 168D. On the other hand, the curvilinear shaping of the carefully placed figure cutting the meat in the study for *La Charcutière* (No. 168F) and the outlines of the studies of the turkeys in No. 168C, as well as the dash and freedom of individual strokes, and the tendency to dwell upon repeated contours, are all features wholly characteristic of the 1880s. Sketchbook XV (No. 168) can assuredly be placed amongst Pissarro's finest achievements as a draughtsman.

Where the figure drawings of the 1870s are characterized by short, relatively straight outlines of more or less equal length with the figure itself assuming a geo-

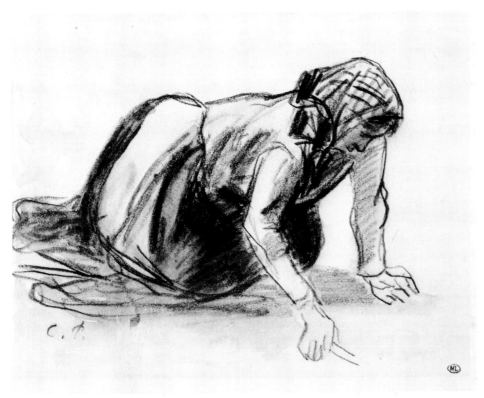

Figure 6. Camille Pissarro, *Study of a Female Peasant Weeding*. Black chalk with watercolours. 172 × 211 mm.

metric form, those of the 1880s tend to be fluidly and rhythmically drawn, and are often highlighted with watercolour. Some of the best examples are in the Cabinet des Dessins in the Louvre, on a series of sheets that, in fact, once formed part of a sketchbook (Fig. 6). Each figure, sometimes two to a page, is shown either in complete isolation or with a limited indication of the setting, posed as if engaged in some rural activity. The contours are frequently redrawn and are often repeated, or strengthened with the brush, so that the figure is silhouetted against the page. No longer are the figures placed parallel to the picture plane. Rather, Pissarro approached them from different directions, from beneath, from above, and from various angles to the side, in the manner perfected during the same years by Degas, who exerted more influence on Pissarro's figure drawings during the early 1880s than did any other artist. A specific activity is always granted the figures in these sheets, so that, although the background has been suppressed, there is, fact, no need for it, because the figure itself suggests the setting. Perhaps the most important aspect of these sheets is that the figures are nearly always in contact with the ground, either reclining upon it, or working it in some way. As in the paintings of this period, the horizon lines are very high, and therefore even when standing the figures are placed against

fields, or vegetation. This helps to create a unified composition in which the figure and the earth are conjoined and not separated by horizontals, verticals, or diagonals.

Modelling, too, in these figure drawings, was carried out with rapidly drawn free strokes, as opposed to areas of regular hatching, or tonal shading. The irregularity of these strokes is perhaps explained by the fact that the page, or piece of paper, was often rotated while the drawing was being made, so that almost accidentally Pissarro began to use cross-hatching. The form of the figure was indicated with flurries of lines resembling electric sparks as in Sketchbook XVIII (No. 175). These lines are exaggerated versions of those characterising certain drawings done in the period 1873–80 (Nos. 85A recto and 85H verso). As a result, modelling in blocks is not so commonly found between 1880–90, and, where Pissarro wanted to suggest it, he used a wash, as in No. 168G and 168K from Sketchbook XV (No. 168), or else, in the case of chalk drawings, by adding coloured chalks and occasionally pastel (No. 169). This flamboyant use of line results in the form being enmeshed in a series of strokes in which it is sometimes difficult to distinguish between the contours and the modelling: thus, the contours, which were presumably drawn first, eventually become less isolated. This is particularly true of the pen and ink studies (Nos. 171A, 214, and 217), where the pen lines have a fineness that can only be compared with those made with an etching needle. The main result of this more sporadic use of line as a system of modelling is that light helps to define the form of the figure, and perhaps the most brilliant examples of Pissarro's chalk style in the 1880s are those in which the freedom of the individual strokes is combined with sudden bursts of hatching which capture the effects of light moving across an object, or a body, while at the same time providing it with a sense of form (Nos. 174A recto and 175C recto).

In addition to the chalk drawings on a small scale, there are the figure studies in a larger format (for example Nos. 239–42). The dexterity with which Pissarro handled the chalk in the smaller studies is here retained and the same principles of drawing apply, only the actual thickness of line is greater. The contours are often redrawn, but the physical impact of these sheets is derived from the strength of the line itself and from the starkness with which it is offset by the paper, aided on occasions by pastel, or gouache highlights. It is no accident that these drawings are the rural equivalent of Degas's ballet dancers, since the two men continued to see each other and to correspond during the 1880s. Indeed, Pissarro spoke of Degas as 'certainmement le plus grand artiste de notre époque'.[22]

Although the majority of Pissarro's drawings from the decade 1880–90 are figure studies, he also made several important landscape studies. Those in watercolour are discussed in detail below (see pp. 32–3), but he also used coloured chalks in this context. The delicate application of black chalk with the fugitive effects that Pissarro had mastered during the 1870s was maintained in his handling of coloured chalks.

[22] *Camille Pissoro. Lettres à son fils Lucien*, ed. J. Rewald with the assistance of Lucien Pissarro, Paris, 1950, 9 May 1883, p. 42.

Figure 7. Camille Pissarro, *Study of a Landscape at Pontoise*. Coloured chalks. 250 × 323 mm.

Two such landscape studies now in the Louvre are of outstanding quality from this point of view (Figs. 7 and 8). The tonal gradations in both these examples emphasize the space within the compositions and the full width of the paper is used. The gentle manipulation, almost stroking, of the chalk with small firmly controlled areas of cross-hatching is a technique that Pissarro also adopted in his paintings and it is faintly reminiscent of some of the landscape drawings done in 1852–5. The Ashmolean Museum possesses some fine drawings by Pissarro in coloured chalks, which exhibit this same mellifluous style (Nos. 169, 181, and 192 recto). In No. 169 the texture of the roof of the farm building is suggested by horizontal striations in different coloured chalks, so that the intermingling of the strokes creates a wattled effect.

The landscape drawings from the second half of the decade are stronger and more linear. They show a greater concern for compositional aspects, and some of them can be directly related to Pissarro's paintings of the period. The most notable features of these drawings are the curved horizon lines and the strong emphasis on trees in the immediate foreground, which, as in No. 182, spread their branches as if to clasp the composition together. This feeling for organic growth is one of the fundamental

Figure 8. Camille Pissarro, *Study of a Landscape at Pontoise*. Coloured chalks. 247 × 317 mm.

principles underlying the simplified compositions of the mid 1880s. There are, in-
deed, several independent studies of branches of trees and foliage (Nos. 138 and
139) in the collection, which testify to Pissarro's prevailing interest in spreading
forms at this time and recall his early fascination for studies of trees and vegetation
while in South America. Significantly, in No. 168L, a sheet from Sketchbook XV
(No. 168), the trunk of the tree is very summarily drawn in outline with coloured
chalks, while, for the branches above, the chalk breaks out into a blossom of rapidly
drawn and variously accented strokes that glory in the changing patterns of the foliage
of a tree, just as Monet had done in the 1860s.

There is one isolated aspect of Pissarro's draughtsmanship dating from this period
that cannot be overlooked. This is the small group of tenebrist drawings, which bears
a direct relationship to both Millet and Seurat (Nos. 159, 187 and 194 recto). It
could be argued that these drawings represent an internal development from those
sheets characterized by the softer tonal modelling found in Pissarro's style during
the mid and late 1870s, but, in fact, the external influences of Millet and Seurat,
perhaps acting uniformly, although independently, on Pissarro, are perhaps the more
likely explanations. No. 187 made in 1887 on grey-blue paper, represents a female

figure seated under a tree. It has been damaged, but is sufficiently well preserved for one to observe the tentatively drawn outlines and the evenly distributed modelling that concentrates more on the shape of the figure as a silhouetted form than on its volume. It is a drawing that specifically recalls Millet's tenebrist studies that Pissarro had probably studied afresh at the retrospective exhibition of Millet's work held in 1887[23] at the Ecole des Beaux-Arts. A second drawing (No. 159), a study in charcoal of the Ile Lacroix at Rouen, is, on the other hand, much closer to Seurat in its style and imagery even though it may date from as early as 1883. The tone is darker and, although the charcoal is applied evenly, flecks of the white paper appear through from beneath. The buildings resemble black shapes looming out of the distance, but the surface of the drawing is enlivened by the texture of the charcoal and by its interaction with the surface of the paper. No. 159 is a brilliant drawing in that, like Seurat, Pissarro achieves his effects of distance, atmosphere, and design with a single medium used in a most controlled and restricted way. The painting in the Neo-Impressionist manner *L'Ile Lacroix, Rouen, effet de brouillard* (P&V 719, of 1888), which is evolved from No. 159, is hardly an improvement upon this preparatory study.

(f) 1890–1903

The final period of Pissarro's life shows no decline in his creative powers and there are only minor stylistic changes in his drawings. He continued to work prodigiously hard, and to the various categories in which he was already prolific he added that of collaboration with his son Lucien for the purposes of book-illustration (see pp. 58–85). After the stylistic difficulties that he had experienced during the 1880s, particularly during the second half of that decade, there is now a feeling of renewed confidence, which is detectable in both the paintings and the drawings. In the drawings this regained confidence is most apparent in the strength and freedom of line, in addition to which there is a willingness to essay projects that involved the complex use of mixed media.

The most striking drawings of this final period are the figure studies now often executed in coloured chalks on paper of varying tints. An outstanding example is the large sheet of figure studies in the British Museum (Fig. 9). In this the outlines are bold and firmly drawn, and they are longer, and less curvilinear, than the more rhythmical outlines dominating the figure drawings of the 1880s. Pissarro has now adopted straighter, broader outlines, almost brutally executed, within which there are areas of close modelling, or else patches of pastel roughly applied. This combination of line and modelling reveals a fresh interest in volume, which had already preoccupied Pissarro during the 1870s, only now the results are a great deal more imposing. In certain drawings, such as Nos. 239, 256, and 257, where the curvilinear outlines of the 1880s are still to be found, there is also an awareness of the form

[23] *Lettres*, 16 May 1887, pp. 149–51.

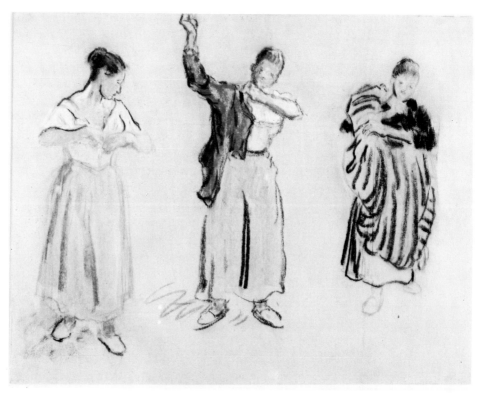

Figure 9. Camille Pissarro, *Study of Three Female Figures*. Pastel on pink paper. 451 × 604 mm.

of the figure contained by those same outlines. As the 1890s progressed, however, Pissarro began to define form far more closely with the aid of powerful modelling in blocks. He clearly revelled in the texture of the coloured chalks when used on this large scale, and even in the smaller figure studies one finds a similar appreciation for the texture of line itself, as in No. 225B, which strikingly recalls the fugitive effects that the artist had gained in his chalk drawings of the late 1870s. The crudity and brutal strength with which the large scale figure drawings are executed during the 1890s contrasts strongly with the more elegiac depiction of the human figure that Pissarro had developed during the previous decade. Again, as in so many other instances, Pissarro's late style of drawing the human figure, when seen on this large scale, closely parallels that of Degas, whose contemporary drawings share the same ruggedness and fascination for the texture of medium.

Interestingly, many of the figure studies done on a reduced scale were made in preparation for prints (Nos. 294, 295, and 301). In these, the use of a brush, or reed pen, for the outlines brings to mind the drawings of the 1880s, but the lines themselves tend to be broken and more rigid. There is, however, as in the larger drawings, a great assurance in the creation of volume. This feeling for volume is quite different

from the organic unity found in the figure studies of the 1880s and it represents a return to one of the main tenets of Pissarro's style of the 1870s, only now the figure plays a far more positive role within the composition as a whole. It is, for instance, the figures that dominate the scene in P&V 855, *Faneuses, le soir, Eragny*, for which there is a series of studies in the collection, and it is the harvesters themselves, rather than the act of harvesting within a specific setting, that interests the artist (Nos. 247–50).

The essence of Camille Pissarro's latest style of drawing is found in the pages of the two sketchbooks used in Dieppe and Le Havre during his final years (Sketchbooks XXVI (No. 277) and XXVII (No. 278)). The subjects that caught the artist's imagination and the control over the media—charcoal, pencil, black chalk—are the result of a lifetime's experience and dedicated application to his art. There are brief studies of human figures, rural landscapes, animals, markets, townscapes, cliffs, bridges, ships, harbours, sailing boats. It is Pissarro's world in microcosm—what is omitted being of equal significance to what is included. The style, too, is rapid and matches the episodic flavour of the subject-matter. Pissarro in the privacy of his sketchbook developed a calligraphic shorthand of dots, dashes, comma-shaped strokes, often heavily accented, and sudden bursts of flat two-dimensional hatching, the origins of which can be seen in two landscape drawings (Nos. 243D and 243E) dating from the early part of the decade, which combine the delicate cross-hatching of the landscapes drawn in the early 1880s with clusters of strong flicks. Together with the anecdotal character of the contents of these two sketchbooks there is a return to the style of 1852–5, with less striving for effect and less calculation, as Pissarro's hand moves restlessly and tirelessly across the page. What he records in this shorthand style, whatever its scale, or however briefly it is treated, is still imbued with a commanding sense of form. The figures in the market scene (No. 277E) in Dieppe are volumetric, their shape defined by vertically hatched lines, while distant views (No. 277C) are contained by a firmly controlled compositional balance. These attributes can be demonstrated by a closer examination of No. 277D, a drawing of the cliffs at Dieppe, in which the composition is anchored by the descending line of the cliffs in the upper half, while in the foreground, on the beach, set on a shallow diagonal are figures animated with single, deftly executed strokes. It is an image drawn with such speed and dexterity, like a view of Kew Gardens made a little earlier (No. 243D), that the details of the vision are almost blurred, and yet the whole remains in focus because of Pissarro's masterly manipulation of space. The sketch is divided into three equal sectors, the blank sky at the top, the cliffs in the middle, and the tumult in the foreground. Distance is achieved with the varying texture of the black chalk. The cliffs aré modelled with even hatching, but this is limited to the near cliff-tops in the middle distance, and the emphasis is gradually diminished as they are modulated and finally disappear into the far distance, eventually becoming a single straggling line stretching out across the page. The figures on the beach, however, are strongly accentuated with chalk of the darkest hue. The flicks and dots in this part of the composition are deliberately dark, so as to suggest that the figures

are near to the spectator, but the main area of hatching on the cliff-tops is only a shade or two lighter, so that the blank sky in the upper half of the composition and the dark passages in the lower half are bound closely together, like the notes of a musical chord.

Sketchbook XXVII (No. 278) is chronologically the last that can be constituted from amongst the drawings in the collection at Oxford. The same stylistic features that characterize Sketchbook XXVI (No. 277) are also in evidence here, but there is another aspect of this sketchbook that deserves to be noticed. This is the haunting quality of its imagery. There are views of the harbour and the quayside at Le Havre, and, although not densely populated in these brief sketches, they are places where scenes of bustle and intense activity normally took place. There are also sketches of vessels far out at sea, steam-boats and sailing ships, either making their way cautiously into harbour, or else slipping hull down over the horizon. There is little indication of temporal effects, but occasionally the angle at which a boat is drawn indicates that the motion of a boat pitching, or rolling, in a swell has caught Pissarro's eye, or else he has been inspired by the elegance of a yacht becalmed on a windless day. It is almost impossible to avoid the speculation that the sheets in the Le Havre sketchbook are the final testament of the aged Pissarro, who did not live out the year, for many of these images of boats sailing out to sea are standard symbols in nineteenth-century art representing the passing of life into death.

III
Individual aspects of drawing

(a) Watercolour

Watercolour has been considered since the nineteenth century to be essentially an English medium, and the extensive literature which defines its history and character is, by and large, devoted to the watercolour in England. French artists, by contrast, have been seen as suspicious of the medium, and, almost as proof of the validity of this idea, the only serious modern investigation of the watercolour in French nineteenth-century art stresses both the seminal importance of Bonington and the tardiness of any official recognition of the watercolour in France.[24] This investigation, so far principally conducted by Alain de Leiris, brings a considerable number of French watercolours to light and, more importantly, hints at a far greater role for that medium in the history of French art of the nineteenth century than has previously been thought. Pissarro was a particularly important watercolourist among major French artists of the last half of the nineteenth century. His own efforts in

[24] A. de Leiris and C. Hynning Smith, *From Delacroix to Cézanne. French Watercolour Landscapes of the Nineteenth Century*, catalogue of an exhibition held at the University of Maryland Art Gallery, J. B. Speed Art Museum, Louisville, and the University of Michigan Museum of Art, Ann Arbor, 1977–8.

that medium are not only numerous, but also span his full working life. His investi-
gation of the diverse qualities of the medium was always probing, and, if the
watercolours did not play the crucial role in his career that those of Jongkind, or of
Cézanne, did in theirs, it is virtually impossible to deny their significance altogether
or to forget that many of them were made before his arrival in France and were
probably known to Cézanne before that artist's own systematic investigation of the
medium.

Perhaps the most persistent formal problem for the watercolourist is the establish-
ment of a clear relationship between line and colour, drawing and wash; and, as
such, the watercolour played a small, but definite part in the bitterly fought battle
between the linearists and the colourists. Pissarro's watercolours, like those of Dela-
croix, Huet, Jongkind, and Cézanne, show considerable evidence of this struggle.
After a tentative beginning in 1852 on St. Thomas (Nos. 6 and 7), his early water-
colours made in the isolated regions around Caracas vacillate between fresh and freely
brushed evocations of the lush vegetation and carefully planned, more 'finished'
watercolours. In the former case, the best of which remain in South American collec-
tions, the linear scaffolding over which the washes are applied is lightly drawn, even
hesitant, and all but overwhelmed by the strong brushwork (Fig. 10). These early
experiments in the medium were surely executed *plein-air* and anticipate in both
their style and composition Pissarro's most characteristic Impressionist pictures of

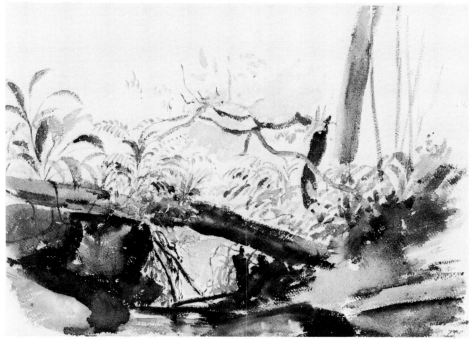

Figure 10. Camille Pissarro, *Study of Orchids growing over the branch of a fallen tree.* Watercolour
over indications in pencil. 377 × 543 mm.

the first half of the 1870s. Important additional characteristics of these early water-
colour sketches is the positive use made of the paper and their relative lack of layered
washes. They were evidently created at a single sitting without waiting for each appli-
cation of wash to dry before placing another wash on top of it. Indeed, the sophis-
tication of these watercolours is remarkable, and they can be related to the earlier
tradition of landscape studies executed in wash, often in monochrome, which in-
cludes such renowned artists as Dürer, Rembrandt, Claude, Poussin, and Cozens.

Yet the idea of the watercolour as a medium dominated by washes and governed
by the positive use of paper was countered both in contemporary practice and in
Pissarro's own early career by another kind of watercolour in which the drawing
still controlled the design. A watercolour like No. 16 in the Ashmolean collection
has little evidence on the surface of the drawing beneath, in spite of the fact that
the underdrawing mapped out in advance the boundaries of the watercolour. In fact,
No. 16 suggests that watercolour formed two different aspects of Pissarro's early
working methods—the rapid sketch and the coloured compositional study. As such,
the watercolour, rather than the oil sketch, was the principal method of preparation
in colour for Pissarro before 1855. This fact is interesting in itself and provides evi-
dence of an early link between Pissarro and the North European, specifically English,
watercolour tradition, a link which was fortified by Melbye, who made watercolours
rather than oil sketches in preparation for his paintings. These two different types
of watercolour, therefore, were, respectively, the *étude* and the *esquisse* of Pissarro's
early working methods.[25]

What is particularly interesting about Pissarro's development as a watercolourist
is that after his arrival in France in 1855 he virtually ceases to use the medium. Instead,
the oil sketch, which, as a working process, has been recently studied by John Wis-
dom,[26] replaced the watercolour in his preparatory methods. The informal studies
of vegetation and urban scenery, which are such an important part of his South
American *œuvre*, disappear. Indeed, an examination of Pissarro's watercolours indi-
cates that the period of intensive involvement with the French landscape tradition
in the years 1855–69 caused an interruption in his use of the media, and that only
the example of Jongkind, whom Pissarro probably met in the late 1860s, and of
English watercolours, to which he was exposed in 1870–1, resulted in a renewed
involvement with it.

As the analysis of Pissarro's working processes below will demonstrate, the water-
colour played a crucial role in the Impressionist phase of 1870–3, and it is probably
no accident that the majority of watercolours which do survive from those years relate
very closely to oil paintings. Indeed, the major studies of the development of Impres-
sionism have not made sufficient claim for the watercolour. If, as seems to be the
case, and as Monet recalled later in his life, Jongkind executed watercolours as studies

[25] Boime, op. cit. (1971), 43–4 ('esquisse') and 149–55 ('étude').
[26] J. M. Wisdom and others, *French Nineteenth Century Oil Sketches: David to Degas*, catalogue of
an exhibition held at The William Hayes Ackland Memorial Art Center, The University of North
Carolina at Chapel Hill, 1978.

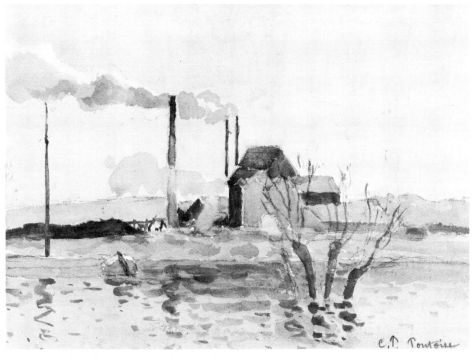

Figure 11. Camille Pissarro, *La Crue de l'Oise, Pontoise*. Watercolour over pencil. 172 × 253 mm.

for oil pictures, the practice was by no means unique to him.[27] Pissarro's watercolour *La Crue de l'Oise, Pontoise*, in the collection of Mr and Mrs Paul Mellon (Fig. 11), served as the basis for a painting (P&V 214) of the same title in a private collection in the Channel Islands, and there are several other such examples. Stylistically, the watercolours of the years 1870–73 seem to continue the characteristics of the *étude* watercolours of the South American period. There is none of the tightness and constraint of the 'finished' watercolours, in spite of the presence of the underdrawing throughout the composition. Pissarro made no attempt either to disguise or to emphasize the linear aspects of the work. The lines and the washes are closely intertwined, but not identical, allowing for an apparent spontaneity lacking in his earlier 'finished' watercolours.

After this extremely important phase in his career, in which the watercolour performed such a vital function, Pissarro does not seem to have retained his interest in the role of watercolours during the rest of the 1870s when his style, imagery, and methods were changing. In fact, during the second half of that decade, when he began to return to the medium, his watercolours lack the close relationship to the paintings which characterized the Impressionist phase. The watercolours of the later 1870s are, as a result, comparatively rare—there are only five in the collection—

[27] For references see de Leiris and Hynning Smith, op. cit. 58.

and they tend to fall into two categories. The first is dominated by a strong under-drawing in black chalk, or charcoal, which is very close in style to that of the figure drawings executed in the polygonal style (No. 92). The forcefully geometric character of the underdrawing is almost at odds with the softness and transparency of the water-colour washes, and the sheets anticipate in this way the 'cloisonniste' mode of paint-ing developed by Gauguin, Bernard, and Sérusier towards the end of the 1880s. Colour, in these sheets, is contained by line. The second type of watercolour, which Pissarro executed in the later 1870s, is represented in the Ashmolean collection by two badly damaged sheets (Nos. 89 and 90). In both of these the underdrawing in pencil is barely visible, but its function is clear. These five watercolours indicate that Pissarro held the medium very firmly in check during the latter part of the 1870s.

Pissarro's watercolours increased in number and importance during the last two decades of his life, reaching a climax in 1890. The reasons for this renewed interest in the medium can, however, only be speculative. In 1878, a large exhibition of English watercolours was held at the International Exhibition in Paris, and, during the following year, the Société d'Aquarellistes français was inaugurated and staged the first in a series of exhibitions, many of which were reviewed in prominent periodi-cals, including the *Gazette des Beaux-Arts*.[28] This professional impetus surely affected Pissarro, who, although never a member of the society, was most probably aware of it. These events, together with an important sale that included watercolours by Jongkind, which took place in 1883,[29] provide clear evidence that the watercolour was more to the fore than it had previously been in France, and it is likely that Pissarro responded to this situation.

The watercolours produced during the last two decades of Pissarro's life are inter-esting chiefly because they rarely relate to his oil paintings and other drawings. In fact, they form a relatively independent group of works with a remarkable stylistic unity during a period that witnessed rapid stylistic changes in the paintings. As had been the case in Venezuela, the watercolours tend to be of two types, those dominated by a free distribution of washes and those characterized by a detailed underdrawing. The majority of the watercolours made around Pissarro's home in Eragny are freely painted with vibrant and fully saturated colour washes. In many of these sheets (Nos. 236 and 238), the washes overlap with a remarkable freedom, and the paper again plays a vital part in the formal structure of the work. Virtually all these sheets are carefully inscribed with the place, date, season, and time of day, in addition to the artist's initials or signature and, therefore, share with the early watercolours of vegetation in Venezuela an interest in the immediacy of the sensation before nature which is so often associated with watercolour. As such, they owe their most profound debt to the watercolours made by Jongkind in the later 1870s and 1880s. By contrast, the watercolours executed away from Eragny on Pissarro's many trips of the 1880s

[28] For references see de Leiris and Hynning Smith, op. cit. 33–4.
[29] C. Cunningham and others, *Jongkind and the Pre-Impressionists: Painters of the Ecole Saint-Siméon*, catalogue of an exhibition held at Smith College Museum of Art, Northampton, Mass., and the Ster-ling and Francine Clark Institute, Williamstown, Mass. 1976–7, p. 30.

or 1890s record topographical information, often in some detail, and tend, therefore, to be tightly organized line drawings in either pencil, or chalk, over which washes have been applied (Nos. 253 and 254).

A proper study of Pissarro's late watercolours still needs to be undertaken. Very few of them have been published, and many of those to which the writers have had access are badly damaged (see p. 88, Condition). However, the brilliance and confidence of sheets like No. 191 and the gradual rediscovery of others, both in museums and in the sale room, indicate that the medium formed a far more important part of Pissarro's *œuvre* than either the *catalogue raisonné*, or the present catalogue, can convey. Indeed, it is fair to say that there were certain periods in Pissarro's career—the Venezuelan years and the Neo-Impressionist phase, for example—in which the watercolour dominated his production to such a degree that any serious study of the artist cannot afford to ignore his achievements in the medium.

(b) Topography

Many of Pissarro's earliest works are frankly topographical. His large monochrome brush drawing of Christian's Fort at Charlotte Amalie (No. 7), as well as his records of the baroque fountains and churches of Caracas, are typical of the drawings produced by nineteenth-century topographical artists. These early connections between Pissarro's drawings and the topographical tradition in general, which has been so well studied by Adhémar and Twyman,[30] were surely encouraged both by his teachers in the school at Passy and later by Melbye. In fact, the sketching tablet which Pissarro used in 1852–4 in Venezuela, now in a private collection in Caracas, was originally purchased at R. A. Ackerman, 101 Strand, London, famous not only as a supplier of drawing materials, but also as a publisher of lithographic travel books and landscape manuals. Such important books as the illustrated *Easy Lessons in Landscape Drawing* (1819) by Samuel Prout were published by Ackermann, and served to indoctrinate a generation of younger artists in the various tenets of this exceedingly rich tradition.[31] Again, as mentioned above, the similarities between Pissarro's early drawings and the illustrations in Prout's various manuals are striking.

It is clear that Pissarro's early interest in the topographical landscape tradition waned after his arrival in France in 1855, but it re-emerged dramatically in October 1883, when he made his first trip to Rouen. Like most artists, Pissarro seems to have equated topographical landscape with travel, and, with virtually no exceptions, his late topographical drawings in all media were executed away from home in Rouen, Gisors, Paris, Knokke, Bruges, London, Dieppe, Le Havre, and the many other places he visited on his frequent trips from Eragny. In fact, many of those topographical views, represented in drawings or prints, rather than in paintings, have precedents in the well-known topographical lithographs executed throughout the nineteenth century, and he chose precisely the same Norman and English sites preferred by artists of that tradition. Pissarro himself was aware of such precedents and actually

[30] See note 9 above. [31] See note 10 above.

mentioned Bonington and Turner in a letter written on 20 November 1883 to Lucien while on his first visit to Rouen. No. 158D, which was certainly drawn in Rouen in 1883, is remarkably similar to certain of the lithographs by Bonington made in 1824 for the first volume of Baron Taylor's monumental *Voyages pittoresques et romantiques dans l'ancienne France*, particularly to *Maison de la rue Damiette*.[32] Pissarro's soft pencil contours, his uncharacteristic fascination with traditional Norman architecture, and his frontal treatment of the motif are all to be found in Bonington, as well as in the work of the prolific Samuel Prout, who also worked in Rouen. Clearly the artists of the topographical tradition appealed to Pissarro for many reasons at this stage. He was turning away from Impressionist landscape painting and broadening his subject-matter to include caricature and urban genre. His recent efforts in print-making, both intaglio and lithographic, opened him to the frankly commercial aspects of nineteenth-century European imagery, perhaps the most important of which was topography. Indeed, his trip of 1883 led to a series of etchings and lithographs of Rouen, which forms what is without doubt the most important of such groupings by any artist of the nineteenth century, including Bonington and Prout (Fig. 12).

It would be a mistake, however, to see the late prints and drawings made by Pissarro while moving around northern France only in terms of the topographical tradition. His views of Rouen, while they share certain distinct similarities with those of other artists, lack their emphasis on the famous architectural sites in which the city abounds. Although he made a print (Delteil 54) of the rue du Gros-Horloge in 1885, undoubtedly in homage to Bonington, Pissarro's etching is consciously different in both direction and viewpoint, making conspicuous use of bourgeois figures in modern dress, rather than the traditionally costumed figures preferred by Bonington. Furthermore, Pissarro never executed a print or drawing in which the façade of Rouen cathedral was the dominant motif, although he borrowed a figure from an etching of the cathedral executed by Lhermitte in 1884[33] (see p. 51), and admired Monet's later series of the paintings of the façade. On the other hand, it has to be admitted that Pissarro's fascination with the harbour and with the play of light across the old houses of Rouen does to some extent recall the topographical depictions of Bonington, Prout, Ciceri, and Huet. None the less, Pissarro's portrait of Rouen was definitely a modern one, in spite of his occasional and inevitable choice of the traditional picturesque sites preferred by earlier topographical artists.

Pissarro's many topographical drawings of the 1880s and 1890s were made as independent images or exercises, and most of them were never used as the basis for any painting or print. There is, in fact, only one surviving topographical drawing of Paris (No. 244), although Pissarro made many paintings of the capital. Conversely, no painted, or printed, images of Grancey-sur-Ource, Compiègne, Lagny, Châtillon-

[32] I. Taylor, Ch. Nodier, and A. de Caillaux, *Voyages pittoresques et romantiques dans l'ancienne France. Ancienne Normandie*, vol. II, Paris, 1825, Pl. 171, dated 1824, for which see Twyman, op. cit., Ch. 15, pp. 226 ff.
[33] See F. Henriet, *Les Eaux-fortes de Léon Lhermitte*, Paris, 1905, p. 85, No. 41 repr. between pp. 44-5.

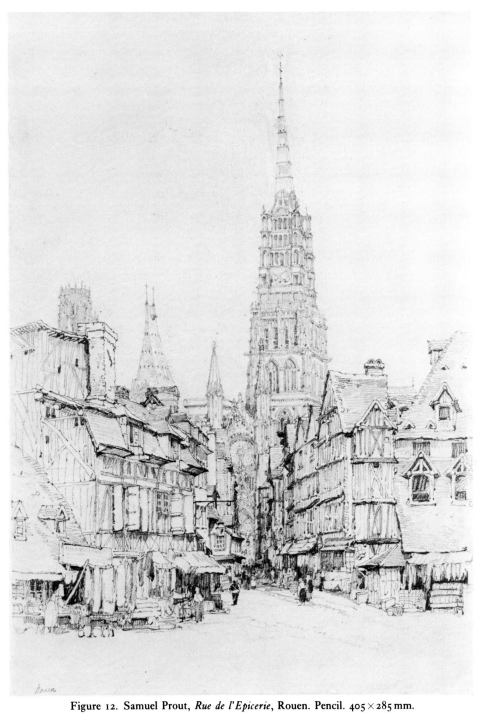

Figure 12. Samuel Prout, *Rue de l'Epicerie*, Rouen. Pencil. 405 × 285 mm.

sur-Seine, or Caudebec-en-Caux survive, even though there are frankly topographical drawings of these places in the collection (Nos. 88, 160A, 160D, 272, and 277G). In fact, during his later years Pissarro seems to have visited such places merely to refresh his eye and to discover new motifs.

The paintings, drawings, and prints of a topographical nature executed by Pissarro after 1883 combine to form the most important group of topographical images produced by any major artist of the late nineteenth century. In choosing to search out such sites and to produce such images, Pissarro transcended the contemptuous definition of topography as a 'tame delineation of a given spot' formulated early in the nineteenth century by Fuseli,[34] and his contribution must be seen as the last great addition to the North European topographical tradition.

(c) Caricature

Inherent in Impressionist painting is an element of caricature, Renoir, Manet, Monet, Degas, and Caillebotte employ cursory depictions of figures that are formulae for social types. Stylistically, too, several of the sources for Impressionist painting, specifically popular illustrations, tended to encourage methods of drawing that veered towards caricature, and Baudelaire's famous essay on Constantin Guys, first published in *Le Figaro* in 1863, equated caricatural drawing with modernity. Amongst the Impressionist painters, Manet and Monet are those most disposed in their drawings towards caricature. For Manet, it is an underlying stylistic impulse, whereas for Monet, about whose drawings we as yet know so little, it seems to have been a separate exercise.[35] In the work of both Degas and Pissarro, however, caricature is far more closely related to the style and subject-matter of their paintings and can be considered almost a seedbed for their art.

Pissarro's interest in caricature was extensive. His early style of drawing with the pencil and the pen before 1855 is often pithy and notational. He hastily recorded the features or individual characteristics of figures with a calligraphic shorthand that is directly comparable with popular caricatures. We do not know exactly what visual sources he had before him while in the Antilles and in South America, but, apart from an acuity of eye, his way of seeing may have been governed by popular illustrations, or drawing manuals, containing exercises in physiognomy. It is important to realize that Pissarro's beginnings encouraged an independent eye and hand that provided him with a freedom of expression that can almost be directly equated with caricature. This ability to observe freshly for himself conditioned his way of drawing and it is emphasized in Camille Pissarro's advice to Lucien on the art of drawing contained in a letter of 5 July 1883: 'Ne pas faire de jolis traits d'adresse, s'en tenir à la simplicité, aux grands traits qui font la physionomie. Se rapprocher plutôt de la caricature que de faire joli!'

[34] J. Knowles, *The Life and Writings of Henry Fuseli, Esq., M.A., R.A.*, vol. II (London, 1831), p. 217, Lecture IV.
[35] For Monet see the article by R. Walter quoted in note 11 above.

Not surprisingly, Camille Pissarro's letters to Lucien evince a considerable interest in such artists as Daumier and Charles Keene, for whom he had an unbounded admiration. Yet the directives and exhortations made to Lucien date from later in his life during the 1880s. Before this, Pissarro appears to have known the work of Constantin Guys. No. 43 recto is a drawing that one instinctively associates with Guys, particularly in the rendering of the shoe, but the ebullient use of line also approaches Manet, as do the slighter studies of female heads drawn c.1880 (Nos. 103 and 104). For these early caricatural studies, which are comparatively few in number, Pissarro chose pencil, and he often favoured the same medium later in his life for drawings of this type, as in a sheet of physiognomical exercises drawn c. 1885 (No. 202).

The most important stylistic development, however, in Pissarro's caricatural drawings is the introduction of pen and ink. The letters show that in Rouen in 1883 the artist began to be more aware of the historical tradition of caricature. He admired Gothic artists for their ingenuousness, both as regards subject-matter and execution. He also bought a volume of Champfleury, *Histoire de la caricature*, first issued in five volumes in 1863–5. Pissarro's reference to Champfleury's work in a letter of 17 February 1884 implies that he bought only the final volume entitled *Histoire de la caricature moderne*, which is devoted to Daumier:

J'ai acheté à Rouen l'*Histoire de la Caricature* par Champfleury, livre précieux avec des illustrations de Daumier. Toute l'histoire de Daumier y est tracée. On reconnaît bien, en parcourant ce livre, que Daumier était l'homme de ses dessins, un convaincu, un vrai républicain. On sent du reste dans ses dessins le souffle d'un grand artiste qui marchait à un but mais qui ne cessait cependant d'être profondément artiste, de façon que—même sans légende, sans explication—ses dessins restent beaux.

Pissarro also possessed a few lithographs by Daumier,[36] but, in fact, the influence of this artist is not easily detected in his work. Sometimes the fine penwork of drawings made in the second half of the 1880s (No. 212 recto) recalls Daumier's own pen drawings with the rhythmical straggling contours overlaid with wash. On other occasions, it is the suppleness of the wrist and the variety of line in the figure studies drawn in chalk that remind one of Daumier's lithographs (No. 184). Clearly, it is the subject-matter of Daumier's art that captured Pissarro's attention, and, indeed, his whole interest in caricature increased during the last half of his life as his political convictions hardened.

The most important influence on Pissarro's treatment of caricature is Charles Keene, whom he regarded as one of the major English artists of his day. His knowledge of Keene was further encouraged by Lucien Pissarro, who lived in England from 1883, and whose own early wood engravings are directly related to Keene's style of drawing. Lucien cut up issues of *Punch* sending Keene's illustrations to his father,[37]

[36] *Lettres*, 22 January 1884 and 17 February 1884, pp. 74 and 78 respectively.
[37] A series of these is still in an English private collection: see the entry below for No. 196.

and, indeed, Keene's influence becomes more pronounced in Camille Pissarro's pen drawings after 1885. The varying strength of the pen lines and the powerful hatching were a direct method of drawing that Pissarro also introduced into his prints. Allied to the directness of expression was the pertness of characterization. An outstanding example of this is the host of figures portrayed on No. 205.

Another influence that can possibly be detected in Pissarro's caricature drawings is that of Gustave Doré, although no mention is made of this artist in the published correspondence.[38] Pissarro's most elaborate exercise in caricatural drawing was the album *Turpitudes sociales* of 1890 (see Nos. 210A and 210B). This is a work where form and content are perfectly matched. In a series of thirty drawings, all in pen and ink, the penury and hardship of urban life for the poor is vividly recorded. Stylistically, the influences of Daumier and Keene can be detected in the penwork, but so, too, can that of Doré in the pattern of continuously jigging lines drawn across the page. Indeed, the very subject of the album could well have been directly inspired by Doré's own illustrations of London.[39]

In *Turpitudes sociales* Pissarro's political viewpoint finds a wholly convincing form of expression. It has to be admitted that, even if Pissarro's style of drawing did initially show a proclivity for caricature, it was in all probability his political ideals that encouraged him to develop it further.[40] His political views and his sympathy for anarchism as a political philosophy are detectable in his correspondence with Lucien, although they have not yet been subjected to a close study in the context of his art. It is true to say that his political views became more radical during the 1880s and 1890s as disenchantment with the Third Republic grew. It is during these two decades that Pissarro's mature style of caricature drawing was evolved. Apart, however, from specific works, such as *Turpitudes sociales*, it is in that famous republican institution, the market-place, that Pissarro was able to develop his feeling for caricature. There he could examine a host of social types at his leisure and observe the confrontation between the social classes. These moments are amply recorded in his paintings, drawings, and prints, which are inhabited by peasants with large noses and awkward feet, and bourgeois figures wearing top hats and spats, with monocles in their eyes, confronting one another across counters laden with produce. Ultimately, Pissarro came to loathe the *bourgeoisie* as much as Daumier did, but whereas Daumier captures the rapacity and egocentricity of the class, Pissarro in a strongly delineated sheet drawn with a thick pen (No. 201) depicts its obesity.

[38] There was, however, a major retrospective exhibition of Gustave Doré's work in 1885, *Catalogue des dessins, aquarelles et estampes de Gustave Doré exposées dans les Salons du Cercle de la Librairie (Mars 1885) avec une notice biographique par M. G. Duplessis*, Paris, 1885.

[39] *London; A Pilgrimage*, first published in England in London, 1872 and in France in Paris, 1876 (see J. Valmy-Baysse and L. Dézé, *Gustave Doré*, Paris, 1930, p. 76). Also see A. Woods, 'Doré's London: Art and Evidence', *Art History*, i (1978), 341–59.

[40] See *Portrait of Cézanne* (P&V 293), formerly in the collection of Baron Robert von Hirsch (sold Sotheby's, 26 June 1978, lot 715), which has two caricatures from contemporary French journals hanging on the wall in the background (T. Reff, 'Pissarro's Portrait of Cézanne', *Burlington Magazine*, cix (1967), pp. 627–33).

IV
The role of drawing

(a) Presentational drawings

Throughout his life Pissarro made a kind of drawing that may best be termed presentational. Unlike the drawings in the sketchbooks and the independent sheets made privately in preparation for a finished painting, or print, presentational drawings are works of art in their own right made for exhibition and sale. They can be linked in this way to the highly finished drawings made for presentation by artists as early as the High Renaissance. This kind of drawing played a very important role in French art during the last half of the nineteenth century, a role which has so far received no systematic study. There is considerable evidence to suggest that French connoisseurs, critics, and collectors became increasingly interested in finished works on paper and that many artists responded to the demand.[41] The careers of such major artists as Millet, Jongkind, and Degas, each of whom exerted considerable influence on Pissarro, would be considerably weakened without their presentational drawings. Yet it must be remembered that Pissarro's initial interest in large, signed drawings predates the various periods when he was influenced by these artists. There are, in fact, two presentational drawings in the collection (Nos. 7 and 16) and several more in private collections, which were made while the artist was in South America.

If the presentational drawings made in the period 1852–5 represent only a small fraction of Pissarro's total graphic production during those years, they do constitute a greater proportion of his output during the period 1855–69. There are at least six landscape drawings in the Ashmolean, which are highly finished, inscribed, and either initialled or signed in a formal manner. These sheets, like the delicate landscape of Bérelle (No. 54) or the highly finished drawing of wild apple trees at Chailly (No. 60 recto) are carefully, even deliberately constructed and are unrelated to any published oil painting. It is likely that they were made simply as drawings, although there is no evidence that Pissarro exhibited or sold such drawings until the later 1870s. All the surviving evidence suggests that, excluding those watercolours and gouaches which seem to have been made as part of a preparatory process, Pissarro made many fewer presentational drawings in the later 1860s and 1870s, and that he did not increase the level of his production until the end of the 1870s. His attention during this interim period never swayed from drawing entirely, but none the less the finished works which do survive are virtually always oil paintings on canvas.

[41] This trend is exemplified by the interests and career of someone like Philippe Burty and also by the establishment of societies such as the Société des Aquafortistes (see J. Bailly-Herzberg, *L'Eau-forte de peintre au dix-neuvième siècle. La Société des Aquafortistes 1862–1867*, 2 vols., Paris, 1972) to which Burty belonged. There was also a rise in the incidence of specialized periodicals and exhibitions of drawings and prints (see *The Art Press. Two Centuries of Art Magazines. Essays published for the Art Libraries Society on the occasion of the International Conference on Art Periodicals and the exhibition The Art Press at the Victoria and Albert Museum*, London, 1976, ed. T. Fawcett and C. Phillpot).

There are certain sheets executed in Foucault in the mid 1870s which have a presentational quality, sheets which might have been motivated by Pissarro's exposure to a large number of finished pastels by Millet shown in the exhibition preceding the sale of Emile Gavet's collection in 1875. Yet, from examination of the finished drawings included in the *catalogue raisonné*, as well as those in Oxford, it is fair to say that 1879–80 was again, as in so many other aspects of his art, the transitional year, during which Pissarro dramatically increased the percentage of presentational drawings within his *œuvre*. The catalogues of the Impressionist exhibitions indicate that Pissarro began to exhibit fan compositions and pastels in the fourth Impressionist exhibition of 1879 and that his offerings to the first three exhibitions were exclusively paintings on canvas.[42] The exhibition of 1879 encouraged Pissarro to exhibit finished drawings as well as prints, a trend which continued until his death.

Pissarro's motivations for this new emphasis are complex. His letters indicate a dissatisfaction with his manner of painting during the later 1870s, and the state of his finances was certainly not a strong one at that time. The possibility of painting in comparatively cheap and quick-drying media on paper must have been attractive for someone whose works were selling for relatively low prices and who, therefore, would want to increase his production quantitatively. Surely, these economic matters and Pissarro's aesthetic problems with his paintings were not unrelated, and Degas, who had been exhibiting pastel drawings, paintings on paper, and prints in the Impressionist exhibitions since 1874, provided a precedent for Pissarro.[43]

The three largest presentational sheets in the Ashmolean collection (Nos. 107, 219 and 220) were made before painted compositions of the same subjects, suggesting that, apart from including them in the preparatory process, they were executed in advance of the laborious and expensive version in oil. It is difficult, however, to generalize from these examples. The collection in Oxford is not rich in presentational drawings, many of which were sold in Pissarro's lifetime and did not, therefore, remain in the family's possession. Yet the fact that these examples could serve a dual purpose suggests that the working methods adopted by Pissarro in preparation for a picture could be remarkably complex and they should now be discussed.

(b) Drawing and the preparatory process

Drawing is by definition an exploratory exercise usually, but not solely, undertaken in the context of the preparation of a painting or print. Yet, with the important exception of detailed studies on Degas, Manet, and Cézanne, little has been written about the preparatory processes of the Impressionists. The work on the landscape sketch by Boime[44] and on the landscape watercolour by de Leiris[45] contains many hints that Impressionist pictures were not nearly as rapidly executed, or as spontaneously conceived as is commonly thought.

[42] L. Venturi, *Les Archives de l'impressionnisme*, ii, Paris–New York, 1939, pp. 255–61.
[43] Ibid. 255–71. [44] Boime, loc. cit. (1971).
[45] De Leiris and Hynning Smith, loc. cit.

Dr John House[46] has recently examined Monet's complex method of painting, and the gradual publication of Sisley's sketchbooks[47] indicates that he, too, made numerous compositional pencil sketches before beginning his oil paintings. The collection of drawings by Pissarro in the Ashmolean Museum is both large and diverse enough to allow the writers to make certain generalizations about his working methods and, perhaps more importantly, to reconstruct in detail the preparatory processes for certain key works. The separate entries, which form the main part of this catalogue, treat the preparatory aspects of each drawing in some detail, and so it is our purpose in this introductory section to examine as fully as possible important groups of preparatory drawings on which some general conclusions can be based.

Pissarro's interest in an almost hierarchical process of pictorial creation dependent upon drawing was already apparent in South America, and there are several inscribed sheets dating from 1852, which represent a genre subject entitled *Lovers Meeting* (No. 3 verso). These sheets form the earliest evidence of Pissarro's conscious striving to prepare an elaborate composition, but the sequence is not complete enough to make detailed discussion possible. Perhaps the most accomplished early compositional studies in the collection depict a group of artists and their travelling companions in the mountainous region near Catuche, Avila. The three drawings in Oxford (Nos. 26 verso, 27 recto and verso), together with a superb sheet in a private collection in New York,[48] can be placed in chronological order beginning with No. 26 verso, in which the figures appear at the far right of a sheet devoted to the surrounding trees and rocks, and continuing with the recto and verso of No. 27, before concluding with the finished drawing in New York. The transition in medium is from pencil, to pen and brush with ink over pencil, to pen and ink alone. This progression suggests that Pissarro made his preliminary drawings in soft pencil and that his pen and ink work was done later, probably in the studio. As Pissarro worked on the composition, it became tighter as he first proceeded from landscape to figural genre and then to a combination of the two. It is not known whether he intended to make a watercolour, or oil painting of this particular subject, but the existence of several finished watercolours and elaborate monochrome wash drawings from this period (see p. 29) suggests that there were further steps in this particular working process.

Although there are several other important compositional studies dating from Pissarro's visit to South America (Nos. 29 recto, 30, and 31 recto), the majority of his drawings were not made directly for use in any finished work of art. It is, however, true that the informal figure studies, such as those found on the sheets in a large unpublished sketchbook in a private collection in Caracas, were made as part of a more general preparatory process by which the artist provided himself with a wide

[46] J. House, *Claude Monet: His Aims and Methods c. 1877–1895*. Thesis submitted for the degree of PhD to the University of London, 1976, pp. 51 and 345–54.

[47] Most recent books on Sisley reproduce sheets from his sketchbooks. See, for example, R. Cogniat, *Sisley*, Næfels, 1978.

[48] Reproduced Boulton, op. cit. 44, and, by the same author, 'Camille Pissarro in Venezuela', *Connoisseur*, clxxxix (1975), p. 40 fig. 7.

repertoire of motifs for use in the studio. This method of drawing as a quotidian exercise recording the landscapes, buildings, and figures around him, was to be particularly important for Pissarro, who, like Degas, kept and even reused his sketchbooks and informal drawings throughout his life.

Pissarro's drawings from the first fifteen years in France are much less numerous than the sheets made in South America in a mere three-year period of intense activity. Although this fact can be partly explained by there having been no systematic attempt to accumulate these drawings in the same way as the South American sheets, it is probable that Pissarro interested himself far more in the problems of the oil sketch during this period than in drawing. Unlike the South American period, no important sketchbooks have been reassembled, and there is a much higher percentage of signed and dated drawings, which seem to have been made independently from paintings. In general, it can be said that the preparatory role of drawing declined during this period. The important exception, namely the groups of drawings done in 1859 in Montmorency and La Roche-Guyon, have already been briefly referred to (see p. 12), but the inscription on one of these sheets (No. 50) indicates that the next step in the process was an oil study.

This comparative rejection of preparatory drawing was rescinded during the period 1869–73, when Pissarro again took up sketching tablets and made the large and important series of drawings related to the painting formerly incorrectly entitled *Eglise à Westow Hill* (P&V 108). The sheets made in preparation for this painting move from pencil drawings in which the basic character of the composition was established (No. 68D recto and verso) to a study in pen and ink over pencil in which the composition was refined (No. 68E recto), then to a watercolour (No. 69), based on a detailed drawing in pencil with colour notations now in the Metropolitan Museum, New York (see entry for No. 68D), in which the colour and the disposition of the figures were again studied, to a gouache (P&V 1321), which records some further compositional changes, and finally to the painting itself. This sequence represents a highly ordered process, and the fact that we so far have only one such grouping suggests that Pissarro did not undertake it for every oil painting. It is clear, however, from all the known drawings executed during this period, that virtually every sheet produced between 1869–73 was made in connection with a specific work of art, and that Pissarro's preparatory methods were still remarkably like those evolved in Venezuela. There is the same hierarchy of media extending from pencil, to pen and ink, to watercolour, and the same shift from sketchbooks to independent sheets of paper.

Pissarro's correspondence with Duret in 1873–4, two key passages of which have been quoted above (see pp. 15–16), provide some written evidence for the importance of drawing and, in addition, for its preparatory role between 1874 and 1879. Not only do the number of sketchbooks increase during the mid and later 1870s, but, also, the notion of drawing as a continuous study of form, an exercise for both the hand and the eye, gained a new prominence. In fact, while drawings themselves become more numerous in the period 1874–9 than they had been in 1869–73, the

percentage of directly related drawings declined. With the exception of No. 80, which was clearly a compositional study for P&V 321, and a few figure studies, which were used in other contexts (No. 73A verso), Pissarro seems to have drawn more, but to have used his drawings less in preparation for paintings. The rare exceptions are to be found among the figure studies, and there is an important compositional study in pen and ink (No. 307) for *Le Semeur* of 1875, Pissarro's earliest work in homage of Millet.

It was not until 1879 that Pissarro began to evolve the highly sophisticated preparatory process that he was to use for the remainder of his life. Although it is possible to argue that a great deal of the impetus for this shift was provided by Degas, all the evidence presented so far indicates that Pissarro had never totally accepted the tenets of pure landscape painting and was therefore already keen to adopt a highly complex figural art. Indeed, after 1879, drawings of the human figure, either in isolation, or in groups, observed *plein-air*, or posed in the studio, virtually never ceased, in spite of the fact that Pissarro tended to paint figure compositions at irregular intervals. In fact, the last two decades of Pissarro's working life attest a dichotomy between the interest in the human figure shown in his drawings and the art of pure landscape represented in his paintings. In practically every case, the major figure paintings stand at the end of an elaborate pictorial process involving many drawings. When one balances the number of figure studies against landscape studies in the drawings, and then relates this ratio to the paintings dating from before 1879, they are roughly proportionate for both categories. After 1879, this situation altered, so that there are suddenly fewer landscape drawings in relation to a greater proportion of landscape paintings and a similar disproportion between the large number of figure drawings and the comparative paucity of figure paintings.

The earliest studies in the collection from which figures were transposed into paintings were originally drawn on one sheet in 1879 in the studio at Pontoise from posed models (Nos. 105 and 106). The two figures were used in separate paintings, and it is likely that this was common practice for Pissarro at this period, and that he did several large-scale preparatory drawings from the same hired model. The fact that the figures on the sheet are as large, or larger, than those in the final paintings indicates that Pissarro, in the manner of Degas, attempted to deal with the figure in as bold and complete a way as possible before undertaking the painting. Although the drawings are clearly preparatory, they are not compositional. However, the survival of a large pastel in the collection (No. 107), which is related to a finished painting, and for which there is also a squared compositional drawing, indicates that Pissarro did sometimes combine compositional drawings with independent figure studies in his preparatory process.

The most complete group of preparatory drawings which survive from the early 1880s was made in preparation for the large tempera painting on canvas, *La Moisson* (P&V 1358), dated 1882 and exhibited in the seventh Impressionist exhibition in April of that year (Fig. 13). The preparatory process for this picture was among the most diverse and complex in Pissarro's career, and it epitomizes his attempts

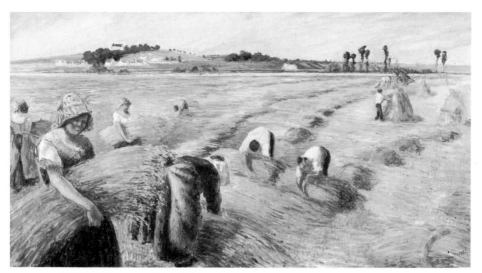

Figure 13. Camille Pissarro, *La Moisson* (P&V 1358), Tempera. 71 × 127 cm.

at creating an image, which was at once rooted in the art of Millet and steeped in the advanced trends of figure painting being explored in the late 1870s and early 1880s, principally by Degas. The earliest drawings, which relate to the finished tempera, were executed *plein-air* in the fields adjacent to St. Ouen-l'Aumône near Pontoise probably during the harvest of the late summer of 1881. An almost panoramic composition (No. 118) is the only study for the general setting and is an early attempt at creating a bold, dramatically receding pictorial space defined by small haystacks and piles of freshly cut hay. As one might expect, the majority of Pissarro's *plein-air* drawings made during the harvest are figure studies. Both the rectos and the versos of Nos. 119 and 120 are rapidly drawn studies of single figures, often two or three on a page, engaged in the various acts of harvesting. The sheets were drawn first with the pencil in a loose, freely drawn style, which is very similar to the figure studies of the Impressionist period 1869–73. However, in the later sheets, Pissarro chose the brush rather than the pen for the overdrawing, which may have been done in the studio. The brush lines follow the original contours of the figures and aid the illusion of movement. In at least one case, Pissarro chose to make larger and more elaborate studies of two of the figures (see entry for No. 120), but for these the brush has been replaced by a soft pencil. What is interesting about all these beautiful sheets is that they were not used in any direct manner in the final composition. Rather, they were made as generic figure studies, which would help the artist in re-creating the harvest in the final painting. In fact, Pissarro made still other figure studies during the harvest in combinations of pencil, chalk, charcoal (No. 121), and wash, and when taken together, this group of drawings represents Pissarro's most systematic attempt since 1852–5 to make a complete graphic study of a genre activity before beginning the actual compositional process.

There are two surviving compositional studies for the tempera *La Moisson* (P&V 1358), one in the Ashmolean collection (No. 122) and the other in pastel, formerly in Adolphe Tabarant's collection, known only through the photograph in the *catalogue raisonné* (P&V 1558). Of these, the sheet in Oxford is undoubtedly the earlier and is closely related in style to the brush drawings of single peasant figures already mentioned. In it, Pissarro has drawn one standing and one bending figure, both of which are placed in the foreground and seen from above. His choice of a square ruled paper for this compositional study suggests that he may have intended to transfer it straight on to the canvas. However, the existence of the pastel, once in Tabarant's collection, which has many more figures and is in other respects closer to the final picture, indicates that Pissarro did not make any further use of No. 122. Both these compositional studies, regardless of the difference in medium, are rapidly and confidently executed. In fact, Pissarro has sustained the spirited *brio* of his *plein-air* figure studies in the compositional stage. It is important at this point to stress that neither of the compositional studies discussed here was used entirely as the basis for the tempera. In fact, the many differences between them and the finished work indicate that, for Pissarro, the preparatory process was still fluid. As a result, the final execution of the tempera must have been a creative act both compositionally and technically.

Perhaps the most interesting aspect of the preparatory process for *La Moisson* was that the final stage is represented solely by a very large study of two figures on a single sheet (No. 123), rather than by a detailed compositional study. The figures in No. 123 are virtually identical in scale to those in the final picture; yet there is no evidence of any transfer process. However, the fact that even in No. 123 the positions of these two figures do not coincide exactly with those in P&V 1358 suggests that Pissarro may have considered still further compositional alterations at this late stage, but chose instead to retain the basic arrangement of the figures which he had already arrived at in the first compositional study. The fact that Pissarro seems to have had doubts about the final placement underlines the point that a number of important compositional decisions were reserved for the painting itself.

The preparatory process described for *La Moisson* can in no way be called 'traditional' or 'academic', and was, like the working processes of Degas, as experimental as the manner of painting itself. It has now been demonstrated that Pissarro began his preparation with many drawings done *plein-air*, both of the landscape and, more insistently, of the figures. The various figure drawings gave the artist the opportunity to work from a large number of possible poses and provided him with a way of translating individual actions on to the pictorial surface. This initial process was followed by a compositional stage in which the figures were disposed in various attitudes across the landscape. Finally, Pissarro ended the process in his studio far from the fields by arranging hired models in poses and costumes. It is interesting to note that he used virtually every graphic medium in this preparatory process and that there is now no clear hierarchical distinction in their selection. The introduction of brush drawing at this date, a technique which Pissarro had not used with any consistency

earlier, was in accord with the mellifluous curvilinear style which he adopted for his figures towards 1880.

This almost complete group of drawings made in preparation for *La Moisson* is probably somewhat larger than others relating to figure paintings of the same period. *La Moisson* was among the largest and most ambitious figure paintings which Pissarro had attempted by that date, and he approached it with a care commensurate with its importance. However, the group provides us with some insight into Pissarro's elaborate working methods and illustrates the skill with which he could deploy different types of media. Indeed, it is fair to say that there is virtually no important figure composition after this date which did not have an elaborate preparatory process, or which, alternatively, was not based on an earlier composition, therefore allowing access to another series of preparatory studies.

Pissarro's career during the last two decades of his life can be described as resembling an internal dialogue, in which certain compositions, figures, or ideas were taken up or put down as needed. By that point in his life, Pissarro had produced a large body of work including sketchbooks and drawings, which he could refer to for ideas or inspiration. Such is surely the case for the important painting *La Charcutière* (P&V 615) of 1883, now in the Tate Gallery, London, for which there are at least two closely related studies (see entry for No. 168E) and one other drawing (No. 168 F), two of these being included in a sketchbook in the collection at Oxford (Sketchbook

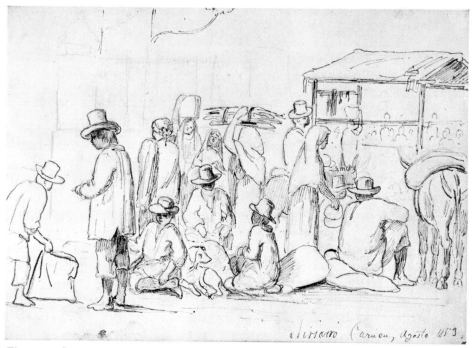

Figure 14. Camille Pissarro, *Study of Figures at a Market*. Pen and ink over pencil. 180 × 270 mm.

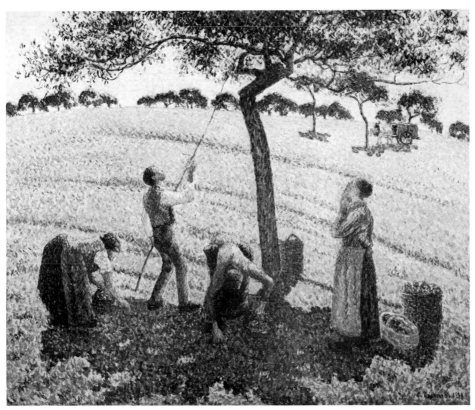

Figure 15. Camille Pissarro, *La Cueillette des pommes, Eragny*. Oil. 58·5 × 72·5 cm.

XV (No. 168). These three sheets show Pissarro reverting to those studies undertaken in a sketchbook dating from 1853–4, now in a private collection in Caracas, in which he examined the relationship between the figure and the armature of a temporary market stall (Fig. 14). Although Pissarro does not seem to have referred to any particular sheet from this early sketchbook, the general similarities in the handling of the composition are marked, suggesting that, when he returned to the subject of the market after a period of nearly thirty years, he did so with a clear memory of the earlier market studies done in Venezuela. The careful student of Pissarro's career in the 1880s and 1890s can find hundreds of cases of reuse and reversion. Indeed, the painter seems to have considered his entire career as a process of preparation.

The existence of several important sketchbooks with numerous figure studies, and the dramatic increase in the number of drawings, indicates that during the 1880s Pissarro not only followed the example of Degas, but also, more importantly, that he returned to his own earlier manner of working. The process of pictorial preparation itself fascinated Pissarro, and, by the middle of the 1880s, drawing dominated his *œuvre* almost to the extent that it had done in South America. The complexity

Figure 16. Camille Pissarro, *L'Ile Lacroix, Rouen, effet de brouillard*. Oil. 46·5 × 55 cm.

of the interrelationships among the drawings themselves, and between the drawings and paintings, can be exemplified by a brief analysis of the landscape drawings which relate to *La Cueillette des pommes, Eragny* (P&V 726) of 1888, in the Dallas Museum of Fine Arts (Fig. 15). The landscape for this figural genre composition seems to have been first essayed in a rhythmical black chalk drawing dating from the mid 1880s (No. 182) and was further elaborated on two sheets from Sketchbook XX (Nos. 180F and 180G recto), as well as in an independent sheet drawn with coloured chalks (No. 181), which may date from slightly later than No. 182, namely from 1886–8. What is interesting about these sheets is that, in spite of their undeniably close similarity to the painting and to an oil study of the landscape now in the Musée Fauré, Aix-les-Bains,[49] they do not in fact approximate closely enough to either of the oils to have been used directly in preparation for them. Indeed, these sheets are closer to a drawing, *Le Printemps* (No. 332), executed for a print by Lucien in 1895, and to a lithograph, Delteil 166, also dating from the mid 1890s, at least seven years after the landscape studies were executed. All this evidence suggests that, for Pissarro, preparatory drawings were often done as a means of establishing a general

[49] Reproduced R. Cogniat, *Pissarro*, Naefels, 1974, p. 48.

Figure 17. Camille Pissarro, *Study of L'Ile Lacroix, Rouen*. Black chalk. No dimensions known.

compositional type or of studying independent figures and objects, which could then be moved about and placed within various pictorial contexts. It is, therefore, often misleading to speak of certain drawings as having been made directly for a projected painting, or to date preparatory drawings in the same year as a dated finished work.

Another complicated and protracted preparatory sequence can be reconstructed from a series of drawings, prints, and a painting dating from the 1880s entitled *L'Ile Lacroix à Rouen* (P&V 719) (Fig. 16). There are three related drawings, one dated 1883 (No. 287), another undated (No. 159), and a third sheet formerly in the collection of Lucien Pissarro (see entry for No. 159) (Fig. 17). The presence of soft-ground on the verso of the dated sheet indicates that it was clearly used in the transfer process for a print unrecorded by Delteil, the plate for which is now in the Bibliothèque Nationale, Paris (Leymarie and Melot, P. 131).[50] Pissarro evidently abandoned the plate and produced another, smaller print, Delteil 69, one impression of which (Avery Collection, New York Public Library) is also dated 1883.[51] The undated sheet in Oxford (No. 159) and the sheet formerly in the collection of Lucien Pissarro (Fig. 17) are not easily placed in the sequence. The latter appears from the photograph

[50] Reproduced J. Leymarie and M. Melot, *The Graphic Works of the Impressionists*, Eng. edn., London, 1972, P. 131.
[51] Reproduced Rewald, op. cit. 58.

to have been executed in crumbly chalk, or charcoal, and is very closely related to the early version of the print, namely Leymarie and Melot, P. 131. No. 159 is very similar in certain details and in the atmospheric effect to the painting of 1888, but it is almost identical in size to the print published by Leymarie and Melot and dated 1883, and it shares certain compositional features with Delteil 69. No. 159 may, therefore, have been made at an intermediary stage between the abandoned plate and Delteil 69. This suggests that Pissarro made one drawing (that formerly owned by Lucien Pissarro, reproduced Fig. 17), then executed a print (Bibliothèque Nationale, to which No. 287 relates), which he abandoned, finally making a second drawing (No. 159) in preparation for Delteil 69 (dated impression, New York Public Library), all in 1883. It is, however, possible that Pissarro himself misdated the Avery impression at a later point when that collection was assembled, and that, therefore, both Delteil 69 and No. 159 could have been made after 1883, possibly as late as 1887, the date suggested for the print by Delteil. Pissarro then returned to this group of prints and drawings in 1888 and adopted certain aspects of the various earlier compositions for the Neo-Impressionist picture (P&V 719) now in the Philadelphia Museum. As such, the process of 'preparation' for the picture took place over a period of five years.

It was, in fact, for the process of print-making that Pissarro made the most extensive use of directly preparatory drawings. The drawings which survive for the earlier of the etchings representing Rouen suggest that such studies not only provided the extensive topographical information which Pissarro needed for the later execution of a print, but that they also played an active role in the transfer process. In fact, the drawings in the collection (Nos. 280, 281, 284, 286) made for such prints as Delteil 29, 30, 48 and 53 are closer to the final image than any preparatory drawings done for paintings. The fact that so many of these drawings are for topographical, or figural subjects, is evidence that Pissarro had greater difficulty with reversing the image for these types of prints and that he needed an intermediary step. This is particularly true for the prints dating from the early and middle 1880s.

Perhaps the most elaborate series of preparatory drawings for a print relates to Pissarro's important etching in colour, *Marché à Gisors, rue Cappeville* (Delteil 112) executed in 1894–5. The urban setting for the etching derives from a painting of the same title (P&V 690), dating from 1885, where the figures are differently disposed. Regardless of this connection, Pissarro arrived at the composition for Delteil 112 after an elaborate preparatory process, which probably dates *in toto* from 1894. The first related drawing is a compositional study on tracing paper (No. 295), which is larger than the final print, thus indicating that the artist conceived of a more elaborate and ambitious print than the one he in fact executed, and more importantly that he originally planned the composition in the form of a frieze. The presence of an isolated figure study (No. 256) for the seated female figure in the centre of the first compositional study (No. 295) suggests that Pissarro's interest in the relationship between that figure and the male figure on the far right of the composition began to dominate his conception of the scene, so much so that he appears to have hired

a model for this independent figure study, the only one which relates to the etching. It is interesting to note that the pose of this figure was borrowed directly from the female figure in the centre foreground of Léon Lhermitte's major etching of 1884, *La Cathédrale de Rouen*[52], and that, in order to assimilate the pose, Pissarro had to draw it from life. If these suppositions are true, it follows that Pissarro chose to concentrate his attention on the right half of the frieze-like composition. This is borne out by the existence of a very complicated drawing, formerly in the collection of Lucien Pissarro (Fig. 18), and, like No. 295, on tracing paper, a compositional study which is very close to, but much larger than, the final etching. This sheet is surely the most complicated surviving study for any print by Camille Pissarro, and, on the evidence of scale and medium, it can be assumed that the two fragmentary studies on tracing paper in the collection (Nos. 296 and 297) were probably made as possible corrected additions to this final compositional drawing. It is clear from the medium selected for this final study (Fig. 18) with its brown and grey washes and use of chinese white, that Pissarro was experimenting not only with the design of the composition, but also with the tonality of the final print.

At this point in its history, the preparatory process for Delteil 112 became somewhat simpler. Pissarro next made a smaller drawing on tracing paper (No. 298), which is a distillation of the main features arrived at in the compositional drawing formerly in the collection of Lucien Pissarro (Fig. 18). This smaller sheet (No. 298) corresponds exactly in scale with the final print. It is worth noting, however, that, in spite of the fact that No. 298 was redrawn in pencil on the verso, it played no direct role in the transfer process. Rather, it aided Pissarro in seeing the complicated group of figures in reverse. The final drawings for Delteil 112 are, in fact, impressions of the print hand-coloured by Camille Pissarro (No. 299). This series of preparatory studies makes it clear that drawings were as extensively used in the preparation of prints as they were for paintings, and it is safe to say that no painting of these same years resulted from as extensive and complicated a process as that for Delteil 112.

These groups of preparatory drawings form threads which can with care be followed throughout the patterned fabric of Pissarro's mature career. They reveal a highly intellectual and self-critical artist who considered each new work of art not as an isolated transcription of reality, but within the context of other works of art. In this way, Pissarro, like Cézanne, Gauguin, Degas, and Renoir, responded to the general trend away from the idea of Impressionism as pure landscape painting, a principle which was never adhered to as strongly by Pissarro as it was by Sisley or Monet. Pissarro himself viewed his own career after 1880 as a search for 'unity', a concept which was fashionable in the various aesthetic systems of the last two decades of the nineteenth century.[53] In this case, Pissarro's 'unity' was not simply the search for the single unified image, but, rather, a synthesis of the various strands of his own career.

[52] Reproduced Henriet, op. cit. (1905), between pp. 44 and 45.
[53] As enunciated by Camille Pissarro in a letter to his future daughter-in-law dated 5 May 1890, for which see *Archives de Camille Pissarro*, Hôtel Drouot, Paris, 1975, No. 146.

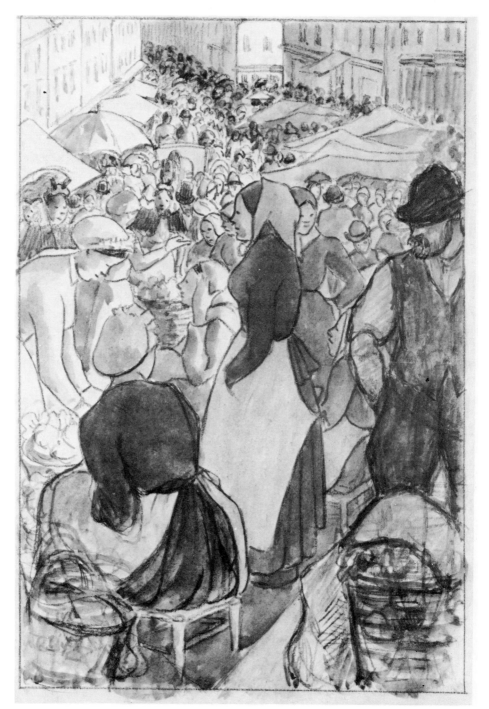

Figure 18. Camille Pissarro, *Study for Marché à Gisors. rue Cappeville*. Black chalk with pen and ink and grey and brown washes heightened with white on tracing paper. 275 × 109 mm.

V

Materials and techniques

(a) Media and paper

Camille Pissarro's lack of official training in academic method is reflected in his choice of materials. His attitude to these aspects of draughtsmanship inclined towards that of the autodidact, in that he displayed little direct knowledge of tradition and therefore tended to be experimental. Only after settling in France in 1855 did Pissarro feel the impact of official academic training, a discipline to which he paid lip-service, before continuing his own pattern of development. As a draughtsman who possessed a superabundance of natural talent, it was to be expected that Pissarro's approach to the art of drawing would be basically unorthodox, and it is the conjunction of a completely free adoption of techniques with an intensely individual and rigorous search for subject-matter that makes this artist's drawings so significant in the history of late nineteenth-century draughtsmanship.

The earliest drawings made by Pissarro while still in St. Thomas reveal a proclivity for the pencil. This is the case for both the figure studies and the landscape drawings. The pencil is normally hard and kept sharpened to a point so that the hatching is light and feathery. Often there is strengthening with the pen, which amounts, in fact, to a reworking of the drawing, and from these exercises Pissarro seems to have learnt to use the pen with greater confidence. As a result, certain drawings made in pen and ink (Nos. 1 and 3 recto) are so densely worked in pen that they approach the type of drawing made for the purposes of engraving. Although Pissarro did not begin print-making until after 1855, these drawings do demonstrate how readily his technique lent itself to engraving and etching.

The most striking aspect of Pissarro's early development as a draughtsman is the speed with which he gained confidence in the handling of all media. There is, therefore, not only a greater freedom in the treatment of subject-matter, but also in the adoption of a less constricted style. Softer pencils are selected and hatching is obtained more readily by turning the instrument on to its side so that areas of tonal hatching lend greater variety to the drawing. While in Venezuela, too, Pissarro appears to have used thicker pens (No. 27 recto). The most marked advance, however, is in the use of watercolour. Where in 1852 the watercolour resembles the treatment of pencil in its nervous application with small brushes, the watercolours done in Venezuela of vegetation and of genre scenes are of a different calibre in their boldness and freedom of execution. Pissarro's successful use of watercolour was not simply a question of eye and hand, but also of an improvement in the quality of materials, particularly in the paper. Many of the watercolours are executed on a thicker-wove paper with a smoother surface so that a quicker, more even application with a heavily loaded brush was positively encouraged. It is not possible to give a complete account of the various types of paper chosen for use during the period 1852–5, since there is, as yet, no detailed catalogue of all the sheets now in Caracas.

A preliminary investigation suggests that the paper obtainable varied enormously in quality, extending from rough oatmeal to Whatman products, all of European origin. It is likely that there was a wider choice of paper available in Venezuela than on the island of St. Thomas.[54]

On arriving in France in 1855 Pissarro experimented with the different media and papers that he observed other artists using. Clean pencil outline and fine penwork were continued for drawings that relate stylistically to Corot, but, equally, softer, more crumbly media were added to Pissarro's repertoire for tonal drawings. Black chalk and charcoal are now favoured and were sometimes combined with washes and chinese white.[55] Coloured papers—brown, beige, grey/blue, off-white—are also introduced and utilized in the traditional way for creating a middle tone, thereby allowing the artist greater freedom in the play of light and dark. In the years following 1855, therefore, Pissarro's curiosity for different styles was matched by a more adventurous selection of media.

There is little change with regard to media during the rest of Pissarro's life, although the combinations and actual method of application vary with some frequency, sometimes as a direct result of the subject-matter, and sometimes in accordance with his greater knowledge of the technical possibilities of a particular medium. Pure watercolour is again used in 1890, but it is more commonly applied in conjunction with black chalk, or charcoal, during the 1870s, and more often with pencil during the later 1880s, although neither usage can be described as a fixed rule, particularly during the 1890s when he appears to have used every combination with watercolour. Black chalk and charcoal are utilized throughout Pissarro's lifetime after 1855 and for drawings of varying scale. On larger sheets Pissarro was able to create some of his most powerful drawings, particularly of figures. Yet, even by the end of the 1870s, the artist could also use the same media to equally good effect for landscape studies, which comprise only a few brief lines. The appeal of the softer media for Pissarro lies in the variety of strokes and nuances of tone that could be achieved with differing pressures of the hand. Pissarro often also applied the softer media roughly, so that the paper is almost abraded, and a similar scoring of the paper can be observed on the early drawings in pencil. Occasionally, the artist wetted the tip of the chalk, or pencil, so as to gain a sharper accent. Surprisingly, Pissarro only turned to pastel spasmodically, perhaps with the encouragement of Degas, and his corpus contains relatively few drawings made in that medium alone. As regards the use of the softer media there is one interesting drawing in which black chalk, charcoal and pastel are combined (No. 125). In this powerful figure study the underdrawing is in black chalk, but the dress is redrawn in charcoal, and the kerchief added in pastel. The differentiation between the media is perfectly illustrated by the drawing and so, too, is Pissarro's free use of them.

[54] See for the moment the exhibition catalogue *Camille Pissarro au Vénézuéla*, Paris, 1978, where some watermarks are recorded (Nos. 3, 4, 10, 23, 26, 29, 30, and 39).
[55] There is only one instance, so far discovered, of Pissarro using red chalk (Sotheby's, 6 May 1959, lot 2), for which see entry for No. 52.

The pen does not seem to have been used so frequently immediately after 1855. Although initially Pissarro continued to use it for drawing landscapes, only very occasionally was it picked up for figure studies related to paintings (Nos. 109 and 110). In fact, only in the contexts of caricature and print-making was it preferred with any consistency. For caricature the agility of the pen and the precision of its lines on a small scale aided the swift delineation of character. For prints there was, as we have seen at the outset of Pissarro's career, a connection between the style of his penwork and engraving, and it was presumably the similarity between the pen lines and engraved, or etched, lines that encouraged the artist to use pen again for drawings made in preparation for his prints. Pen lines also had the advantage of being easily visible through tracing paper at the time of transference.

Pencil was retained during the 1870s and 1880s, but was limited to underdrawing, landscape drawings, and small-scale figure studies. There is one example in the collection of a large-scale figure study in pencil (No. 108), but the possibilities of creating breadth of outline are considerably less, and Pissarro therefore selected pencil only for those studies demanding clear, but mellifluous outlines. Some of his most rhythmical drawings are made with the pencil, and it is interesting to observe that Pissarro often reworks those same drawings with the brush denoting that there is the same degree of flexibility in these two media. The most distinctive feature of the 1880s from the technical point of view is the employment of the brush in the same context as the pencil. The point of the brush is often preferred for the figure drawings of that decade so that the brushwork has a calligraphic quality (No. 168D). Very occasionally, the artist favoured washes, sometimes thickened with gouache or chinese white, as a system of modelling with the brush in a strictly traditional way (No. 168G). Yet the calligraphic method of brushwork is also found in the landscape studies with the trunks, branches, and foliage of trees delicately suggested with the point of the brush, which thickens and contracts in the same way as a piece of chalk, or charcoal, becomes blunted and has to be turned on to its side (No. 168I). On a technical basis, this supple brushwork is, perhaps, the most important advance in Pissarro's development after 1855 and one wonders to what extent it was derived from Japanese example.

The most complex combinations of media in Pissarro's graphic *œuvre* are found in his drawings made for the joint projects with his son Lucien, namely *Daphnis and Chloë* and *Travaux des champs* (see pp. 58–85). Here the choice of media is in all cases dictated by the process selected for printing, just as the style of drawing itself in these two cases is determined by the act of cutting the design on wood. Thus, the combination of indian ink and chinese white for *Daphnis and Chloë*, and the evolution from simple ink outlines to broad washes for *Travaux des champs*, are directly connected with the type of print that Lucien Pissarro chose for each of these projects. Pissarro's willingness, and, above all, his success in adopting these differing styles, demonstrates yet again how outstanding he was as a draughtsman.

An important aspect of the draughtsmanship of this period is the role played by the paper. Reference has already been made to Pissarro's adoption of a variety of

coloured papers immediately after arriving in France, but during later decades he shows a preference for pink and blue papers, particularly when drawing large-scale figure studies. The main function of paper for Pissarro was a creating a fixed tone against which outline and modelling could be placed to advantage. There were also the physical properties of the paper itself. The tufts of the wove and the laid lines of the chain possess distinct textural possibilities when a piece of black chalk, or charcoal, is dragged across the surface. Pissarro had begun to take advantage of the texture of paper during the last half of the 1870s (Nos. 74-5, 80 and 83), but this tendency is more pronounced in those tenebrist drawings where Pissarro's debt to Millet and Seurat is clear. Like these artists, Pissarro occasionally sought out paper of the finest quality including Whatman, L. Berville, Lalanne, or, more often, a type with the watermark E.D. & Cie (see Index 2).

Until, however, more is known about the manufacture and dispersal of paper in the nineteenth century it is difficult to develop these bare facts any further.[56] It is possible none the less to make one generalization about Pissarro's use of paper. Unlike Seurat, who preferred Michallet, a particular brand of 'Ingres' paper, Pissarro drew on an enormous variety of papers, which differ not only in colour, but also in texture and scale. Furthermore, far from limiting himself to hand-made papers, he also bought glazed machine-made varieties, and two of his most important sketch-books are on machine-made papers (Sketchbooks XV (No. 168) and XXI (No. 210)). Even with items like sketchbooks that could be bought in standard sizes Pissarro singularly failed to buy two of the same dimensions. This variety in the scale and type of paper again reflects Pissarro's interest in a wide range of media. In fact, in all these technical matters he was not a purist, and his graphic *œuvre* attests the increase in the production of cheap papers, as well as the greater availability of art materials from around the world, although he does not seem to have used oriental papers for drawings, reserving them for prints.[57] Neither did Pissarro spurn paper of a more mundane sort, often employing odd sheets torn from account-books. Both No. 1 and an important compositional drawing for P&V 394, *Le Jardin à Pontoise* of 1877 (private collection, London), were made on portions of account-books,[58] which suggests that Pissarro often drew indiscriminately on whatever paper was to hand, and was not always concerned with its intrinsic qualities.

[56] A certain amount of information on Whatman paper may be gleaned from M. B. Cohn, *Wash and Gouache. A Study of the Development of the Materials of Watercolour*, catalogue of an exhibition held at the Fogg Art Museum, Cambridge, Mass., 1977. During the course of writing the present catalogue it has been observed that both Degas and Lhermitte also used paper watermarked L. BER-VILLE (namely sheets exhibited in *Selected Works from The Andrew Gow Bequest*, Hazlitt, Gooden, and Fox, London, 20 October-10 November 1978, Nos. 26 and 47 respectively where, however, no note was made of the watermark clearly visible in the paper).

[57] No. 235 is the one instance in the present collection of a Japanese paper being used. For the paper used for prints see the short essay by R. L. Parkinson in B. Shapiro, *Camille Pissarro. The Impressionist Printmaker*, Museum of Fine Arts, Boston, 1973.

[58] Details of this compositional drawing may be found in *A Selection of drawings, watercolours and pastels by Camille Pissarro c. 1853-1903*, JPL Fine Arts, London, 1978, No. 12. Interestingly, Gauguin also used account-books as sketchbooks, see M. Bodelsen, 'Gauguin, the Collector', *Burlington Magazine*, cxii (1970), pp. 590-615, fig. 16.

(b) Sketchbooks

Closely related to the preceding comments on Pissarro's technique and materials is the question of his sketchbooks. The utilization of sketchbooks by nineteenth-century artists in France is a matter that is in need of close examination. As in the case of Cézanne, the study of Pissarro's drawings has led to the reconstitution of several sketchbooks whose contents are now scattered in various collections following their dismemberment after the artist's death. From amongst the four hundred or so separate sheets in the collection of the Ashmolean Museum the writers have been able to find pages from as many as twenty-seven sketchbooks, and their work on drawings in other collections has revealed the existence of at least two further sketchbooks. Unfortunately, in contrast with the *carnets* of Corot and Degas, none of these sketchbooks has remained intact, and the two with the most extensive number of sheets are Sketchbooks XV (No. 168) of the present catalogue and one now in a private collection in South America. The short inventory of Camille Pissarro's studio at Eragny that was drawn up by Lucien Pissarro, possibly in 1903, mentions only twenty-two sketchbooks (see p. 2), but this was most probably only the nucleus of Pissarro's own collection of sketchbooks, as there are likely to have been others elsewhere.[59]

On internal evidence, therefore, it is difficult to calculate precisely the extent of Pissarro's reliance on sketchbooks. It seems that he most probably used them far more than a preliminary investigation of his drawings might suggest, since many of them have subsequently been trimmed. Although perhaps not to the same extent as Degas, it is possible that about half of Pissarro's drawings were committed to sketchbooks and in this there is a parallel with Cézanne who, like Pissarro, fluctuated between pocket sketchbooks and outsize sketching tablets. From the outset in St. Thomas and while in South America Pissarro bought sketchbooks of medium or large size. In France, however, after 1855 he appears to have favoured sheets of a large size only, which may have been assembled in sketching tablets. These tablets probably comprised different coloured papers, even different makes, having been made up by the supplier, and so they are difficult to reconstitute with confidence. Only in Louveciennes and in London does Pissarro begin to use slightly smaller sketchbooks and this was to remain his practice for the rest of his life, apart from two notable examples (Sketchbooks XV (No. 168) and XXI (No. 210)). Pissarro was a peripatetic artist and the pocket-size sketchbook had obvious advantages in this context. Thus, the sketchbooks used in Rouen and Gisors (Sketchbooks XIII (No. 158) and XVI (No. 171)), as well as those begun during the final decade of his life

[59] The notebooks of Degas, for instance, number thirty-eight (Reff, op. cit) and the *carnets* of Corot seventy-nine (see A. Robaut, *L'Œuvre de Corot. Catalogue raisonné et illustré*, iv, Paris, 1905, pp. 87–99. Both the notebooks of Degas and the *carnets* of Corot have, in the main, survived intact. Pissarro occasionally seems to have used a type of small sketchbook with square ruled paper printed in blue ink similar to those favoured by Manet and Degas (see principally Sketchbooks XIII (No. 158), and XIV (No. 160)).

in Dieppe and Le Havre (Sketchbooks XXVI (No. 277) and XXVII (No. 278)), are of small dimensions. To a certain extent the dimensions determined the use to which the sketchbooks could be put and perhaps even the style. Yet, unlike both Degas and Cézanne, Pissarro very rarely crowded the pages with small studies. The sheets do not teem with detailed sketches, but rather reflect Pissarro's overall concern with compositional formulae, particularly as regards landscape. Most usefully, however, the evolution of Pissarro's style of figure drawing can be traced through the sketchbooks. Again, unlike Degas, Pissarro did not use his sketchbooks in an intensely private manner. They are practically devoid of inscriptions, or private musings, which would reveal information about Pissarro's personal life. Instead, they are used specifically for drawing in the purest sense of the word and not as notebooks.

Although the Ashmolean Museum does not possess a sketchbook by Camille Pissarro that is still intact, there is a whole series of Lucien Pissarro's sketchbooks, some ninety in all, nearly thirty of which were in use during Camille Pissarro's lifetime. These sketchbooks relate directly to compositions and ideas found in the works of Camille Pissarro, thereby emphasizing the close alliance between father and son which also emerges from a reading of their correspondence. From a practical point of view, however, Lucien Pissarro's sketchbooks are presumably of a similar type to those purchased by Camille at that stage of his working life, and, therefore, the principal suppliers are worth recording here. First, there is P. Contet, successeur de L. Latouche, 34 rue Lafayette, Paris, whose sketchbooks have soft cloth-bound covers. Lucien Pissarro owned a whole range of sizes of these sketchbooks: 165×260; 128×219; 82×120; 108×170; 112×195, many of which approximate to the dimensions of those drawings by Camille Pissarro that once formed part of sketchbooks. Other suppliers were E. Schwartz and E. Morin, both of 5 rue Lepic, Paris.

VI
The collaboration of Camille and Lucien Pissarro**

The collection in Oxford has a large number of drawings by Camille Pissarro which were executed for the two collaborative projects undertaken during the final decades of his life with his son Lucien. Although there has been some discussion of these projects in the literature devoted to the career of Lucien,[60] little has been written about Camille's active participation in them, and many of the relevant letters, or sections of letters, are unpublished. For that reason and because of the importance

** In the quotations from the correspondence between Camille and Lucien Pissarro, which has been extensively used in Section VI of the Introduction and in the relevant catalogue entries below, some have been repunctuated for the sake of clarity. Definitive editions of both sets of letters are in preparation.

[60] W. S. Meadmore, *Lucien Pissarro. Un Cœur Simple*, London, 1962, p. 46 and A. Fern, *The Wood Engravings of Lucien Pissarro with a Catalogue Raisonné*, doctoral thesis submitted to the University of Chicago, 1960.

of the collaboration itself in the lives of the two artists, we have decided to treat the two major projects, *Daphnis and Chloë* and *Travaux des champs*, in some detail.

In addition to the many drawings which relate to these projects, there are also several other drawings made by Camille Pissarro for prints that were cut on wood by Lucien Pissarro. These drawings are usually on tracing paper and were used either for the purpose of transfer, or correction. They are also catalogued separately below (Nos. 305–12).

(a) Daphnis and Chloë

The first reference to a series of illustrations for the pastoral romance *Daphnis and Chloë*, written by the Greek author Longus probably in the fourth century AD, occurs in a letter from Lucien Pissarro to his father dated 14 January 1895: 'je te propose de me faire 12 petites compositions pour Daphnis & Chloé. Je suis sûr que ce sujet te convient parfaitement, je vois déjà tes compositions avec des moutons des biques ou des baigneurs. Si la proposition te plaît je t'enverrai la grandeur des feuilles de papier que tu auras à employer'. Camille Pissarro replied to this suggestion enthusiastically, 'Quant à Daphnis et Chloé, je suis prêt à faire les douze dessins et si tu y mettais de jolies lettres, ce serait épatant' (*Lettres*, p. 363, 18 January 1895). The project, however, was abandoned before the completion of the twelve drawings and is not mentioned again in its original context after February of the following year when it is referred to in an undated letter written by Lucien Pissarro in reply to one from his father dated 26 February 1896. Interestingly, already in April 1895 it seems that the original project was proving to be too ambitious, and Lucien suggested reducing the number of illustrations from twelve to four: 'Dis-moi quand tu vas à Rouen, et si tu as le temps de t'occuper de Daphnis & Chloé, maintenant 4 dessins sont suffisant il y a 4 livre un par livre' (Letter from Lucien Pissarro to his father dated 25 April 1895).

The mythological subject-matter is unprecedented in Pissarro's *œuvre* until this date, and the idea of illustrating the text of *Daphnis and Chloë* was most probably inspired by, and perhaps even intended to rival, the illustrations accompanying the translation by George Thornley (1657) published by Charles Shannon and Charles Ricketts at the Vale Press in 1893. Indeed, Lucien Pissarro wrote to his father in January 1895:

Il y a aussi une autre raison pour que je ne le fasse pas R[icketts] & S[hannon] en ont fait un (qui est épuisé maintenant) une traduction anglaise, les illustrations sont comprises à la grecque ou plutôt, comme du temps de la Renaissance, je pense qu'une édition française et tout à fait moderne avec des paysans serait fort intéressante, et comme tu les connais très bien j'ai pensé que tu ferais des choses très épatantes.

As Lucien Pissarro observed, the illustrations accompanying the volume printed at the Vale Press are well versed in the Italian tradition. The designs are intensely linear

and in nearly every instance there is a disguised quotation from a famous work of
the Italian Renaissance, including those by Botticelli, Pollaiuolo, Mantegna, and
others. Ultimately, as far as the art of book production is concerned, Ricketts and
Shannon were attempting to emulate the famous book by Francesco Colonna, *Hyp-
nerotomachia Poliphili*, published in Venice by the Aldine Press in 1499 and a typo-
graphical masterpiece that was also deeply admired by Burne-Jones and William
Morris.[61] In France, on the other hand, there was an equally strong tradition for
the illustrations to the text which had reached its peak in the eighteenth century.
Yet the drawings produced by Camille Pissarro for *Daphnis and Chloë* owe virtually
nothing to either the firmly established French tradition or to the more recent revival
of printing in England at the end of the nineteenth century, and there are no obvious
sources in the history of art for what he set out to achieve. It is hardly surprising,
therefore, that the treatment of the subject-matter was a point of some concern
for Pissarro:

Ce que tu me dis, à propos de Daphnis et Chloé et l'opinion de R[icketts] ne m'étonne
pas du tout il a absolument raison j'ai été fort bête dans cette affaire il aurait été si simple
de faire Chloé toute nue, comme du reste j'en avais eu l'intention, mais j'ai voulu faire
du grec, sans en avoir fait les recherches nécessaires, ce qui nous aurions dû faire à la
bibliothèque ou au Louvre (*Lettres*, p. 383, 6 October 1895).

Where the illustrations of Shannon and Ricketts seem to emphasize the aridity of
the landscape and their interpretation to underline the decadence of the society which
frustrates the pure love of Daphnis and Chloë, Pissarro places their innocent passion
in a sympathetic arcadian setting that is far more appropriate to the bucolic
descriptions in the text. In this sense Pissarro's illustrations may be described as
traditional, the style and technique approaching the pastoral tradition of English
artists, such as Samuel Palmer, whose work, however, Pissarro is unlikely to have
known. The drawings stress the rural simplicity of the setting and presuppose a
Virgilian quality in the text, so that the landscapes abound in an almost tapestry-like
wealth of natural detail.

It is clear from the correspondence between Camille and Lucien Pissarro that both
artists felt that an illustrated edition of a famous text would be a more viable com-
mercial proposition than the two portfolios, *Twelve Woodcuts in Black and Colours*
(1891) and *Travaux des champs* (1895), so far published by Lucien Pissarro. In fact,
the drawings for both *Daphnis and Chloë* (Nos. 313–21) and the second phase of
Travaux des champs (Nos. 333–42) were designed in a similarly densely packed,
heavily worked black and white style specially chosen to harmonize with the typo-
graphy. The drawings for *Daphnis and Chloë* (Nos. 313–21), therefore, have a stylistic
uniformity and format that is lacking in any of the phases of *Travaux des champs*,
both published and unpublished. Discussion on the ultimate intentions of the artists

[61] J. Rewald, 'Lucien Pissarro: Letters from London 1883–1891', *Burlington Magazine* xci (1949),
p. 191.

in any involvment with *Daphnis and Chloë* dates from the first half of 1895. Lucien Pissarro wrote to his father in January 1895:

A propos de Daphnis je dois dire que je n'avais pas songé à ce que tu m'en dis dans ta 2e lettre. Je n'avais que l'idée de faire un beau livre. Ce qui est toujours une bonne affaire, quand on réussit, cela prend sa place tòt ou tard. Du reste il restait pour ma part de collaboration, l'encadrement des pages les lettres ornée & la gravure, ce qui est déjà pas mal important. Le livre aura de l'unité quoi que tu en penses. Les beaux livres qui existent ne sont pas pour la plus part œuvre d'un seul. Ton dessin s'accorde très bien avec la gravure, surtout si tu fais tes traits sans discontinuité. Je veux dire sans arrêts de blanc dans le milieu d'une forme. Cela s'explique car une page imprimée est un arrangement en blanc & noir. Je suis persuadé tu t'en sortiras tout à fait bien pour les nuds, ce qui me serait difficile n'en ayant jamais fait, et n'ayant aucune facilité pour des modèles.

Again on 25 April 1895 he offered some further advice to his father:

'J'ai une idée que je crois bonne si tu faisais tes compositions sur plaque pressées pour te rendre compte des effets, que nous tâcherons de transposer pr. le bois? Un point important pour accompagner la typo: c'est d'observer un certain balancement des blancs et des noirs. Ce qui arrive dans les lettres à cause du côté mécanique'.

Camille Pissarro was for a short time fascinated by the prospect of executing the illustrations to *Daphnis and Chloë*, and he asked his son for a report on its progress in a letter dated 11 September 1895:

D'Estrée m'a bien recommandé de te prier de l'avertir *en premier* quant Daphnis et (comment s'écrit) Chloé sera prêt. Il a l'air d'y beaucoup tenir ... il a probablement des attaches avec des amateurs qu'il doit avertir ... Viau m'a fait de grands reproches de ne lui avoir pas vendu une R.[eine] des P[oissons]. Je lui ai dit que je lui avais envoyé un prospectus, il ne l'a pas reçu, ce doit être vrai, ses commis ont du jeter cela au panier ... Il m'a dit qu'il retenait d'avance le Daphnis et Chloé ... tu peux le mettre sur ta liste. J'en trouverai d'autres (passage omitted in *Lettres*).

This enthusiasm, however, soon waned. Difficulties were encountered and are described in a letter from Lucien Pissarro to his father dated 4 December 1895:

Je prépare aussi pour le futur! Je vais faire les Contes de Perrault avec un bois en couleur, je crois que ce sera sage de faire suivre un livre noir, par un autre avec de la couleur, car c'est surtout là ma particularité. Et cela nous donnera le temps de nous arranger pour Daphnis & Chloé, car notre bois est certainement encore trop noir pour la typographie et il y a encore une question pratique qui me la fait reculer, c'est que je n'ai pas assez de typographie pour le moment pour le composer, et les frais d'imprimerie seront un peu lourdes pour le début...

The lack of type may have been the main factor that held the project up, for at this time Lucien Pissarro was borrowing type from the Vale Press for the publication

of his books (see *Gentle Art*, p. 8), but there were also stylistic difficulties that remained unresolved, as Lucien Pissarro argued in a letter to his father written in reply to one dated 26 February 1896:

A propos du Daphnis & Chloé je l'ai laissé de côté pour 2 raisons 1. c'est un gros volume et je n'ai que peu de typographie il prendrait longtemps à faire et pour le moment il faut que je gagne de l'argent et les petits livres se vendent en proportion plus cher et plus facilement et 2. nous avons fait fausse route, les bois sont de beaucoup trop noir pour les lettres et ne cadrent pas avec une formule assez décorative pr. la typographie. Il faudra étudier la question plus à fond.

Already by 16 October 1895, Camille Pissarro had begun to express doubts about the style, 'Je crains que la manière de Daphnis et C. ne soit un peu trop monotone … J'ai lâché les dessins pour m'occuper de peinture, j'y reviendrai' (*Lettres*, p. 389). After the exchange of February 1896 the project seems to have been abandoned.

The only evidence in the subsequent correspondence that the project was ever revived at a later date is contained in an exchange of letters dating from the last two months of 1899 when Lucien Pissarro printed two of the blocks which he had prepared for engraving some time before (*Chloë washing Daphnis at a stream* and *Vendange* (Fern, Nos. 115–16, pp. 208 and 209)). The first reference is in a letter written by Camille Pissarro to Lucien dated 24 November 1899, 'Si tu veux m'en croire, tu ne devrais pas publier les deux gravures de Daphnis et Chloé, elles sont noires, lourdes et me semblent banales et trop compliquées, cela n'irait pas avec tes lettres'. This letter, in turn, exacted a most interesting reply from Lucien Pissarro, which reiterates many of the difficulties experienced by the two artists in preparing the illustrations for *Daphnis and Chloë*,

Tu as raison les bois du Daphnis et Chloé sont trop noirs pour la typographie. Aussi si tu n'objectes pas de les redessiner j'en ferai d'autres. Voici ce qui je crois serait le meilleur moyen: tu pourrais faire les petites compositions comme tu voudrais ou au crayon ou à l'encre de chine n'importe et d'après ce croquis je ferai le dessin des tailles ayant l'expérience de ce que cela donne une fois gravé et ce dessin je te le soumettrai, peut être corrigé au besoin. C'est comme cela que les anciens procédaient et Morris lui-même a fait ainsi pour les dessins de Burne-Jones, dans tous les cas nous pourrions essayer et si le résultat ne nous plaît pas voilà tout. Je tiens à ce que nous fassions ce livre ensemble car c'est peut-être celui qui convient le plus à ta manière, tu pourrais y introduire des animaux, vaches moutons, chèvres etc. et en somme ne pas trop te préoccuper des personnages grecs. C'est je crois la faute que nous avons faite. Les gothiques ne se gênaient pas pour affubler les personnages antiques des costumes de leur temps, en somme l'illustration est un livre à côté du texte il n'est pas absolument nécessaire de refaire le livre en dessin (written between 24 November and 1 December 1899).

Yet even this revised system of working was not implemented, and, once more, the pressure of other commitments prevented the two artists from concentrating upon

the project, as evidenced by a final letter on the subject from Lucien Pissarro to his father in reply to one dated 1 December 1899:

Le Daphnis & Chloé n'est pas pressé du tout, car j'ai en main la préparation de 3 ou 4 volumes, mais je suis obligé de faire le plan de mes bouquins à l'avance, ce Daphnis & Chloé ne sera guère imprimé avant un an ou deux. Comme je te le disais dans ma dernière lettre tu n'as pas besoin de t'occuper du tout de la gravure fait ta composition très librement au conté ou au pinceau le moyen n'y fait rien et je redessinerai ta composition avec les tailles comme elles doivent être gravées. La composition perdra sans doute le charme de ton trait mais gagnera en harmonie avec la typographie, il reste à savoir si cela compensera, nous ne pouvons juger de cela que quand nous verrons les épreuves. Après tout je peux bien essayer d'interpréter ton dessin dans ce medium que je connais, étant donné que tu es interpreté par d'autres artistes quelquefois. Certainement je pourrais au besoin faire le Daphnis moi-même, mais comme je te le disais je ne vois pas d'autres livres s'appliquant si bien à ton dessin et ce serait dommage de perdre l'occasion de faire quelquechose ensemble. J'ai beaucoup de sujets pour lesquels je puis travailler.

Apart from the two prints of the designs for *Daphnis and Chloë* made in 1899, Lucien Pissarro did pull one other (*The Nuptials of Daphnis and Chloë*) in 1920 (Fern, No. 258, p. 313), and it is clear from this that even at this late stage he hoped to complete the project (see Fern, Appendix I, *Lucien Pissarro. Notes on the Eragny Press*, pp. 76–81, especially p. 81).

There is one vital piece of evidence regarding the *mise-en-page* as conceived by Lucien Pissarro. This is a drawing, similar to No. 317, *Vendange*, set within an elaborate foliated border (Fig. 19). Both the border and the drawing are on separate pieces of tracing paper, but between the lower edge of the drawing and the border below there is a section of letterpress in the Brook type finally adopted by Lucien Pissarro in 1903–4.[62] This *mise-en-page* proves that, like several other books designed by Lucien Pissarro and issued by the Eragny Press after 1903 with Brook type, the main source of inspiration, for the decorative features at least, was French books produced in the early sixteenth century by such engravers as Geofroy Tory. That Lucien Pissarro had previously pondered the *mise-en-page* for *Daphnis and Chloë* is attested by three letters written by Lucien Pissarro to his father in 1895:

la bordure pr. le Dap. et Chl. n'est pas encore entièrement dessinée mais cela avance, j'ai composé une lettre initiale qui devra être imprimée en noir et les ornements en rouge ... (September 1895)

La Vendange est presque gravé, mais je l'ai laissé en plan pour faire une bordure pour Ruth le Livre d'Esther pour lequel je vais ajouter un bois. (14 October 1895)

[62] The letterpress is a section from a broad sheet entitled *A Liberal Education* signed by T. H. Huxley. Although the letterpress is definitely in Brook type, the sheet is undated and there is no reference to it in the Studio Book. Mr. David Chambers has pointed out, however, that the capital *T* with which the piece begins resembles the initial *I* in C. Perrault, *Deux Contes de Ma Mère Loye*, printed by Lucien Pissarro in 1899. Perhaps significantly, in the Ashmolean collection *A Liberal Education* has been inserted in the back of Milton, *Areopagitica*, printed by Lucien Pissarro in 1903.

Figure 19. Camille and Lucien Pissarro, *Design for the mise-en-page of Daphnis and Chloë*. Pen and dark ink with chinese white on tracing paper. c. 232 × 174 mm.

J'ai été, en effet, fort occupé avec la typographie, j'ai composé une page d'essai pour nous rendre compte de l'effet de la typographie et cela dépasse notre attente, elle est je crois une des plus belle qui ait jamais existé, je t'envoie cette épreuve pour que tu t'en rends compte. Il y a quelques fautes de composition que je n'ai pas eu le temps de corriger mais cela ne fait rien à la chose. La feuille est celle de Ricketts mais plus tard je t'en enverrai d'autres épreuves avec les miennes (October 1895)

The *mise-en-page* for *Daphnis and Chloë* dating from 1895 must reflect Lucien Pissarro's first tentative attempts to design a new typeface of his own, which he only managed to bring to fruition slowly over a number of years.

Although not finished, the drawings for *Daphnis and Chloë* executed by Camille Pissarro, most of which are in the Ashmolean collection, constitute a remarkable group and attest a fascinating episode in the life of the artist. Of his contemporaries, only Manet and Redon made important sets of designs for book illustrations and these were for contemporary works. It is an interesting reflection on the art of Camille Pissarro that the subject-matter of *Daphnis and Chloë* lent itself in so many ways to his artistic imagination, especially as we know it during the final decade. This was not just in the setting, where the rural, arcadian aspects of the romance must have appealed to him, but also in the neat, precise technique that book illustration with a high finish necessitated. Pissarro possessed a copy of the French translation (1559) of *Daphnis and Chloë* by Jacques Amyot. This famous translation ran into several editions. The one used by Pissarro was published by Lemerre in Paris in 1873 and is listed in the typescript entitled *Pissarro Books as remaining at The Brook Stamford Brook, after the decease of the late Mrs Lucien Pissarro, née Esther Bensusan*, No. 736, prepared by Mr John Bensusan-Butt and dated 25 November 1951. The whereabouts of this copy is now unknown. The evidence of *Daphnis and Chloë* indicates that Camille Pissarro thought a great deal about book illustration. As is clear from the correspondence, he was prompted by Lucien Pissarro to consider carefully the relation between the text and the image, thereby creating a style of illustration which would accord well with the subtle rhythm of black and white on the printed page. As such, Pissarro's book illustrations of the middle 1890s are considerably more restrained than the masterly lithographs by Manet for Edgar Allan Poe's *The Raven* (1875), or the mysterious lithographs by Redon for Baudelaire's *Les Fleurs du mal* (1890) and Flaubert's *Tentation de Saint Antoine* (1888, 1889, and 1896).

Daphnis and Chloë is a pastoral romance set in Lesbos. Both the chief protagonists were exposed in infancy and discovered by two humble shepherds, named respectively, Lamo and Dryas. They spend their childhood tending the flocks of goats and sheep owned by their foster parents. They fall in love and pursue their relationship innocently in the beautiful setting of Lesbos. The plot woven around their experiences includes a number of tests of the strength of their love. The various adventures are recounted in a rapid style interspersed with passages of highly charged poetic and lyrical beauty. Eventually, the identity of the true parents of both Daphnis and Chloë are revealed and the couple are married. The text achieved widespread popularity on account of its style and strong narrative, and it holds an important place

in the development of Greek literature. Ricketts and Shannon illustrated the romance in their publication issued by the Vale Press in 1893 with thirty-five woodcuts, but by the time Camille and Lucien Pissarro finally abandoned their scheme they had only achieved five of the twelve projected illustrations. Significantly, Pissarro chose only the moments in the lengthy narrative in which the naïve passion and the joy of Daphnis and Chloë are most apparent. These illustrations include none of the descriptions of physical trials and separations which Ricketts and Shannon emphasize in their version. The illustrations selected and finished by Camille and Lucien Pissarro do, however, represent a complete history of Daphnis and Chloë from their youth to their eventual marriage and can therefore be regarded in many ways as complete.

(b) Travaux des champs

Travaux des champs, like *Daphnis and Chloë* (for which see pp. 59–66), was an important joint project carried out by Camille and Lucien Pissarro. It was first mooted as early as December 1886 and was continued intermittently up to the time of Camille Pissarro's death in 1903. The various phases of evolution, three in all, are discussed and analysed below.

Lucien Pissarro finally published many of the drawings made for the last phase in Emile Moselly, *La Charrue d'érable* (Paris, 1912), a book produced by the Société du Livre contemporain. This, however, was but a pale reflection of the work as it was originally projected by Camille and Lucien Pissarro, and even the published portfolio, *Travaux des champs, Ière Série*, published at the Vale Press by Charles Ricketts in 1895 (*Gentle Art*, No. 3 a-f, pp. 20–1, states the date as 1893, but see pp. 69–72 below), gives only a truncated version of their intentions. On a stylistic basis these intentions were clarified as one phase succeeded another, but in the correspondence there is also some discussion as to the character of the accompanying text, whether, for instance, it should be written by a contemporary writer, or else illustrate a specific work such as Virgil's *Bucolics*. These ideas remained fairly flexible throughout the preparatory stages, but an attempt has been made in this catalogue to provide a detailed reconstruction of the arguments and discussions involved for which the drawings and the letters are the primary sources. The two early phases represent a vague plan to illustrate peasant activities in the country, perhaps inspired by J.-F. Millet, but the scheme adopted for the final phase, which records the seasonal changes, was decided by the artists themselves and is far more detailed than anything that Millet undertook in this context. The scheme is of interest because of its loose iconographic connections with medieval cycles of the months of the year and also with illustrations for almanacs. At some stage during the final phase the scheme was totally changed and expanded in collaboration with a chosen author, Benjamin Guinaudeau, a writer chiefly associated with the newspaper *L'Aurore*. The new scheme with which Guinaudeau became involved has, as one might imagine, undeniable political overtones. The introduction of Guinaudeau into the project is a strange

but none the less revealing development, although he does not appear to have produced a finished text. Benjamin Guinaudeau (born 1858) was a radical writer and former abbé whose main themes were social and religious injustices, as well as moral issues. He also contributed reviews of exhibitions of paintings. He was a leading contributor to the daily anarchist newspaper *L'Aurore—Littéraire, Artistique, Sociale*, which was edited by Ernest Vaughan from its offices at 142 rue Montmartre, Paris. It ran from 1897–1904 and among its regular contributors were Geffroy, Clemenceau, Lecomte, Tabarant, Mirbeau, Zola, Grave, and Mauclair. It is hardly surprising, given the fact that most of the contributors were either friends or acquaintances of Camille and Lucien Pissarro, that the paper was read in the Pissarro household (*Lettres*, p. 445, 13 January 1898). In political terms, therefore, as conceived in its final, but alas unfinished, form *Travaux des champs* can be interpreted as a rural counterpart to *Turpitudes sociales* (for which see Sketchbook XXI No. 210).

The drawings made by Camille Pissarro for the various phases of the project are of some stylistic significance. The compositions may have been derived for the most part from his paintings, but a great deal of thought went into the question of the medium and the technique, and in both these respects Camille Pissarro was extending the boundaries of his own artistic experience. The project was left incomplete for a number of reasons: the fact that Lucien was living in England, the constant pressure of other work, the recurrent difficulties of finding either a text or a publisher. The drawings, however, allow us to reconstruct the full extent of *Travaux des champs* beyond the published portfolio, so that the work as a whole is not lost.

PHASE I

The first phase of *Travaux des champs* is the only one of the three that was completed and sold during Camille Pissarro's lifetime. The portfolio (*Travaux des champs Ière Série*, the Vale Press, 1895), comprised six wood engravings and was the result of a working process lasting for nearly a decade. The large span involved in the planning and execution of the prints included in the portfolio is reflected in the variety of subjects portrayed. Indeed, the portfolio, which is, in fact, the best known version of the *Travaux des champs*, is the least unified, both stylistically and thematically, of the various phases and does not seem to have followed any specifically prepared plan. Stylistically, it records in miniature the change from the compositions conceived in the Impressionist manner (No. 1 *Le Labour* or No. 2 *Gardeuses de vaches*) to a more abstract Synthetist style characterized by rigid outlines and areas of contained colour (No. 5 *Les Sarcleuses* and No. 6 *Femmes faisant de l'herbe*), a change which was in reality effected throughout French art within the decade 1885–95.

Travaux des champs is first mentioned in a letter from Camille Pissarro to Lucien written on 10 December 1886 as 'notre livre du Travail de Champs' (*Lettres*, p. 116). It is interesting to note that the project was originally conceived as a book, presumably with an accompanying text and illustrations, as opposed to the unbound

portfolio of six prints that it eventually became. The contents of the portfolio can be divided into three parts on the basis of style. The first wood-engravings, consisting of *Le Labour* (No. 1), *Gardeuses de vaches* (No. 2) and the title-piece, *Travaux des champs* (No. 3), are characterized by numerous free strokes and concentrated areas of hatching comparable with Lucien Pissarro's illustrations to *Mait Liziard* (Fern, Nos. 27–30, pp. 129–32) of 1886. It is probable that these first three blocks were cut during the period 1886–8 and *Gardeuses de vaches* (No. 2), technically the most advanced of the three, is surely 'la gravure faite d'après mon dessin pour le Travail des champs, les deux fillettes assises au bord d'un chemin' mentioned by Camille Pissarro in a letter to Lucien of 4 September 1888 (*Lettres*, p. 177, in part only). It is significant that no detailed finished drawings, or transfer drawings, for these first three prints have survived, and it is certainly possible that Lucien Pissarro affixed the drawing to the block and cut through it into the wood in the manner described by Fern for *La Marchande de marrons* (Fern, No. 3, p. 54), thereby destroying the drawing. There is, however, no evidence suggesting that Pissarro himself drew on the block in the way implied by Leymarie and Melot (P. 199–204), and also by Melot (No. 267 pp. 127–8).

 The second of the three styles in the published portfolio is represented by only one print, *La Femme aux poules* (No. 4), for which there is a preparatory drawing in the Ashmolean collection (No. 322). The pose of the standing woman is starkly rigid. She is seen in profile, facing left, her body rendered with a minimum of hatched modelling. It is the style that heralds the 'cloisonniste' technique that was perfected in France during the late 1880s. For some reason, Lucien Pissarro used a complicated printing process for this third engraving, combining a wood block for the outlines and a zinc plate raised in relief for the two colours.

 The third style evident in the portfolio is represented by two elaborate colour engravings (*Les Sarcleuses*, No. 5, and *Femmes faisant de l'herbe*, No. 6), which are perhaps the most successful. In technique, and to a lesser extent in their compositions, these two colour wood-engravings owe a great deal to Japanese prints of the eighteenth and nineteenth centuries. It is well known that Japanese art was one of the principal sources for the development of the Synthetist style, and it is therefore highly significant that the portfolio of *Travaux des champs* should be referred to on at least two separate occasions in the correspondence as 'notre Mangoua' (Lucien Pissarro to Camille, 25 May 1891, and Camille Pissarro's reply of 28 May 1891), as noted by Mrs Lullie Huda in her introduction to the catalogue of the exhibition of drawings by Camille Pissarro from the Ashmolean Museum held in London, Nottingham, and Eastbourne in 1977–8. Mr John Bensusan-Butt first observed that this was a clear reference to Hokusai's *Manga*.[63] Interestingly, Lucien Pissarro had attended an exhibition of Hokusai's work held at The Fine Art Society in London in 1890 (*Cata-*

[63] For the *Manga* see J. Hillier, *Hokusai* (London, 1955), pp. 44–6, and J. A. Michenes, *The Hokusai Sketchbooks—Selections from the Manga* (Tokyo, 1958). There are further references to the project as 'Mangoua' in the correspondence between Lucien Pissarro and his wife Esther (23 September and 1 October 1892, Esther to Lucien, and Lucien Pissarro's reply written on 3(?) October 1892).

logue of a Collection of Drawings and Engravings by Hokusai, London, 1890), which undoubtedly included the *Manga*. Presumably, Lucien communicated his enthusiasm for the *Manga* (meaning 'rough sketches') to his father, and it is possible that they intended their portfolio to resemble those of Hokusai. In fact, of the series comprising the published portfolio of *Travaux des champs*, the third print, the title-piece, reflects the appearance of the *Manga* most closely.

There seems to have been some confusion over the date of publication of the portfolio, *Travaux des champs*, of which twenty-five copies only were issued, and it is therefore desirable to attempt a proper reconstruction from the written evidence of the project's protracted gestation period. The correspondence between Camille and Lucien Pissarro suggests that work began late in 1886, the first reference being that quoted above from the letter dated 10 December 1886, and on 12 January 1887 Camille Pissarro writes to Lucien (passage omitted in *Lettres*), 'Une idée si je demandais à M. Lebre de mettre les deux bois du travail des champs avec un mot annonçant la publication de ces dessins . . . c'est peu chanceux.' Regardless of the stated intention to publish the prints in book form declared in the letter of 10 December 1886, this was by no means a settled matter, for in a letter from Lucien Pissarro to his mother dated February 1889 it is to be understood that some of the prints were sold as single sheets, 'Je viens de vendre chez Goupil 25 épreuves d'un de mes bois sur les "Travaux des Champs" á raison de 5f l'épreuve ce qui me fait 125f comme tu n'as pas argent je m'empresse de t'envoyer 100f tu ne saurais croire combien je suis heureux d'avoir fait cette petite affaire qui arrive si à propos dans un moment aussi dur.' Furthermore, this is a transaction that is already hinted at in a letter from Camille Pissarro to Lucien dated 4 September 1888 (*Lettres*, pp. 175–7), 'Enfin Van Gogh m'a prie de te demander combien tu veux vendre une épreuve de la gravure faite d'après mon dessin pour le Travail des champs, les deux fillettes assises au bord d'un chemin . . .' Progress, however, was slow and difficult:

Je viens de terminer un bois dont ci-joint l'épreuve je l'avais commencé à Eragny, mais j'y ai fait quelques modifications, tu trouveras que c'est toujours le même sujet, mais les autres choses étaient les 1ères idées dont ce bois est le résultat. Dis-moi que tu en penses et si tu crois qu'il y aurait quelque chose à retoucher. (Letter from Lucien Pissarro to his father written in reply to one dated 26 December 1890)

There was, in addition, the difficulty of finding a publisher. Both Camille Pissarro and Lucien sought for a suitable outlet for their project and on 2 October 1892 Camille wrote to Lucien, 'J'ai vu Joyant qui s'intéresse beaucoup à notre publication' (*Lettres*, p. 293). Yet it was not until July 1893 that Lucien announces to his father that he has arranged for the publication of *Travaux des champs* with Charles Ricketts: 'J'ai causé avec Ricketts à propos des Travaux des Champs. Nous le publierons après tout comme mes bois, cela nous fera éviter le tirage à la machine et nous laisse toute liberté pour les choses en couleurs' (undated letter written in reply to one from Camille Pissarro dated 26 July 1893). It is at this moment that Lucien Pissarro begins

printing again from those blocks already prepared and working on others, and it is significant that 1893 is the date he uses for the portfolio in his Studio Book I ff. 56–9, Nos. 92–5. Most of the printing appears to have been done during the course of 1894:

Je travaille à ma gravure des 'femmes faisant de l'Herbe' en toute diligence, elle sera fini à temps. Au moment d'imprimer la 'femme aux poules' je m'aperçois que le zinc sur lequel sont mordus les couleurs est hors d'usage. Je joins une épreuve du trait, pour que tu me dises si tu la juges assez complète pour être donnée telle quelle. Si non, voudrais m'envoyer un dessin du même sujet (je ne veux pas dire exactement la même composition, mais n'importe quel arrangement que l'on puisse appeler 'femme aux poules', car le catalogue est déjà fait). Je le ferai reporter sur bois et le graverai tout de suite. Seulement il me le faudrait aussitôt que possible car je n'ai que bien juste le temps. Ricketts est en train de signer les papiers avec le bailleur de fonds et bientôt il sera éditeur. Il va falloir que je me mette au courant de la reliure, car je serai chargé de la reliure d'art. C'est à dire que lorsqu'un amateur commandera une reliure de prix, c'est moi qui l'executerai, d'après mes propres dessins naturellement . . . (Letter from Lucien Pissarro to his father, 22 October 1894)

The matter is referred to again in an undated letter from Lucien Pissarro to his father written shortly after that just quoted:

J'ai bien reçu le dessin que tu m'envoies — moi non plus je ne l'aime pas beaucoup, cela ne te ressemble même pas. Je comprends que tu ne sois pas à cela, ayant tant de choses à faire et à penser. Puis tu t'es donné la peine de refaire le même sujet cela a dû t'embêter. Je vais refaire les zinc de l'autre et j'espère que cela ira comme cela. Il faut que je sois prêt pour le 7 Nov. tu vois que je n'ai pas de temps à perdre.

In reply to another letter from his father which is dated 4 November 1894, Lucien writes:

Je viens de finir et de tirer à 25 exempl. pour le porte-feuille la planche des faiseuses d'herbe. Mon vieux c'est épatant. Je n'en reviens pas, elle est d'un réussi. Tu verras cela, car je vais t'en envoyer un aussitôt prêt. Je vois mon chemin maintenant, notre prochaine série n'en sera que plus belle.

Finally, in a letter written by Lucien Pissarro to his father between 17 and 22 November 1894, there is the statement:

Le porte feuille Travaux des Champs (Ière série) est fini. Je vais t'en envoyer un à Eragny. Marty doit déjà avoir reçu les siens. Veux-tu en parler aux amis qu'on s'en occupe un peu. Demande à Lecomte d'aller les voir. Je reçois ce matin (avec 15 jours de retard) un mot de Destrée m'annonçant que Durand accepte d'en prendre quelques uns en depôt. Je vais les faire expédier.

Yet towards the end of November 1894 Lucien Pissarro reports to his father that there has been a delay:

Voila le hic. Comment faire faire les cadres sans le sou. Enfin je verrai cela avec Ricketts, mais je suis assez ennuyé, car ils viennent de faire faire les porte-feuilles sans que j'aie rien eu à payer, Dieu merci, sans quoi je n'aurais pas pu les publier, mais c'est assez delicat surtout qu'ils sont eux-même gênés, car la boutique est remise à 6 mois, la gravure de leur typographie demandera à peu près ce temps là.

On the last day of November 1894 Camille Pissarro acknowledged the receipt of his proof copy:

Tes épreuves sont vraiment belles, quoique je les connaisse, cela a été une surprise, la dernière, les sarcleuses est vraiment d'un bel effet. J'espère que cela aura du succès, quand on se rend compte des difficultés vaincues vraiment cela le mérite. Je me rend bien compte du mal que tu as dû te donner pour obtenir ces tons gris passés, surtout depuis que je me suis mis à chercher la gravure en couleurs, je suis arrivé à tirer des épreuves grises commes des Gouaches, malheureusement j'en rate tout le temps, puis je ne suis pas satisfait de mon dessin qui cloche et qui demanderait un grattage considérable pour rattraper la forme, c'est trop absorbant et cela n'en vaut pas le peine. (Not in *Lettres*)

This letter crossed with an anxious one from Lucien dated 3 December 1894 asking if his father had yet received the portfolio and so Camille replied again on 6 December:

La lettre que je t'ai écrite ces jours-ci a dû se croiser avec la tienne que je reçois ce matin. Je te parlais de tons portefeuille que j'ai eu grand plaisir à voir si bien présenté et les tirages si parfaits, surtout le dernier venu. Shannon de qui j'ai reçu une charmante lettre et si flatteuse pour moi, en fait aussi un grand cas, il s'agit maintenant de les vendre, malheureusement ici on fait bien peu de cas des estampes en général et de celle sur bois en particulier; hier j'ai eu la visite inopinée de Portier, je lui ai montré ton portefeuille qu'il a trouvé de toute beauté, il m'a demandé si je voulais le lui confier pour le montrer à Lucas l'intermédiaire d'estampes pour les marchands et collectionneurs américains, naturellement j'ai accepté, seulement il faut vendre à Lucas le prix marchand, il faudrait écrire à Portier le plus tôt possible et lui dire ce que tu en demandes. (Not in *Lettres*)

From this moment, various sales of the portfolio are recorded in the correspondence; 'Une portefeuille vient d'être vendu à Londres par van Wisseling. J'espère que cela va continuer' (letter of 8 December 1894 from Lucien Pissarro to his father), and also:

J'ai reçu un réponse à une lettre que j'ai écrite à Nijhoff une demande pour 6 portefeuille des Travaux des champs (en dépôt) pour qu'il en demande autant il faut qu'il en ait la vente. J'en ai envoyé 4, car c'est tout ce que j'ai de disponible en ayant fait faire seulement 12 pour commencer. Donc il serait urgent d'en faire 6 autres en cas de besoin pour ne pas en manquer la vente et il y a encore d'autres Maisons auxquelles je puis les remettre

en dépôt. Tout cela pour finir par te dire qu'il me faudrait de quoi faire faire ces quelques frais. (Letter written between 14 and 27 December 1894 from Lucien Pissarro to his father)

These protracted proceedings must account for the variety of dates sometimes given for the publication of *Travaux des champs*, as in *Gentle Art*, for example, where a date of 1893 is given, but, as Mr David Chambers has pointed out, the earliest bibliographical reference to *Travaux des champs* is in an undated prospectus, which includes *The Dial No. III* (of 1894), *Hero and Leander* (of 1894), and *The Queen of the Fishes* (of 1894), but before the announcement of *The Dial No. IV* (of 1896). Furthermore, according to an Eragny Press prospectus dated February 1898, *Travaux des champs* was issued in 1895 and this may be regarded as conclusive.

Finally, there is the question of the second portfolio of *Travaux des champs*, which the artists themselves referred to as the second series. This appears to have been planned fairly early on while the first series was still in progress. Lucien Pissarro wrote to his father in a letter dated February 1891:

Maintenant je suis à peu près sûr de pouvoir éditer tout ce que je veux chez Rickett, aussi je crois qu'il serait temps de continuer notre série sur les travaux des champs. N'y aurait-il pas des choses bien interessantes à faire? Que dis-tu de grands bois, representant des marchés, avec ces compositions épatantes dont tu t'es servi pour tes gouaches, avec des figures pleines de style, des fenaisons en forme de danse comme dans le tableau qui a eu tant de succès à ton exposition du boulevard? J'aimerais avoir tous les bois dessinés d'avance pour pouvoir montrer l'album dans son ensemble. J'espère que ton œil va te permettre de reprendre tes travaux dans ce cas tu pourrais très bien entre tes séances faire ces petits dessins. Me permetes-tu de te dire que les derniers, la batterie et un petit marché, ne sont pas aussi typiques que les autres que j'ai gravés précédemment dans l'un tu as cherché peut-être un peu la difficulté pour ne pas embarrasser Luce qui devait le graver, et dans l'autre tu as employé de l'encre de 2 couleurs pour faire comme Keene et je trouve que cela fait perdre un peu de la simplicité qu'avaient les premiers. Dans le cas où tu pourrais te procurer des bois voici les dimensions Om20 sur Om17 pour les grands sujets et n'importe quelles dimensions plus petites pour les autres, tu peux choisir des bois longs et étroits ou hauts ou carrés pourvu qu'ils puissent être contenus dans le rectangle 0.20 sur 0.17. Je pense qu'un marché, une fenaison et une moisson feraient bien dans la grande dimension.

In a fragment from a letter written some time between 17 and 22 November 1894 Lucien writes to his father,

Tu me diras ce que tu penses de la dernière gravure en couleur. Je crois que je tiens le bon moyen. C'est le moment d'aborder les choses importantes. Tu pourrais me faire un autre dessin du marché, car d'un moment à l'autre j'aurai le temps de m'y mettre, et en y travaillant petit à petit cela finit toujours par se faire. Permets-moi un avis que je fais seulement au point de vue de l'esthétique de la gravure sur bois — soigne tes types de bons hommes et de bonnes femmes au point de vue du caractère, les qualités d'ensemble (je crois) seront toujours données par les couleurs. Je compte que le prochain portefeuille sera beaucoup mieux que celui-ci. Je t'enverrai la liste des sujets que nous aurons à traiter. Nous ne ferons que 2 bois en couleurs — le Marché et le printemps — j'attends pour le

graver que je l'aie fait photographier de façon à abolir l'espace entre les deux bois [sketch illustrating this]. Peut-être aimerais-tu mieux le refaire sur papier? Dans ce cas écris-moi et je t'enverrai un décalque de la composition ou les bois eux-même, si besoin.

Then on 31 December 1894 Lucien reports to his father,

Je vais commencer bientôt le livre de Ruth et aussi le No. 2 des Travaux des Champs quoique de ce côté j'aie peur que les eaux-fortes originales ne flanquent par terre les bois, ce qui est tout naturel après tout. Le bois devant surtout être l'accompagnement de la lettre.

Although carefully planned, perhaps more so than the first series, the second portfolio was never finished. There are two final references to it, or its contents, in 1899, both in letters from Lucien addressed to his father:

Je t'envoie ci-inclus une grossière épreuve du printemps que je viens de finir. Je t'enverrai à Eragny des épreuves plus soignées pour que tu y mettes la couleur. Je crois que maintenant je les vendrai à l'épreuve, car le dernier portefeuille n'a pas marché du tout malgré le tirage très restreint. Après tout les livres rapportent plus, une gravure au frontispice peut rapporter ainsi un millier de francs et on se plaint que nos livres n'ont pas assez de gravures. (Letter written in reply to one from Camille Pissarro dated 29 October 1899)

Je t'envoyais une grossière épreuve du bois le 'Printemps' que je viens de finir. J'ai mis aujourd'hui à la poste quelques épreuves pour que tu y indiques la couleur. (Letter written before 3 November 1899)

The composition known as *Printemps* is No. 332 of the present catalogue.

It is interesting to note that Camille Pissarro's generous praise of Lucien Pissarro's printing of the blocks for the first portfolio of *Travaux des champs* was upheld later during work on the other phases of the project when he used the portfolio as an exemplar for the subsequent parts. Thus, Camille Pissarro wrote in a letter of 18 December 1901,

Tâches de revenir à tes anciens bois, taillés grossièrement, mais gras et fermes, avec un haut sentiment de la couleur, sans chercher des finesses que ne comporte pas la chose, suivre en un mot ce que tu faisais avant, la manière de graver y est pour beaucoup, ne pas chercher la petite bête et ne pas chercher trop a perfectionner le tirage, tu n'as qu'a comparer tes anciennes épreuves, si tu fais des tirages sur zinc il faudrait tâcher d'obtenir ces qualités de gras que tu obtenais, comme la femme qui donne à manger aux poules, tiré en jaune verdâtre, et d'autres que je n'ai pas présent à la mémoire ... [brief sketch in margin],

and he wrote again on 31 December 1901:

Je crois moi aussi que ce n'est pas dans le dessin qu'il faut aller chercher le défaut, c'est comme tu dis dans la façon de traiter chaque planche en couleurs et dans la façon de graver, je te signalerai le début de ce défaut dans les épreuves des femmes cueillant de l'herbe

sur la pente d'un coteau, soleil couchant, le terrain est mécanique ... c'est bien difficile d'expliquer cela par écrit ... Si nous étions ensemble, je suis sûr que nous arriverions à trouver le joint. Il faudra que nous travaillions ensemble soit à Dieppe soit ailleurs cet été. (Both given in part in *Lettres*, pp. 487–8 respectively)

Lucien Pissarro replied to this criticism in a letter dated 2 January 1902:

Je t'envoie ci-inclus une épreuve noir des planches de couleur du bois que tu me cites comme model et aussi du dernier. Tu verras qu'ils sont fait de la même manière. J'ai découvert ce qui en fait la différence. Tu comprends que pour avoir une teinte claire en typo, il faut absolument surcouper les lignes d'où l'usage du vélo et l'aspect mécanique mais dans un petit bois l'espace à surcouper étant restreint ne donne pas un aspect aussi mécanique que dans une grande planche, dorénavant je ne l'emploierai que quand il me sera impossible de faire autrement. Les sarcleuses dont tu me parles est le bois que je considère comme le plus réussi au point de vue de la combinaison des planches mais là aussi l'aspect mécanique se montre à cause de la dimension du bois.

The first project of *Travaux des champs* may be profitably compared with an earlier project of the same title undertaken by Jean-François Millet in 1853 and published in 1855 in a portfolio. Appearing originally as ten illustrations to an unrelated text entitled *Revue Agricole* by Saint-Germain-Leduc in the issue of *L'Illustration, Journal Universal* Vol. XXI No. 519 for 5 February 1853 (pp. 90–4), the series was drawn on blocks of identical size and cut by A. Lavieille. The only evidence that Pissarro knew of this series by Millet is indirect, namely in his choice of a similar title for his own project and in his reference to his own undertaking as 'notre livre du Travail des Champs' (*Lettres*, 10 December, 1886, p. 116) perhaps to differentiate it from Millet's. Furthermore, the fact that the first two prints of Pissarro's published portfolio are printed in black and white, and are to a certain extent in the same style as that adopted by Lavieille to interpret Millet's drawings, does suggest that Pissarro had seen the earlier designs. There are, however, no direct quotations from it and, viewed as a whole, Pissarro's series differs considerably in its interpretation of the themes.

Millet in his ten designs concentrated his attention on single figures performing a difficult and often burdensome task. As such, Millet's figures have a monumentality and an emphasis on physical labour which is not shared by the peasants in Pissarro's series of prints, who are, by comparison, placed in relatively bucolic settings. In every case where Pissarro did choose to represent the same subject as Millet his version differs to such an extent that it is as if he was attempting to reinterpret the scenes. The title-piece in Pissarro's portfolio (No. 3) has the closest affinities to Millet in subject-matter, since the latter had devoted no less than five designs to harvesting scenes. Yet, by grouping the separate figures on a single page and by choosing to print the sheet in a gold-brown ink Pissarro has avoided emphasizing the physical difficulties involved in harvesting and stresses instead the communal nature of peasant labour. The figures in Pissarro's scheme are not conceived on a monumental

scale. Rather, they are imagined on a miniature scale and the figural groupings owe a great deal to Japanese prints, particularly Hokusai's *Manga* (see above pp. 68–69).

It seems, therefore, on the basis of such differences that Pissarro's debt to Millet was not a great one as regards the treatment of the subject-matter in *Travaux des champs*. In fact, the lack of accord between the two artists in their approach to rural life is underlined by Pissarro's response to the large exhibition of Millet's paintings held at the Ecole des Beaux Arts in 1887 — a response vividly recounted in a letter written to Lucien in May of that year (*Lettres*, pp. 149–50). Indeed, as Pissarro continued with this first phase of *Travaux des champs* he seems to have moved even further from Millet both stylistically and iconographically. For instance, the two women in *Les Gardeuses de vaches* (No. 2) are not performing any physical labour at all, and by the time Pissarro had begun to work on the three colour prints (Nos. 4, 5, and 6) the already tentative connection with Millet has almost completely disappeared. The subjects chosen for these colour-prints, *La Femme aux poules*, *Les Sarcleuses*, and *Femmes faisant de l'herbe*, have no precedent in Millet's project and their style is closer to the 'cloisonniste' principles propounded by Gauguin and Emile Bernard. Like so many of Pissarro's peasant genre scenes, these three colour-prints are dominated by the gentle activity of female peasants at work in the fields, or within the confines of the farmyard. It is the rhythm of their work, rather than the physical effort involved, that Pissarro strives to capture.

PHASE II

The drawings which constitute the second phase of *Travaux des champs* are united by their immensely detailed technique, similarity of size, and close relationship of subject-matter. Like Phase I, but unlike Phase III, no specific programme for the choice of subjects appears to have been drawn up, although it could be said that some were transferred from the projected second portfolio (see letter of February 1891 from Lucien Pissarro to his father quoted above, p. 72). In a general sense, the subjects united in this second phase could be said to illustrate the changing seasons of the year, a scheme which, in fact, did ultimately form the basis of the final phase of *Travaux des champs*. Indeed, a passing reference to such a scheme exists in a letter from Camille Pissarro to Lucien dated 16 October 1895, 'n'aies aucune crainte, je ferai les 4 saisons, paysages, mais j'attendrai que tu me dises si mes derniers essais ne sont *pas trop blancs*. Le moissonneur surtout. Je crains que la manière de Daphnis et Chloë ne soit un peu trop monotone ... J'ai lâché les dessins pour m'occuper de peinture, j'y reviendrai' (*Lettres*, p. 384). As implied in this letter, the style of the drawings belonging to this phase is very close to that of those illustrating *Daphnis and Chloë* (see Nos. 313–21), and both projects were worked on contemporaneously.

Je ne sais si le portefeuille [*Travaux des champs*] se vendra, mais je suis d'avis que le livre accompagné de bois doit avoir plus d'amateurs, et réellement c'est évidemment un tout

complet, rien que ton petit prospectus le prouve, c'est charmant à l'œil, aussi je fonde un
grand espoir sur la Ruth et sur la Reine des P[oissons]. Même la gravure en noir me parait
être un art d'avenir, c'est égal, nous pouvons continuer les Travaux des Champs, quant
à Daphnis et Chloe, je suis prêt à faire les 12 dessins et si tu y mettais de jolies lettres
ce serait épatant. Si je ne te parle pas souvent des dessins pour les Travaux des champs
c'est que je suis pris par un tas de choses ... (Letter of 18 January 1895 from Camille
Pissarro to Lucien, published in part in *Lettres*, p. 363)

The close similarity in style between the two sets of drawings is clearly an indication
that Camille and Lucien Pissarro had come to regard the outcome of both projects
in the same light, namely as illustrations to a printed text. Certainly, this detailed
style, which provided a considerable challenge for both artists, was designed to suit
a typographical context:

Ta dernière gravure est fort remarquable beaucoup mieux que les autres, si cette manière
au trait blanc fait bien avec la typographie tu feras bien de l'adopter, on dirait que tu sens
mieux les valeurs. Je crois que tu feras bien de recommencer les deux premières, la récolte
et la chaumière qu'en penses-tu? (Letter from Camille Pissarro to Lucien, 19 May 1895,
not in *Lettres*)

Furthermore, from a letter written to his father as early as 14 January 1895 Lucien
Pissarro seems to imply from the outset that an illustrated book would attract more
buyers than a portfolio of loose engravings:

Je t'ai souvent parlé des gravures à faire pour les Travaux des Champs et tu ne m'en parles
jamais — trouves-tu que cela ne marche pas? Nous ferons cependant beaucoup mieux cette
fois-ci, ayant plus d'expérience et commençant à connaître le métier. Je suis pursuadé
qu'avec encore un peu de patience je gagnerai un peu d'argent avec des gravures, le public
y vient et c'est le moment de tenir bon, surtout, comme je te le disais dans mes dernières
lettres, que nous allons avoir une typographie merveilleuse.

Camille Pissarro reiterated this concept in his reply to this letter dated 18 January
1895 (quoted above pp. 75-6).

The second phase of *Travaux des champs* was begun shortly after the publication
of the first series contained in the portfolio and it may well have replaced the idea
of a second series to be published in another portfolio, which, as we have seen, was
started by the end of 1894. There are several brief references to individual drawings
from this second phase in letters dating from the later months of 1895, and these
are mentioned in the relevant catalogue entries below. The chief difficulty, however,
was the matching of the styles and the balancing of the tonal values as discussed
in a letter dated 28 April 1895 written by Camille Pissarro to Lucien:

La petite gravure que tu m'envoies est absolument bien d'arrangement. Cependant je trouve
encore par-ci par-là des blancs qui papillotent. C'est une des grandes difficultés la distribution
des valeurs, en un mot l'effet. Il faudrait regarder les anciens; ce que tu me dis de la chau-
mière est en effet vrai et c'était mon avis — il y a trop de blanc éparpillé, mais aussi je

trouve que tu progresses cela viendra parfait en continuant. Mais cette dernière gravure a un charme moderne et oriental qui me plaît c'est naif et déjà savant. (Passage omitted in *Lettres*)

The final references to this second phase of *Travaux des champs* are probably the triumphant one contained in a letter of 11 October 1895 in which Camille Pissarro writes, 'J'ai fini cinq dessins pour Travaux des Champs', which is followed by the more doubtful one, 'Je crains que la manière de Daphnis et C ne soit un peu trop monotone... J'ai lâché les dessins pour m'occuper de peinture, j'y reviendrai' (letter of 16 October 1895 from Camille Pissarro to Lucien, *Lettres*, p. 384). Pissarro, however, did not return to this style for *Travaux des champs* and Lucien failed to cut all the finished designs on wood before the phase was abandoned. The advantages and disadvantages of working in this style were discussed again in 1899 in the context of *Daphnis and Chloë* (letters exchanged between Camille and Lucien Pissarro on 24 November 1899 and 1 December 1899 quoted above pp. 62–3). It should be observed that three of the drawings from this phase specifically mentioned in the correspondence cannot be positively identified: they are as follows: 'un faucheur' in a letter from Camille Pissarro to Lucien dated 26 September 1895, and 'la chaumière' in letters from Camille Pissarro to Lucien dated 28 April 1895 and 19 May 1895, and 'le moissonneur' in a letter from Camille Pissarro to Lucien dated 16 October 1895. It is likely that 'un faucheur' and 'le moissonneur' are the same drawing (for which see No. 341), whereas 'la chaumière' cannot be identified with any known drawing. Therefore, out of the full quantity of twelve drawings that were to have been undertaken for this second phase of *Travaux des champs*, seven are in the Ashmolean collection (see Nos. 333–42), one is definitely missing, and the three remaining may not even have been begun. At present, Phase II comprises the following subjects, most of which have seasonal associations:

1. Les sarcleuses (No. 333)
2. La fenaison (Nos. 334–5)
3. Gardeuse de vaches (Nos. 336–7)
4. Récolte des pommes (Nos. 338–9)
5. Porteuses de fagots (No. 340)
6. La moisson (No. 341)
7. La batterie mécanique (No. 342)

Of these, only the last (No. 342) appears to have been abandoned before completion.

Pissarro spent a great deal of time and effort on the second phase, and many of his compositions seem to have been devised especially for it. Although it lacks the iconographic cohesion of the last phase of *Travaux des champs*, it is far better defined and more consistent than Phase I. In it, Pissarro was surely clarifying his own attitudes towards rural life and peasant imagery in response to thirty-five years' experience as a painter of *la vie agreste*. What is absolutely clear from Phase II is that Pissarro's view of rural civilization was considerably more optimistic than that of

Millet, whose work is so often wrongly connected with that of Pissarro. It is, indeed, no accident that Pissarro chose to depict the labour of the harvest as a series of dance-like movements (No. 335), and the carrying of bundles of faggots as a noble communal activity (No. 340), at the same time, and in the same style, as he was celebrating the love of Daphnis and Chloë in an ageless Arcadia. Pissarro, like so many of the intellectuals in France during the last decade of the nineteenth century, turned away from the disturbing realities of peasant life to create a view of an ideal rural world.

PHASE III

The third and final phase in the evolution of *Travaux des champs* is the most extensive. It can be divided into two separate parts. The first part is difficult to date with precision, but there are a certain number of drawings from it which are identifiable on the basis of the uniformity of style and technique, as well as by the inscriptions. These inscriptions relate to an outline of the scheme for the final phase written on a sheet of paper which has unfortunately been cut from an original letter from Lucien Pissarro to Camille and mounted separately in an album of drawings in the Ashmolean Museum labelled *Travaux des Champs* (f. 5 verso). Attempts have been made to match the paper, but these have so far failed, and there is no internal evidence with which to establish its date. The suggested scheme is as follows:

Dessins pour les Travaux/des Champs — pour être gravés/par Lucien
No. 1 printemps — sarcleuses
No. 2 printemps — faneuses
No. 3 l'été — cueillettes de petits pois
No. 4 l'automne — paysanne bêchant la terre
No. 5 l'été — paysan mettant des rames/aux haricots
No. 6 — la laitière

No. 7 — laveuses
No. 8 ... le cidre

This scheme is rather more diffuse than the final one which replaced it, and it is based on general seasonal divisions, which were to some extent implied by the choice of subjects in the first two phases of the project. This scheme, however, was quickly adapted to incorporate a larger number of scenes which were selected and approved by Benjamin Guinaudeau, who had agreed to write an accompanying text. The new scheme is explained by Lucien Pissarro in an undated letter to his father probably written between 21 and 24 October 1900. It is as follows:

J'ai reçu hier au soir les 6 dessins. Le papier à décalquer viendra très bien en photographie. Les dessins sont charmants, mais hélas! il y a beaucoup trop de valeurs différentes dans tes 2 tons, cela me laisse un choix parmi les accents qui, j'en ai peur, changera ton dessin et lui retirera de son caractère. Il me semble que tu devrais exagérer le parti pris et c'est en imprimant que nous rapprocherons le valeur des tons en choisissant des encres d'une gamme très peu distante. Enfin je vais faire un des petits comme essai, cela nous donnera

la marche à suivre. Je crois que nous obtiendrions des résultats plus satisfaisants en ayant une planche plate sur laquelle des lumières blanches seraient coupées ... Nous ferons bien de suivre la marche que Guinaudeau nous a conseillée — c'est-à-dire de diviser les relations des paysans en 3 catégories —

1^0. Dans les champs
2^0. Dans le maison
3^0. Relations sociales
De chacune de ces 3 catégories nous ferons 4 dessins:

1ère Catégorie
1^0. Labour 3^0. Fenaison
2^0. Sémaille 4^0. Moisson

2 ème Catégorie
1^0. l'étable et la traite des vaches
2^0. La barateuse, laiterie
3^0. La volaille ou le berger
4^0. La batterie mécanique ou au fléau

3e Catégorie
1^0. un marché du foin (bestiaux)
2^0. ,, ,, (blé ou legumes)
3^0. Au Café
4^0. La Noce
Il me semble que cela serait assez complet.

On 24 October 1900 Camille Pissarro replied to Lucien's letter, 'J'approuve entièrement les trois catégories dont tu parles, ainsi divisé ce sera clair et pratique, seulement il y a une noce à faire? il faudra que je fasse une composition que je n'ai jamais osé faire! enfin on fera le possible'. The six drawings referred to in the first part of Lucien's letter written to his father between 21–4 October 1900 are most probably those done for the earlier scheme, perhaps hastily drawn up by the artists themselves before consulting Guinaudeau. Another copy of the second scheme in Lucien Pissarro's hand, again cut from a letter and mounted separately with no indication of its date, is contained in the album of drawings in the Ashmolean Museum labelled *Travaux des Champs* (f. 9 verso).

It will have been observed that the two schemes for this final phase overlap and to begin with there was a measure of agreement about the outcome. Guinaudeau, for instance, wrote as follows to Lucien Pissarro on 25 October 1900:

Je n'ai aucune objection à faire à votre nouveau plan. Il en résulte, évidemment, que mon texte sera beaucoup plus étendu. Si nous faisons trois volumes de 24 pages, à quatre planches seulement par volume, c'est vingt ou seize pages de texte à chaque fois que j'aurai à fournir. La chose n'a pas d'importance. Le tout est d'être fixé.

J'ai écrit, il y a quelques jours, à Monsieur votre père. Je lui disais que, désireux de faire, moi aussi, œuvre aussi artistique que possible, j'avais songé à recourir au vers et à composer, pour chaque volume, quatre petits poèmes. Songez que les sujets ont été ressassés

et rebattus, et qu'il est difficile d'éviter la banalité. La forme des vers m'y aiderait beaucoup, ça me semble, et puis il me serait agréable de rimer un peu; j'ai beaucoup rimé autrefois. Qu'en pensez-vous? Monsieur votre père trouve mon idée très bonne. Mais, est-ce possible? Si oui, le calcul das vers que peut contenir une page doit être facile — et je marcherais à coup sûr.

Unfortunately, the retention of similar titles, combined with the failure of Lucien Pissarro to date all his letters, makes the firm identification of drawings specifically referred to in the correspondence extremely hazardous. For instance, the earliest reference to 'petits dessins' occurs in a letter from Lucien Pissarro to his father dated 23 January 1896 in the context of chiaroscuro woodcutting and so could easily refer to the first group of drawings made for the first of the two schemes for this final phase (Nos. 343–56). The relevant passage from the letter is quoted below (see p. 85). On the other hand, the labels inscribed by Camille Pissarro with the titles and numbers assist the identification of the drawings done for each of the schemes. There are also distinct differences in the handling of the drawings from each of the two groups, which do therefore have a recognizable stylistic unity of their own. The innumerable references to the drawings made for both the schemes, mainly in the correspondence dating from the years 1900/1, are mentioned in the individual catalogue entries below. As regards the number of drawings actually completed, it should be noted that in a letter of 18 October 1900 written by Camille Pissarro to Lucien it is stated 'Je t'expédie en même temps que la présente six dessins que j'ai tâché de faire en deux teintes ...', and that by 31 October 1900 Camille Pissarro writes to Lucien 'Je viens de terminer les 3 Divisions et les 3 catégories' (not in *Lettres*), which claim is repeated in another letter of 1 November 1900, 'Je t'expédie les 3 catégories de dessins avec les esquisses qui pourraient te servir au besoin' (*Lettres*, p. 480) to which Lucien replies between 1 and 4 November 1900:

J'ai bien reçu les dessins il y en a de charmants! Je vois bien la façon de les faire. J'aime surtout le semeur d'un dessin concis. Le labour est aussi fort bien quoique je ne voie pas le moyen de faire les brides. J'aime beaucoup la baratteuse mais c'est un bois en 3 planches enfin de temps en temps on peut se permettre cela. Quand tu emploies la ligne blanche tu te sers quand même d'un ton d'accent et d'un trait ce qui fait 3 tons. Tu t'es très bien tiré de la noce. Le berger gris bleu est le plus compris au point de vue que je veux dire on peut le faire en 2 planches tandis que le même dessin décalqué ne pourrait se faire qu'avec 3 planches quoique moins riche d'effet. La petite noce sur papier vert se ferait en 3 planches. Je trouve que ton faucheur en chapeau melon n'a pas autant de style que le semeur, par exemple, et quant à la fenaison en 2 planches je te demanderai de n'en faire qu'une car cela m'entraînerait peut-être en peu loin d'en faire 2 en 2 couleurs, cela fait un supplément de 2 bois, c'est beaucoup de travail, surtout qu'il faut que je fasse tout moi-même, impossible de me faire aider, ayant continuellement à choisir ce qui appartient à l'un ou l'autre block. Pour la fenaison au lieu d'avoir une double planche ce qui fait 4 gravures ne vaudrait-il pas mieux en avoir qu'une simple en 3 tons ce qui ferait une économie d'une gravure et ferait une variété. Si tu as le temps ne pourrais-tu pas en faire un autre dans le genre de la noce ou du berger?

Many of the references to individual drawings after these letters are to corrections, or reworkings, undertaken to facilitate the process of engraving.

The final phase of *Travaux des champs* is remarkable for the introduction of two new elements into the project. Firstly, there is the decision to incorporate a text, for which purpose Benjamin Guinaudeau was invited to contribute. The earliest reference in the correspondence to Guinaudeau is in a letter from Lucien Pissarro to Camille dated 6 April 1900:

Pour les Travaux des champs je ne suis pas encore prêt à les imprimer ayant plusiers volumes à faire avant, mais cela ne fait rien, il vaut beaucoup mieux être prêt d'avance, donc inutile de dire à Guinaudeau que ce n'est pas pressé. Voilà ce que je compte faire: chaque bois doit accompagner un texte d'une vingtaine de pages, il m'avait demandé si il pouvait faire le travail en vers, cela ne fait rien si il le sent mieux comme cela. Tu pourras lui faire voir le Labour et il pourrait toujours préparer celui-là, car c'est le premier de la Série, et tâche de savoir que sera le prix, car pour combiner un volume il faut savoir à peu près quel en sera le prix de revient. Je lui ai écrit, et il ne m'a pas répondu.

An undated autograph copy of the letter sent by Lucien Pissarro to Guinaudeau is in the Ashmolean Museum. It reads as follows:

Vous me demandez si vous pouvez faire le texte en vers—il m'est bien difficile de vous répondre, car naturellement si vous sentez la chose en vers il faudrait mieux la faire comme vous la sentez d'un autre côté je crois que mon éditeur n'ayant à faire qu' avec un public de langue anglaise se préférerait sans doute de la prose. Ne pourriez-vous pas combiner les deux et faire de petits poèmes en prose? Dans tous les cas jugez en dernier ressort et faites ce qui vous conviendra. J'avais dis à M. Bertier que de vous dire que nous désirions vous rétribuer pour ce petit travail. Je vous serai bien obligé de bien vouloir me dire ce que vous demanderez afin que je puisse établir le prix de revient'.

There are further references in later letters with regard to the subjects to be treated. For instance, Camille Pissarro wrote to Lucien.

J'ai prié Rodolphe de t'envoyer le livre de M. Guinaudeau, je n'ai pas son adresse pour le remercier. Je suis assez embarrassé pour lui envoyer mes dessins, je crois qu'il ne pourra pas y démêler grand-chose, car comme tu penses je ne les fais pas par ordre, Printemps, été, automne etc, je les exécute comme cela me vient, je crois qu'il faudra que tu les voies avant lui, ne sachant pas, en somme, quels sont ceux qui seront gravable, autant que je puis me rappeler il aurait voulu s'y mettre tout de suite, nous lui avons peut-être parlé trop tôt, qu'en dis-tu? (17 October 1900, omitted in *Lettres*)

More space was taken up, however, over the question of the costing and the nature of the text, matters which remained unresolved. In an undated letter, apparently written in April 1901 by Lucien Pissarro to his father, it is stated:

C'est dommage que Guinaudeau n'aie pas donné un prix, car de dire qu'il prendra tant pour cent revient au même que de dire je demanderai une certaine somme, c'est justement

ce qu'il m'est indispensable de savoir. Quant à trouver le livre trop maigre c'est seulement le mot livre qui effraye mettons que ce soit une petite brochure, c'est tout ce qu'il me faut. Mes raisons pour agir ainsi sont que le public me paiera 10/- pour chacune de ces brochures et ainsi chaque bois me rapportera plus que si mis tous ensemble car pour 4 gravures et un livre un peu plus gros on ne me paiera pas 40/- ou du moins l'édition sera plus difficile à vendre. A-t-il commencé le travail? Va-t-il le faire en vers? Autant de questions qui sont assez importantes. Dans tous les cas je ne les imprimerai pas cette année ayant sur la planche plus que je ne peux faire. J'aimerais aussi attendre que j'aie une typographie à moi. Mais je ne sais pas comment ou quand je pourrai la faire faire.

Earlier, in October 1900, this question had been more extensively discussed:

L'employé de Ricketts dit que 100f pour un volume est beaucoup trop et ne répond pas de la vente. Voici ce qu'il conseille: puisque vous faites 12 gravures dans ce volume pour 100f. Ne pourriez-vous pas avec ces 12 gravures faire 3 volumes avec 4 gravures dans chaque que vous vendrez 30 ou 40f. Cela vous ferait la même somme pour vos bois et faciliterait la vente des livres énormément. Il connaît la clientèle, peut-être a-t-il raison. Aussi voici ce que je propose (j'ai écrit à Guinaudeau dans ce sens) faire un premier volume contenant les 4 sujets suivant:

1°. Le Labour
2°. La Semence
3°. La Fenaison
4°. La Moisson

Ci-joint une feuille de papier de la grandeur du livre avec la dimension de la gravure. Un même sujet peut prendre les 2 pages, il aurait, par conséquent le double de la dimension de la page. Un seul des 4 peut-être traité de la sorte. (Letter from Lucien Pissarro to his father, 18 October 1900)

As regards the text, Camille Pissarro wrote to Lucien on 24 October 1900, 'M. Guinaudeau m'a écrit pour me demander si il y aurait aucun inconvénient à faire le texte en vers, je lui ai dit que personnellement je n'en voyais pas mais qu'il fallait te prévenir que tu jugerais mieux cela que moi les vers devant imprimer un caractère ornemental spécial au livre' (not in *Lettres*). To this Lucien Pissaro replied at the beginning of November:

Si cela n'ennuie pas trop Guinaudeau je crois qu'il vaudrait mieux faire le texte en prose— en voici la raison le livre se vendant principalement en Angleterre et en Amérique à des étrangers qui pour la plus part comprennent le français plus ou moins bien ce serait peut-être beaucoup leur demander que de la comprendre en vers, ce qui est beaucoup plus difficile (undated letter replying to those of 24, 31 October and 1 November 1900).

Guinaudeau, however, failed to produce a text either in prose or in verse, and the discussions about the general character and purpose of the work show a certain amount of indecision. Shortly after the letter of 18 October 1900 quoted above it seems that Lucien Pissarro had proposed an even more diffuse arrangement of the prints, which is outlined in a letter to his father dated 29 January 1901:

Etant donné le soin et la difficulté du tirage pour garder ces qualités je me sens disposé à les publier tous séparément de façon à pouvoir imprimer chaque sujet suivant les couleurs qui lui iront le mieux, faisant ainsi une série de petits livres. Le premier serait donc le 'Labour'. Aussitôt que j'aurai une épreuve décente je l'enverrai à Guinaudeau en lui faisant part de ce changement. A propos je lui avais écrit pour lui demander ce qu'il prendrait pour faire ce travail, il ne m'a pas répondu—cela ne l'a pas offensé, j'espère—il m'était utile de le savoir pour pouvoir établir les frais de publication et savoir combien je pourrai vendre le travail.

Yet, this idea, which Lucien advanced on more than one occasion, had already been rejected once by Camille Pissarro at the very beginning of January 1901, 'Ton idée de ne faire qu'un petit volume de chaque sujet me paraît retirer de l' importance à l'œuvre d'ensemble, ne crains-tu pas que cela soit maigre et mesquin? ... Guinaudeau t'a-t-il répondu?'. (Letter of Camille Pissarro to Lucien, 4 January 1901, not in *Lettres*.) Clearly, the idea did not appeal at all to Camille Pissarro, for he returns to the subject in a letter to Lucien dated 10 February 1901:

Je ne comprends pas bien ta nouvelle idée, il me semble que ce ne sera plus un tout d'ensemble, en effet ce sera des estampes, le texte en ce cas ne compte plus, rumine ton affaire car je ne crois pas que tu as résolu la question primitive, qui était de faire une série de volumes, je crains que comme estampes isolées cela ne fasse le même effet que tes *Travaux des champs* et par conséquent pas de succès. (Not in *Lettres*)

It was even suggested that the text should be taken from Virgil and not from an original piece of work prepared by Guinaudeau:

Je crois que tu as raison il faut mieux faire un livre, mais je persiste à croire que chaque bois peut faire le frontispice d'un petit volume. L'autre jour le commis de Ricketts disait que nos bois iraient fort bien pour illustrer des poèmes de Virgile. Je regrette maintenant que nous avons demandé à Guinaudeau car le latin est si beau imprimé à cause de certaines lettres d'une vilaine forme qui viennent assez souvent en français sans compter les accents qui rompent la ligne et lui donne l'air de dancer. (Letter from Lucien Pissarro to his father dated 17 February 1901)

But this suggestion too was rebutted by Camille Pissarro:

Il est possible que tes bois fassent bonne figure dans les poèmes de Virgile, je pense qu'il est préférable de rester sur notre première décision, je craindrai fort que tes volumes perdent au point de vue moderne. Quoique les Bucoliques soient toujours d'actualité, mais le bourgeois aime mieux pouvoir le lire dans sa langue. (Letter from Camille Pissarro to Lucien, 21 February 1901, passage omitted in *Lettres*)

In these circumstances it is hardly surprising that Guinaudeau failed to produce a text, and little progress seems to have been made on deciding upon the final appearance of the book. Further slight references to the project occur in a letter of 24

February from Lucien Pissarro to his father and in a letter from Camille Pissarro to Lucien dated 4 April 1901, which has a hint of urgency:

Ma lettre a pour but de te faire savour que je compte avoir à déjeuner mardi prochain, Guinaudeau, voudrais-tu m'écrire le plus tôt possible où tu en es avec lui à propos de la publication et ce que tu as décidé pour la partie littéraire, tant au point de vue de tes intérêts qu'à celui de Guinaudeau afin je lui en parle si cela te convient. (Not in *Lettres*)

Similarly, running like a refrain throughout Camille Pissarro's letters to Lucien of 1902 is the question of when the printing of *Travaux des champs* is about to begin: in a letter of 17 January 1902) 'Cela marche-t-il ta bâtisse? à quand la mise en œuvre des travaux des champs y aurais-tu renoncé?' (not in *Lettres*); in a letter dated 28 March 1902, 'Quand commenceras-tu les travaux des champs? y as-tu renoncé ... je crains bien qu'étant de l'Eragny style tu ne craignes que cela ne plaise pas outre manche. Il est vrai que ton installation va te demander beaucoup de temps avant d'avoir ton courant. Je crois que de ce côté-ci tu aurais du succès de vente ...' (*Lettres*, pp. 490–1 in part); and, finally, with an air of resignation a letter of 11 August 1902, 'Et notre publication, les travaux des champs????' (*Lettres*, p. 492.)

During 1902 contact with Guinaudeau seems to have been lost and was only renewed, as recorded in the correspondence, at the very end of the year in December.

Je n'ai pas vu Guineaudeau depuis qu'il a quitté l'Aurore, mais, il y a une semaine, Berthier m'a écrit un mot me demandant si je ne pourrais pas avancer 300f. à Guinaudeau qui est dans une profonde misère, que peut-être consentirais-je à faire cette avance sur le travail qui est convenu avec Lucien, travail qui est tout prêt naturellement je les lui ai envoyés, sans parler en rien de conditions, je t'en préviens pour que tu en tiennes compte au moment voulu. (Letter from Camille Pissarro to Lucien 23 December 1902, not in *Lettres*)

The final references to Guinaudeau date from 31 January 1903 and 14 February 1903 when the advance of 300 francs was the subject of further deliberation.

J'écrivais à Guinaudeau pour lui demander si il serait disposé à t'envoyer son poème, mais tu sais que je n'ai rien convenu directement à propos du prix qu'il en demande. Berthier de l'Aurore, que tu connais sans doute, m'avait écrit pour me demander si je pouvais rendre le service d'avancer 300 f. à Guinaudeau et me disait que ce dernier ayant une poésie à faire pour un de tes bouquins pourrait servir comme avance. Guinaudeau m'a redemandé 200 frs, sans cependant me parler du prix de son œuvre, de sorte que je ne sais pas encore ce qu'il en demanderait définitivement. Je crois que tu ferais bien de lui écrire directement et t'entendre avec lui afin qu'il n'y ait pas de malentendu au sujet du prix définitif, en même temps tu pourrais lui dire que tu serais désireux de l'avoir afin de mettre ton livre sur le chantier. C'est toujours délicat, ces sortes de transactions, il faut savoir nettement ce qu'il en est. (Letter from Camille Pissarro to Lucien, 31 January 1903, not in *Lettres*).

The project of the final phase of *Travaux des champs*, therefore, foundered partly as a result of the slowness with which the text—apparently in the final analysis to

have been a poem from Guinaudeau's hand—was produced, a hesitancy stemming from Lucien Pissarro's own indecision regarding the literary content, and partly as a result of aesthetic considerations. Perhaps it was only Camille Pissarro who really knew what format was required and realized what the ultimate purpose of the publication was, but it was his death in November 1903 that brought the whole affair to a close. It is clear that the work as published in 1912 as *La Charrue d'érable* with a descriptive text by Emil Moselly lacked the political sympathies inherent in the combined efforts of Camille and Lucien Pissarro, and the enigmatic Benjamin Guinaudeau.

The second new element introduced in this last phase concerns style. Lucien Pissarro adopted a chiaroscuro technique that is a continuation of the colour prints found at the end of the published portfolio dating from 1895. The prints from this last phase, however, are printed on coloured paper often in two or three tones. For these Lucien Pissarro was inspired by the Italian chiaroscuro woodcuts which he had seen in London at an exhibition held at the British Museum in January 1896:

J'ai étudié au British Museum les Chiaroscuros italiens (gravures en camaïeux), mon cher, il y a des choses épatantes et certaines épreuves sont vraiment des merveilles qui peuvent lutter avec n'importe quel japonais illustre, comme hardiesse de même comme beautés de matière quand tu retourneras à Paris va aux Estampes et demande pour le David & Goliath gravé par Hugo da Carpi d'après Raphael et aussi: Le Triomphe de César gravé par Andréa Andréani d'après Mantegna. Peut-être même les ont-ils à la Bibliothèque de Rouen. C'est tout a fait dans le genre des petits dessins que nous avions faits, mais avec une liberté épatante! Que de choses à faire, si seulement on avait du temps!!! (Letter from Lucien Pissarro to his father, 23 January 1896)

As might be expected, the introduction of a new style of printing created difficulties in the process of collaboration and much of the correspondence dating from between 1900–3 is devoted to the quality of the proofs pulled from the blocks, a subject on which Camille Pissarro often made forceful comments. It may be said, therefore, that the combination of the late adoption of a new process, the lack of certainty regarding the text, and the shortage of time, all contributed to the failure of the project as it was envisaged during Camille Pissarro's lifetime.

VII
Conclusion

An examination of Camille Pissarro's drawings reveals a far more complex artist than an inspection of his paintings might suggest. There is a wide variety of styles matched by a diversity of media, and a range of subject-matter that attests an unending search for the relevant means of artistic expression. In this quest Camille Pissarro consulted both the artists of the past and younger contemporaries. It is above all else this

Janus-like feature of his character that makes Pissarro such an important catalyst in the history of late nineteenth-century art. He is assuredly a pivotal figure and the whole of his life and work can be seen as a series of paradoxes. For instance, he combined a fresh observation of life around him in all its forms and manifestations with a fascination for works of art in their historical contexts; he managed to find an outlet for his political views without compromising either his art or his ideals; and he offset carefully gauged preparatory processes by creating completed images that recaptured those sensations originally experienced before nature. If it is decided to term this act of veritable funambulism a compromise, then it was most definitely one of the utmost creative significance, certainly equal to that of Manet and Degas, and perhaps challenging that of Cézanne, or even Picasso. Pissarro regarded himself as a teacher, and, like all good teachers, he led by example, remaining, as he put it, his own most diligent pupil. It is now apparent that Pissarro's role in the history of art can only be fully appreciated when his drawings are considered alongside his paintings and prints. This catalogue is an attempt to set the study of his drawings in motion.

Explanations

Lugt 613a, Lugt 613e

These refer to the stamped initials (C.P.) that occur on nearly all the drawings issuing from the family collection. For a full explanation of these see F. Lugt, *Les Marques de collections de dessins et d'estampes. Supplement*, The Hague, 1956, pp. 89–90. Work on the drawings in the Ashmolean Museum has revealed only one fact not recorded by Lugt. This is the occasional use of purple ink for 613e instead of grey-black, which is the colour of ink applied in the majority of cases.

CI neg.

The whole of Lucien Pissarro's collection of his father's drawings was photographed in 1950. This was undertaken by the Witt Library at the suggestion of Mrs Lullie Huda when she was working on the collection. Some of the negatives still in the Witt Library are of the drawings passed to the Ashmolean Museum in 1950–2, but others are of drawings that were retained by the family, some of which have been subsequently dispersed. These negatives are, therefore, an invaluable record of drawings that have not been easy to rediscover in the short term. This is usually the case when the drawings are no longer in the family possession and, as a result, only the negative numbers can be quoted. Where the writers have been able to rediscover the drawings, either still in private possession, or elsewhere, such details as size, medium, inscriptions, follow the negative number.

Numbering and inscriptions

The drawings from Lucien Pissarro's collection nearly all bear some evidence of the numbering systems adopted by Mrs Lullie Huda for the purposes of sorting out the mass of material before, and at the time of, the gift to the Ashmolean Museum in 1950. There are three numbering systems which can occur on either side of the drawings. Firstly, there is a very elaborate system (for example, E V e 4), which denotes the categories of subject-matter, and, secondly, a simple tabulation (for example, LP 345) which is no more than a record of the total number of drawings in the collection. It has been decided not to enter these numbering systems in the present catalogue. Where, however, the more elaborate numbering system appears on drawings not in the Ashmolean Museum it can be taken as an indication of provenance. Besides adopting these two numerical systems for the drawings, Mrs Huda sometimes indicated to which paintings, prints, or other works of art the drawings related, or to which sketchbook the sheets belonged (this last denoted with a number). These inscriptions and numbers, although helpful to the writers, especially in the reconstitution of the sketchbooks, have again not been entered in the present catalogue. A

few other inscriptions of a similar nature and of recent origin, but not made by Mrs Huda, also occur and these, too, have not been recorded. It should be emphasized, however, that a clear distinction has been made between these memoranda and the original inscriptions made by the artist, or by members of his immediate family (usually Lucien, or Esther Pissarro), which do, of course, have an important bearing on the origin and subsequent use of the drawings, and therefore rightly belong in the text of a critical catalogue. There falls into this last category a third system of numbering found on the drawings. This comprises those numbers in blue chalk, which usually occur on the verso of the drawings. These blue numbers were almost certainly applied after the death of Camille Pissarro, probably by Lucien Pissarro himself, or under his direction. These numbers do not appear very frequently on the drawings in the Ashmolean Museum, but they do also occur on sheets owned by other members of the Pissarro family. It is conceivable, although it cannot be proved, that these blue numbers were applied to the drawings during the *partage* that took place after Camille Pissarro's death or, alternatively, after that following the death of his widow, Julie, in 1926 when the collection was further divided.

Condition

The poor condition of some of the drawings, particularly the watercolours, is explained by the fact that at the beginning of the Second World War Lucien Pissarro put his collection into storage with the Chancery Lane Safe Deposit and Offices Co. Ltd., London. This was damaged by enemy action in October 1940 and the strongroom was flooded. In the official restoration report compiled by Herbert Walker (Ashmolean Museum, Pissarro Family Archive, Lucien Pissarro box XXXVIII), the paintings are described as being 'very badly damaged', thirty-six of the watercolours and drawings are recorded as 'total loss', and, of the rest, 'a great many watercolours were badly damaged though capable of some restoration'. A similar fate befell various sections of the collection of prints. Some of the watercolours and drawings now in the Ashmolean Museum can be identified from amongst those items summarily listed with short titles in the official report. They are as follows: Nos. 91 (?), 92, 187, 233 (?), 236, 237 (?) 252, 253, 264, 277 G.

Sketchbooks

The reconstitution of Camille Pissarro's sketchbooks has been one of the major tasks in compiling this catalogue. This has not always been easy, owing to the trimming or drastic cutting of many of the sheets. An acute example of this is provided by sketchbooks XIV (No. 160) and XXV (No. 273) where the sheets are all on paper with square ruled lines printed in blue ink and where the edges, perhaps originally tinted in red, have all been trimmed. The authors have adopted Roman numerals for the numbering of the sketchbooks in the present catalogue. Where there is only a single sheet from a particular sketchbook this, too, has been given a Roman numeral, but only if other sheets from the same source have been found in other collections, thereby confirming the origin of the sheet in the Ashmolean collection. Sketchbooks have, therefore, only been

granted numbers if their identification as such is secure. There are several instances in the South American period (Nos. 2–4 and Nos. 32–4), where the writers have assembled groups of sheets which may have constituted a sketchbook, or tablet. However, owing to the fact that the paper of the other sheets of similar dimensions in South American collections has not been examined, it has been decided to leave these unnumbered.

Dimensions
Sizes are given throughout the catalogue in millimetres, height preceding width.

Abbreviations

1. Books

Boulton
A. Boulton, *Camille Pissarro en Venezuela*, Caracas, 1966. Text in Spanish with French and English translations.

D.
L. Delteil, *Le Peintre-Graveur illustré (XIX et XX siècles), vol. XXVII. Camille Pissarro. Alfred Sisley. Auguste Renoir*, Paris, 1923. The copy in the Ashmolean Museum used for this catalogue belonged to Esther Pissarro. It has been extensively annotated.

Fern
A. Fern, *The Wood-Engravings of Lucien Pissarro with a Catalogue Raisonné*, doctoral thesis submitted to the University of Chicago, 1960, of which there is a photocopy in the Ashmolean Museum.

Gentle Art
The Gentle Art. A Collection of Books and Wood-Engravings by Lucien Pissarro, Zürich, 1974.

Lettres
Camille Pissarro. Lettres à son fils presentées, avec l'assistance de Lucien Pissarro, par John Rewald, Paris, 1950. There are various English editions of these letters, including several issued in 1943 in both London and New York, and a new edition published in New York in 1972. All references are to the French edition.

Leymarie and Melot
J. Leymarie and M. Melot, *The Graphic Works of the Impressionists*, English edition, London, 1972.

P&V
L. R. Pissarro and L. Venturi, *Camille Pissarro. Son art—son œuvre*, 2 vols., Paris, 1939.

Studio Book I and II
Catalogue of Wood-Engravings by Lucien Pissarro. 2 vols. Contains impressions of all Lucien Pissarro's engraved work with extensive annotations. Bequeathed to the Ashmolean Museum by the artist's daughter, Orovida Pissarro, in 1968 (inv. 1973.156–7).

Rewald
J. Rewald *Camille Pissarro*, London, 1963.

2. Exhibitions

Herbert
Jean-François Millet. Catalogue by Robert Herbert of an exhibition held at the Grand Palais, Paris, 17 October 1975–January 1976, and at the Hayward Gallery, London, 20 January–7 March 1976. All references are to the French edition of the catalogue.

JPL Fine Arts 1978
A selection of drawings, watercolours and pastels by Camille Pissarro c. 1853–1903, London, JPL Fine Arts, June–July 1978.

Leicester Galleries 1955
Catalogue of a Collection of Pastels and Studies by Camille Pissarro (1830–1903), London, Leicester Galleries, June–July, 1955.

Leicester Galleries 1958
Catalogue of a Collection of Drawings by Camille Pissarro (1830–1903), London, Leicester Galleries, June, 1958.

Leicester Galleries 1967
Catalogue of an Exhibition of Early and Other Drawings by Camille Pissarro (1830–1903), London, Leicester Galleries, February, 1967.

London/Nottingham/Eastbourne 1977–8
Camille Pissarro. Drawings from The Ashmolean Museum, Oxford. Catalogue by Mrs Lullie Huda of an exhibition held at Morley Gallery, London (November–December 1977), University Art Gallery, Nottingham (January–February, 1978), and Towner Art Gallery, Eastbourne (February–March, 1978).

Marlborough Fine Art 1955
Camille Pissarro 1830–1903. Alfred Sisley 1839–1899, Marlborough Fine Art (London) Ltd., June–July 1955.

Marlborough Fine Art 1968
Pissarro in England, Marlborough Fine Art (London) Ltd., June–July, 1968.

Melot
L'Estampe impressionniste. Catalogue by Michel Melot of an exhibition held at the Bibliothèque Nationale, Paris, 1974.

Paris/Venezuela 1978
Camille Pissarro au Vénézuéla. Catalogue of an exhibition of drawings held at the Venezuelan Embassy (11, rue de Copernic), Paris, 24 February–21 April 1978.

Shapiro
Camille Pissarro. The Impressionist Printmaker. Catalogue by Barbara Shapiro of an exhibition of prints held at the Museum of Fine Arts, Boston, 1973.

Wildenstein
C. Pissarro. Loan Exhibition, Wildenstein & Co. Inc., New York. 25 March–
1 May 1965.

THE CATALOGUE

(a) Numbers 1–279

1 Study of a seated female figure sewing (recto)
Pen and brown ink over pencil
Lugt 613e

Portion of an alphabetized account-book written in English (verso)
107 × 120

The technique of the penwork on the recto of No. 1 is typical of Pissarro's figure studies of 1852. Comparison should be made with a drawing, *Costumes des femmes du peuple, St. Thomas* (Christie's, 3 July 1970, lot 116 repr.), which is dated *22 Oct. '52*.

The verso (not repr.) reflects the commercial background of Pissarro's early life on St. Thomas where his father was a merchant. The sheet is presumably part of a discarded ledger that Pissarro used for sketching. The list is as follows:

Ripleys & Jackson	51
Rio & Deville	70
Ross, Richard	82
Ritson, James	94
Rowe, Joshua	95
Robinson, Charles	121
Rashleigh, Ann	137
Remsen & Co., Peter	156
Rotgers & Gaedicke	179

Ramsen & Co. P their Act. with/the Estate of Jas. Murphy 185

2 Study of a horse (recto)
Pencil
Slightly stained
Dated in pencil *11 Avril/52* lower right of centre
Lugt 613e

Two studies of the head and shoulders of a male figure wearing spectacles seen in profile to left: faint compositional study of peasant figures
(verso)
Pencil
Slightly stained
211 × 93

The study of the horse on the recto has a delicacy of outline that anticipates Pissarro's pencil drawings made in the manner of Corot between 1855 and 1867.

The faint compositional study on the verso is possibly a market scene.

No. 2 and the two following sheets (Nos. 3 and 4) were drawn in St. Thomas on successive days. They are on the same make of paper, and the similarity in size suggests that they were once part of a sketching tablet, which has since been dismembered and trimmed.

3 Two studies of a young boy with faint indications of a female figure (recto)
Pencil with pen and ink (indian ink for the study on the left of the sheet, brown ink for that on the right)
Lugt 613e (twice)

Whole-length study of a small boy with faint studies of his face and his left leg seen from the back (verso)
Signed in pencil lower left corner *Camille Pizzarro* (slightly obscured by the mount). Inscribed and dated in pencil lower centre *Frederick David/12 Avril 52/Lovers Meeting* (the beginning of the last line slightly obscured by the mount)
199 × 282

The inscription *Lovers Meeting* on the verso, presumably the title of a composition, also occurs on a sheet of studies in the Museo de Bellas Artes, Caracas (inv. 59. 71 (A), pen and ink over pencil, 177 × 296), which includes the figure of the same boy seen in profile to right. Both drawings are probably preparatory studies for a large genre composition.

Another drawing made on the same day as No. 3 and probably from the same sketching tablet (see No. 2) was formerly in the possession of Lucien Pissarro (CI neg. 52/44 (41)). A pencil study of another negro boy called William Thomas, drawn

on 16 September 1852, was sold at Sotheby's, 7 November 1962, lot 70, but it does not form part of the same sketching tablet as Nos. 2, 3, and 4.

4 'Route de Bussy' (recto)
Pencil
Slightly stained on left
Signed in pencil *Camille Pizarro* and dated in ink *13 Avril 1852/St.T* lower right corner. Inscribed in pencil with the title lower right of centre
Lugt 613e

Studies of sheep grazing in a landscape (verso)
Pencil
Slightly stained on right, showing through from recto
214 × 287

Nos. 2, 3, and 4 were drawn on consecutive days and show the range of Pissarro's visual curiosity at this early date. The minute scale of the hatching used for the foliage on the recto of No. 4 is characteristic of the landscape drawings executed on St. Thomas before Pissarro's departure for Venezuela in November 1852.

5 Landscape with a road
Pencil
Stained lower left
Lugt 613e
214 × 304

The handling of the foliage and the rather disjointed treatment of the composition are comparable with No. 4. The composition itself, the main feature of which is a road, is one which Pissarro used frequently throughout his life, particularly in Louveciennes during the period 1869–73.

6 View of the island of St. Thomas
Watercolour and pencil
Stained and rubbed in upper half
Inscribed in black chalk *St. Thomas* lower right corner, possibly added later
Lugt 613e
241 × 339

Stylistically, No. 6 belongs to the earliest group of drawings by Pissarro. A sheet in a similar technique

dated 1852 was sold at Sotheby Parke Bernet, 23 October 1974, lot 102 repr. Pissarro made a similarly composed watercolour of the port of La Guaira in Venezuela shortly after his arrival there which is inscribed and dated December 1852 (Alfredo Boulton Collection, Caracas, formerly O'Hana Gallery, London).

7 View of a military fortress
Brown wash over pencil
Somewhat damaged by damp
Lugt 613e
362 × 543 (Imperial)

This monochrome wash drawing is one of several topographical studies in this medium made by Pissarro (see, for example, those repr. by Boulton pp. 19, 21, opp. 26, and 31). These are all executed with greater panache than No. 7 and the weaker effect of the present drawing may be due to damage. Mr Alfredo Boulton has pointed out that the fortress can be identified as Christian's Fort on the harbour front at Charlotte Amalie, the principal town on the island of St. Thomas. For a representation of the port as it appeared when Pissarro was living on the island see the frontispiece to J. P. Knox, *A Historical Account of St. Thomas W.I.*, New York, 1852.

The treatment of the figures and comparatively controlled brushwork suggest that No. 7 was drawn shortly before Pissarro's visit to Venezuela and not after his return in 1854.

8 Sheet of studies of female figures and of a child (recto)
Pencil and pen and ink
Badly stained on right
Inscribed in pencil *Caraqueña* in centre
A further inscription in ink, lower left of centre, has been cut. Only the letters *St. T.* can be made out
Lugt 613e

Study of a plant with five slight studies of animals (verso)
Pencil
Badly stained on left showing through from verso
Lugt 613e
211 × 277

The two inscriptions in different media on the recto indicate that the sheet was used on separate occasions. The pen and ink inscription, *St. T.*, is connected with the studies in the same medium of the woman sewing, possibly Pissarro's mother, and the child in the lower left corner. Although *La Caraqueña* was the name of the ship on which Pissarro and Melbye sailed to Venezuela in November 1852 (Boulton, p. 89), the adjectival use of the word, meaning woman from Caracas, is surely the proper interpretation in the context of the studies of female figures in pencil. The central one of these, placed in a niche topped by a cross, was most probably inspired by a piece of funerary sculpture, or a votive picture.

The study of vegetation on the verso is typical of a type of drawing that Pissarro was to make with increasing frequency and far greater assurance during his stay in Venezuela.

9 **A street in Venezuela** (recto)
Pencil
Lugt 613e (purple ink)

Various figure studies with a tree and buildings
(verso)
Pencil and pen and brown ink
136 × 221

The intricate technique and the generally light touch used on both recto and verso are reminiscent of the style developed on St. Thomas, but both the topography and the tendency to use a heavier, more accented pencil line suggest that No. 9 was drawn in Venezuela. Mr Alfredo Boulton has identified the site as the Plaza Vargas, La Guaira, Venezuela. A sheet that displays similar stylistic features is the *View of Pissarro's and Melbye's House in La Guaira* (Banco Central de Venezuela, Caracas, repr. Boulton, p. 13).

On the verso only the figure of the woman walking with a stick has been drawn in pen and ink. For some discussion of the paper, see No. 10.

10 **'Camino de Gabilan, La Guyra'** (recto)
Pencil
Badly stained
Inscribed in pencil with the title lower left
Lugt 613e

Slight study of a female figure holding a bowl moving to right (verso)
Badly stained
137 × 221

This sheet is one of a number of drawings of the Venezuelan port of La Guaira where Pissarro landed in November of 1852. Many of these drawings of the port itself, the buildings in the town, and the surrounding districts are reproduced by Boulton. For example, the same group of buildings as shown in No. 10 occurs on a drawing owned by the Banco Central de Venezuela, Caracas (No. 22, pencil, 262 × 361, inscribed *Camino del Gabilan*, repr. Boulton, p. 47, and Rewald, p. 51, exhibited Paris/Venezuela 1978, No. 29). This last is more detailed and shows more of the valley on the right with the addition of several figures in the foreground.

No. 10 provides clear evidence of Pissarro's early ability to convey the general qualities of a motif with a few rapidly drawn pencil lines. The sheet lacks the fussiness which had marred Pissarro's drawings of 1852, and must have been done somewhat later.

Although Nos. 9 and 10 are virtually identical in size, they are on markedly different paper. It is possible, however, that they are part of a sketching tablet composed of different coloured papers. One other sheet, also of an architectural subject and of a similar size, is in the Museo de Bellas Artes, Caracas (inv. 59. 77 (A)), pen and ink over pencil, 146 × 206.

11 **Sheet of studies: whole-length figure of a woman seen from the back (upper half), a man riding a donkey seen from the back (lower half), brief study of a female face (left)**
Pencil
Slightly stained and marked by the imprint of another sheet of paper
Inscribed in pencil across right hand basket of man riding on donkey, *cosy à* (?)
Lugt 613e
243 × 232

Pissarro made numerous studies of this kind while in Venezuela. Comparison should be made with those occurring on a sheet in the collection of the Banco Central de Venezuela, Caracas (No. 20, pencil, with some outlines strengthened in pen, 208 × 276).

There is also a very similar sheet, which seems

to have been executed later than No. 11 in France shortly after 1855, in the collection of the Museo de Bellas Artes, Caracas (inv. 59. 80, pencil, 242 × 320).

12 Study of a female figure seated outside a hut (recto)
Pencil
Repaired at upper left corner. Several creases on left. Stains showing through from the verso
Lugt 613e

Sheet of studies: head of a young man (left), female figures washing clothes (right), faint indications of an eye (upper centre) (verso)
Pencil with evidence of some red chalk
Stained by two drops of red oil paint
Lugt 613e
278 × 282

Both the style and subject of No. 12 may be compared with No. 32 recto, which suggests that the present sheet was drawn in Venezuela. The studies on the verso, however, might be somewhat earlier. The head of the young man is both tentatively and rather awkwardly drawn, while the genre study in the right half might have been made in connection with the projected composition entitled *Lovers Meeting*, for which other drawings were made while Pissarro was still on St. Thomas (see No. 3). Yet, although the system of hatching employed for the group of figures on the verso is close to the earliest style developed on St. Thomas, the confidence with which the figures are drawn stands comparison with the studies in a sketchbook dating from 1853–4 in a private collection in Caracas (see, particularly, No. 18 of the sketchbook).

13 Study of female figures washing clothes in a river
Pencil
Slightly stained
Lugt 613e
239 × 284

The subject of women washing clothes in a river fascinated Pissarro during this early period, and there are four such compositional studies in the collection (see also Nos. 14–16). In addition to these, there are five studies of the same subject in the Museo de Bellas Artes, Caracas (inv. 59. 59(B), pencil, 303 × 477; inv. 59. 63(A), pen and ink over pencil on pink paper, 268 × 380; inv. 59. 69(A), pencil, 280 × 352; inv. 59. 70(A), pen and ink over pencil, 246 × 166; and inv. 59. 72(A), pen and ink over pencil, 165 × 245). Three of these sheets are isolated figure studies, and the last two were probably part of a small sketching tablet. There are also two sheets of studies of women washing clothes in a large sketchbook of 1853–4 in a private collection in Caracas (Nos. 10 and 26 of the sketchbook). All these sheets were drawn in the series of five small valleys, which run from the mountains of the coastal range of Avila into Caracas itself.

14 Mountainous landscape with figures by a river
Pencil
Slightly stained, particularly along the upper edge and on the left
Lugt 613e
229 × 311. Framing indicated in pencil, *c.* 185 × 270

No. 14 is a typical compositional study of the Venezuelan period. The style is close to that of No. 12 recto where a similar method of hatching has been used.

15 Landscape with female figures washing clothes in a river (recto)
Pencil
Lugt 613e

Studies of female figures with children by a fire (verso)
Pen and indian ink with pencil
Stained at the edges and marked by the imprint of another sheet of paper
Lugt 613e
300 × 360

Literature: Boulton, p. 53 repr. (recto only)

The subtlety of the tonal effects on the recto and the character of the penwork on the verso, both of which can be found in other drawings in the collection (Nos. 18 verso and 29 recto respectively) indicate that No. 15 was drawn towards the end of the

Venezuelan period. Mr Alfredo Boulton has pointed out that the buildings in the middle distance in the left half of the recto are part of Caracas.

Of the several pencil drawings (Nos. 13 and 14) of this subject in the collection, No. 15 is the most complete and was clearly made as a compositional study.

The figures on the verso of No. 15 are very close in style to the many figure studies in a large sketchbook dating from 1853–4 in a private collection in Caracas (compare, for example, No. 9 of the sketchbook).

16 Landscape with figures by a river
Watercolour over pencil
Repaired along the lower edge where there are several tears, particularly on the left
Stained upper left with further damage throughout caused by damp
Lugt 613e
371 × 541 (Imperial)

Exhibited: London/Nottingham/Eastbourne 1977/8, No. 9; London, JPL Fine Arts 1978, No. 1

No. 16 is one of two large-scale watercolours from this period in the collection. No. 7 is the other. The present example combines the breadth of Pissarro's less formal landscape studies, of which *Entrance to the Forest* (Banco Central de Venezuela, Caracas, No. 1, watercolour, 365 × 525, exhibited Paris/Venezuela 1978, No. 17, repr. Boulton, opp. p. 32) is a fine example, with the more classically arranged landscape compositions and genre scenes purveyed by Pissarro's companion, Fritz Melbye, many of which have been published by Boulton (repr. pp. 58 ss.).

For some discussion of the subject of the present sheet see No. 13. The figure of the man riding a donkey in the left foreground may be compared with a similar study on No. 11 and many of the other figures are closely related to those occurring on sheets in a sketchbook of 1853–4 in a private collection in Caracas. The female figure holding a basket of washing in the lower right corner resembles that on the right of a monochrome wash drawing, *Baile de Carnaval*, Banco Central de Venezuela, Caracas (repr. Boulton, opp. p. 26, exhibited Paris/Venezuela 1978, No. 35).

17 View of La Guaira (recto)
Pencil with pen and indian ink
Stained along the edges, somewhat rubbed with offset from another drawing
Inscribed in pencil *La Guayra* lower left
Lugt 613e

Study of a male peasant (verso)
Pencil
Stained along the edges, somewhat rubbed with offset from another drawing
Inscribed *plaza de Ma[iquetia]* (*cut*)
214 × 273

Literature: Boulton, p. 12 repr. (recto only)

No. 17 surely dates from 1854 prior to Pissarro's return with Melbye to the island of St. Thomas in August of that year. For the dating, comparison may be made with the drawing *View of Candelaria* (Museo de Bellas Artes, Caracas, inv. 59.99(A), pen and indian ink with pencil, 245 × 313, inscribed and dated in pen, *Caracas anauco 2 de julio de 1854 vista de Candelaria*, exhibited Paris/Venezuela 1978, No. 9 verso only repr.), which shares with No. 17 recto the same broad panoramic composition and a simplified linear structure in pencil reinforced with the pen.

The handling of the pencil on the verso is comparable with that on No. 27 verso.

18 Portrait of Fritz Melbye (1826–1869) (recto)
Pencil on oatmeal paper
Small tear at lower edge right of centre
Stained with ink in places
Lugt 613e

'Caracas' (verso)
Pencil on oatmeal paper
Inscribed in pencil with the title and signed *C. Pissarro* lower right
Lugt 613e
311 × 238. Framing indicated in pencil with ruled lines on verso only 182 × 254

The recto of No. 18 is drawn with considerable panache, and the features seem to correspond with those of Fritz Melbye, whom Pissarro first met on St. Thomas and with whom he later visited Venezuela. For other portrait drawings of Melbye made by Pissarro in Venezuela see that in the collection of the Nationalhistoriske Museum, Frederiksborg

(Hillerød), Denmark (repr. Boulton, p. 20), and one other attributed to Camille Pissarro now in the Royal Museum of Fine Arts, Copenhagen (for which see E. Fischer, *Herbert Melbye's Samling, en illustreret oversigt*, Copenhagen, 1977, p. 22 with full details), as well as No. 29 verso below. Two further portraits of Melbye by Pissarro were exhibited at Leicester Galleries, 1967, No. 8, dated 1853, and No. 9 verso.

The verso of No. 18 is one of Pissarro's finest panoramic landscape drawings done in Venezuela. Mr Alfredo Boulton has pointed out that in the present drawing the city is seen from the west. For a comparable view by Fritz Melbye (Fig. 3), which is clearly related to No. 18 and served as a preparatory study for a painting, see Boulton, p. 63 repr. Pissarro's painting of this view, if he in fact completed it, has not survived.

Another panoramic view of Caracas drawn by Pissarro, although not one that is as far evolved towards a finished composition as No. 18, is in the Museo de Bellas Artes, Caracas (inv. 59. 97(A), pencil heightened with chinese white on buff-coloured paper, 155 × 189 (irregular) inscribed *Valle de Caracas* and dated *Caracas Mai 1853*).

19 Portrait of a girl
Pencil
Slightly stained and rubbed, although the drawing itself is undamaged
Signed in pencil in monogram right of centre
Lugt 613e
273 × 216

No. 19 is another example of Pissarro's portrait drawings done in Venezuela. The head is closely modelled with the strands of the hair carefully delineated somewhat in the manner of Ingres, or Corot, and in these respects contrasts strongly with the freer technique of No. 20 recto. Again, unlike this last drawing, the pose of the figure in No. 19 is strictly conventional.

There are some faint figure studies towards the upper left corner of the sheet: a face and a whole length study of a female figure can just be made out, but they are badly rubbed. There also seem to be some other studies on the opposite side of the sheet in the upper right corner, but these cannot be properly interpreted.

20 Portrait of a young man seated on a chair
(recto)
Pencil on rose beige paper
Splashed with chinese white
Signed in pencil in monogram lower right (cut)
Lugt 613e

Brief study of a landscape (verso)
Pencil
Splashed with chinese white
278 × 238

No doubt the sitter, posed in this casual unconventional way, was one of the artist's friends in Caracas. For the social background of Pissarro and Melbye in Caracas and for an account of their studio there, see Boulton, p. 89. A similar portrait drawing, which may even be of the same sitter, was sold at Sotheby Parke Bernet, 12 May 1977, lot 204 recto repr.

The preparatory sketch on the verso appears to have been abandoned. Its terse summary style anticipates some of the compositional studies drawn in the early 1870s (for an example see No. 68F).

21 Study of a reclining female figure leaning on her left elbow
Pencil
Slightly stained on left
Lugt 613e
204 × 288

The figure appears to have been specially posed for this study. The awkward and geometric character of the style contrast markedly with the soft and curvilinear quality of the pose. In fact, No. 21 is an uncharacteristic subject for Pissarro to have attempted both in this early period, or even later in his life. There is however a comparable sheet (No. 41), representing Mme Pissarro reading, executed about 1860.

22 Two studies of a male figure (recto)
Pen and indian ink over pencil
Faintly stained by a red wash (?)
Lugt 613e

Study of a clipper (verso)
Pencil

Badly rubbed and damaged. Faintly stained by
 a red wash (?)
155 × 100

The type of broad hatching with the pen found on
the recto of No. 22 seems to have been developed
during the late Venezuelan period. The sheet is
closely related in style to the figure studies in a large
sketchbook in a private collection in Caracas dating
from 1853–4.

No. 22 anticipates the figure studies found in
those sketchbooks dating from the decades 1880–
1900 in its delineation of the general character of
a figure which Pissarro probably briefly observed in
a street, or at a local market. Indeed, No. 22 may
itself have been part of a small sketchbook.

23 **Study of the head of a young woman**
 (recto)
 Brown wash on beige paper
 Lugt 613e

 Study of a bull (verso)
 Pencil
 292 × 278

The recto of No. 23 is very faint, but does not appear
to have suffered any damage. On the contrary, it is
a drawing of supreme quality notable for its subtle
use of wash. Without the evidence of the verso,
which was clearly drawn in Venezuela, one might
be inclined to associate the recto of No. 23 with
Corot and, therefore, to date the sheet slightly later.

24 **Study of a donkey** (recto)
 Pencil on beige paper
 Badly stained
 Lugt 613e (purple ink)

 Two studies of a ram (verso)
 Pencil
 Badly stained
 Lugt 613e (purple ink)
 245 × 314

The recto of No. 24 is drawn in a bolder, more confi-
dent style than No. 2 recto with which it may be
compared, and greater use has been made of
accented line. The studies on the verso may be com-
pared with No. 4 verso. Such stylistic features
suggest that both the recto and verso of No. 24 were

made in Venezuela, perhaps in connection with the
composition recorded on No. 31 recto.

25 **Study of a plant**
 Pencil
 Inscribed in pencil upper left *juliman (?) simple*
 Lugt 613e
 175 × 116

No. 25 is more tightly handled than the botanical
studies made in Venezuela, which are usually on
larger sheets and often very much bolder and freer
in execution. Yet, it is possible to find stylistic
parallels in drawings from this early period. Com-
pare, for instance, the plant on No. 8 verso, or closer
still, although on a different scale, a botanical study
in the collection of the Banco Central de Venezuela,
Caracas (No. 16, pencil on beige paper, 367 ×
257, signed *C. Pizzarro* and inscribed *Catouche*).
Identification of the plant has caused some diffi-
culty and cannot be resolved with the aid of Pis-
sarro's inscription. The plant is unidentifiable from
the drawing, but if the inscription can be read as
julienne simple, which is the name for the European
plant otherwise known as Dame's Violet (*Hesperis
matronalis*), then No. 25 could not have been drawn
in Venezuela. The drawing, however, from a strictly
botanical point of view only partly suits this hypo-
thesis and the more likely rendering of the inscrip-
tion is *juliman simple*, which does not seem to refer
to a specific plant. The matter remains unresolved.
The compilers gratefully acknowledge the help of
Dr John Lewis of the Department of Botany in the
British Museum (Natural History) in considering
No. 25. For a list of botanical specimens found on
the island of St. Thomas in the middle of the nine-
teenth century see J. P. Knox, *A Historical Account
of St. Thomas W.I.*, New York, 1852, pp. 230–46.

26 **Study of a plant** (recto)
 Pencil on beige paper
 Repaired in lower left corner where the paper
 is also slightly stained
 Signed in pencil *C. Pizarro* lower right and in-
 scribed *Catouche* lower left

 Study of figures in a wooded landscape
 (verso)
 Pencil

Stained along the right edge and marked by the imprint of another sheet of paper
Inscribed in pencil at right edge above centre *sombre*
Lugt 613e
371 × 253

The inscription on the recto of No. 26 refers to a ravine of that name in the wooded environs of Caracas. Pissarro in the company of Fritz Melbye made a number of drawings of the area. These are as follows: (1) formerly in the possession of Lucien Pissarro (CI neg. 52/46(4), no details known), which is a general view overlooking the ravine, apparently drawn in pen and ink over pencil and inscribed in pen *Catouche—Caracas*; (2) formerly in the possession of Lucien Pissarro (CI neg. 52/61(7)), *Study of the roots of a tree*, pencil on beige paper, 357 × 255 (sight), signed and inscribed in pencil *C. Pizarro Catouchi* lower left; (3) in the Museo de Bellas Artes, Caracas (inv. 59. 65), pencil, 379 × 309, inscribed in pencil *la forêt Catuche, riviere aux environs de Caracas* lower left; and (4) *Study of a plant*, Banco Central de Venezuela, Caracas (No. 16), pencil on beige paper, 367 × 257, signed *C. Pizzarro* and inscribed *Catouche*. It is likely, although still in need of confirmation, that these five drawings were made on the same outing and that the sheets are from the same sketching tablet.

The drawing on the verso of No. 26 is a preliminary idea for the composition that was evolved on No. 27.

27 'Excursion au Mont Avila—Venezuela' (recto)
Pen and indian ink with the brush over pencil
Stained on right
Inscribed in ink with the title along the lower edge
Lugt 613e

An artist sketching a camping scene (verso)
Pencil
Some rubbing with offset from another drawing
269 × 377

Literature: Boulton, pp. 43 and 42 repr. respec-

tively; A. Boulton, 'Camille Pissarro in Venezuela', *Connoisseur*, clxxxix (1975), p. 40 figs. 5–6

Both the recto and verso of No. 27 are related to a more highly finished drawing in pen and ink now in a private collection, New York (Christie's, 30 November 1971, lot 377 repr.), which has been published twice by Boulton (p. 44 repr. and 'Camille Pissarro in Venezuela', *Connoisseur*, clxxxix (1975), p. 40, fig. 7). According to Boulton, these three drawings form a sequence beginning with the verso of No. 27, which shows Pissarro's companion, Fritz Melbye, preparing his palette, and continuing on the recto of No. 27, where Pissarro places himself on the left of the composition sketching the whole group, including Melbye, a motif that he retained in the third drawing, formerly in the Avnet collection, where the setting in the tropical forest is more elaborately indicated. Boulton did not observe that the brief indication of figures on the verso of No. 26 may anticipate the composition evolved on both sides of the present sheet.

The subject of the artist, or of a sketching party, located in a landscape is often represented in the topographical tradition. In depicting this subject, therefore, Pissarro once again associates himself with a distinctly European theme emphasizing the self-consciousness of the artist in the midst of nature.

28 Three studies of an old man seated in a landscape
Pencil
Lugt 613e
230 × 300

The subject of this drawing of an aged beggar belongs to a well-established European tradition associated with Rembrandt and other seventeenth-century painters, and one that was reintroduced into France by realist painters during the middle part of the nineteenth century. The style of the sheet and the presence of cacti indicate that it was made in South America. There is an earlier study of the same figure on a sheet inscribed *Caracas Aout 53* which is part of an early sketchbook dating from 1853–4 in a private collection in Caracas, (No. 17). No. 28 seems to have been an elaboration of the smaller study in the sketchbook, which occurs on a sheet of figure studies.

29 Group of figures on the porch of a house
(recto)
Pen and indian ink over pencil on faded blue
 paper
Watermark on left (cut)
Inscribed in ink *Venezuela* lower left (partly
 obscured by a dark wash)
Lugt 613e

Portrait of Fritz Melbye (1826–1869) (verso)
Charcoal with grey wash
241 × 304

Exhibited: London/Nottingham/Eastbourne 1977–
8, No. 8

The recto of No. 29 is typical of the genre studies
done by Pissarro in Venezuela, some of which must
have been made in preparation for paintings. This
appears to have been the intention here, since a
dated compositional study developed from the recto
of No. 29 is also in the collection (No. 30). A related
drawing of three female figures formerly in the pos-
session of Lucien Pissarro (CI neg. 52/46(8), no
details known) represents an earlier stage in the
evolution of the composition.

 The verso of No. 29 is a romanticized portrait
probably of Fritz Melbye. It is a loose drawing in
which the medium and the freedom of handling
somewhat recall the portrait of Melbye by Pissarro
in the Nationalhistoriske Museum, Frederiksborg
(Hillerød), Denmark (repr. Boulton, p. 20), which
is, in turn, similar to that attributed to Camille Pis-
sarro now in the Royal Museum of Fine Arts,
Copenhagen (for which see E. Fischer, *Herbert Mel-
bye's Samling, en illustreret oversigt,* Copenhagen,
1977, p. 22 with full details). For another portrait
drawing of Melbye by Pissarro in the Ashmolean
collection see No. 18 recto. The freely applied
washes and the use of charcoal are uncharacteristic
of Pissarro's drawings done in Venezuela and
suggest that the verso of No. 29 might have been
executed in France.

30 'Savana Grande—Caracas'
Pencil
Inscribed in pencil with the title along the
 lower edge and signed and dated in the lower
 right corner of the composition *CP fecit 54*
 with two further signatures in pencil in
 monogram in the lower left corner of the
 composition

Lugt 613e
203 × 272. Framing indicated in pencil with
 ruled lines, 163 × 230

Literature: Boulton, p. 49 repr.

This is the final drawing of the composition first
evolved on No. 29 recto. No finished painting of this
subject, if one was actually undertaken, has sur-
vived. The present drawing, one of the most
accomplished compositional studies executed by
Pissarro in Venezuela, is dated 1854. The two seated
figures right of centre are reminiscent of those
occurring on another compositional study of a
domestic genre scene set in an interior in the collec-
tion of the Banco Central de Venezuela, Caracas,
No. 39, pen and ink over pencil, 247 × 360.

**31 Compositional study of a peasant family
 with a donkey in a landscape** (recto)
Pencil
Stained along right edge
Signed in pencil *C. Pizzarro* lower left corner
 and inscribed *Venezuela–Caracas* lower
 right
Lugt 613e

Landscape in France (La Roche-Guyon)
 (verso)
Charcoal
Lugt 613e
299 × 454. Framing indicated in charcoal,
 c. 355 × 268

Literature: Boulton, p. 53 repr. (recto only)

While clearly inspired, as attested by the inscrip-
tion, by a genre scene witnessed in Venezuela, the
composition on the recto of No. 31 has its roots in
French or Italian painting of the seventeenth cen-
tury. Although no precise source has been found,
Boulton (pp. 94–5) has rightly suggested that the
figures are disposed as in a painting of The Flight
into Egypt. The buildings in the background on the
right resemble those occuring on a sheet of studies
in the Museo de Bellas Artes, Caracas (inv. 59.
83(A), pencil 212 × 255) and are probably an out-
lying part of Caracas.

 It is well known that Pissarro continued to paint
Venezuelan scenes after his arrival in France in 1855
(see P&V 5–8), but the character of the inscription
and the signature make it unlikely that No. 31 recto

was drawn in connection with one of these reworked compositions, and it seems that the sheet must have been used on two separate occasions, since the verso is of a French landscape. There are several other examples of Pissarro reusing paper in this way (see Nos. 42–3). The landscape study on the verso of No. 31 is most probably of La Roche-Guyon where Pissarro painted in 1859–60. The disposition of the elements of the landscape is very similar to those in P&V 45 (formerly Robert von Hirsch collection sold Sotheby's, 26 June 1978, lot 716 repr.), entitled *La Promenade à âne à la Roche-Guyon* and dated *c*. 1864–5 in the *catalogue raisonné*.

32 'Camino de la Guaira à Macuto' (recto)
Pencil
 Badly stained, slightly rubbed, and marked by the imprint of other sheets of paper.
 Inscribed in pencil with the title lower right and originally dated *1853*; the title in black chalk repeated in French lower left was added later
 Lugt 613e

Five studies of a female figure (verso)
Pencil
 Badly stained and marked by the imprint of other sheets of paper
 277 × 345

Literature: Boulton, p. 50 repr.

Although the drawing was originally dated 1853, the last digit has been changed from a 3 to a 2. La Guaira is the port to the north of Caracas. Macuto is on the coast to the east close to La Guaira.

The tonal hatching used on both the recto and verso of No. 32, and the stronger, more broken outlines prescribing the figures on the verso quickly became the principal hallmarks of Pissarro's style of drawing in Venezuela. The composition of the recto is brilliant, witty, and original. The measurements and the type of paper used for No. 32 correspond with Nos. 33 and 34, and it is probable that they form part of a sketching tablet used in both Venezuela and St. Thomas during 1853–5. There are six other sheets of similar dimensions, one in the collection of the Banco Central de Venezuela (No. 11, pencil, 350 × 281) and five in the collection of the Museo de Bellas Artes, Caracas (inv. 59. 61(A), pen and ink over pencil, 270 × 353; inv. 59. 62, pencil, 271 × 360; inv. 59. 64(A), pen and ink over

pencil, 268 × 356; inv. 59. 68(A), watercolour over pencil, 271 × 360; and inv. 59. 69(A), pencil, 280 × 352). In spite of slight differences in size, probably due to trimming, there is a remarkable stylistic unity among the sheets, which do no doubt, together with Nos. 32–4, constitute an important early sketching tablet.

33 Study of a landscape
Pencil
 Lightly marked by the imprint of another sheet of paper.
 Extensively annotated in pencil from left to right *violet (?)*, ..., *plus sombre (?)*, *vapeur blanchâtre*, ..., *chaud*, *vers chaud*, *clair*, *tons violet (?)*, *l'horizon plus haut* ...
 Lugt 613e
 271 × 342

Stylistically, this sheet closely resembles No. 34, which was certainly drawn on St. Thomas in 1854–5. Such extensive annotations as occur in the present drawing are rarely found in early drawings and anticipate the heavily annotated sheets made in France after 1855 (see, for example, No. 68B). The inscriptions indicate that the drawing was made as an *aide-mémoire* for a painting. No. 33 may have formed part of a sketching tablet, for which see No. 32 above. No. 33 represents the same view as that on a sheet formerly in the collection of Lucien Pissarro (CI neg. 52/61(6), no details known), which, due to the similarity in size and style, may also have come from the sketching tablet discussed in No. 32.

The word *clair* occurs in the sky (centre) and is very faint.

34 Wooded landscape on St. Thomas
Pencil
 Inscribed in pencil *St. Thomas* lower left
 Lugt 613e
 345 × 277

Although related in subject to the wooded landscapes undertaken while in Venezuela, both the inscription and the highly generalized character of the hatching indicate that this splendid sheet dates from 1854–5 before Pissarro's departure for Paris.

The measurements and the types of paper of No. 34 correspond with Nos 32 and 33, and the drawing may have formed part of the same sketching tablet (see No. 32).

35 Male écorché study (recto)
Pencil
Repaired at upper left corner
Stained along upper edge
Extensively annotated in pencil: *larynx ou
 pomme d'Adam, région antérieure du cou, tra-
 pèze, apophyses mastoïdes, siterne interne mas-
 toidiens, muscle omoplate ici d' … (?), ligne
 blanche, droit, oblique, pyramide grd (?)*
Lugt 613e

**Study of the head of the Emperor Vitel-
lius, after a plaster cast, with a faint
study of another male head** (verso)
Pencil
Badly stained throughout
Various numerical calculations in pencil lower
 right corner
314 × 237

No. 35 must surely date from the time of Pissarro's
brief period of study at the Ecole des Beaux-Arts
c. 1855–6. Professor Robert Herbert has suggested
that No. 35 recto may have been copied from a book
of anatomical illustrations. Another écorché study
of the back of a male figure with Latin inscriptions
was sold at Sotheby Parke Bernet, 4 February 1970,
lot 2, and one other is in the Museo de Bellas Artes,
Caracas, inv. 59. 88, pencil, 247 × 320, exhibited
Paris/Venezuela 1978, No. 16.

 The study from the plaster cast of the so-called
head of Vitellius, the original of which is in the
Museo archeologico, Venice (G. Traversari, *Museo
archeologico di Venezia. I ritratti* (Rome, 1968), No.
43 pp. 63–4 repr. fig. 44a–d), is, like the recto,
another academic exercise that was in all likelihood
done at the Ecole des Beaux-Arts. The second study
on the verso is very faint. It is slightly to the left
of the head of Vitellius and may have been sketched
from a death mask.

**36 Study of a male nude seen in profile facing
left** (recto)
Charcoal with traces of highlighting in white
 chalk on blue paper
Repaired at lower right corner
Lugt 613e

**Study of a female nude carrying a pitcher
on her left shoulder** (verso)
Charcoal
445 × 257

No. 36 clearly dates from shortly after Pissarro's
arrival in France, and, like Nos. 37 and 38, was
probably drawn at the Ecole des Beaux-Arts. A let-
ter written by Pissarro's brother, Alfred, in
November 1856 enquiries of the artist whether he
was still studying in the atelier of Isidore Dagnan,
a professor at the Ecole des Beaux-Arts (informa-
tion from Mr Ralph Shikes in a letter to the com-
pilers, 28 November 1977). It is not entirely impos-
sible, however, that such studies could have been
made at the Académie Suisse where Pissarro met
Monet in 1860 and may even have been working
earlier. Pissarro's studies of the nude are all charac-
terized by clear outlines containing areas of soft
evenly modulated shading. Technically, the draw-
ings are of a high quality, although at first sight the
fleshy realism of the treatment of the model may be
offputting.

 The female nude on the verso of No. 36 is also
of some quality and relates to a double-sided sheet
of two female nude studies (Sotheby's, 11
December 1969, lot 15 repr.), both of which are
somewhat in the manner of Corot's figure studies.

**37 Study of a male nude posed against a wall
seen in profile facing right**
Charcoal with traces of highlighting in white
 chalk on blue paper
Lugt 613e
468 × 295

This fine drawing presumably represents the same
model as that used for the recto of No. 36 and again
for No. 38.

**38 Study of a seated male nude with his left
knee raised** (recto)
Charcoal
Lugt 613e (smudged)

**Outline of a seated male nude with his left
knee raised** (verso)
Charcoal
Stained along lower edge
245 × 315

This delicately modelled study was made from the
same model as that used for No. 36 recto and again
for No. 37. Another fine and very large whole-
length study of a similarly bearded, although

different, model seen from the front was exhibited at the Beilin Gallery, New York, *50 Drawings by Camille Pissarro*, March–April, 1965, No. 1 repr. (charcoal, 609 × 425, stamped Lugt 2031b). A freer, far less finished, study of yet another model seen from the front with the left leg pulled up over the right knee was formerly in the possession of Lucien Pissarro (CI neg. 53/8 (34a), black chalk, 137 × 186). This last sheet may be of a somewhat later date.

The faint outline on the verso appears to have been a tentative start for a study of the same figure posed as on the recto. It has been started too low on the sheet and for this reason was probably abandoned.

39 Portrait of the artist's mother
Pencil
Inscribed in pencil *25 Janv. 1856–Paris* and later below by Lucien Pissarro in pencil *grand'mère*
91 × 55

Literature: Rewald, p. 52 repr.

Rachel Petit (née Pomie (Manzana)) married Frédéric Abraham Gabriel Pissarro on 18 November, 1826 on the island of St. Thomas. She was born in 1795, probably on St. Thomas. Her family came from the neighbouring island of St. Dominic. Before marrying Frédéric Pissarro, she had previously been the second wife of Isaac Petit, Frédéric Pissarro's uncle. She died on 30 May 1889 aged ninety-four. Camille Pissarro made a number of drawings and two prints of his mother during her last years (for which see Nos. 145, 152, 194, and 195).

40 Portrait of Jules Cardoze (recto)
Pencil heightened with chinese white on grey paper
Inscribed in brown chalk *Jules Cardoze par CP* lower right possibly added at a later date, but certainly by the artist's own hand

Portrait of the artist smoking a pipe (verso)
Pencil
159 × 123

Jules Cardoze, a novelist, was apparently a cousin of Camille Pissarro, as stated in a letter written by Pissarro to Octave Mirbeau (12 February 1892), for which see C. Kunstler, 'Lettres inédites de Camille Pissarro', *Revue de l'art ancien et moderne* lvii (1930), p. 224. In 1861 he is recorded as living at 17 rue Notre Dame de Lorette, Paris, and he seems to have maintained a close connection with the family throughout Camille's lifetime. A letter of 31 December 1857, written by Cardoze to Raoul Pannet discusses their mutual friend Pissarro (*Archives de Camille Pissarro*, Hôtel Drouot, Paris, 21 November 1975, No. 138), and in a letter written to his father in January 1887, Lucien Pissarro refers to the fact that he might illustrate some of Cardoze's books (written before 12 January 1887, the date of Camille Pissarro's reply), and Camille again mentions Cardoze in a letter of 22 January 1898 (not in *Lettres*).

On the verso of No. 40 is the earliest known self-portrait dating from after Pissarro's removal to France, perhaps drawn *c.* 1860. Two earlier self-portrait drawings are known: (1) The Royal Museum of Fine Arts, Copenhagen, black chalk, 302 × 255, repr. M. N. Benisovich and J. Dallet, 'Camille Pissarro and Fritz Melbye in Venezuela', *Apollo*, lxxxiv (1966), p. 44, fig. 1 (2) formerly in the possession of Lucien Pissarro (CI neg. 51/57 (11), no details known).

The self-portrait on the verso of No. 40 must have been drawn well after both of these sheets just described, because the full beard that Pissarro wore for the rest of his life is clearly shown.

Two painted self-portraits, which are certainly earlier in date than any of the self-portrait drawings, are now in the Royal Museum of Fine Arts, Copenhagen (see E. Fischer, *Herbert Melbye's Samling, en illustreret oversigt*, Copenhagen, 1977, p. 22). Reference should also be made to the two drawings made by Pissarro in Venezuela, which show both the artist and Fritz Melbye in their studio at Caracas. The first of these is in the collection of the Banco Central de Venezuela, Caracas (No. 34, brown wash over pencil, signed *C. Pissarro fecit* and dated 1854 (? the corner has been repaired and the final digit is therefore cut), 380 × 548, exhibited Paris/Venezuela 1978, No. 37 repr., also Boulton, p. 21, repr.), and the second in the Ellen Frydensberg collection, Faaborg, Denmark (pencil, no measurements known, signed *C. Pissarro fecit* and dated *Caracas 25 de April 1854*, repr. Rewald, p. 50 and Boulton, p. 23). This visual evidence seems to show that the young Pissarro altered his personal

appearance several times before the adoption in the 1860s of the persona of the patriarch which is so evident in his later self-portraits (P&V 200, 1114, 1115, and 1316).

Both the recto and the verso of No. 40 are drawn in a style which has clear affinities with the portrait drawings of Ingres, Chassériau, and the early Corot. They are both considerably more subtle and accomplished than the portrait drawings executed in Venezuela (Nos. 19 and 20).

41 **Study of a woman reading on a bed with a separate study of a child's head**
Pencil
Foxed
Signed in pencil with the artist's initials centre right
Lugt 613e (purple ink)
257 × 351

The drawing is almost certainly of Madame Pissarro and was most probably made in connection with P&V 15, which is dated 1860 in the *catalogue raisonné*. Another early study by Pissarro of a woman in a similar pose, which is, however, executed in charcoal and in a chiaroscural style, was sold at Sotheby's, 8 December 1966, lot 143 repr. It is interesting to compare No. 41 with a drawing of the same subject by Cézanne (A. Chappuis, *The Drawings of Paul Cézanne. A Catalogue Raisonné*, i, London, 1973, No. 663 p. 180) dating from much later (1883–6).

The slight sketch of the child's head in the upper left corner of the sheet cannot be of Lucien Pissarro, since he was born only in 1863.

42 **Study of a negress** (recto)
Charcoal
Repaired along lower edge
Lugt 613e

Study of a male figure wearing Spanish costume (verso)
Charcoal
199 × 219

Old photographs (CI neg. 51/45(38a) and 51/45(39a)) show that the drawing is fragmentary and had been badly torn before being remounted in Oxford.

While the subject-matter of both the recto and verso of No. 42 is highly suggestive of St. Thomas, or Venezuela, the style is not compatible with the figure drawings of that period. The clean outlines and the softness of the modelling on the recto is close to the academic figure studies drawn after Pissarro's arrival in France (No. 38 recto) and the tendency to adopt the simplified broken outlines seen on the verso anticipates the modular style also developed after the painter's removal to France.

Pissarro made a number of such studies after 1855. The closest in style and costume to the recto of No. 42 is the *Study of a seated negress seen from behind* (Museo de Bellas Artes, Caracas, inv. 59. 74(A), charcoal on brown paper, 188 × 249, exhibited Paris/Venezuela 1978, No. 14). Others include *La Coiffeuse* (Christie's, 1 December 1970, lot 38 repr.), which has an academic study on the verso, *La Négresse* (Sotheby Parke Bernet, 13 December 1967, lot 7 repr.), which is a study for the early etching of 1867 (D.6), and a whole-length *Study of a Negress seen from behind with her right arm extended* (Paris, private collection), black chalk, 310 × 250. The compilers are grateful to Mme Arlette Sérullaz for bringing this last drawing to their attention.

With regard to the costume study on the verso of No. 42, it may be observed that there was a vogue in France during the 1850s and 1860s for Spanish subjects, and Pissarro with his early experiences in the West Indies and South America was well prepared to exploit such themes.

43 **Study of a woman wearing Spanish costume walking to left** (recto)
Pencil
Lugt 613e

Study of a seated woman in an attitude of grief (verso)
Pencil
306 × 222

The disparate nature of the subject-matter, the various media, and the fact that the Spanish subjects chosen have both Spanish and French characteristics, make No. 43 difficult to date. Although drawn in a loose and vigorous pencil style that had been perfected by Pissarro during his two years in Venezuela, the recto of No. 43 also reflects the manner of Constantin Guys under whose influence Pissarro seems to have developed his earliest caricatural

style. It is therefore reasonable to date the recto 1860–5.

The seated woman on the verso posed in the traditional attitude of grief is the same model as that used on two other occasions: (1) *Study of a seated woman facing right*, Museo de Bellas Artes, Caracas (inv. 59. 90, pencil on buff paper, 225 × 315); (2) *Study of a woman sketching*, formerly in the collection of Orovida Pissarro and once offered for sale by the O'Hana Gallery, London, no details known, apparently in pencil. Both these drawings and the figure study on the verso on No. 43 may also date from after 1855.

The evocative river landscape, also on the verso of No. 43, is, in the opinion of the writers, an experimental lithograph. If this conclusion is correct, and it should be stated that several scholars have expressed their dissent, then it is perhaps an early example of Pissarro's interest in print-making techniques. Unlike the distinct Spanish flavour of the figure studies occurring on No. 43, the topography of this river landscape is clearly French and could on stylistic grounds have been done during the 1860s.

44 Three studies of Lucien Pissarro as a baby
Pencil
Foxed
Lugt 613e
215 × 331

Lucien Pissarro, the artist's eldest child, was born on 20 February 1863, and this sheet of three studies must date from 1863–4. A number of other studies of Lucien as a baby are extant: (1) *Study of Madame Pissarro suckling Lucien Pissarro*, formerly in the possession of Lucien Pissarro (CI neg. 52/25(23)), probably identifiable with Sotheby's 6 May 1959, lot 1; (2) *Study of Lucien Pissarro as a child seated in a high chair*, formerly in the possession of Lucien Pissarro (CI neg. 51/57(7)), pencil, dated *5 Mars 1864*, exhibited Leicester Galleries 1967, No. 23; (3) *Study of Lucien Pissarro as a child*, exhibited Leicester Galleries 1967, No. 25.

Studies of this type precede those made by Cézanne of his son, an example of which is in the Ashmolean Museum (A. Chappuis, *The Drawings of Paul Cézanne. A Catalogue Raisonné*, i, London, 1973, No. 692, pp. 187–8).

45 Portrait of Lucien Pissarro a young boy
Brush drawing in dark ink heightened with chinese white on a dark green paper prepared with a brown wash
254 × 352

The technique resembles the academic procedure adopted for *études*, namely that of painting light and dark tones on a prepared ground comprising a middle tone. No. 45 is a remarkably sensitive study and, judging from the sitter's age, must have been executed 1868–70.

The present study may perhaps have formed the basis for a pastel of Lucien Pissarro (P&V 1520), which is dated *c.* 1874 in the *catalogue raisonné* at a time when Pissarro produced a series of similarly composed family portraits (Nos. 70 and 71).

46 Whole-length study of Lucien Pissarro seen from the back in three-quarters profile facing right
Pencil
Stained along both edges and upper right corner
Small fold upper left corner with other prominent creases on the left
Inscribed in pencil *Lucien* lower left
Lugt 613e (purple ink, smudged)
304 × 197

Two other whole-length studies of Lucien Pissarro seen from different angles are comparable with No. 46. Although in the same fine pencil style the related drawings are on larger sheets of paper. They are as follows: (1) *Study of Lucien Pissarro seen from the back*, formerly in the possession Lucien Pissarro (CI neg. 52/26(25), pencil on light grey paper, 440 × 270, numbered *35* on verso; (2) *Study of Lucien Pissarro seen in profile facing left*, formerly in the possession of Lucien Pissarro (CI neg. 52/26(27)), pencil on light grey paper, 440 × 270.

47 Studies of peasants working in a field
Pencil
Annotated in pencil at upper edge *rouge et jaune (?) ..., violet ...* (both cut)
Lugt 613e
166 × 230

Stylistically, No. 47 is compatible with No. 51 in that both are drawn in the anecdotal pencil style de-

veloped by Pissarro in Venezuela. Such drawings are amongst the earliest instances of Pissarro's French peasant subjects in the open fields. A strikingly similar figure to the female peasant standing on the left of No. 47 occurs in *La Varenne Saint-Hilaire, vue de Champigny* (P&V 31, Budapest, Museum of Fine Arts), dated *c*. 1863 in the *catalogue raisonné*, which may, however, be earlier.

48 Study of a hay wagon with a team of four horses in front of a farm
Pencil with some outlines strengthened with the pen in brown ink on beige paper
Discoloured in places
Lugt 613e (smudged)
281 × 446. Framing indicated in pencil with ruled lines, 250 × 413

No. 48 is a compositional study for a painting, but no picture of this subject seems to have survived. For another study of a horse that might be related to the same composition see No. 60 verso.

Pissarro painted farmyard scenes as early as 1863 (P&V 26, sold Parke-Bernet, 6 April 1967, lot 17 repr.) and P&V 28. This last picture, entitled *La Charette de bois*, depicts a cart pulled by a team of horses similar to that in No. 48. The style and compositional method of the present drawing both suggest an early dating. The farm in the background may be the one at Foucault owned by the artist's friend Ludovic Piette, which Pissarro visited for the first time in 1864 and where he painted a number of farmyard scenes during the 1870s.

49 SKETCHBOOK I

49A Study of a saddled donkey seen in three-quarters profile facing right
Pencil
Stained in centre
122 × 205

49B Slight study of a saddled donkey seen in profile left
Pencil
Stained on right
122 × 207

49C Landscape with trees
Pen and brown ink over pencil
Lugt 613e
122 × 207

These three sheets are from an early sketchbook dating from 1855–60.

Nos. 49A and 49B appear to have been drawn in connection with a painting *Paysage à Montmorency*, which was acquired by the Louvre in 1976 (H. Adhémar and A. Dayez-Distel, *Musée du Jeu de Paume*, 3rd edn., Paris, 1977, p. 132 repr. and p. 170, not in P&V).

50 'Montmorency'
Pencil
Stained and somewhat rubbed. Marked by the imprint of another sheet of paper, particularly along the right edge. Small tear centre of left edge
Signed in pencil with the artist's initials, inscribed with the title and date *1857* lower left corner. Inscribed *étude à l'huile à faire* upper right
314 × 481

Regardless of the inscription in the upper right corner of No. 50, neither an oil sketch nor a finished painting of this subject has survived. It is interesting, however, to observe that in 1859 Pissarro exhibited a painting entitled *Paysage à Montmorency* at the Salon, the first of several occasions that he had a picture accepted (*Paris Salon de 1859. Explication des ouvrages de peinture, sculpture, gravure, lithographie et architecture des artistes vivants exposés au palais des Champs-Elysées le 15 Avril, 1859* (Paris, 1859), No. 2472, Camille Pissarro, élève de Anton Melbye, rue Fontaine St. Georges 38 bis, *Paysage à Montmorency*).

Pissarro made a number of drawings in the area of Montmorency where he lived in 1858, many of them inscribed. In addition to Nos. 50 and 51 these are as follows: (1) Sotheby Parke Bernet, 12 May 1977, lot 212 repr. inscribed *Chemin Riseo Montmorency*; (2) *Study of landscape at Montmorency*, formerly in the possession of Lucien Pissarro (CI neg. 52/43 (36)), pencil, 235 × 314, inscribed *Montmorency* ... with several annotations, now Armand Hammer Collection, Los Angeles, for which see *The Armand Hammer Collection*. Catalogue of an exhibition held at Los Angeles County Museum of Art;

London, Royal Academy of Arts; Dublin, National Gallery of Ireland, 1972, No. 78 repr.; (3) JPL Fine Arts, London, *Study of trees at Montmorency*, inscribed *Montmorency* and *Chataignes*, pencil, on beige paper, 223 × 310; (4) JPL Fine Arts, London, *Study of landscape at Montmorency*, no details known. Of these (1), (2) and (3) appear to be from the same sketching tablet. Two other drawings, not so inscribed, but which may have been drawn in the area of Montmorency, were sold at Sotheby Parke Bernet, 12 May 1977, lots 207–8 repr.

51 'Route de la maison blanche'
Pencil
Inscribed in pencil with the title lower left and *Montmorency* lower right
Annotated in pencil *luzerne*, *jaune*, *blés*, with several other annotations now indecipherable
Lugt 613e
152 × 351

The horizontal format, the breadth of the composition, and the uniform minuteness of the forms are features clearly derived from Daubigny, although the manner of the drawing owes little to him. A closely related drawing and one that is similarly inscribed was sold at Sotheby Parke Bernet, Los Angeles, 29 November 1973, lot 4 repr. For this second study Pissarro has changed his viewpoint slightly while retaining the horizontal format, so that the trees on the right of No. 51 now appear on the left. Another difference between the two drawings is that the one offered for sale in 1973 is a pure landscape, whereas No. 51 includes harvesters at work, for which purpose Pissarro has approached nearer to the scene. A painted composition of a harvesting scene, *Paysage avec faneurs*, which is signed and dated 1858, was sold at Christie's, 6 July 1971, lot 24 repr. (not in P&V) and might have been derived from these two drawings.

This type of composition with a low horizon and a broad vista anticipates the painting entitled *L'Automne* (P&V 185), which is one of a series of pictures depicting the four seasons painted in 1872–3.

52 Landscape study of La Roche-Guyon
Pencil on grey pulp paper
Damaged in lower right corner

Signed in pencil *C. Pissarro* and inscribed *La Roche 1859* lower left.
Annotated in pencil upper right *soleil | après-midi la Roche | 1 forte lumière | 2/2 lumiere | 3 ombre | 4 ombre foncé* with appropriate enumerations throughout the drawing
Numbered in pencil *37* upper left
293 × 461

Nos. 52 and 53 form part of an extensive series of drawings of La Roche-Guyon, which appears to have been made in preparation for P&V 13, *Prairies de la Roche-Guyon*, of 1859. Other drawings of La Roche-Guyon may be tabulated as follows (1) formerly in the possession of Lucien Pissarro (CI neg. 52/27 (32)), pen and brown ink over pencil on grey pulp paper, signed in monogram, and inscribed in pencil *La Roche-Guyon*, 360 × 293 (sight), numbered in pencil *38* in upper right corner, exhibited Leicester Galleries 1967, No. 26 repr.; (2) Sotheby's, 6 May 1959, lot 2 once in the possession of Lucien Pissarro (CI neg. 53/34 (11a)), exhibited Leicester Galleries 1955, No. 9 and 1958, No. 37; (3) Sotheby's, 11 December 1963, lot 17; (4) Sotheby's, 25 November 1964, lot 264; (5) Sotheby's, 29 June 1972, lot 17 verso repr.; (6) formerly in the possession of Lucien Pissarro (CI neg. 52/61 (4) or 52/37 (34)), pen and ink over pencil on faded blue paper, signed, dated, and inscribed in pencil *C. Pissarro 1859 LaRoche Guyon* lower left and in ink *C. Pissarro La Roche Guyon* lower right, numbered *68* upper left corner, 315 × 480, exhibited Leicester Galleries 1955, No. 3; (7) Sotheby Parke Bernet, 12 May 1977, lot 205; (8) JPL Fine Arts, London, pencil, signed, dated, and inscribed in pencil *C. Pissarro La Roche 1859*, lower left, numbered *58* upper left corner, no measurements known; (9) JPL Fine Arts, London, no details known; (10) exhibited Marlborough Fine Art 1968, No. 33 repr. Of these drawings, (2) was used as the basis for the etching D. 5 dating from *c*. 1866, and (7) is distantly related to D. 27 of 1880, although the drawing is clearly earlier in date.

Some interesting features emerge from this sequence of drawings, although the compilers have been unable to inspect all the sheets. No. 52, together with (1), are on grey pulp paper and appear to be from the same sketching tablet. (6) is drawn on a pale blue paper and is from the same sketching tablet as No. 53. No. 52, together with (1), (2), (5), (6), and (8), are numbered by the artist with the

following numerations *37*, *38*, *3*, *35*, *68*, and *58* respectively. The drawings are also signed, dated, and inscribed with some regularity, while, stylistically, whatever the medium the main allegiance is still to Corot with areas of precisely hatched lines contained within finely drawn outlines. Linear outline and tonal modelling are perfectly blended. (2) is apparently in red chalk, which is a particularly rare medium for Pissarro.

La Roche-Guyon is near Montmorency where Pissarro was living in 1858.

53 Study of trees with a slight study of a barge
Pen and dark ink over pencil on grey-blue
 paper. Pencil only for the study of the barge
Creased in upper corners
Lugt 613e
311 × 483

No. 53 is closely associated in subject and style to the preceding drawing (No. 52). The topography is undoubtedly that of La Roche-Guyon, although the drawing lacks any inscription to this effect, unlike the majority of the related drawings listed under the previous entry. The penwork, characterized by short, fine lines, is reminiscent not only of the style of Corot, but also of Daubigny, except that the treatment of the foliage is perhaps slightly more schematized than in the drawings of either of these masters. For a comparable drawing by Daubigny, see the *Study of an Orchard at Saint-Denis* in the Ashmolean Museum (K. T. Parker, *Catalogue of the Collection of Drawings in the Ashmolean Museum*, i, Oxford, 1938, No. 570).

54 'Bérille'
Pen and dark ink over black chalk and pencil
 with grey wash
Signed and dated in ink *C. Pissarro 1860* lower
 left. Inscribed in pencil with the title and
 dated again *1860* lower right, and in black
 chalk, or charcoal *près Lille* lower right be-
 neath the composition
Annotated in pencil *blés jaune*
284 × 441. Framing indicated in pencil with
 ruled lines, 243 × 410

No. 54, like many of the drawings of this early period, is signed, dated, and annotated. Clearly,

such detailed drawings were made in preparation for finished pictures, but very few have survived.

The compositional principle of dividing the picture surface into several horizontal planes was frequently used by Pissarro during the 1870s and the 1880s. Significantly, the row of trees, the low horizon line, and the church spire are all features that recur in the famous views of Bazincourt executed during the 1880s.

Another drawing inscribed 'Bérille' and dated 1860, a compositional study of a postman, was exhibited at JPL Fine Arts, London, 1978, No. 3 repr. Janine Bailly-Herzberg and Edda Maillet have pointed out that the place name should be spelt Bérelle, which is a village near Lille apparently visited by Pissarro in 1860.

55 Landscape with a female peasant walking along a road and a male peasant plough-ing a field
Pen and dark ink over charcoal with grey wash
 on grey paper
Signed in ink with the artist's initials lower left
 with a date, also in ink, now erased, above
 which another date *1860* has been inscribed
 in pencil
257 × 431

The technique of No. 55, with its loose penwork used in combination with a wash and the calculated effect of the tone of the paper, is compatible with No. 54, which is dated 1860. The original date on the present drawing has been erased, but that rewritten above in pencil appears to have been done so by the artist. The composition is not dissimilar to that of P&V 10, of 1856, but the emphasis on the figures suggests a slightly later date closer in this respect to P&V 44 and 45, which are dated in the *catalogue raisonné c.* 1864–5.

56 *Sous-bois* (recto)
Black chalk on grey pulp paper
Numbered in black chalk *No. 7* (?) (cut) upper
 left corner
Lugt 613e

Study of a female peasant carrying a load (verso)
Black chalk
292 × 222

No. 56 most probably dates from *c.* 1860. The style of drawing, the type of paper, and the system of numeration are all compatible with No. 52. Indeed, when allowance is made for cutting, it could be claimed that No. 56 is a sheet from the same sketching tablet. The loosely handled composition and the freely distributed chalk lines are also characteristic of drawings of this early date. A painting with which the study on the recto may be compared is P&V 38 assigned a date *c.* 1864 in the *catalogue raisonné.*

The verso is only a slight study, but appears to date from the same time as the drawing on the recto. It is a subject that occurs with greater frequency later in Pissarro's *œuvre.*

57 *Sous-bois*
 Pencil on grey paper with a pink hue
 Numbered in pencil *20* upper left corner
 Lugt 613e
 444 × 280

Sous-bois was a motif employed extensively in mid-nineteenth-century landscape painting, particularly by artists associated with the Barbizon school. The delicate lines of the branches and the silvery tonality of the drawing, partly induced by the effect of pencil on grey-pink paper, are somewhat reminiscent of Corot, and the style may be compared with Nos. 52 and 56. Significantly, like those two drawings, No. 57 is also numbered.

No. 57 is closely related to an early oil study of the same subject, P&V 54, dated *c.* 1867–8 in the *catalogue raisonné.*

58 Study of a tree (recto)
 Pencil
 Pin marks in the corners
 Lugt 613e

 Studies of female peasants gleaning (verso)
 Black chalk
 238 × 316

The fine pencil line used for the drawing on the recto is in striking contrast with the more robust and anecdotal pencil style of the studies done in Venezuela, and is closely related to the pencil drawings of Corot, particularly those dating from the 1820s and 1830s. Pissarro, following Corot and departing

from his own style developed in Venezuela, is here concerned with the contours and the linear appearance of the tree, rather than with the tonal values. The younger artist never approached Corot's style of drawing with the pencil so closely again as on the recto of No. 58. Yet, Pissarro imposed a tighter, more geometric order to the branches and the foliage, avoiding the rhythmic, curvilinear patterns favoured by Corot.

The studies on the verso are markedly different from the recto. Some of the stylistic tendencies exhibited in these studies, however, do first appear in certain drawings made in Venezuela (for example, a sheet of figure studies in the Museo de Bellas Artes, Caracas, inv. 59. 88(A), pencil, 246 × 320). The strong broken outline of these studies on the verso of No. 58, assuming volumetric shapes derived from a modular treatment of the human form (particularly evident in the study top centre), suggests a later date than the study on the recto, most probably 1874–5, when Pissarro worked at Foucault in Brittany. A drawing in the collection of Professor Charles de Tolnay in Florence (black chalk, 240 × 314, initialled by the artist in black chalk lower left corner) is remarkably close in style to the verso of No. 58 and may even be from the same sketching tablet.

59 Compositional study of a landscape with trees, a road, and figures
 Pen and dark ink over pencil
 Two prominent stains on right; other stains throughout
 Erased inscription, or signature, lower left corner
 Lugt 613e
 244 × 321

No. 59 is among the most eclectic of Pissarro's early landscape drawings. The composition, which is characterized by hills and trees folding towards the centre, has loose affinities with those landscapes by Corot and Chintreuil which were painted in the period 1855–65. The dominating motif of the tree is found in compositions by painters of the Barbizon school, particularly Rousseau and Corot. The pen style, however, with its awkwardly drawn contours and its evenly distributed hatching, is not exactly similar to that of any major French artist. It is considerably tighter and more timid than Corot's pen drawings and hints at a move away from that master.

Stylistically, the closest connection within Pissarro's own *œuvre* is with No. 52, which seems to have been drawn in 1859.

60 'Chailly' (recto)
Charcoal on beige paper
Discoloured in places. Creased upper right corner and at lower edge right of centre
Inscribed in charcoal with the title and signed *C. Pissarro* lower left
Pin marks in corners
Framing indicated in charcoal horizontally *c*. 54 mm above lower edge

Brief study of a horse seen in three-quarters profile facing right (verso)
Pencil
Signs of offset from another drawing
315×488

No. 60 is an outstanding example of Pissarro's use of charcoal during his early period in France. A comparable, but not identical, group of trees may be found in the painting *Paysage aux environs de Paris* (P&V 11), of 1857. The subject, the composition, and to some extent the handling of the charcoal on coloured paper are suggestive of drawings made by the painters of the Barbizon school, particularly Rousseau and Daubigny. See, for instance, two studies of trees by Rousseau in the British Museum (inv. 1908.6.16.57 and 1938.2.12.5). Two other studies of a group of trees drawn by Pissarro at Chailly are now in the collection of Mr and Mrs Paul Mellon, Upperville, Virginia, having been sold at Sotheby Parke Bernet, 12 May 1977, lot 211 repr. and Sotheby's, 19 June 1963, lot 19 repr. respectively.

The faint study on the verso of No. 60 is possibly related to the composition developed on No. 48.

Chailly is near the Forest of Fontainebleau. Monet painted there in 1864–5 (D. Wildenstein, *Claude Monet. Biographie et catalogue raisonné*, i, *1840–1881*, Lausanne–Paris, 1974, Nos. 19, 55–57).

61 'Nanterre'
Charcoal heightened with white chalk on grey paper
Inscribed in charcoal with the title lower right
Lugt 613e
243×309

This strong drawing executed in a chiaroscural style at a site very close to Paris has some compositional affinities with the landscapes of Antoine Chintreuil, a follower of Corot with whom Pissarro worked during the early 1860s (see *Antoine Chintreuil 1814–1873*, Musée Bourg-en-Bresse, 1973, No. 18). The combination of black and white chalks on coloured paper was one also favoured by Rousseau. The handling of the medium is close to that in a study of La Roche-Guyon drawn in preparation for the etching D. 5 (Sotheby's, 6 May 1959, lot 2, once in the possession of Lucien Pissarro (CI neg. 53/34 (11a), exhibited Leicester Galleries 1955, No. 9 and 1958, No. 37).

Nanterre lies seven miles to the north-west of Paris, and No. 61 is the only record of Pissarro's visit to what was then a small town, but is now a suburb of the city.

62 Compositional study of a wooded landscape
Charcoal with grey and blue washes thickened with chinese white
Pin marks in three corners
Lugt 613e
300×479. Framing indicated in charcoal with ruled lines, 243×410

No. 62 is interesting for its technique of two-tone washes used in combination with charcoal. The tonal subtleties and the sylvan setting are reminiscent of Corot, and, indeed, are also characteristic of some of Pissarro's own early paintings, such as P&V 30, *Paysage vallonné*, dated *c*. 1863 in the *catalogue raisonné*, and to which No. 62 may be related.

63 Study of a river landscape with boats
Pencil
138×308

River scenes of this kind drawn in the environs of Paris were depicted with great frequency by Daubigny, but both the style of No. 63 with the schematic hatching, first developed in Venezuela, and the composition are wholly Pissarro's own. A similar subject, but one without figures, is P&V 29 (Sotheby's, 19 June 1963, lot 24 repr.), which is dated 1863 and is entitled *La Varenne-Saint-Hilaire*, a village situated on the river Marne where Pissarro rented a house in 1863–4.

64 Study of a river landscape with boats (recto)
Pen and dark ink over black chalk with grey
 wash on grey paper with a pink hue
Lugt 613e

**Two compositional studies of a domestic
interior with a woman arranging
flowers in a vase** (verso)
Pencil
307 × 473

The paper appears to be of the same make as that
used for No. 57, but the present sheet is larger. Sty-
listically, No. 64 shares the same characteristics as
Nos. 54 and 55. The compositional motif of the river
landscape is again, as in No. 63, derived from Dau-
bigny. Comparison with P&V 46, *Bords de la Marne
à Chennevières* (Edinburgh, National Gallery of
Scotland), which is dated *c.* 1864–5 in the *catalogue
raisonné*, suggests that the river shown in No. 64 is
also the Marne. Pissarro rented a house at La
Varenne-Saint-Hilaire near Chennevières in 1863–
4 and made a drawing of the place, which provides
further confirmation for the identification of the
river in No. 64. This other drawing was formerly
in the possession of Lucien Pissarro (CI neg. 52/
27(33), pen and dark ink over black chalk, 241 ×
343).

The verso, which is divided vertically into two,
is a strongly delineated compositional study of a
domestic interior. While the composition antici-
pates the domestic genre scenes of the early 1880s
(see, for example, P&V 575, of 1882, London, Tate
Gallery), the manner of drawing, specifically the
long broken contours, which are so forcefully
redrawn, and the areas of terse modelling, imply an
earlier dating of 1865–70 in common with the recto.
In fact, there is notable similarity of style to No.
68A recto, which relates to a painting executed in
1870. Subjects of domestic interiors dating from the
1860s or 1870s are extremely rare in Pissarro's
painted *œuvre* and the verso of No. 64, therefore,
constitutes important evidence for his compo-
sitional ideas on such themes at this early date, as
well as being an outstanding example of a large-scale
figure drawing made in France prior to 1870. It may
well be the case that the influence of Monet deter-
mined Pissarro's choice of the subject-matter
(see, for example, *Le Déjeuner*, of 1868, Städelsches
Kunstinstitut, Frankfurt-am-Main, repr. D. Wil-
denstein, *Claude Monet. Biographie et catalogue rai-*

sonné, i, *1840–1881*, Lausanne–Paris, 1974, No.
132).

**65 The Mill at Pâtis and a View of l'Hermi-
tage** (recto)
Pencil (Mill at Pâtis). Watercolour (View of
 l'Hermitage)
Stained (Mill at Pâtis). Damaged by damp
 (View of l'Hermitage)
Lugt 613e

Design for a fan (verso)
Pencil and watercolour
Numbered in blue chalk *146*
Inscribed in brown chalk by Camille Pissarro
 aquarelle | de Armand Guillaumin
408 × 251

Exhibited: London/Nottingham/Eastbourne 1977–
8, Nos. 10–11

The recto of No. 65 comprises two drawings on a
single sheet of paper divided vertically into two by
the mount. The approximate sizes of the two com-
positional drawings on the recto are 193 × 258 (Mill
at Pâtis) and 192 × 258 (View of l'Hermitage).

The topography, the type of composition, and the
palette used for the *View of l'Hermitage* (green, yel-
low, and light brown washes) indicate that the two
studies on the recto were made in Pontoise some-
time between 1867–9. The studies relate closely to
a group of Pontoise landscapes of that period (P&V
52, 55–9, and 60–2). Indeed, the drawing of the mill
at Pâtis may have been made in preparation for the
painting P&V 62, of 1868, although in the finished
painting the building has been incorporated into a
more distant view. The almost cubist treatment of
the architecture and the strong broken pencil line,
which characterize the same drawing, are also found
in a study of a *Street in l'Hermitage* (Sotheby's, 11
December 1969, lot 174 repr.). No. 65 is one of the
few surviving drawings from the first truly signifi-
cant moment in Pissarro's career. l'Hermitage and
Pâtis are both in the area of Pontoise, a small town
north of Paris. Pissarro lived in the Fond de l'Her-
mitage at l'Hermitage from 1866–8.

The design for the fan on the verso (not repr.)
of No. 65, which is spread across the whole sheet,
was, according to the inscription by Camille Pis-
sarro, drawn by Armand Guillaumin. The principal
elements of the design are floral motifs in the two

lower corners and a roundel at the top edge with a nude figure of Cupid. In the catalogue of the exhibition of drawings by Camille Pissarro from the Ashmolean Museum circulated in 1977–8, it was suggested that a letter of 3 September 1872, written by Pissarro to Antoine Guillemet (J. Rewald, *Histoire de l'impressionisme*, Fr. edn. Paris, 1955, p. 192), which refers to the presence of Guillaumin and Cézanne in Pontoise, helps to date the studies on the recto of No. 65. Both sides of the sheet, however, need not necessarily have been used on the same occasion, so that while the letter may help to date the verso, it does not follow that the recto is of the same date.

66 Study of four men making a wheel
Charcoal
Stained lower left corner
Lugt 613e
187 × 257

Although difficult to date closely and, in many respects, an unusual subject for Pissarro, the style of No. 66 seems to be closest to that of the decade 1865–75. The figures drawn with hunched shoulders, the emphasis on outline, the tightly controlled, almost geometric sense of form, and the episodic treatment of the subject-matter suggests a date during that decade.

67 SKETCHBOOK II

67A Whole-length study of a female figure seen from the back in three-quarters profile facing left
Charcoal
Creased diagonally from upper left corner towards lower right
Lugt 613e
153 × 87

67B Study of two male peasants
Pencil
Lugt 613e
87 × 154

No. 67A is a drawing of some quality and may be compared with No. 68A recto. The present sheet, however, is somewhat more tentatively drawn and is loosely related to Pissarro's staffage figures occurring in paintings of the late 1860s and early 1870s.

68 SKETCHBOOK III

Used at the time of Pissarro's closest association with Monet, this sketchbook is among the most important in the collection. Pissarro appears to have first taken it up in Louveciennes in 1869–70 before his departure for England where he continued to use it in London. The sketchbook, therefore, escaped destruction during the German occupation of Pissarro's house at the time of the Franco-Prussian war. Sketchbook III includes preparatory studies for several important paintings and gouaches, and serves as a valuable reminder that drawings played a significant part in the creative processes of the Impressionist painters.

68A Study of Madame Pissaro with her daughter, Jeanne, in the front garden of their house in Louveciennes (recto)
Black chalk with incised lines evident throughout
Stained along left edge
Lugt 613e

Study of a man holding a stick and three other slight studies of the same figure (verso)
Pencil
Inscribed in pencil *la* [*sic*] *fumier | le paysage vue attravers une vapeur complètement trans-par[ent]* (cut) *et les couleurs fondues d'une dans l'autre et tremblotants*
200 × 150

The recto of No. 68A is a preparatory study for the painting *La Route de Versailles à Louveciennes* (P&V 96), of 1870, now in the Bührle Collection, Zürich (see *Fondation Emil G. Bührle Collection*, Zürich, 1973, No. 40 p. 118 repr.). Beneath the figures in the drawing there is a faint study of a building drawn in pencil that is almost certainly of one of the houses in Louveciennes, although it cannot be specifically identified in any of the paintings. No. 68A must have been drawn at a fairly early stage in the preparatory process for P&V 96 and there is no indication of the third figure, a maid, who appears in conversation with Madame Pissarro in the picture. The little girl, Jeanne-Rachel, was the eldest daughter and the second of the seven children

born to Camille and Julie Pissarro; she was born in 1865 and died in 1874. She was drawn and painted several times by her father.

The subject of the verso of No. 68A, *Le Fumier*, is made clear by the inscription. The style, although it is weaker and tighter, may be compared with No. 68C recto. The wording of the inscription itself is of interest and amounts to a summary of the Impressionist technique of dividing areas of local colour into isolated patches, which was first adumbrated in 1866–8 by Monet and Renoir.

As indicated by the inscription, the figure is burning dung, and Pissarro's chief interest in the subject is the view of landscape seen through the smoke. The effects of smoke and steam were of great importance for the Impressionists, particularly for Monet, whose treatment of the subject culminated in the group of pictures representing the Gare St. Lazare painted in 1877 (D. Wildenstein, *Claude Monet. Biographie et catalogue raisonné, i, 1840–1881*, Lausanne–Paris, 1974, Nos. 438–48). It is significant that Pissarro should find a rural equivalent to Monet's urban, industrial imagery, and that he should base his own representation of smoke and light on a figure subject.

This slight study with its lengthy inscriptions anticipates a series of drawings and paintings of similar subjects begun in 1883 and continuing into the early 1890s (see No. 160B).

68B 'Le soir soleil couchant'
Pencil

Repaired along left edge. A small tear upper left corner. Stained in lower half

Inscribed in pencil with the title below composition

Annotated in pencil *ciel gris clair, noir, gris, chaud, noir, gris, vert, sombre, gris, jaune, gris, gris vio ... [?] chemin, vert sombre*

Lugt 613e

195 × 150. Framing indicated in pencil along lower edge of composition 55 mm from the edge of the paper

No. 68B does not seem to have been used for a finished painting, although it was undoubtedly drawn for that purpose. Another view of the same house depicted in No. 68B occurs in at least three other paintings of Louveciennes: P&V 119, of 1871, where it is seen on the right half-hidden by a tree,

P&V 140, of 1872, where it can be clearly seen on the right, and P&V 142, where it is again half-concealed by a tree on the right.

68C Study of two male figures hauling on ropes with a further study of a mooring ring with rope attached (recto)
Pencil

Slight study of two male figures hauling on ropes (verso)
Pencil
150 × 202

Although the subject is not easily described, the loose flowing pencil lines are characteristic of drawings made in 1870–1, particularly those done in London (see No. 68F). Comparison with No. 68A verso shows that Pissarro has here adopted a style that in its freedom of line is somewhat reminiscent of drawings by Manet and Monet.

68D Study of Upper Norwood, London, with All Saints Church (recto)
Pencil
Lugt 613e

Slight study of All Saints Church, Upper Norwood, London (verso)
Pencil
Stained with ink from another page in the sketchbook (No. 68E below)
156 × 198

Literature: M. Reid, 'Camille Pissaro: Three Paintings of London 1871. What do they represent?', *Burlington Magazine*, cxix (1977), pp. 257–61 repr. fig. 45 (recto only)

No. 68D, like the following drawing (No. 68E recto), and a watercolour (No. 69), is a preparatory study for the painting P&V 108, of 1871, incorrectly entitled *Eglise de Westow Hill, Neige*. Another related drawing is in the Metropolitan Museum, New York (inv. 56. 173, pencil, 284 × 445, repr. Reid, op. cit., fig. 47). The sequence in which all these drawings was made reveals a great deal about Pissarro's working methods at this date. It seems that the brief pencil study (No. 68D recto) was executed first and was followed by No. 68E recto, in which the artist has shifted his viewpoint, added a gig in the right foreground, and reinforced the

pencil lines with pen and ink. The drawing in the Metropolitan Museum, which is of larger dimensions than any of the related studies in Oxford, has several colour notations, and is a careful study of the scene, but without the gig, or any of the figures. The watercolour (No. 69) incorporates motifs from all these drawings, and inasmuch as it appears to be a snow scene which includes both the gig and the figures, was most probably done immediately prior to the finished painting. All these preparatory studies, it seems to the compilers, were executed on the spot, but it is not impossible, as Mr Reid suggests, that P&V 108 was painted from memory after Pissarro had returned to France. Two related gouaches (P&V 1321) and Christie's, 5 July 1963, lot 45 repr., which also form part of the preparatory process, may have been done later as well. The same composition served as the basis for a fan (see No. 101 below).

The correct identification of the scene is due to Mr Martin Reid, who has proved conclusively that the church is that of All Saints at Upper Norwood, a suburb to the south of London, which was built in 1829. On the recto of No. 68D the building is seen from the north side viewed from Beulah Hill, but on the verso Pissarro has begun to draw the same building seen from the south. Westow Hill is also in Upper Norwood, but is, in this case, a confusion with Beulah Hill.

68E Study of Upper Norwood, London, with All Saints Church (recto)
Pen and brown ink over pencil
Lugt 613e

View from Upper Norwood, London (verso)
Pen and brown ink over pencil
Inscribed in pencil by a later hand *Upper Norwood/Wimstow Hill* (altered to *Windsow (?) Hill*) upper right, possibly intended for Westow Hill (see No. 68D)

Literature: M. Reid, 'Camille Pissarro: Three Paintings of London 1871. What do they represent?', *Burlington Magazine*, cxix (1977), pp. 257–61 repr. fig. 46 (recto only)

For the recto see No. 68D

The drawing on the verso of No. 68E is of considerable iconographic interest combining as it does

for the first time many of Pissarro's favourite motifs—rural foreground with an industrial landscape that includes factories and a train. Mr Martin Reid, to whom the compilers are greatly indebted for his help, has identified the scene. The drawing appears to have been done looking south-eastwards at a point about a quarter of a mile from Palace Road, Upper Norwood, where Pissarro was staying in 1870–1. The train in the middle distance, partly screened by trees, is on the West End and Crystal Palace Railway travelling towards the Crystal Palace (Lower Level) station from Norwood Junction. The buildings on the left are very probably the North Surrey District Schools (Industrial) and Infirmary in what is now Anerley Road, London SE20.

As regards the iconography of No. 68E verso, it is worth noting Pissarro's statement to Wynford Dewhurst made in a letter of November 1902, and quoted verbatim by Dewhurst (W. Dewhurst, *Impressionist Painting: its Genesis and Development*, London, 1904, pp. 31–2). 'In 1870 I found myself in London with Monet, and we met Daubigny and Bonvin. Monet and I were very enthusiastic over the London landscapes. Monet worked in the parks, whilst I, living at Lower Norwood, at that time a charming suburb, studied the effects of mist, snow, and springtime.' It is remarkable to what extent the treatment of the subject on the verso of No. 68E anticipates Monet's painting *Le Convoi de chemin de fer*, of 1872 (D. Wildenstein, *Claude Monet, biographie et catalogue raisonné*, i, *1840–1881*, Lausanne–Paris, 1974, No. 213).

68F Study of Lower Norwood, London, with St. Stephen's Church, South Dulwich
Pencil
There is a brief illegible inscription in pencil lower right written by the same hand as that which inscribed No. 68E verso
Annotated in pencil *brouillard*
Lugt 613e
154 × 198

The church on the left on No. 68F has been identified by Mr Martin Reid as St. Stephen's Church in College Road, South Dulwich, which was consecrated in 1868. Pissarro made a painting of this subject in 1870 (P&V 113, sold Sotheby's, 11 June 1963, lot 33 repr.), but not according to the composition drawn in No. 68F, which looks south-

eastwards towards Sydenham Hill. It is possible, however, that Pissarro drew No. 68F at the very beginning of the creative process for P&V 113 when he began to contemplate incorporating the church as a motif in a painting.

69 **Study of Upper Norwood, London, with All Saints church**
Watercolour over black chalk with traces of pencil
Badly damaged by damp and repaired lower left corner. Rubbed and abraded on the left and along right edge. Evidence of a number in blue chalk offset from another drawing upper centre. Marked by the imprint of other sheets of paper
Lugt 613e
249 × 385

Literature: M. Reid, 'Camille Pissaro: Three Paintings of London 1871: What do they represent?', *Burlington Magazine*, cxix (1977), pp. 257–61 repr. fig. 48

No. 69 is a rather damaged watercolour of the composition evolved in Nos. 68D an 68E for which see the preceding entries.

Pissarro seems to have renewed his interest in watercolour during this visit to England in 1870–1, and such studies undoubtedly began to serve an important part in his working processes. The palette used for No. 69 (orange, violet, grey/black, yellow, and pink) suggests that Pissarro had seen the paintings and watercolours of J. M. W. Turner, whom he admired whilst he was in England. This palette is far removed from the fresh green, yellow, and brown tonalities adopted during the 1860s in France.

70 **Portrait of Jeanne-Rachel Pissarro (1865–1874) seated at a table**
Watercolour over black chalk
Slightly damaged by damp
Signed in pen *C. Pissarro* lower left
245 × 192

Exhibited: London/Nottingham/Eastbourne 1977–8, No. 2

Jeanne-Rachel, also called Minette, was Pissarro's second child. He painted her many times between 1872–4 (P&V 193, P&V 197, and P&V 232—this last now in the Ashmolean Museum). The pose of the figure in No. 70 recalls that of the child seated at the table in the early compositional study for a domestic genre scene on the verso of No. 64. In general, both the sombre tonality and the composition itself are reminiscent of the work of François Bonvin, whom Pissarro met in London in 1870–1 (W. Dewhurst, *Impressionist Painting: its Genesis and Development*, London, 1904, pp. 31–2).

71 **Half-length portrait of Lucien Pissarro (1863–1944)**
Watercolour over charcoal
283 × 235

Exhibited: London/Nottingham/Eastbourne 1977–8, No. 1

In No. 71 Lucien Pissarro appears to be approximately the same age as he is shown in the painted portrait (P&V 333), which is dated *c.* 1875 in the *catalogue raisonné*, and in the lithograph (D. 128), of 1874, although there is no other connection between either of these works and No. 71.

The position of the head in the present drawing, seen in three-quarters profile against a flat background, is characteristic of other portrats of this period (for example, the *Self-Portrait*, of 1873, in the Musée du Jeu de Paume, Paris, P&V 200).

The chief stylistic feature of No. 71 is the unified palette (various hues of grey, pink, red, purple, and white), and, in this respect, it is more successful than No. 70.

72 **Portrait of Mlle Marie Daudon**
Pastel
Signed and dated in pastel *C. Pissarro/1er Janvier 1876*
lower left corner
368 × 253

Literature: P&V 1534 repr.
Exhibited: London/Nottingham/Eastbourne 1977–8, No. 3 repr.

The sitter was the niece of Mme Pissarro and No. 72 was drawn as a pair with a *Portrait of Jules Daudon* (P&V 1533), which was destroyed in the damage suffered when the drawings were in storage in 1940 (see above Explanations, Condition, p. 88). Jules

Daudon was the brother of Marie. He died in 1882 aged twenty-three. Marie's married name was Vermond. The compilers are grateful to Janine Bailly-Herzberg for this biographical information. There are several references to Marie Vermond in family correspondence dating from 1883, principally between Julie Pissarro and Lucien Pissarro.

An earlier drawing of Marie Daudon, dating from the 1860s, was exhibited at JPL Fine Arts, London, 1978, No. 2. This is inscribed by Pissarro with the name of the sitter in black chalk, but was clearly added at a later date.

73 SKETCHBOOK IV

The following five sheets are from a small sketchbook that seems to date from the mid 1870s. It appears to have been used primarily in Pontoise. No other sheets from the sketchbook have yet been found.

73A Study of a woman bending (recto)
Pencil
Lugt 613e

Study of female peasants working in a field (verso)
Pencil
Lugt 613e
150 × 93

The studies on the verso of No 73A were made in preparation for the two figures in the foreground of P&V 301, *Sarcleuses dans les champs, Pontoise*, of 1875. In the painting, the kneeling woman is in the immediate foreground and the woman lying on her side is positioned slightly behind and to the right. It is possible that the fine study on the recto of No. 73A was also done in preparation for this same painting.

The drawings on the verso are rather more tentatively executed than the figure studies on other sheets from this sketchbook. The outlines have not been reinforced by constant redrawing, as in No. 73D recto, and they appear to have been conceived almost geometrically, as in the manner of the figures on No. 58 verso.

73B Study of a small girl seated seen from the back: a study of a female peasant seen **from the back carrying faggots and a pail** (recto)
Pencil

Landscape with a cart on a road (verso)
Pencil
149 × 93

The pose and disposition of the figure drawn in the lower half of the recto resembles that of the peasant seen in the middle distance of P&V 301, *Sarcleuses dans les champs, Pontoise*, of 1875, where, however, she is shown advancing towards the viewer rather than seen from the back.

For other studies in this sketchbook for this same painting see No. 73A.

73C Landscape near Pontoise (recto)
Pencil
Annotated in pencil, *bleu* (3), *haricots jaune*
Lugt 613e

Study of three female peasants in a donkey-drawn cart (verso)
Pencil
Annotated in pencil *rouge-brun, clair*
92 × 149

Both the recto and the verso of No. 73C are rapidly drawn notational sketches, and neither can be related to a specific painting. The drawing on the verso, however, does have compositional affinities with No. 82 where there is a similar emphasis on frontality and verticality.

73D Study of a female peasant bending seen in three-quarters profile facing right: part of a short compositional study of a landscape (recto)
Pencil

Compositional study of a landscape at l'Hermitage (verso)
Pencil
Lugt 613e
149 × 93

Another study of the bending figure in the top half of the recto of No. 73D occurs similarly placed in No. 73E recto where it is more briefly drawn. Both these figures may be compared with that on No. 81 recto.

The slight landscape drawing in the lower half of the recto of No. 73D is continued on the verso

of No. 73E implying that these two sheets were placed in sequence in the sketchbook. See the following entry (No. 73E).

73E Study of a female peasant bending seen three-quarters profile facing right: part of a slight compositional study of a landscape (recto)
Pencil

Landscape at l'Hermitage (verso)
Pencil
Lugt 613e
149 × 93

As in the case of the preceding drawing (No. 73D), the brief compositional study of a landscape in the lower half of the recto of No. 73E is a continuation of that drawn on the verso of No. 73D. These two landscapes were most probably drawn in l'Hermitage in 1874-5. The most prominent feature of both compositions is the stack of wood, which occurs in P&V 265 of 1874 and P&V 315 of 1875. In the drawings Pissarro positions himself to the right of the stack, but, none the less, changes his viewpoint in both studies. Such slight shifts of position indicate how carefully Pissarro composed the features of a landscape even though there is no finished painting of this particular view at l'Hermitage. It is also notable that Pissarro introduces a *repoussoir* motif of an overhanging branch along the upper edge of No. 73D verso, which he repeats on No. 87A verso.

74 Five studies of peasants harvesting
Pencil
Watermark along lower edge at right, in a cursive script, possibly *Lalanne*
Lugt 613e
230 × 301

This sheet of fine figure studies dates from 1874-6 when Pissarro painted a number of harvesting scenes inspired by his visits to Foucault. Of the two principal paintings resulting from these visits (P&V 363 and P&V 364, both of 1876), the figures in No. 74 relate most closely to those occurring in P&V 363, although the correspondence is not exact. In the study of the male figure in the centre of the lower half of the sheet Pissarro is clearly seeking the fugitive effects that could be more successfully obtained with the softer media of chalk, or charcoal, which

he used almost continuously throughout the 1880s in place of pencil.

Another sheet of figure studies in black chalk, heightened with a dark grey wash, in which all the female figures are posed in almost exactly the same positions, but which lacks the male figure in the lower half, was sold at Christie's, 6 December 1977, lot 110 recto repr.

No. 74 is drawn on the same type of paper as No. 80.

75 Sheet of studies, principally of an interior with a woman opening a chest, and other slight studies of a peasant carrying a rake, a female peasant, and the head of a woman (recto)
Black chalk with some pencil
Watermark: L. BERVILLE along lower edge
Lugt 613e

Study of a woman polishing a wooden chest and a study of a female peasant flailing (verso)
Black chalk
238 × 313

No. 75 is drawn on the same type of paper as Nos. 83 and 84. Stylistically, the sheet is related to No. 74 where the study of the male peasant carrying the rake is also found. The brief study of a woman's head placed over the drawing in the centre of the recto resembles in style those on No. 85E. The main studies on both the recto and verso of No. 75, which show, respectively, a woman lifting the lid and polishing a wooden chest, may be preliminary ideas for a painting of a domestic genre subject, but there is no finished picture which includes this motif. All these connections place No. 75 in the period 1874-6.

76 Study of a bed
Black chalk on heavy wove paper
Lugt 613e
201 × 261

Pissarro rarely made detailed studies of still-life objects. Both with regard to the style and the subject-matter No. 76 dates in all probability from the years of his close friendship with Cézanne during

the mid 1870s. Cézanne also made many studies of furniture and other utilitarian domestic objects during this period (A. Chappuis, *The Drawings of Paul Cézanne. A Catalogue Raisonné*, i, London, 1973, Nos. 333-49, pp. 119-21).

Although there are slight differences, the bed appears to be the same as that in which Pissarro's eldest daughter, Jeanne-Rachel, died in 1874. Comparison should be made with the lithograph D. 129, which is dated 3 February 1874, and entitled *Enfant mort*.

77 Half-length study of a male peasant seen in three-quarters profile holding a farming implement facing left
Black chalk on grey paper
Lugt 613e
241 × 224

The drawing is of high quality. The broken contours, the varied texture of the hatching, and the upright pose of the figure suggest a date some time in the middle of the 1870s for No. 77. The drawing may be compared with the studies of a man carrying a rake on Nos. 74 and 75 (recto), although the present study is conceived on a larger scale. The broken outline and the handling of the chalk connect No. 77 with Cézanne's drawings from this same period, of which Cézanne's portrait of Pissarro in the Louvre is an apposite example (A. Chappuis, *The Drawings of Paul Cézanne. A Catalogue Raisonné*, i, London, 1973, No. 300, p. 112).

78 SKETCHBOOK V

Study of a female peasant pushing a wheelbarrow seen from the back with the outline of the gable of a house indicated top centre (recto)
Charcoal over pencil
Lugt 613e

Two studies of a female peasant kneeling (verso)
Lugt 613e
213 × 129

No. 78 is the only sheet in the Ashmolean collection from an important sketchbook that appears to have been used in the mid 1870s and from which several

other sheets are known to have once been in the possession of Lucien Pissarro. These may be listed as follows: (1) *Study of a female peasant carding wool with a study of a female peasant using a pump* (CI neg. 53/7 (31a)), black chalk, 128 × 210 (sight); (2) *Studies of nude and semi-nude female peasants weeding* (CI neg. 53/3 (30a)), pencil and black chalk, 127 × 210 (sight); (3) *Study of a female peasant pushing a wheelbarrow seen in profile to left* (CI neg. 52/72 (8a)), no details known; (4) *Study of a seated female peasant* (CI neg. 52/72 (9a)), no details known, inscribed and dated *Pontoise 1875*; (5) *Sheet of studies including a female peasant lifting a bucket seen from the back* (CI neg. 52/70 (4a)), no details known; (6) *Brief study of a landscape with a study of a nude female peasant lying on the ground* (CI neg. 53/3 (29a)), no details known; (7) *Study of a female peasant weeding with a further study of the head and shoulders of another female figure* (CI neg. 53/6 (24a)), pencil, 190 × 120; (8) *Study of a female peasant weeding with a slight study of a sheep (?) below* (CI neg. 53/6 (22a)), no details known. Of these eight sheets (4) is dated 1875, whilst (3) and (5) are very close in style to the recto of No. 78, the vigorous dark hatching being particularly characteristic. Another interesting factor emerging from these sheets is that (2), (7), and (8), together with the verso of No. 78, were all drawn in preparation for P&V 301, *Sarcleuses dans les champs, Pontoise*, of 1875. In the case of (2) the connection is strikingly close, but the poses of the figures on (7) and (8), and on the verso of No. 78, have been considerably altered. Presumably both the studies on the verso of No. 78 were made for the figure kneeling in the left foreground of the finished picture. The study in the upper half of the sheet, however, is also very close to a figure occurring in P&V 1333, a gouache, which is dated *c.* 1881 in the *catalogue raisonné*.

The content of Sketchbook V overlaps with that of Sketchbooks IV and VI. Two sheets in Sketchbook IV (Nos. 73A and 73B) are also related to P&V 301, whereas No. 85 G recto from Sketchbook VI reveals Pissarro's growing interest in the female nude. The style of the recto of No. 78 is more forceful than that of any other sheet in Sketchbook V. The three Sketchbooks (IV, V, and VI) reflect Pissarro's increasing concern with the human form that began to absorb him during the mid-1870s and which became supremely important to him during the first half of the 1880s.

**79 Study of the head of an elderly man wear-
ing spectacles seen in profile facing right**
Pencil
Lugt 613e
170 × 111

Judging from the quality of the paper No. 79 is
almost certainly from a sketchbook, but no other
drawings from the same source have yet been firmly
identified.

The style is compatible with those drawings
found in Sketchbook V (see No. 78). Another draw-
ing of the same figure seen in three-quarters profile
facing right was exhibited at the Beilin Gallery,
New York, *50 Drawings by Camille Pissarro*,
March-April, 1965, No. 7 repr. (Christie's, 30
November 1971, lot 378 repr.).

**80 Study of a female peasant carrying a load
of hay in the farmyard at Foucault**
Charcoal
Watermark evident along lower edge, at left in
a cursive script, possibly *Lalanne*
Lugt 613e
239 × 305

No. 80 is perhaps the finest example in the collection
of Pissarro's handling of chalk during the middle
1870s.

A similar figure carrying a load of hay occurs in
P&V 321, of 1875, but in the painting she stoops
more under the load and is shown in a different part
of the farmyard. A similar background is used, how-
ever, in a pastel, P&V 1529, *Paysage avec batteuse
à Montfoucault*, c. 1875.

No. 80 is drawn on the same type of paper as No.
74.

81 Study of a female peasant harvesting
(recto)
Charcoal on grey-brown paper
Small stains upper left and lower right
Pin marks in corners
Lugt 613e

**Study of a group of women descending a
flight of steps** (verso)
Brown chalk over traces of charcoal with grey-
brown washes on grey-brown paper.

Rubbed
Lugt 613e
229 × 304

This important drawing was in all probability made
at Foucault on one of the farms of Pissarro's friend
Ludovic Piette where the artist stayed for long
intervals during 1874–6. The treatment of the figure
on the recto of No. 81, drawn with broken contours
and placed virtually parallel to the picture plane,
originates in such studies as No. 58 verso. A similar
figure occurs in two paintings: on the left of P&V
225 and, in reverse, in the right background of P&V
263, of 1873 and 1874, respectively. The technique
of the drawing is of interest. The outlines are
harshly scored, and there is considerable stumping.

The drawing on the verso of No. 81 represents
a group of women descending a flight of steps and
is further elaborated on No. 82. The medium, as
in the case of the recto, is notable. Pissarro has used
a combination of chalk with wash, which is repeated
in the related drawing, No. 82. Neither sheet
appears to have been excessively damaged and the
ghostly effect of the figures emerging as though
through a haze was perhaps intended. No. 81 is
drawn on the same type of paper as No. 82.

**82 Study of a group of women descending a
flight of steps**
Brown chalk over traces of charcoal with grey-
brown washes on grey-brown paper
Rubbed
278 × 222

This sheet is a more detailed study of the composi-
tion recorded on No. 81 verso. The columnar
monumentality of the main figure is a characteristic
feature in the treatment of the human figure in those
studies dating from the Foucault period (1874–6).

A drawing which explores a similar motif as on
No. 81 verso and the present drawing, was sold at
Sotheby's, 27 April 1967, lot 35 repr. The paper of
No. 82 is the same type as that used for No. 81.

**83 Compositional study of a female peasant
herding cows at Foucault** (recto)
Black chalk
Repaired upper right corner
Faintly stained throughout by a red wash (?)
not discernible in reproduction

Watermark along left edge ... VILLE (cut), probably L. BERVILLE (see No. 75)

Lugt 613e

Study of a cow seen in profile facing left (verso)

Black chalk

218 × 288. Framing indicated in black chalk along bottom of composition of verso *c.* 75 mm from the lower edge

No. 83 appears to have been drawn on the same make of paper as the following drawing (No. 84), as well as No. 75.

A painting dating from 1874 with a related motif is P&V 286. The motif was reused several times: P&V 554 (1882), P&V 761 (1891), and a gouache (P&V 1461, *c.* 1891). No. 83 recto was clearly intended as a compositional drawing (note the horizontal line along the lower edge of the composition approximately 75 mm from the bottom), but it was not used directly by Pissarro, since there are several differences in the composition of P&V 286, mainly in the background and in the higher viewpoint, which is also a feature of all the later versions.

The handling of the chalk indicates that the drawing dates from the mid 1870s.

84 Study of the farmyard at Montfoucault

Black chalk

Lugt 613e

234 × 307

No. 84 is one of the many studies made by Pissarro of the farms owned by the Piette family near the village of Foucault in Brittany. The farmyard is most probably that at the farm called Montfoucault. The Ashmolean Museum has in its collection a painting of the farmyard in winter seen under snow (P&V 283) of 1874, but Pissarro introduced the farm, and motifs from the farmyard, in so many other pictures dating from 1874–6 that it is difficult to tell for which work No. 84 was made.

The black chalk has been very delicately and deftly applied. Another study of the same building was formerly in the possession of Lucien Pissarro (CI neg. 53/22 (27a)). The paper of No. 84 is the same type as that used for Nos. 75 and 83.

85 SKETCHBOOK VI

The following eight sheets are all from a sketchbook used mainly in Foucault and Pontoise. Although none of the drawings can be directly related to a finished composition, they contain a multiplicity of ideas that Pissarro began to use during the second half of the 1870s and was to reuse during the 1880s—interiors and rural subjects most probably drawn at Foucault, landscapes made at Pontoise, nude studies, and a visual record of daily peasant toil. The variety of subject-matter and the diverse methods of treatment are both matched by the range of media found in the sketchbook. The style spans the years 1874–9 and reveals a greater awareness of J.-F. Millet than Pissarro had shown so far in his work. Pissarro's friend, Ludovic Piette, died in 1877, and so his visits to Foucault cease after this date. No other sheets from this sketchbook beyond those in the Ashmolean Museum have yet been identified.

85A Study of a female peasant pushing a wheelbarrow seen from the front (recto)

Black chalk

Stained with ink from a preceding sheet in the sketchbook

Lugt 613e

Study of an unidentified landscape (verso)

Pencil

196 × 113

The study on the recto of No. 85A dates from the earlier part of the period spanned by this sketchbook. Pissarro painted a similarly posed, but differently costumed, figure in 1874 (P&V 244, Stockholm, the Royal Museum of Fine Arts). The short splashing lines used for the modelling of the figure in the drawing are found elsewhere in the sketchbook (No. 85 C recto and No. 85H verso) and connect the drawings of this phase in Pissarro's career to the drawings and etchings of J.-F. Millet (see, for example, Herbert, Nos. 114, 125, and 130). The suppleness with which the chalk has been used in contrast with the solidity of the figure, and the impression of arrested movement are characteristic of Pissarro's style during the 1870s in both paintings and drawings.

The style of the landscape study on the verso of No. 85A may be compared with the two landscapes in Sketchbook IV (Nos. 73D verso and 73E verso). It is an equally loose drawing, perhaps the first idea for a composition, but not one that was developed further.

85B Two studies of a domestic genre scene
(recto)
Pen and brown ink over black chalk (study in upper half of sheet)
Black chalk (study in lower half of sheet)
Lugt 613e

Study of a landscape with rocks and trees
(verso)
Black chalk
193 × 116

The drawing in the upper half of No. 85B recto is a compositional study, the dimensions of which are roughly indicated (*c.* 77 × 65). The composition is related in subject to P&V 276 (*La Cuisine chez Piette, Montfoucault*) and P&V 277 (*Une fileuse, intérieur breton, Montfoucault*), both painted in 1874. Indeed, the fireplace shown in the drawing closely resembles that in P&V 276. The briefer study in black chalk in the lower half of the recto is of the two figures only. The technique of the more finished drawing in pen shows certain affinities with etching in its use of vertical hatching to suggest tonal areas, and it is interesting to observe that Pissarro has adopted this same technique in an etching of 1874 (D. 12), which is also of a domestic genre scene. Another drawing directly related to No. 85B recto was formerly in the possession of Lucien Pissarro (CI neg. 53/32(45a), pencil 165 × 193 (uneven), framing indicated in pencil, 155 × 160, exhibited Leicester Galleries 1958, No. 36). This last drawing is larger and rather more carefully drawn than the studies on the recto of No. 85B, which most probably precede it. A loosely related idea for a similar composition where a woman is seen carrying a bowl through the doorway of a house to another figure seated outside is recorded in a drawing owned by JPL Fine Arts, London.

The landscape study on the verso of No. 85B is similar in style to No. 87A. P&V 282, *Paysage avec rochers, Montfoucault*, of 1874, contains a similar motif, but the present study does not seem to be directly related to the paintings.

85C Two studies of a male peasant hoeing
(recto)
Pencil, some outlines of the figure on the left strengthened with pen and brown ink
Annotated in pencil *bleu, verdâtre, chamois, gris bleu* (cut), *noir, velours*

Study of farm buildings at Foucault
(verso)
Pencil
Framing indicated in pencil by a vertical line on right
113 × 193

The studies on the recto of No. 85C are of interest because Pissarro made relatively few drawings, or paintings, of male peasants, and most of those that he did undertake date from the 1870s when he made his first sustained investigation of rural life. The numerous notations suggest that the figure was to have been used in a painting, but no related work has been found.

The slight compositional drawing on the verso of No. 85C is almost certainly of Piette's farm at Montfoucault, the most prominent architectural feature of which was the hayloft (compare the front of the farm as depicted in P&V 287 of 1874). In fact, it is conceivable that the verso of No. 85C may have been drawn in connection with the series of paintings of Foucault subjects executed in 1874–6 (see, particularly, P&V 283–7). It will be observed that the drawing on the verso only extends across three-quarters of the sheet, and, on comparison with Pissarro's practice in Sketchbook IV (see Nos. 73D and E), it is likely that the composition was continued on another page.

85D Study of a female peasant raking (recto)
Watercolour and black chalk
Stained by rust from the verso
Lugt 613e

Study of a female peasant with a cart
(verso)
Black chalk
Extensively damaged in upper half by rust, which appears to take the form of a saleroom cypher. Watercolour offset from another drawing on right
115 × 193

The studies on both the recto and verso of No. 85D were most probably made at Foucault. Signifi-

cantly, in both, Pissarro has indicated an architectural background, which reflects one of his main preoccupations throughout the 1870s, namely the problem of integrating figures into specific settings.

85E Study of two women seated at a table
Pencil, some of the outlines and the hatching on the figure on the left added in pen and brown ink
Lugt 613e
117 × 154

Although somewhat cut down, there are good reasons for assuming that No. 85E once formed part of the present sketchbook. The paper matches, and in such matters as technique, style, and subject the drawing can also be related to the other sheets. The same composition is recorded in a more finished drawing reproduced in T. Duret, *Histoire des peintres impressionnistes*, Paris, 1906, p. 9, in which the two figures are seen from a slightly different angle.

85F Studies of a cat and a hearth with cooking utensils (recto)
Pen and brown ink over black chalk with grey wash
Lugt 613e

Three studies of a cat (verso)
Pen and brown ink over black chalk with grey wash
Lugt 613e
116 × 193

Both the recto and the verso of No. 85F suggest the domestic scenes recorded in P&V 276–7, of 1874, although the drawing is not directly related to either of these pictures. Of considerable interest is Pissarro's use of the brush for drawing outlines, as in the study of the cat in the lower half of the recto and the two studies in the upper half of the verso. The subject and the technique recall certain drawings by Manet, whose studies of cats were made for the second edition of Champfleury, *Les Chats: histoire, mœurs, observations, anecdotes*, Paris, 1870 (see A. de Leiris, *The Drawings of Edouard Manet*, University of California Press, Berkeley and Los Angeles, 1969, No. 226 p. 112 repr. fig. 245, datable to 1868, of which Manet published an etching listed in J. Harris, *Edouard Manet. Graphic Works. A Definitive Catalogue Raisonné*, New York,

1970, No. 64 pp. 176–7, and, particularly, de Leiris No. 328 p. 118, formerly Robert von Hirsch Collection sold Sotheby's, 27 June 1978, lot 824 repr.)

85G Three studies of female nudes (recto)
Black chalk strengthened in places with pencil
Lugt 613e

Study of trees and a hitching post, Pontoise (verso)
Pen and brown ink over pencil
Lugt 613e
113 × 194

The studies on the recto of No. 85E are reminiscent of the drawings of bathers made by Cézanne during the 1870s when, in fact, he was working closely with Pissarro in Pontoise (see A. Chappuis, *The Drawings of Paul Cézanne. A Catalogue Raisonné*, i, London, 1973, Nos. 365–73 pp. 125–6 repr.). It is, therefore, reasonable to assert that Cézanne influenced Pissarro in the drawing of the female nude, for the types, the poses, and the ragged outlines are all comparable with Cézanne's own drawings of this subject.

The penwork of the study on the verso of No. 85G is close in style to that used in the landscape drawings of J.-F. Millet (see, for example, *Maison à Dyane*, Ashmolean Museum; Herbert, No. 210). The same trees and fence appear in the foreground of P&V 92, *Bords de l'Oise à Pontoise*, of 1870, and the same trees, but without the fence, recur in P&V 182 (Pasadena, Norton Simon Museum), of 1872. Both these paintings are too early in date to be associated with No. 85G verso and it seems on the evidence of the present study that Pissarro intended to reuse the motif.

85H Study of an unidentified landscape in winter (recto)
Watercolour over black chalk
Annotated in pencil *degel, paille, paille jaune (?), sombre (?)*
Lugt 613e

Sheet of figure studies (verso)
(1) and (2) Two studies of female peasants resting (upper left corner and lower right corner respectively); (3) Study of a nude woman crouching (upper right corner); (4) Study of a seated female peasant (lower left corner)
(1) Watercolour over black chalk

(2) Copying pencil
(3) Coloured chalks
(4) Black chalk
Lugt 613e
195×116

Pissarro painted several winter landscapes during the second half of the 1870s, but the study on the recto of No. 85H does not seem to relate to any finished composition. The fact that Pissarro tended to screen architecture with trees and vegetation during this period makes it difficult to identify the buildings in the present drawing precisely. In all probability the landscape is of Pontoise.

The studies on the verso of No. 85H are important and anticipate the figure drawings of the 1880s, particularly Nos. 175A and 175C recto. The two reclining figures (1) and (2), may have been suggested to Pissarro by J.-F. Millet, whose pastel *La Méridienne*, of 1866 (Herbert, No. 176, Museum of Fine Arts, Boston), was exhibited at the Gavet sale in 1875 (No. 60). Such figures do, however, only recur in two gouaches executed in the next decade by Pissarro (P&V 1411 and P&V 1415, both of 1887), but, significantly, these were made after the large exhibition of Millet's work held in Paris during the same year. The handling of the reclining figure in the lower right corner is close to two such studies of the 1870s drawn by Cézanne (see A. Chappuis, *The Drawings of Paul Cézanne. A Catalogue Raisonné*, i, London, 1973, Nos. 261–2 p. 106 repr.). The study of the female bather with her hair swept forward in the upper right corner of the sheet (3) continues the motifs explored on No. 85G recto. It is possible that this figure may have been drawn in connection with P&V 376, *La Baigneuse*, painted on the verso of a landscape (P&V 337), of 1876.

86 The pond at Montfoucault, autumn
Pastel
Damaged by flaking left of centre and by a vertical abrasion *c.* 60 mm from left edge
Signed in pastel *C. Pissarro* lower left
Numbered in pastel *No. 13* lower right
249×354

Literature: P&V 1525 repr.
Exhibited: London/Nottingham/Eastbourne 1977–8, No. 12; London, JPL Fine Arts 1978, No. 7

No. 86 is one of Pissarro's finest surviving pastels and is correctly dated 1874–5 in the *catalogue raisonné*. It seems to have been drawn as a pair with P&V 1527, which shows the same pond in summer. Pissarro often made seasonal pairings of this kind during the 1870s, (P&V 209 and P&V 238; P&V 262 and P&V 341; and P&V 328 and P&V 329) There are several painted versions of the same subject dating from this same decade (P&V 268, sold at Sotheby's, 29 November 1976, lot 7 repr. from the Spingold Collection; 275; 317–18; 320; 328–9).

Pissarro's handling of the pastel was most probably inspired by Degas, but the idea of employing this method of varied application in the context of landscape is surely derived from J.-F. Millet. The pastels have been used in a variety of ways: for instance, the water has been reworked so that it has a smooth, almost reflective surface, which is counteracted by the roughly applied pastel of the trees and foreground. Pissarro revels in the complexity of the scene, using intense colours, thereby anticipating Gauguin's principle of hue intensification, which was propounded during the 1880s.

87 SKETCHBOOK (?)

Although there is slight difference in the colour of the paper, possibly caused by exposure to light, the dimensions, medium and style of the following two drawings (Nos. 87A and 87B) suggest that they come from the same sketchbook. No other sheets from the sketchbook have yet been found, but it should be pointed out that both these drawings are approximately the same size as the sheets belonging to Sketchbook VII (No. 97). It is often the case that at this time in France sketchbooks comprised different coloured papers and it is therefore possible that Nos. 87A and 87B also belonged to Sketchbook VII (No. 97).

87A Study of a wooded landscape (recto)
Copying pencil
Faint stains of chinese white upper centre and on right
Lugt 613e

Studies of branches of trees and vegetation (verso)
Copying pencil
135×214

The subjects of both the recto and verso of No. 87A recall those studies made during the 1860s in the environs of Paris (Nos. 56 and 61). Pissarro renewed his interest in pure landscape during the 1870s when he moved to Pontoise, and, stylistically, No. 87A recto and verso may be compared with the landscape studies in Sketchbook IV (Nos. 73D verso and 73E verso), which he used while in Pontoise.

87B Sheet of studies: three studies of a female peasant holding a rake; two studies of a male peasant flailing (recto)
Copying pencil
Lugt 613e

Sheet of studies including a small boy urinating and several slight studies of animals (verso)
Copying pencil
216 × 135

The figures on the recto of No. 87B are closely related to the harvesting scenes of 1876 (P&V 363-4 and 367-8). The subject and pose of the child on the verso recall the composition devised by J.-F. Millet, *La Précaution maternelle*, of 1855-7 (Herbert, No. 111), a painting which was sold at the Millet sale of 1875, possibly attended by Pissarro. Another slight study of the small boy urinating occurs on a sheet of studies formerly in the possession of Lucien Pissarro (CI neg. 53/2 (18a), no details known). The recto of No. 87B can be compared with another sheet of figure studies recently exhibited at JPL Fine Arts, London, 1978 No. 10.

88 Study of a farm at Grancey-sur-Ource
Brown wax crayon
Inscribed in brown wax crayon *Grancey-sur-Ource* upper right
Lugt 613e
206 × 307

Nos. 88 and 89 are the only surviving records of a visit made to Grancey-sur-Ource during the mid 1870s. Grancey, a village near Troyes, was the birthplace of Madame Pissarro (née Julie Vellay). The only documented visit in the letters is that of June 1898 (*Lettres*, p. 455).

Both the subject-matter and the style of No. 88 are compatible with drawings dating from the Fou-

cault period and there can be little doubt that No. 88 was drawn during the mid 1870s.

The lithographic quality in the handling of the brown wax crayon, which is not often used by Pissarro, bespeaks his early interest in that medium, although the drawing does not relate to any of the lithographs of the 1870s catalogued by Delteil.

89 Study of a farm at Grancey-sur-Ource
Watercolour over black chalk
Rubbed and badly damaged by damp and offset, particularly in the lower right where the tree is offset from No. 90
Inscribed in pencil *Grancey* upper right
Numbered in blue chalk on the verso *247*
Lugt 613e
164 × 234

No. 89 is badly damaged. It is closely related to the preceding drawing (No. 88) and presents exactly the same view of the farm, except that it extends fractionally further to the left and includes the corner of the wall. No doubt this watercolour was done on the same occasion as No. 88.

On the verso, there is a whole-length figure of a man wearing a fur-collared coat, which has been offset from No. 209.

90 View of Le Chou, near Pontoise
Watercolour over pencil
Rubbed and badly damaged by damp. Marked by the imprint of other sheets of paper
Signed in pencil *C. Pissarro* lower left and inscribed ... *tire* lower right
172 × 248

Like No. 89, the present drawing is one of the comparatively few watercolours surviving from the mid 1870s, but, unfortunately, like so many of the other watercolours in the collection, it is badly damaged (see Explanations, Conditions above. p. 88).

The landscape is in the area of Pontoise known as Le Chou where Pissarro began to paint with great frequency during the last half of the 1870s and during the early 1880s. The same landscape from a similar viewpoint, for example, is shown in the background of P&V 414, which is dated *c.* 1877 in the *catalogue raisonné*, but when offered for sale at Sotheby's, 23 October 1963, lot 63 repr. it was dated July 1876 with no specific explanation.

For another drawing of this landscape in the Ashmolean collection see No. 97B recto, which is part of Sketchbook VII.

91 The climbing path at l'Hermitage, Pontoise
Watercolour and charcoal
Damaged by damp throughout and marked by
 the imprint of another sheet of paper along
 the upper edge
Lugt 613e
175×231

Unlike those watercolours made at the beginning of the 1870s (No. 65, *Mill at Pâtis*), Pissarro here contains the areas of watercolour within strongly drawn charcoal outlines. Both the compositional motif of distant roofs seen from above and the geometric character of the composition connect No. 91 to a painted view of the same pathway seen from the opposite direction, P&V 308 (New York, Brooklyn Museum) of 1875. The charcoal lines are applied in the same manner as those in other large sheets dating from the mid 1870s (see No. 81 recto).

92 'Valmondois'
Watercolour and charcoal
Damaged by damp throughout and marked by
 the imprint of other sheets of paper
Inscribed in charcoal with the title and signed
 C. Pissarro lower left
Lugt 613e (purple ink)
221×289

Although damaged, No. 92 has retained something of its original quality, particularly in the middle distance. The technique resembles that of No. 91, to which it is presumably close in date.
 Valmondois is a hamlet near Auvers-sur-Oise. There is one passing reference to the place in a letter from Camille to Lucien Pissarro (*Lettres*, p. 80) dating from 17 February 1884, which suggests that Pissarro had already explored landscape motifs there on a previous occasion. No. 92 can certainly be dated before 1884, probably 1877–80.

93 Landscape near Pontoise with a ploughman working a field
Watercolour over charcoal

Damaged by damp throughout, marked by the
 imprint of a sheet of paper at left, with a
 figure right of centre offset from No. 189
 verso
Lugt 613e
174×250

No. 93 cannot be related to a specific painting, but the motif of the sloping hill that serves as a diagonal in the composition is one that Pissarro began to use in the 1870s. The best known example of this motif is P&V 203, *Gelée blanche* (Paris, Musée du Jeu de Paume, inv. RF 1972–27), which was painted in 1873 and exhibited in the first Impressionist exhibition of 1874. However, the freedom with which the washes are applied and the breadth of the composition in No. 93 suggest a date in the later 1870s (compare P&V 381, of 1877).

94 View of Pontoise from St. Ouen-l'Aumône
Black chalk
Lugt 613e
177×229

No. 94 shows both the stylistic and compositional influences of Monet. The loose lightly drawn hatching used for the foliage on the right is unusual for Pissarro, whose compositions are normally invested with a strikingly formal quality. The handling of the subject is reminiscent of *Les Bords de la Seine, Île de la Grande Jatte* and *Les Bords de la Seine à Courbevoie*, both of which were painted by Monet in 1878 and were exhibited in the fourth Impressionist exhibition of 1878 (see D. Wildenstein, *Claude Monet. Biographie et catalogue raisonné*, i, 1840–1881, Lausanne–Paris, 1974, p. 312, Nos. 456, 457, and 458).
 Pissarro never approached the impressionism of Monet more closely than he did in this small experimental drawing, which most probably dates from 1878–9. Another sheet in a comparable style, showing trees against a hillside, was with JPL Fine Arts, London, in 1978 (no details known).

95 Two compositional drawings: 'Le coup de vent' and 'Le verger—Montbuisson' (recto)
Pen and brown ink over pencil on squared
 paper
Folded vertically in the centre

Inscribed in pencil with the respective titles beneath each composition, followed in the case of 'Le coup de vent' only by the size *T8*

Framing indicated in pencil at the right edge and along the lower edge of 'Le coup de vent' (*c.* 87 × 120) and along the upper edge only of 'Le verger—Montbuisson' (111 × 131)

Compositional drawing: 'Basse-cour' (verso)

Pencil on squared paper

Inscribed in pencil with the title beneath the composition with the size *toile de 8*

Lugt 613e (purple ink)

207 × 131

Literature: P&V 408 ('Le coup de vent' only)

The drawing in the upper half of the recto of No. 95, which is entitled 'Le coup de vent', relates directly to P&V 408. In the absence of the original painting the appropriate section of the drawing was reproduced in the *catalogue raisonné*. The painting was, in fact, sold at Sotheby's, 27 June 1977, lot 70 repr. The drawing in the lower half of the recto is connected with P&V 345, *Le Verger à Maubuisson, Pontoise*, and the verso in turn to P&V 431, *Les Poules, basse-cour à Pontoise*, of 1877. The title given P&V 345 in the *catalogue raisonné* is Maubuisson and not Montbuisson as in the inscription of No. 95 recto.

The drawings were clearly made after the paintings and therefore date from after 1877. As might be expected in making summary drawings of this kind, there are certain discrepancies between the compositions and the finished paintings and this is particularly so in the case of the drawing on the verso. The fact that the sizes given by Pissarro at the bottom of No. 95 verso do not correspond with the dimensions of the finished painting is perhaps due to a faulty memory (*toile 8* instead of *toile 6*). The size of *Le Verger à Maubuisson*, recorded as *toile 8*, is correct.

The pen style of No. 95 is very close to that developed by Pissarro during the Impressionist period (see No. 68E).

96 Study of a landscape at Pontoise with a girl guarding cattle

Black chalk on grey paper

Annotated in black chalk *trop grand, orange*

Lugt 613e

120 × 208

Stylistically and compositionally, No. 96 belongs to the period 1879–83. The treatment is broader and the composition more schematic than in the drawings from earlier in the decade. The method of hatching and the freedom of line are similar to No. 99D, a sheet in Sketchbook IX dating from the late 1870s. No. 96 seems to have been drawn in the hills near Oise in the area of Pontoise called Le Chou. An example of this type of composition, conceived on a far larger scale, is P&V 509, *Paysage à Chaponval* (Paris, Musée du Jeu de Paume, inv. RF 1937–51), of 1880.

97 SKETCHBOOK VII

This sketchbook appears to have been used mainly in and around Pontoise during the second half of the 1870s. The sheets in the Ashmolean collection are predominantly of landscape subjects drawn in winter time. Two other sheets from the sketchbook have so far been found, one of them dated 1876. Both were exhibited at JPL Fine Arts, London, 1978, Nos. 8 and 10.; *Study of Le Chou*, pencil, inscribed and dated in pencil, *Pontoise 1876 Chemin de Choux* (*sic*), lower left; *Two half-length studies of a male peasant seated seen in profile facing right* (*recto*): *sheet of figure studies* (verso), pencil and black chalk.

97A Two compositional studies of Pontoise seen from St. Ouen-l'Aumône (recto)

Pencil

Lugt 613e

Study of the quayside and the bridge at Pontoise (verso)

Pencil

Lugt 613e

211 × 130

The recto of No. 97A is divided vertically into two halves, each half containing a compositional study measuring approximately 115 × 130 and 98 × 130 respectively. For both studies Pissarro seems to have positioned himself on the same part of the river and only altered his viewpoint fractionally. These drawings are among the several views of the river Oise that the artist executed in the later 1870s (see

No. 99A). Although carefully prepared, neither of the studies appears to have been used for a finished painting.

The drawing on the verso of No. 97A is no less interesting topographically. Pissarro has crossed the river, moved closer to the town, and included river barges in the foreground of the composition. The handling of the study on the verso is rather more summary than that adopted for either of those on the recto, and, like those studies, does not seem to have been developed further. This view of Pontoise includes the Hôtel Dieu, which appeared prominently in only one other picture, P&V 556, *Quai du Pothuis, soleil couchant, Pontoise*, of 1882.

97B Study of Le Chou with fruit trees, Pontoise (recto)
Pencil
Annotated in pencil *rouge, violet, poirraux*

Study of Le Chou, Pontoise (verso)
Pencil
Annotated in pencil *vert, chamois, vert et ... chamois*
Lugt 613e
128 × 213

The recto of No. 97B has general compositional features in common with No. 90 and the same landscape may have provided the background for P&V 414, *Paysanne avec un âne, Pontoise*, which is dated *c*. 1877 in the *catalogue raisonné*, but was redated July 1876 when offered for sale in 1963 (Sotheby's, 23 October 1963, lot 63 repr.) without a specific explanation.

The views on recto and verso of No. 97B offer two different aspects of the same landscape. The study on the recto includes fruit trees and the river path in the foreground, whereas the verso shows a broader view of the valley and is drawn from further back on the river bank.

97C Two studies of a duck and a slight study of a female nude (recto)
Copying pencil (studies of the duck). Black chalk (nude study)
Lugt 613e

Compositional study of a potato harvest with two female figures (verso)
Pencil
129 × 211

The studies on the recto on No. 97C clearly relate to the series of paintings of poultry executed in 1877 (P&V 426–32) and may have been made specifically for P&V 430. A similar drawing of a duck was formerly in the possession of Lucien Pissarro (CI neg. 52/24 (21), no details known). The brief nude study also on the recto should be compared with those on No. 85G recto and 85H verso, which forms part of Sketchbook VI dating from this same decade.

Although the study on the verso appears to relate to P&V 295, of 1874, there are a number of differences between this drawing and the finished painting, and its inclusion in this sketchbook indicates that it was drawn in the later 1870s when Pissarro reworked so many of his earlier compositions. In fact, P&V 295 itself was remade in 1880 (P&V 1338), for which this slight study was probably drawn. For another drawing of this same subject see No. 98A verso.

98 SKETCHBOOK VIII

The dimensions of these two sheets are similar to those of the drawings comprising Sketchbook IV (No. 73), but the colour of the paper is different. The style of drawing is also slightly more advanced and therefore later in date.

98A Study of a female peasant bending seen in profile facing left (recto)
Pencil
Lugt 613e

Slight study of a potato harvest (verso)
Pencil
150 × 91

The recto of No. 98A recalls the figure studies found in Sketchbook IV, particularly No. 73A recto, where the method of hatching and the accented line are similar. The present drawing, however, may be slightly later in date, towards the end of the 1870s.

The brief compositional study of a potato harvest on the verso is comparable with the more elaborate study of this subject occurring on the verso of No. 97C from Sketchbook VII. No. 98A verso is probably also related to the gouache P&V 1338, *c*. 1880. The composition must have been continued on another sheet from this same sketchbook, since

neither No. 98A nor 98B appears to have been excessively trimmed.

98B Study of a man sitting on a bench seen from the back in nearly three-quarters profile facing left
Black chalk
Lugt 613e
150 × 91

Although the connection is not strikingly close, it is possible that this study is of the same figure as that seated prominently in the left foreground of the gouache P&V 1361, *Marché à volaille, Pontoise*, of 1882, for which there is a compositional study in the Louvre (inv. RF. 22752, black chalk, 231 × 180).

Another sheet from Sketchbook VIII, which is close in style to No. 98B and was formerly in the possession of Lucien Pissarro (CI neg. 52/66 (26a), pencil, 92 × 153), shows a male figure raking seen from the back and may possibly have been drawn in connection with P&V 367, *La Batterie à Montfoucault* (private collection, England), of 1876.

99 SKETCHBOOK IX

The sketchbook can be dated towards the end of the 1870s and during the early part of the 1880s. The drawings are in a transitional style heralding the looser manner of the 1880s. Yet the best clue as to the date is perhaps provided by the iconography, for Pissarro is here beginning to rework old subjects with the aid of a more developed style and to define specific themes more closely. As a result, there are many iconographical connections with paintings executed during the final years of the 1870s.

Five other sheets, some double-sided, from this same sketchbook were also formerly in the possession of Lucien Pissarro (CI negs. 52/67 (30a); 52/67 (28a); 52/67 (27a); 52/67 (29a); 52/57 (14); 52/67 (31a); 52/67 (32a)). These pages are untrimmed, each measuring approximately 170 × 104. Black chalk is the medium in all cases and the subjects, in the same order as the negative numbers above, are as follows: *Study of a female peasant bending with a spade seen in three-quarters profile facing left* (recto); *Two half-length studies of a female peasant in profile facing right* (verso); *Study of a female peasant carrying a load seen from the back* (recto); *Study of a female peasant bending with a spade seen from the front* (verso); *Study of a cow eating seen in profile facing left*—possibly for P&V 1329, of 1880; *Study of five female peasants at a market*—for P&V 1396 dated c. 1884 in the *catalogue raisonné*; *Study of a female peasant digging seen from the front* (offset).

99A Study of St. Ouen-l'Aumône (recto)
Pencil on horizontally ruled printed paper
Inscribed in pencil *St. Ouen* lower left
Annotated in pencil *vert, soleil derière* [sic] *le peintre*
Lugt 613e

Study of a female peasant scything seen from the back (verso)
Black chalk on horizontally ruled printed paper
103 × 165

The recto of No. 99A was most probably intended as a compositional study, although it does not seem to have been developed further. Having included views of isolated factories in a number of his landscapes during the first half of the 1870s, Pissarro began another series of industrial landscapes during the second half of that decade. P&V 344, *Vue de St. Ouen-l'Aumône*, of 1876, is a prominent, and possibly the first, example of this reuse. Iconographically, the recto of No. 99A is of interest, for it shows the bourgeois *promeneurs* of Impressionist painting placed against an industrial background, and this juxtaposition is repeated, for instance, in *Le Pont de Pontoise* (P&V 443), which was exhibited in the fourth Impressionist exhibition of 1880.

The style of the figure on the verso of No. 99A approaches the rhythmical curvilinear style of Pissarro's figure drawings of the 1880s and was probably executed c. 1881.

The horizontal lines above and below the figure presumably indicate the contours of the setting. The study has been made with great rapidity. The pose and the position of the figure on No. 99A verso, as well as the brief indication of the setting, are repeated on another sheet formerly in the possession of Lucien Pissarro (CI neg. 52/68(35a), no details known).

99B Study of a seated female figure seen in nearly full profile facing left
Black chalk on horizontally ruled printed paper
Lugt 613e
166 × 103

Although the present study does not seem to have formed the basis for a painting, this pose, which first occurs in P&V 192, *Jeanne au jardin, Pontoise*, of *c.* 1872, is one that is frequently used by the painter during the 1870s (compare P&V 270–1, 290–1, 373, 421–2). The most likely connection for No. 99B, however, is with P&V 373, *La Mère Gaspard, Pontoise*, of 1876, even though there are several basic differences between the drawing and the finished painting. Pissarro himself states in a letter to Eugène Murer written in 1877 that P&V 373 was 'longuement étudiée' (quoted in the *catalogue raisonné* in the relevant entry). In No. 99B the figure appears to be sewing.

99C Two studies of a cat (recto)
Black chalk on horizontally ruled printed paper
Lugt 613e

Study of the roofs of houses seen through the branches of a tree (verso)
Black chalk on horizontally ruled printed paper.
164 × 104

The studies on the recto of No. 99C may be compared with the drawings of the same subject in Sketchbook VI (No. 85F).

The study on the verso relates loosely to certain landscapes that Pissarro painted towards the end of the 1870s in which the main feature is the screening of the buildings by trees, or foliage. Prominent examples of this motif are P&V 380 and P&V 384, both of 1877, and both painted in Pontoise. An aquatint (D. 16), of 1879, shows Pissarro's continuing interest in the screening of landscape.

99D 'Soleil couchant'
Black chalk on horizontally ruled printed paper
Inscribed in black chalk with the title along the lower edge
Annotated in black chalk *bleu fond pur | jaune doré | verdâtre* (2)

Lugt 613e
103 × 170

The composition of No. 99D recalls those landscapes executed by Pissarro during the first half of the 1870s (for example, P&V 177), but, structurally, it is looser suggesting a date towards the end of the decade. No. 99D, therefore, like several other drawings in this sketchbook, is a reworking of an earlier composition. Although Pissarro did not evolve this particular version into a finished painting, there are general similarities with P&V 490, *Soleil couchant, côte des Grouettes, Pontoise*, of 1879.

For other drawings of this theme see Nos. 68B, 141B verso, 176A, and 237.

100 SKETCHBOOK X

Two other sheets from this sketchbook have so far been found. Both were in the possession of JPL Fine Arts, London, in 1978. The first is *View of St. Ouen-l'Aumône* (recto), black chalk, 110 × 195, inscribed in black chalk upper right *grde route Osny, Studies of female figures at a market* (verso), pencil with pen and ink. The second sheet is *Compositional studies of peasants working in a field and a landscape* (recto), copying pencil and black chalk, 116 × 197, with *Study of four cows* (verso), black chalk. This second sheet is uncut.

100A Compositional study of a landscape with the Île de Pothuis and the factory at St. Ouen-l'Aumône (recto)
Black chalk
Lugt 613e

Brief study of a landscape at Pontoise (verso)
Pencil
113 × 193

The spaciousness of the composition of the drawing on the recto of No. 100A characterizes Pissarro's paintings dating from the final years of the 1870s, a time when the artist also adopted a broader technique in his brushwork, which is to some extent matched by the free handling of the chalk on the recto of the present drawing.

The verso is faintly and rapidly drawn. It is a

slight landscape study. The contours are reminiscent of those of Le Chou near Pontoise and comparison should be made with No. 97B verso.

100B Compositional study of a landscape with the factory at St. Ouen-l'Aumône
Pen and dark ink over pencil with grey wash
Inscribed in pen *Pontoise à Mery* upper right
Lugt 613e

Pissarro painted several views of St. Ouen-l'Aumône, in which the factory is the most important feature, in 1876. A painting with this same motif, but viewed from further down the river and from the opposite bank, is P&V 398, of 1877. The clarity of the pen line and the economic use of the wash are here combined in a drawing that resembles in many respects the landscape drawings of J.-F. Millet (compare, for instance, Herbert, No. 217, *Le Lieu Bailly*, Ashmolean Museum, and Herbert, No. 206, *Le Sentier, près Vichy*), and even anticipates those of Degas, of which there are two fine examples in the Ashmolean collection (Grete Ring Bequest, 1954).

101 Compositional study for a fan
Pencil on beige paper
Lugt 613e
169 × 129. Shape of fan indicated in pencil, 107 × 260

The fan for which this study was made has not survived and may not even have been begun. The composition is a reworking of P&V 108, the incorrectly entitled *Eglise de Westow Hill, Neige*, of 1871, for which there are a number of preparatory drawings in the collection (Nos. 68D, 68E, and 69). Pissarro first exhibited fans in 1879, and No. 101, like the following drawing, undoubtedly falls into an early group of such designs.

The sheet has been stuck down, but lines, possibly in blue chalk, can be made out on the verso. They appear to be in the shape of a Japanese fan.

102 Compositional study for a fan with two brief studies of female peasants upper left
Pencil on beige paper
211 × 290. Shape of fan indicated in pencil, 117 × 265

No. 102 is most probably an early study for the fan P&V 1626, *L'Hiver, retour à la Foire*, which was exhibited at the fourth Impressionist exhibition of 1879 (No. 189) and was subsequently in the collection of Paul Gauguin (M. Bodelsen, 'Gauguin, the Collector,' *Burlington Magazine*, cxii (1970), p. 612, Cat. No. 43). There are many changes in the final composition, but the basic conception is the same. The fan itself has many more figures, and those on the right of No. 102 have been changed so that in the fan they look outwards balancing those on the left. The contours of the landscape have been retained in P&V 1626.

The style of No. 102 is very close to that of the preceding drawing, which was also drawn in connection with a projected fan.

103 Study of the head of a woman wearing a hat seen from the back in three-quarters profile
Pencil on card
93 × 57

No. 103, drawn on the verso of a visiting card printed *J. K. Huysmans | 11, rue de Sèvres*, and No. 104, drawn on the verso of similar card printed *Franc Lamy | 79, rue Lemercier* and further inscribed in pencil by Pissarro *35 rue Capron*, provide evidence that Pissarro's interest in urban caricature began before his trip to Rouen in 1883. Huysmans, an early follower of Zola, met the Impressionists in the later 1870s and wrote lengthy reviews of their exhibitions in 1880 and 1882, which were published in his collection, *L'Art moderne*, of 1883. Lamy was a minor landscape painter who exhibited at the third Impressionist exhibition held in April of 1877 (L. Venturi, *Les Archives de l'impressionnisme*, ii, Paris-New York, 1939, pp. 259, 308, and 329). It is probable that these two drawings, with their rapidly drawn pencil style, were executed in the period 1878–83 when Pissarro kept a studio in Paris and painted several urban scenes (P&V 435 and 475).

104 Study of the head of a woman wearing a hat seen in profile facing left
Pencil on card
Creased at upper right and lower left corners
Lugt 613e
95 × 56

See No. 103 above.

105 Study of a female peasant cleaning a saucepan
> Black chalk heightened in places with gouache
> on pink paper prepared with a thin layer of
> chinese white
> Lugt 613e
> 468 × 316

No. 105 was drawn in preparation for the painting, *Femme lavant une casserole* (P&V 473), of 1879, which was exhibited at the fifth Impressionist exhibition of 1880 (No. 133). The pose of the figure in the finished painting is considerably more constrained with the body more upright and columnar. An early photograph (reproduced below) indicates that Nos. 105–106 originally formed one sheet, which was later cut in half.

Nos. 105–106 are among the earliest examples of those large-scale studies which became such a dominant feature of Pissarro's draughtsmanship during the 1880s and 1890s. They are characterized by a curvilinear style which is markedly different from the modular figure drawings of the mid 1870s, and, in this way, they anticipate the loosely drawn outlines of figure studies dating from the early 1880s.

106 Nearly whole-length study of a female peasant with a detailed study of the fore-shortening of the right forearm and hand above
> Black chalk on pink paper prepared with a
> thin layer of chinese white
> Numbered in blue chalk *14A* upper left
> corner
> Lugt 613
> 462 × 276

See No. 105 above.

No. 106 relates to the painting, *La Cueillette des pois* (P&V 519), of 1880, which was exhibited at the fifth Impressionist exhibition of that year (No. 130). The figure occurs in the right half of the painting and is almost unchanged.

107 Paysanne cueillant de l'herbe
> Pastel heightened in places with a pink wash
> 592 × 425 (sight) (Imperial)

Literature: P&V 1554 repr.
Exhibited: London/Nottingham/Eastbourne 1977–8, No. 15 repr.

No 107 is illustrated uncut in the *catalogue raisonné* where the dimensions are given as 630 × 510. The study is related to P&V 543, *Paysanne ramassant de l'herbe*, of 1881, and was most probably made in preparation for that painting. A related drawing in charcoal, squared for transfer, and comparable in size (660 × 480) to No. 107 before it was trimmed, was sold at Sotheby Parke Bernet, 18 May 1978, lot 104, repr.

108 Three-quarters length study of a female peasant eating seen in profile facing left
> Pencil
> Lugt 613e
> 310 × 201

Exhibited: London/Nottingham/Eastbourne 1977–8, No. 14

This rather tentative drawing was made in 1881 and relates to the figure standing on the right of the tempera, *La Marchande de Marrons, Foire de la St. Martin, Pontoise* (P&V 1348), of 1881. In No. 108 Pissarro has attempted to execute a full-scale figure study in pencil rather than in the chalk, or pastel, which he came to favour for drawings conceived on this scale during the 1880s and 1890s. The nervousness of the hatching and the complexity of the repeatedly drawn outlines weaken the effect of the drawing, and it is perhaps significant that, as far as one can tell in the present state of knowledge, Pissarro rarely, if ever, made figure studies in pencil on this scale again. A very similar figure to this one had already been used in reverse by Pissarro for the etching of the same subject (D. 15), of 1878. Since only one arm of the figure is shown in the etching, whereas in both No. 108 and in the completed tempera the right arm is included, it is reasonable to conclude that the drawing was made in preparation for P&V 1348. The composition was reused in reverse in 1891 for a pastel (P&V 1592).

109 'Récolte de petit-pois'
> Pen and brown ink over pencil
> Inscribed in ink with the title along lower
> edge
> Lugt 613e
> 198 × 310

See No. 110 below.

110 Study of figures harvesting peas
Pen and brown ink over pencil
Lugt 613e
196 × 304

Nos. 109 and 110 were very probably drawn in connection with P&V 518, *La Cueillette des pois*, which is dated *c*. 1880 in the *catalogue raisonné*. Whereas during the late 1870s Pissarro was principally concerned with the relationship between the figure and the landscape, during the 1880s he showed a new concern for the interrelationships among the figures themselves. This accounts for the interest displayed by the artist in the internal rhythm set up by the disposition of the figures within each of these drawings. The underdrawing was probably done rapidly on the spot and then later reinforced in pen and ink, a technique that recalls some of the drawings done before Pissarro settled permanently in France in 1855.

The composition of No. 110 is closely related to an unpublished fan in a private collection, New York, which was discovered by Mrs Barbara Shapiro (B. S. Shapiro, *Mary Cassat At Home*, Museum of Fine Arts, Boston, Exhibition held between 5 August–24 September 1978, No. 66). The compilers are grateful to Mrs Shapiro for information regarding the fan and for supplying them with a photograph.

111 Study of a woman and child riding on a donkey led by a man
Pen and brown ink
Repaired along the upper edge and creased in
 lower left corner
Lugt 613e
101 × 152

The treatment of this subject suggests the theme of The Flight into Egypt, which is also reflected in one other drawing in the Ashmolean collection (No. 31 recto). The origin of the composition perhaps lies in a genre scene witnessed by Pissarro, which he then interpreted as The Flight into Egypt inspired by Rembrandt's etching of the subject (Bartsch 52 and 54).

No. 111 dates from the period 1879–81. The style of the penwork is very close to that of Nos. 109 and 110, which were executed in 1880–1. The treatment of the head and kerchief of the female figure in No. 111 are directly comparable with that of the figure

on the extreme right of No. 110. Pissarro, in fact, included a version of The Flight into Egypt in a painting of 1878, *Paysage près d'Auvers, avec une Paysanne montée sur un âne* (P&V 494), which was once in the collection of Paul Gauguin (M. Bodelsen, 'Gauguin, the Collector', *Burlington Magazine*, cxii (1970), p. 611, Cat. No. 36 repr. fig. 47).

112 Five studies of a male peasant working
Black chalk
Creased upper left corner
Lugt 613e
229 × 173

It is highly likely that Nos. 112 and 113 come from the same sketchbook, although there is a slight difference in size, no doubt due to cutting. Another sheet possibly from this same source is a drawing in the Schonemann collection (exhibited Norton Gallery and School of Art, West Palm Beach, Florida, December 1976–January 1977, No. 9 *Three studies of a peasant woman working in the fields*, black chalk, 171 × 229).

The suppleness of line and the handling of the chalk suggest a date some time during the 1880s. There is a similar rhythmical flow in the chalk underdrawing of No. 127, which is a study for a gouache, P&V 1347, of 1881. The two pictures entitled *Le Père Melon au repos* and *Le Père Melon sciant au bois, Pontoise* (P&V 497 and 498), both of 1879, and the gouaches, P&V 1336 and 1337, the first of which is dated 1880, attest Pissarro's interest in the male peasant as a subject at this time. Another study of the same figure at work, as shown in No. 112, occurs on the verso of a drawing known only from a photograph in the Witt Library, London (black chalk, inscribed *grain de carottes*, 230 × 180).

113 Four studies of a nude woman bending
(recto)
Black chalk
Creased in lower left corner
Lugt 613e

Compositional study of the left half of a fan showing two female peasants conversing in a wooded landscape (verso)
Pencil
175 × 219

Since Nos. 112 and 113 appear to be from the same sketchbook, it must be assumed that the design for a fan on the verso, which is only half complete, was continued on another sheet that is still missing.

The verso is a study for the left half of a fan, *Paysage avec deux paysannes à gauche*, P&V 1623, which is dated *c.* 1883 in the *catalogue raisonné* (sold Sotheby's, 6 December 1978, lot 219 repr.). The recto also dates from the first half of the 1880s and shows Pissarro's sporadic, but continuing, interest in the subject of the female nude.

114 Four compositional studies of a conversation piece
Black chalk
Lugt 613e
255 × 317

The four compositional studies on No. 114 all relate to the gouache P&V 1326, *Paysan avec deux paysannes conversant* which is dated *c.* 1879 in the *catalogue raisonné*. The gouache differs considerably in that there is a seated female figure to the left of the man. The pose, dress, and type of the male figure, and the presence of a seated female figure in the immediate foreground seen from the back, are, however, common to all four compositional studies on No. 114 and to P&V 1326.

115 Sheet of studies: four studies of a female peasant bending and two studies of a woman holding a basket seen from the front and from the back respectively
Black chalk. Watercolour over charcoal for study in centre
A few small watercolour blotches in upper half
Lugt 613a
313 × 210

Exhibited: London/Nottingham/Eastbourne 1977–8, No. 19

The two faint studies of a woman carrying a basket in the lower half of the sheet are stylistically akin to those of the man carrying a rake in Nos. 74 and 75 recto. The other studies, all of a female harvester bending, may be compared with No. 116 recto, and, like that drawing, there is a certain similarity in subject and composition with the third woodcut in-

cluded in the published portfolio, *Travaux des champs* (Leymarie and Melot, P. 204). However, the study in the upper left corner of the sheet is closely related to the bending female figure in the centre foreground of P&V 1358, *La Moisson* (Tokyo, Bridgestone Museum), of 1882, an important gouache, for which there are a number of other studies in the collection (Nos. 118–23).

116 Six studies of female peasants harvesting (recto)
Black chalk
Lugt 613e

Study of a landscape at Pontoise (verso)
Black chalk
243 × 155

The sheet on which No. 116 is drawn has been cut into two halves and trimmed. The right half was also formerly in the possession of Lucien Pissarro (no CI neg., black chalk, 248 × 162 (uneven)). The recto of the right half has further figure studies similar to those occurring on the recto of No. 116, while the verso continues the landscape composition on the verso of the present drawing. A copy of the whole landscape made by Lucien Pissarro is in the Ashmolean collection (inv. 77. 981, black chalk, 248 × 327). The type of wove paper used by Lucien Pissarro is the same as that of No. 116 and the size of his drawing is almost exactly that of the two halves of the sheet by Camille Pissarro joined together.

Although the treatment of the landscape on the verso of No. 116 is reminiscent of the motifs explored by Pissarro towards the end of the 1860s and during the first half of the 1870s (for example, P&V 56 and 59), the amount of detail included in this study is unusual for Pissarro's early landscape drawings, which are much broader in style (see No. 65 above). A later date must, therefore, be posited for the verso of No. 116. In favour of this are the paintings P&V 509, *Paysage à Chaponval*, of 1880, and P&V 568, *La Côte du Chou à Pontoise*, of 1882, which are composed like the earlier landscapes of l'Hermitage and yet, also bear, inasmuch as one can compare them, the same detailed technique as No. 116 verso.

It is conceivable that the studies on the recto may have been made for *La Moisson* (P&V 1358), of 1882, for which Pissarro made a number of indivi-

dual figure studies (see Nos. 118–23) The seated figure in the lower right corner recurs on the third woodcut in the series of six issued as a portfolio with the title *Travaux des champs* (Leymarie and Melot, P. 204). Indeed, the *mise-en-page* of the recto anticipates the relevant woodcut as a whole, and it may be the case that No. 116 was reused as part of the working process of *Travaux des champs*, which dates from the mid 1880s.

117 Study of a haycart in a field (recto)
Black chalk
Damaged and creased in three corners (upper
 and lower left, and lower right)
A few small tears along lower edge
Lugt 613e

Study for a fan—fragment (verso)
Black chalk
113 × 173

Although No. 117 may have been made as early as 1876, when Pissarro painted a large number of pictures inspired by the harvest in Foucault, the loose style of the sheet, together with the spaciousness of the setting, link it more convincingly to the series of drawings done near Pontoise during the harvest season of 1881 (see Nos. 118–23).

The verso of No. 117 is a fragmentary study of a fan, which does not relate to any published example.

**118 Study of harvesters working in a field
near Pontoise**
Black chalk and watercolour
Lugt 613e
188 × 305

No. 118 was most probably made during the initial stages of planning for Pissarro's important tempera painting, *La Moisson* (P&V 1358, Tokyo, Bridgestone Museum), which was exhibited at the seventh Impressionist exhibition in April of 1882 (No. 136). This picture is notable for the unusually large number of preparatory drawings which relate to it (see also Nos. 119–23).

It is probable that the majority of these drawings, including No. 118, was made during the harvest of August, 1881.

119 Three studies of a male harvester (recto)
Grey wash over pencil
Stained in lower left corner
Lugt 613e

**Study of a female harvester with a study
of a female peasant emptying a wheel-
barrow (?)** (verso)
Pencil heightened with grey wash
149 × 189

See No. 120 below.

120 Studies of a male and female harvester
(recto)
Grey wash over pencil
Stained in lower left corner
Lugt 613e

Four studies of male harvesters (verso)
Pencil heightened with grey wash
149 × 200

Nos. 119 and 120 were clearly drawn in sequence, probably on the same day. Like No. 118, these studies were made during the harvest season of 1881 in preparation for P&V 1358. Both sheets were drawn with great rapidity. The sense of movement has been caught with fluid outlines drawn with the brush reinforcing the lightly indicated pencil lines below.

It seems likely that Nos. 119 and 120 came from the same sketchbook. The figures on the verso of No. 120 were developed further on a drawing of larger dimensions sold at Christie's, 30 June 1967, lot 41 repr.

121 Four studies of a male peasant flailing
(recto)
Charcoal on faded blue paper
Pin hole centre of lower edge

Three studies of male harvesters (verso)
Charcoal on faded blue paper
Numbered in blue chalk *328* upper left corner
305 × 230

The artist has turned the paper vertically before making the studies on the verso. The most interesting aspect of both the recto and verso of No. 121 is the use of oily charcoal, which owes a great deal to the example of Degas. As such the drawing is

difficult to date, but the subject-matter at least suggests a possible connection with the genesis of the tempera painting *La Moisson* (P&V 1358), of 1882. There does not seem to be a positive connection with any of Pissarro's later harvesting scenes, namely P&V 713 of 1887, P&V 730 of 1889, P&V 771 of 1881, and P&V 1207 of 1901, or with his important gouaches on this same theme (P&V 1394, P&V 1441–4, and P&V 1494–5). It is probable that Pissarro's conception of *La Moisson* was related to Millet's *L'été, les batteurs de sarrasin* (Herbert, No. 245), which was exhibited in 1878 at the large Barbizon School Exhibition held at Durand-Ruel. In the earlier picture, Millet placed the flailers in the background of the composition and it is likely that Pissarro may have included similar figures in the many studies done in preparation for *La Moisson*, although he omitted them in the final painting.

There are two other related drawings of harvesters which were probably also made during the harvest season of 1881: (1) Sotheby's, 11 December 1969, lot 183 repr. exhibited Leicester Galleries 1967, No. 55; (2) formerly in the possession of Lucien Pissarro (CI neg. 52/52 (45), no details known).

No. 121 is notable for the internal rhythm of the drawing and for the unusual power, even crudity, of execution. The motif of the flailer on the recto of No. 121 was reused in the third print of the published portfolio, *Travaux des champs* (Leymarie and Melot, P. 204) and is repeated in *La Charrue d'érable* (p. 19) as a *cul-de-lampe* (Studio Book II. f. 117 No. 317).

122 Study of harvesters working in a field near Pontoise
Brush drawing in grey wash on squared paper printed in brown ink
Stained by watercolour upper left corner and by oil paint upper right corner
Lugt 613e
275 × 478

No. 122 is a preliminary study for the tempera, *La Moisson* (P&V 1358), of 1882, which was exhibited in the seventh Impressionist exhibition of that year. Pissarro also made a preparatory drawing in pastel for the same composition (P&V 1558), which was once owned by his biographer, Adolphe Tabarant. In both the finished tempera and in the pastel Pis-

sarro has altered the disposition of the figures (for instance, the male figure in the centre foreground of No. 122 has been replaced by a woman facing in the opposite direction still seen in three-quarters profile, but from the back), and increased the number of harvesters. Only the female peasant in the lower left of No. 122 remains virtually unchanged. No. 122 is, therefore, presumably an early compositional study for *La Moisson* made before the detailed figure drawings executed in the studio. The style of No. 122 is closely related to that of the preparatory drawings in brush (see Nos. 119 and 120).

123 Study of two female harvesters
Black chalk on pink paper prepared with a thin layer of chinese white
Repaired at the edges. Several folds and creases in left half. Abraded in upper half
Signed in blue chalk with the artist's initials lower left corner
Number in blue chalk *48A* lower right corner
Lugt 613e
428 × 638 (uneven edges) (Imperial)

Exhibited: London/Nottingham/Eastbourne 1977–8, No. 16 repr.

This is one of the most powerful figure drawings in the collection and was drawn in connection with *La Moisson* (P&V 1358), of 1882, a composition for which Pissarro made a number of preparatory studies (see Nos. 118–23). The present drawing is a detailed study of the two main figures in the foreground of the finished composition. The woman seen from the back on the left of the sheet was used as a substitute for the man in the centre of No. 122. In the final composition, however, while Pissarro has retained both these female figures, he has reversed their positions, placing the bending woman to the right of the one carrying the sheaf of wheat. It is probable that the sheet was drawn from models posed in the positions in which Pissarro had observed them in life.

124 Study of a seated woman
Black chalk on grey-blue paper
Stained with spots of wash
Lugt 613e
302 × 234

A similar figure occurs on the right of P&V 531, *Paysannes au bois*, of 1881. Although the pose is virtually unchanged, the figure is seen in three-quarters profile and is placed more on a diagonal in the finished picture. A second seated figure forms part of the composition of P&V 531. There are indications of such a figure on the left of No. 124, but it is difficult to make out the exact pose. A drawing formerly in the possession of Lucien Pissarro (CI neg. 52/57(18), no details known) is also relevant to P&V 531. This shows the two seated figures that appear in the finished painting, but includes a third standing female figure on the left, which Pissarro obviously decided to omit.

125 Study of a female peasant lying on the ground seen from the back
Black chalk with charcoal and some pastel heightened in places with gouache
Signed in ink (?) with the artist's initials lower right
348 × 537 (Imperial)

Exhibited: London/Nottingham/Eastbourne 1977–8, No. 17

This vigorously executed study, one of the outstanding drawings in the collection, is related to the figure centrally placed in the lower foreground of P&V 563, *Les Sarcleuses, Pontoise*, of 1882. In the painting the figure has been placed on a steeper diagonal, but, as in the drawing, the lower part of the body has been omitted. A notable aspect of this large-scale drawing, which forms such an interesting contrast with the related pencil study also in the collection (No. 126), is the combination of media. The charcoal in the lower half of the figure has been ruggedly applied to strengthen the black chalk underdrawing. The pastel and gouache are limited to the kerchief. Although No. 125 dates from 1881–2, the charcoal lines and the pastel may have been added late in the mid 1890s when Pissarro's handling of the softer media became more rugged (see Nos. 240 and 241).

Regarding Pissarro's development in the treatment of the human form in different decades, compare the present drawing with No. 73A verso in Sketchbook IV, which shows a female peasant in a similar pose. Interestingly, this earlier drawing was made in connection with P&V 301, of which P&V 563 is a reworking.

126 Study of a female peasant weeding
Pencil
Lugt 613e
175 × 206

The pose of this tentatively drawn figure is very close to that of the female peasant lying on the ground in the centre of P&V 563, *Les Sarcleuses, Pontoise*, of 1882. A much more powerful study for one of the other figures in this painting is also in the collection (No. 125).

127 Compositional study of the market at Pontoise
Black chalk and grey washes
Repaired at the lower left corner and creased in lower right corner
Lugt 613e
304 × 193

This marvellously fluent drawing was probably made in 1881 in connection with the gouache of that year P&V 1347, *Marché aux blés à Pontoise*. While the basic elements of the composition remain the same in the gouache, Pissarro has omitted one of the women shown in conversation in the middle distance, added a standing figure on the extreme right, and lowered the horizon line.

Like No. 128 below, the present drawing is one of Pissarro's earliest studies of a market scene and formed one of the compositional bases for this important subject which he continued to explore during the 1880s and 1890s.

128 Compositional study of a market at Pontoise
Black chalk
Inscribed in ink *La St Martin Pontoise* lower left
Lugt 613e
195 × 154

No. 128 may have been part of the same sketchbook as No. 129.

The loose and increasingly confident contours of the drawing connect No. 128 with other figure studies of the period 1880–3. Perhaps, as he did on No. 127, Pissarro intended to add a wash to the drawing. The present drawing shows the market at the Foire de St. Martin at Pontoise. Although the seated

female figure so prominently placed in the fore-ground is a feature that recurs in most of Pissarro's market scenes, No. 129 is not directly related to any such finished composition. Here, in contra-distinction to other market scenes, the figure is placed towards the centre instead of to one side, as is usually the case. The pose of the male figure in the upper right corner is close, and possibly related, to the studies of the male peasant on Nos. 206 and 207. Comparison should also be made with a figure seen from the front, but similarly clad, in P&V 862, *Le Marché aux grains à Pontoise*, of 1893. As such, like the woman placed in the foreground, it can be asserted that this male figure is one of the standard types employed by Pissarro in his market scenes.

The Foire de St. Martin, referred to in the in-scription, was the most important annual festival in Pontoise. It took place in early November and Pis-sarro depicted this particular fair several times in different media. He painted it for the first time in 1872 (P&V 178), and dating from the same decade are a lithograph (D. 131, of 1877) and an etching (D. 21, of 1879). There are also numerous paintings dating from the 1880s and 1890s. These depictions of the Foire de St. Martin form a sequence, which moves from landscape to genre painting, and No. 128 reveals Pissarro's growing interest in the figural aspects of the theme.

129 Compositional study of a landscape with a female peasant seen from the back walking along a road
Black chalk with grey wash
Annotated in black chalk *rose, lilas, bleu clair, bleu foncé*
Lugt 613e
192 × 151

No. 129 may have formed part of the same sketch-book as No. 128. The present drawing is slightly smaller, perhaps as a result of trimming, but the paper is of the same type.

Regardless of the annotations, the study does not seem to have been developed further. The wooden pose and the block-like volume of the figure relate to the figures of the middle and later 1870s, but, technically, the simplified, even schematic, com-position, together with the use of a grey wash in combination with the black chalk, suggest a date some time in the early 1880s when Pissarro began

his reinvestigation into the relationship between the figure and the landscape.

130 La Vachère
Charcoal
Stained by small spots of red and blue pigment
Lugt 613e
161 × 135

No. 130 is almost certainly a preparatory drawing for P&V 1362, a gouache entitled *Gardeuse de vache, côte des Grouettes, Pontoise*, which is dated *c.* 1882 in the *catalogue raisonné*. A similar gouache, *Pay-sanne gardant une vache, Osny* (P&V 1386), is dated 1883. While the subject is reminiscent of J.-F. Millet (*Femme faisant paître sa vache*, Herbert, No. 67), the loose handling of the hillside recalls the landscape drawings of Corot.

Lucien Pissarro made two copies of No. 130, both of which are in the Ashmolean Museum (*Travaux des Champs Album* f. 31).

131 Three studies of a goat
Pencil
Annotated in pencil *jaunetre* [*sic*] *chamois*
Lugt 613e
221 × 152

No. 131 is a preparatory study for the goat in *La Femme à la chèvre* (P&V 546), of 1881, which was exhibited at the seventh Impressionist exhibition of 1882. The most detailed study of the goat in the lower half of the sheet was the pose finally adopted in the painting.

132 Study of a goat
Pencil
Annotated in pencil *orange, violet*
Lugt 613e
88 × 149

It seems that Nos. 132 and 133 were drawn in con-nection with either P&V 489, *Le Fond de l'Hermi-tage*, of 1879, or P&V 546, *La Femme à la chèvre*, of 1881. Both drawings are stylistically compatible with No. 131, which is definitely a study for P&V 546.

133 Two studies of a goat
Black chalk
Lugt 613e
150 × 177

See No. 132 above.

The outline of a horse drawn in ink, which is clearly visible in the reproduction, is offset from another drawing.

134 Five studies of sheep
Black chalk
Stained on left by rust
Lugt 613e
242 × 283

No. 134 may have been drawn in connection with the sheep on the right of P&V 535, *Berger et laveuses à Montfoucault*, of 1881, which was exhibited at the seventh Impressionist exhibition of 1882.

135 Two studies of a cow
Black chalk
Stained by rust on left
Annotated in black chalk *trop grosse*
Lugt 613e
214 × 230

The style of this confidently executed drawing of a cow seen from the front and slightly from above with bold foreshortening suggests a date in the first half of the 1880s. Furthermore, there seems to be a positive connection with a gouache, *Paysanne gardant une vache, Osny* (P&V 1386), of 1883.

The brief study of a cow seen in profile facing right in the upper right corner of No. 135 possibly relates to the centrally placed cow in *La Traite des vaches, Pontoise* (P&V 1395), of 1884, for which see Nos. 164–6 below.

136 Study of a landscape with a cave house near Pontoise (recto)
Grey and brown washes with black chalk on blue paper
Lugt 613e

Study of a female peasant using a bill-hook (verso)
Black chalk on blue paper
196 × 301

Cave houses are a particular feature of the area north-west of Paris where Pissarro lived and worked, but he seems only to have painted the subject once (P&V 438, of 1878), for which a related drawing is known (last recorded with the O'Hana Gallery, London).

The caves are situated in the hills near the villages of Chaponval and Valhermeil close to Pontoise. Stylistically, particularly as regards the brushwork, No. 136 seems to be later in date than P&V 438, and was perhaps drawn in the period 1880–3. The brushwork may be compared, for instance, with that of No. 168 I, which belongs to Sketchbook XV. A date in the early 1880s is also acceptable for the verso. The subject recalls the figure occurring in P&V 451 (Florence, Palazzo Pitti), of 1878.

137 Study of a field with a receding row of trees on the left
Black chalk on light brown paper
Annotated in pencil *plus haut, terre laboure, vert*
Lugt 613e
241 × 312

Exhibited: London/Nottingham/Eastbourne 1977–8, No. 21

During the early part of the 1880s Pissarro explored several formulae for landscapes, which he used as backgrounds in his painted figure compositions. No. 137 with its high horizon line and receding row of fruit trees on the left first occurs in P&V 567, of 1882 (Upperville, Virginia, Collection of Mr and Mrs Paul Mellon), for which a study in pastel also exists (P&V 1557), and was adapted ten years later in *La Causette* P&V 792, Metropolitan Museum of Art, New York, Wrightsman Collection).

138 Study of the branches of a fruit tree
Black chalk
Marked in the centre by the imprint of another sheet of paper
Measured numeration in ink along right edge, *41, 42, 43, 44* seen upside down in relation to the direction of the drawing
The marks in black chalk in the upper right corner may be part of an inscription: they are, however, now indecipherable

Lugt 613a
300 × 169

See No. 139 below

139 Study of the branch of a fruit tree
Pencil
Inscribed in pencil *poirier* lower left
Lugt 613e
230 × 291

The linear irregularities created by the branches of
fruit trees fascinated Pissarro throughout the early
years of the 1880s, and such motifs are often promi-
nent in his paintings of that decade (for example,
P&V 545, 590, and 695, this last having been begun
in 1881). Nos. 138 and 139 are good examples of
the studies of trees dating from this period, when,
in contrast with the earlier tree studies (see Nos. 58
recto and 60 recto), Pissarro chose to concentrate
on individual parts, such as branches, often allowing
them to fill the whole sheet. A drawing similar to
Nos. 138 and 139 was sold at Sotheby's, 13 April
1972, lot 121 repr.

Compositionally, Pissarro's use of foliage in his
paintings is of some interest. During the 1870s there
was a tendency to set trees against a specific back-
ground, so that they acted as a screening device, and
it is presumably from this basis that the artist de-
veloped the motif during the 1880s of meshing the
various parts of a composition together with the
spreading branches of a tree.

140 Study of a poppy
Black chalk
The initials *CP* have been applied freehand
in dark ink in the manner of the stamp
Lugt 613e
160 × 104

Botanical drawings are comparatively rare in Pis-
sarro's œuvre after his departure from Venezuela,
but this species of the genus *Papaver* is definitely
not found in Central or Southern America, which
confirms that No. 140 was made in France after
1855. An exact date is difficult to establish for the
drawing, but on stylistic grounds, particularly the
handling of the chalk, it might have been drawn as
late as 1880–90.

The compilers are grateful to Dr John Lewis of
the Department of Botany in the British Museum
(Natural History) for his help in identifying the
species.

141 SKETCHBOOK XI

141A Whole-length study of a woman holding a cabbage (?)
Charcoal on pink paper
Creased along left edge
Lugt 613e
144 × 104

No. 141A probably relates to one of Pissarro's early
market scenes. Indeed, there is a striking resem-
blance to the figure standing right of centre in a
gouache, P&V 1382, *Paysans triant des choux*,
c. 1883. The extensive use of lightly drawn shading
and the tentative outlines help to confirm a date for
No. 141A during the transitional period between
the figure studies of the late 1870s and those made
during the 1880s.

141B Study of a figure on horseback with buildings behind (recto)
Pencil on pink paper
Lugt 613e

Brief study of a landscape with a tree (verso)
Pencil on pink paper
Annotated in pencil *soleil, rouge, gris, glure* (?)
104 × 144

The composition of the drawing on the recto of No.
141B bears a certain resemblance to that used in
two paintings of 1880 (P&V 511–12). Furthermore,
the large-scale treatment of the horse and rider is
evidence of Pissarro's new approach to the problem
of the integration of the figure into the landscape,
a problem which preoccupied him during the period
1879–83.

The verso of No. 141B is related to Pissarro's
schematically composed landscapes of the late 1870s
and early 1880s, of which P&V 436, of 1878, is an
apposite example. It is notable that so many of Pis-
sarro's annotated drawings are of sunsets (see Nos.
68B, 99D, 176A, and 237), a subject rarely repre-
sented in Impressionist pictures of the 1870s, per-
haps because of its associations with the landscape
tradition of Romantic painting.

**142 Study of a female peasant carrying fag-
gots along a road**
Black chalk
Signs of charcoal offset in upper half
Lugt 613e
154 × 90

For a related study see No. 171B below, which
forms part of Sketchbook XVI and where there is
some discussion of the iconography.

The figure on No. 142 may be compared with the
female peasant on the left of the lithograph, *Les Por-
teuses de fagots* (D. 153), of 1896, where not only
the pose, but also the direction of the light is similar.
In the lithograph, however, the figure is in a sharper
three-quarters profile. According to Delteil, the
lithograph was published in the newspaper *Les
Temps Nouveaux* in 1896, but it is difficult to associ-
ate No. 142 with Pissarro's chalk style of the mid
1890s, and he may have made this particular study
somewhat earlier, probably during the period 1880–
5.

Delteil mentions a compositional drawing for D.
153 in pen and ink and gouache then in the posses-
sion of M. Georges Teyssier, but so far this has not
been found.

**143 Study of a female peasant working in a
field with a cow**
Black chalk
Lugt 613e
97 × 145

The style of this drawing is very close to that of No.
142 above. *Vachères* are usually shown by Pissarro,
and indeed by other painters of peasant genre, in
an attitude of repose, but this composition, which
depicts the figure vigorously working, seems to
break with that tradition. No painting, however,
was evolved out of this study.

144 Study of a man ploughing a field
Black chalk
Creases in upper corners
Lugt 613e
110 × 178

No. 144 is almost certainly from a sketchbook, but
no other sheets from the same source have yet been
found.

Although it is conceivable that No. 144 was
drawn as an early preparatory study for P&V 331,
Le Semeur, Montfoucault (*Semeur et laboureur*), of
1875, the connection with the wood-engraving, *Le
Labour*, which was included as the first print in the
published portfolio *Travaux des champs*, is closer.
The compositional similarities with No. 180A,
which is even closer to the final print, are striking.
Furthermore, the loosely drawn outlines and the
bursts of diagonal hatching are characteristic of
drawings made during the mid 1880s, which was the
period when Camille and Lucien Pissarro were be-
ginning their work on *Travaux des champs*.

**145 Bust length portrait of the artist's
mother**
Pencil
Inscribed in pencil by Lucien Pissarro *Grand
mère* lower left corner
The erroneous date in the centre (*1870–5*) is
a later addition by an unknown hand. It has
been written over the date originally in-
scribed by Lucien Pissarro, which is now,
as a result, indecipherable
152 × 93

For biographical details of Rachel Pissarro, Camille
Pissarro's mother, see No. 39 above, which is the
earliest known drawing he made of his mother. The
size and the type of the paper used for No. 145 indi-
cate that it formed part of a sketchbook, although
no other sheets from the same source have yet been
found.

No. 145 is one of an important series of drawings
made by Pissarro of his mother towards the end of
her life (see also Nos. 194 and 195). She is depicted
here, as in the other drawings made of her during
this decade, wearing the loose kerchief that is worn
by so many of Pissarro's peasant women (see, for
example, P&V 513, *La Mère Larchevêque*, Metro-
politan Museum of Art, New York). As such, No. 145
affords an interesting contrast with No. 39 where
the sitter is differently dressed. There is a photo-
graph of Rachael Pissarro wearing a similar kerchief
as in No. 145 in the collection of Dr A. H. Riise,
Horsholm, Denmark (see K. Adler, *Camille Pis-
sarro; a biography*, London, 1978, fig. 4). The rapid
almost notational hatching on No. 145 is used to de-
scribe the effect of light across the face, rather than
to define its structure, a stylistic feature character-
istic of Pissarro's drawings of the first half of the

1880s. The date inscribed on the drawing by a later hand is incorrect.

146 SKETCHBOOK XII

The four sheets preserved in the Ashmolean collection from this small sketchbook have an unusual unity of style and medium, regardless of the variety of subjects portrayed. None of the drawings relates directly to a finished work, but both the freedom of the pencil line and the various motifs suggest a date some time in the 1880s, probably during the first half of the decade.

Two other sheets from this sketchbook are known: (1) Study of a small child, exhibited JPL Fine Arts, London, 1978, No. 15 repr., and (2) formerly in the possession of Lucien Pissarro (CI neg. 52/55(4), 90 × 157), which was made in preparation for D. 29, or D. 30, dating from c. 1880.

146A Three-quarters-length study of a woman seen nearly full face carrying a parasol
Pencil
Lugt 613e
154 × 91

This figure was most probably observed at a market, but it does not recur in any of Pissarro's compositions illustrating that theme. The summary treatment of the facial features and the rapid execution of the torso relate No. 146A to the etchings of Rouen dating from 1883 (see, particularly, D. 54).

146B Study of a small child seated on the ground seen from the back in three-quarters profile
Pencil
Lugt 613e
91 × 154

The child cannot be identified with certainty, but on comparison with the figure on the right of P&V 575, *La Petite Bonne de campagne* (Tate Gallery, London), of 1882, it may be Ludovic Rodo (1878–1952).

Another drawing of this child on a sheet from this same sketchbook was exhibited at JPL Fine Arts, London, 1978, No. 15 repr.

146C Study of a road with two houses and trees in the background
Pencil
Lugt 613e
91 × 154

No. 146C does not seem to have been fully evolved into a finished painting, but two compositions of this type (P&V 582 and 627), both of Osny where Pissarro lived in 1882–3, do perhaps provide guidelines for dating. An alternative identification might be with Auvers-sur-Oise, for which see P&V 229, 511, and 1548.

146D Study of a field with haystacks
Pencil
Lugt 613e
90 × 153

Without relating directly to the picture, it is possible that No. 146D may have been drawn in connection with P&V 589, *Paysages avec meules, Osny*, of 1883, a painting that in many ways anticipates Monet's series of haystacks, and might once have been owned by Gauguin (M. Bodelsen, 'Gauguin, the Collector', *Burlington Magazine*, cxii (1970), p. 611, Cat. Nos. 41–2. The pose of the man building the haystack on the left of No. 146D is repeated later in a composition of 1887 (P&V 713), but the drawing is certainly earlier.

147 Three studies of a child drawing
Black chalk on paper prepared with a light brown wash
Lugt 613e (purple ink)
197 × 158

In addition to the painting entitled *Portrait de Georges à cinq ans* (P&V 470), of 1878, Pissarro made several lithographs of his children in the act of painting, drawing, reading, or writing: D. 128, of Lucien Pissarro in 1874; D. 143, of Jeanne (Cocotte) Pissarro c. 1895; D. 145, of Ludovic Rodo Pissarro c. 1895; D. 146, of Paul-Emile Pissarro c. 1895. No. 147 was once connected with D. 146, probably on the basis of the slight study of the head in the lower half of the sheet, but the annotation to this effect in the lower left corner has since been erased. Indeed, these studies do not immediately appear to be directly connected with any of the lithographs listed above. The drawing on the whole

is not of a high quality, and the sketch of the head in the lower half of the sheet is too slight to enable a firm identification to be made, but a date of 1880–5 may be suggested on the basis of style.

Interestingly, like several other familial themes essayed by Pissarro, this one of a child engaged in some specific activity, such as painting, drawing, reading, or writing, was also treated by Cézanne during the 1880s (see A. Chappuis, *The Drawings of Paul Cézanne. A Catalogue Raisonné*, i, London, 1973, Nos. 853 and 867, pp. 210 and 212 repr.)

148 Five studies of a small child
Black chalk
Inscribed in pencil *Rodo 1882–1883* lower left
 by a later hand
Lugt 613a
124 × 322

According to the inscription, which presumably records a family tradition, the child in No. 148 is Ludovic Rodo, who was born on 21 November 1878. This is the child who appears in the painting, *La Petite Bonne de campagne* (P&V 575, Tate Gallery, London). As in that painting, all the studies on No. 148 are drawn from slightly above.

149 Study of a small child seen from the back
Black chalk
Lugt 613e
274 × 186

The broken outlines, the shifting effects of light, the isolated accents, and the sporadic hatching are all hallmarks of Pissarro's chalk style of the first half of the 1880s. The child is most probably the artist's fourth son Ludovic Rudo (1878–1952), who appears to have been frequently drawn by his father at this time (see Nos. 148 above and 153 below).

150 Whole-length study of a young girl seen in three-quarters profile facing left
Black chalk
Inscribed and numbered in pencil *9 La Bonne debout*
Lugt 613e
290 × 180

Exhibited: London/Nottingham/Eastbourne 1977–8, No. 13

The model used for this marvellous sheet is probably the same as that used for the painting *La Petite Bonne de campagne* (P&V 575, Tate Gallery, London), of 1881. The variable texture of line and hatching, and the treatment of the facial features are again characteristic of other drawings dating from the first half of the 1880s.

It is possible that No. 150 comes from a sketch-book, in which case the numeration on the drawing may be a clue as to the identification of other sheets from the same source.

151 Study of a woman drying her hair (recto)
Black chalk
Small creases in upper corners. Marked by
 the imprint of another sheet of paper along
 lower edge
Lugt 613e

Study of a young boy seated on a chair reading a book (verso)
Black chalk
Numbered in blue chalk *388* upper left
177 × 114

Exhibited: London/Nottingham/Eastbourne 1977–8, No. 18

Both the recto and verso of No. 151 are outstanding examples of Pissarro's small-scale figure studies dating from the mid 1880s. Neither appears to have been developed further, although the study on the recto anticipates the subject of the gouache executed in the Neo-Impressionist style, *Jeune paysanne à sa toilette* (P&V 1421), of 1888. It is difficult to tell in which context the figure on the recto was conceived, for it would fit both a domestic interior in the manner of Degas, or a bathing scene. Another drawing of this subject made from the same model, possibly on the same occasion, was formerly in the possession of Lucien Pissarro (CI neg. 53/5(17), no details known).

On comparison with the family group photograph of 1884 (repr. *Lettres*, pl. 9 between pp. 64–5), the sitter for the study on the verso is either Georges (born 1871), or Félix (born 1874). It is not possible to determine which of these two alternatives is correct on the evidence presented by this drawing. The same model may have been used for a large study in the Louvre of a young male figure bending forward while seated in a chair to do up

his shoe-lace (inv. RF30097, charcoal on pink paper, 464 × 299, watermarked with the letters E.D. & Cie placed in a cartouche).

152 Study of the artist's mother with her maid
Charcoal
Inscribed in pencil *Grand mère et sa bonne* lower left by a later hand
Numbered in blue chalk *275* (?) upper left corner showing through from the verso
Lugt 613e (purple ink)
284 × 219

Rachel Pissarro here appears to be approximately the same age as in No. 145. The effect of light across the figures, which is one of this drawing's finest qualities, and the tendency of the charcoal to break into loose flowing lines, suggests a date during the period 1880–5.

153 Portrait of Ludovic Rodo Pissarro (1878– 1952)
Black chalk
Lugt 613e
211 × 167

Exhibited: London/Nottingham/Eastbourne 1977– 8, No. 7 repr.

No. 153 must rank as one of the finest portrait drawings in the Ashmolean collection. Judging from the subject's age this portrait must have been drawn *c.* 1883–4, that is at about the same time as the drawing of Ludovic Rodo eating an apple formerly in the Robert von Hirsch Collection (sold Sotheby's, 27 June 1978, lot 820 repr., and, also, *Lettres*, pl. 25 opp. p. 256). The principal stylistic qualities of No. 153 are the straight broken outlines, the regular even hatching, and the soft curvilinear lines for the curls of hair. It is, therefore, a drawing that unites three of Pissarro's manners of drawing. For a contemporary photograph of Ludovic Rodo see *Lettres*, pl. 9 between pp. 64–5.

154 Study of a seated woman asleep
Black chalk on beige paper
Stained by damp upper left corner and along the upper edge
Lugt 613e (purple ink)
235 × 189

The style of No. 154, which is one of the most subtle drawings in the collection, suggests a date in the mid 1880s. The sitter may be Madame Pissarro. The intimacy of the portrait and to some extent the technique, particularly the softly drawn mask-like facial features, recall the style of the familial drawings frequently made by Cézanne during the 1870s and 1880s, of which there is a fine example in the Ashmolean Museum (A. Chappuis, *The Drawings of Paul Cézanne. A Catalogue Raisonné*, i, London, 1973, No. 692 pp. 187–8 repr.).

155a Portrait of Madame Pissarro
Black chalk
Folded horizontally across the centre
Pin holes in upper corners
Numbered in pencil *No. 7* by the artist and inscribed in pencil by a later hand, possibly that of Lucien Pissarro, *Mrs. C.P. 1882*
145 × 98

Exhibited: London/Nottingham/Eastbourne 1977– 8, No. 5

Although now mounted separately, Nos. 155a and 155b were both drawn on the back of a letter addressed to Camille Pissarro from Paul Gauguin, which is dated 8 December 1882. In the course of mounting, No. 155a has been extended by 1 cm at the upper edge in order to make it a pair with No. 155b.

Lucien Pissarro left France for England sometime in January 1883, and No. 155b seems to have been drawn by his father immediately before his son's departure. No. 155a must have been drawn at the same time, possibly as a pendant. There has been some doubt in the past as to whether No. 155b is a portrait of Lucien Pissarro, or of his cousin, Rudolf Isaacson, but the drawing can, in fact, now be identified with some certainty as a portrait of the artist's son. The treatment of the hair over the forehead may be thought to militate against this identification, but other aspects of the physiognomy, for instance, the eyebrows, the nose, and the short beard, are characteristic of Lucien at that time. If comparison with No. 157, which was drawn during the last half of 1883 is not thought to be conclusive, then there is another portrait drawing of Lucien Pissarro which might have been made contemporaneously with No. 155b (formerly in the possession of the sitter, CI neg. 52/23 (17), no details

known). Admittedly, this is a less finished study than No. 155b, but it is drawn from the same angle and is also limited to the head and shoulders. In this second drawing the mop of hair is evident, although slightly less pronounced, and the features are unquestionably those of Lucien Pissarro.

There are several portraits of Alfred Isaacson by Camille Pissarro (principally a pastel, P&V 1564 *c.* 1883 subsequently with the O'Hana Gallery, London), but no known likeness of his brother Rudolf, who was, in fact, in America in 1883.

The letter from Gauguin on the back of which Nos. 155a and 155b were drawn has not yet been published in full. The text is as follows:

8 D^{bre} 1882

Mon cher Pissarro,

Je reçois votre lettre ce matin et vous remercie de penser à moi pour les 800 f que je vous avais demandés du scieur de long. Seulement je suis assez embarrassé de deux façons : la première c'est que je croyais que vous deviez garder le tableau et je ne sais si je dois le porter chez Durand Ruel ou toucher simplement l'argent avec un reçu de vous. La deuxième c'est que je dois à Durand à peu près cette somme et chose assez délicate de toucher quand on doit. Vous m'obligeriez donc en faisant toucher par votre fils pour me le donner après. Ecrivez-moi donc un mot précis sur ... vous êtes content du pays nouveau que vous habitez et que vous allez faire des chefs d'œuvres si j'en crois votre enthousiasme. Du reste le nouveau est un attrait pour l'esprit malgré cela la nature doit être un peu semblable à celle de Pontoise

J'irai cet hiver voir comment vous êtes installé & Madame Pissarro m'a dit que vous aviez de la place, en ce cas je partirais un Samedi soir afin d'avoir un Dimanche entier à moi pour faire une esquisse d'hiver.

Et votre fils, vous ne m'en parlez pas a-t-il quelque chose en vue en Angleterre

Bien des choses a votre famille de votre tout dévoué

P. Gauguin.

For some discussion of the content of the first half of this letter see M. Bodelsen, 'Gauguin, the Collector', The *Burlington Magazine*, cxii (1970), pp. 593–4 and 611, Cat. No. 37.

155b Portrait of Lucien Pissarro
Black chalk
Folded horizontally across the centre
Pin holes in corners and at lower edge in centre
Lugt 613e (purple ink)

Exhibited: London/Nottingham/Eastbourne 1977–8, No. 4 repr.

See No. 155a above.

156 Portrait of Félix Pissarro (1874–97)
Black chalk on faded buff paper
Stained with wash upper left
Torn vertically to right of centre. Pin marks in upper left and lower left corners. Indications of the use of a stylus in the hair where there is some rubbing
Lugt 613e (purple ink)
124 × 110

No. 156 has been cut down, as has another drawing of the same sitter, probably made on the same occasion, but with a different pose, which was also in the possession of Lucien Pissarro (CI neg. 52/58(22), no details known). Judging from the photograph, this second drawing appears to be on the same type of paper as No. 156 and has an identical vertical fold with perforations, from which it can be concluded, not only that the present drawing has been cut on the right, but also that it came from the same small sketchbook. The position of the pin marks in the upper and lower left corners respectively of No. 156 verify this conclusion.

The sitter has been identified as Félix Pissarro, the artist's third son. For a contemporary likeness see the family group photograph taken in 1884 (repr. *Lettres*, pl. 9 between pp. 64–5). A full face portrait drawing in black chalk, rather tentatively executed, is also reproduced in *Lettres*, pl. 27 between pp. 256–7 (formerly in the possession of Lucien Pissarro (CI neg. 52/24(19)). For two other portrait drawings of Félix Pissarro see No. 151 verso and a sheet sold at Sotheby's, 30 March 1977, lot 169 repr. The painted portrait of Félix (P&V 550, London, Tate Gallery), of 1881, shows the sitter when slightly younger and with long hair.

The style of No. 156, particularly the close modelling, resembles that of the two portraits drawn by Pissarro on the back of a letter from Paul Gauguin (see Nos. 155a and 155b above).

157 Portrait of Lucien Pissarro (1863–1944)
Pastel
Signed and dated in red pastel C. *Pissarro 83* lower left
552 × 376 (sight) (Imperial)

Literature: P&V 1563; *Lettres,* pl. 2 between pp. 48–9
Exhibited: London/Nottingham/Eastbourne 1977–8, No. 6

The dimensions given in the *catalogue raisonné* are 570 × 370.

No. 157 is dated 1883 and was undoubtedly made during the months of July–October of that year when Lucien returned from England to spend the summer with his family in Osny. A comparable pastel of Madame Pissarro (private collection, England) similarly posed with folded arms facing right, and of approximately the same dimensions as No. 157, was possibly made during the same months (P&V 1565, also repr. *Lettres,* pl. 3 between pp. 48–9, and Rewald, p. 56).

158 SKETCHBOOK XIII

Pissarro visited Rouen for the first time in October 1883 and remained there on this occasion for one month. A particularly fine drawing of a view of Rouen inscribed and dated *Vue de Rouen/route bon secours/1883* is in the Louvre (inv. RF29531). The visit was to have far-reaching consequences for Pissarro's art. The city and the life of its inhabitants were frequently depicted by him in all media, as the result of numerous subsequent visits made after 1883.

Pissarro seems to have used a number of sketchbooks with squared pages printed in blue ink (see Sketchbooks XIV (No. 160), XXII (No. 222), and XXV (No. 273) below) a type of paper often used by Degas for his notebooks and by Manet. This particular sketchbook used by Pissarro in Rouen in 1883 has sheets of paper with small squares measuring 25 mm. Three other sheets apparently from this same sketchbook are: (1) *Study of the head of an old man seen in profile facing left,* formerly in the possession of Lucien Pissarro (CI neg. 52/59 (25), no details known); (2) *Study of a street in Rouen,* JPL Fine Arts, London, inscribed *Rouen rue des arpents* lower right, no further details known, relating to D. 41, of 1883; (3) *Study of a street in Rouen,* with JPL Fine Arts, London, inscribed *rue Malpalue à Rouen* upper right, no further details known, relating to D. 42, of 1883.

158A Two studies of the head and shoulders of a male figure seen in three-quarters profile facing left
Pen and brown ink over pencil on squared paper printed with blue ink
Lugt 613e
168 × 108

No. 158A is testimony to Pissarro's reviving interest in caricature that continued to increase throughout the 1880s. This interest can at first be indirectly associated with the market scenes, but later it becomes more overtly political during the remainder of the 1880s and during the 1890s. Prior to these decades Pissarro had shown a proclivity for a caricatural style in Venezuela, but while there is evidence for his continuing interest in caricature within the family circle after his arrival in France, it is only in the 1880s that Pissarro began to develop his own distinctive style of caricatural drawing. Significantly, he acquired a copy of Champfleury's *Histoire de la caricature* during the course of this visit to Rouen (*Lettres,* p. 80, 17 February 1884), but this may only have been of the final volume devoted to Daumier (*Histoire de la caricature moderne,* 2nd edn., Paris, 1871).

A similar sheet, apparently from this same sketchbook and close in style and medium to No. 158A, is listed in the introductory section to Sketchbook XIII.

158B 'St. Maclou à Pontoise'
Pencil on squared paper printed with blue ink
Inscribed in pencil with the title upper right corner
Lugt 613e
109 × 165

Another interest awakened in Rouen was topography, an aspect of drawing that Pissarro had virtually ignored after his removal from the West Indies to France in 1855. This view of the main church in Pontoise is drawn from the place de la Gare. It cannot be stated with any degree of certainty whether No. 158B was made before, or after, Pissarro's visit to Rouen took place; whether, in fact, it was drawn at the moment of departure, or immediately after his return. Logically, it could be argued that No. 158B was drawn after Pissarro's return to Pontoise, for it was in Rouen itself that the artist's visual imagination had been stirred by both the predominance of late Gothic architecture in the city

and also by the strong topographical tradition in Anglo-French art relating to it (see *Lettres*, p. 67, 20 November 1883).

158C Study of a carved figure

Pencil on squared paper printed in blue ink
Inscribed in pencil *Maison | No. 60 | de la rue | Grand pont | Rouen*
Lugt 613e
160 × 106

In spite of Pissarro's constant advice to his son Lucien to copy other works of art, especially sculpture, No. 158C is Camille Pissarro's only surviving drawing after an original piece of sculpture. Indeed, it is one of his very rare direct copies after a work of art. For another, much later in date, which is after the portrait, *La Belle Zélie*, by Ingres in the Musée des Beaux-Arts, Rouen, see *Lettres*, p. 377, 19 April 1895, repr. p. 378). No. 158C is perhaps referred to in the following passage in a letter dating from 20 November 1883 (*Lettres*, p. 67): 'J'ai dessiné aussi quelques petits motifs de sculpture en bois, du gothique pur, avec des petits ornements, c'est merveilleux. C'est là que l'on s'aperçoit du réalisme de cette époque. Les nus sont admirables.'

158D 'Rue de la grand mesure'

Pencil on squared paper printed in blue ink
Stained by splashes of grey wash
Inscribed in pencil with the title lower right
Lugt 613e
160 × 106

Pissarro made several prints of various streets in Rouen: D. 41–2, of 1883, D. 52–4, of 1884–5, D. 64, of 1886, D. 68, of 1887 (which is a remaking of D. 42), D. 120–2, of 1896, D. 173–9, of 1896. However, No. 158D does not relate to any of these.

Two other topographical studies of this kind, apparently from this same sketchbook, are listed in the introductory section for Sketchbook XIII. A drawing made in connection with D. 52, of 1884, *Rue Damiette à Rouen*, but not from this sketchbook, was sold at Sotheby Parke Bernet, South Africa, 30 October 1975, lot 15 repr.

159 Study of the Ile Lacroix at Rouen

Charcoal
Lugt 613e

142 × 194. Framing indicated in charcoal, 128 × 177.

Exhibited: London/Nottingham/Eastbourne 1977–8, No. 28

Compositionally, No. 159 relates both to D. 69, of 1883 (for the corrected dating see No. 287 below) and to the Neo-Impressionist painting in the Johnson Collection, Philadelphia Museum of Art (P&V 719, *L'Ile Lacroix, Rouen, effet de brouillard*, of 1888). It is difficult to establish exactly for which of these works No. 159 might have been drawn. While the dimensions of the composition are in accord with the abandoned print of Côte Ste. Catherine (see No. 287), the style is more readily associated with Pissarro's Neo-Impressionist phase, which is when P&V 719 was painted. It must be remembered, however, that the tenebrous style of drawing had already been perfected by Millet, whose pastels were exhibited at the Emile Gavet sale in Paris in 1875, and by Seurat, whose tenebrous drawings of 1882–3 share stylistic and iconographical traits with No. 159. Indeed, Pissarro himself owned several drawings of this type by Seurat (see C. M. de Haucke, *Seurat et son œuvre*, ii, Paris, 1961, Nos. 525, 546, 550, 562, 565, 587, 592, 639, and 648), but biographical evidence indicates that he did not meet the younger artist until 1885, after which he presumably began collecting the drawings. It seems clear from this that Pissarro himself used the tenebrous style of drawing in 1883 to capture the effects of smoke and morning haze before his exposure to the darker and more mysterious tenebrous drawings of industrial subjects executed by Seurat. It is therefore likely that No. 159 was drawn in preparation for D. 69 and it should be noticed that there are minor, but none the less significant compositional differences, particularly along the left edge, between P&V 719 and the drawing in Oxford.

Another more loosely handled study of the same subject, which most probably preceded No. 159, was formerly in the possession of Lucien Pissarro (CI neg. 52/57 (17), no details known).

160 SKETCHBOOK XIV

As in the case of Sketchbook XIII, the paper of Sketchbook XIV is square ruled and printed in blue ink, but the size of the squares is larger, measuring 40 mm. All the sheets

have been cut down. Four other sheets from this sketchbook have so far been found: see the entries for Nos. 160A and 160D, to which should be added the sheet exhibited at JPL Fine Arts, London, 1978, No. 25 repr. possibly drawn in connection with P&V 718, of 1888.

160A Study of a river landscape with a barge, Compiègne
Black chalk on squared paper printed in blue ink
Inscribed in black chalk *Compiègne* (slightly cut) upper left
Lugt 613e
92 × 155

Pissarro made only one recorded visit to Compiègne, 7–10 February 1884 (*Lettres* p. 77). The ordering of the composition of No. 160A is reminiscent of Pissarro's earlier river landscapes (for example, P&V 160–1, both of 1872). Another drawing of Compiègne, formerly in the possession of Lucien Pissarro (CI neg. 52/33(7a), pencil, inscribed in pencil *Compiègne/place du marché*, 98 × 161), is on similar paper and is close in style to the drawings in the Rouen sketchbook (Nos. 158B and 158D). Furthermore, this second drawing has red tinted edges and bevelled corners. Since all the sheets included in this sketchbook have been cut down, this other sheet constitutes important evidence as to the original size of the sketchbook.

160B Study of a young female peasant kindling a fire
Black chalk on squared paper printed in blue ink
Lugt 613e
152 × 82

No. 160B is clearly related to the large painting P&V 722, *Gelée blanche, jeune paysanne faisant du feu*, of 1888. It is a composition that occurs later in Pissarro's œuvre in the form of another version, P&V 757, of 1890, for which P&V 756 is a sketch, and it is also recorded in an undated gouache (P&V 1455, sold Sotheby's, 2–3 April 1974, lot 47 repr.). All these works, with the exception of the gouache, have a second figure of a small child standing behind the fire.

It will be noted that No. 160B also lacks this second figure, but the freedom with which it is

drawn suggests that it was a preliminary study for the painting in its earliest form (P&V 722). The gouache may represent a return to the composition as it was first noted by Pissarro as a suitable motif for a painting.

A fine copy of the main figure by Lucien Pissarro after one of the versions of the painting is also in the Ashmolean collection (Imperial).

Iconographically, the motif is a new addition to the tradition of French peasant painting, and it recalls Pissarro's own tentative study of a similar subject (see No. 68A verso). Significantly, J.-F. Millet made a drawing of a young peasant woman burning hay, which was reproduced by A. Sensier, *La Vie et l'œuvre de J.-F. Millet*, Paris, 1881, p. 193.

160C Study of three hens
Black chalk on squared paper printed in blue ink
Lugt 613e
79 × 155

160D Study of the bridge at Lagny
Black chalk on squared paper printed in blue ink
Inscribed in black chalk *Lagny* upper right
Lugt 613e
95 × 158

An old photograph taken when No. 160D was still in the possession of the Pissarro family (CI negs. 53/43(26a) and 53/43(27a)) shows the drawing before trimming. The two upper corners of the sheet were bevelled and there is a slight sketch of the profiles of two houses on the verso, which is at present not visible, as No. 160D has been stuck down.

Pissarro refers to the river town of Lagny-sur-Marne only once in his correspondence with Lucien and that is in a letter of 23 October, 1891 (*Lettres*, p. 264), in which he considers a move from Eragny, either back to Pontoise, or else to Lagny itself. There is, however, no evidence that he went to Lagny in 1891. Lagny-sur-Marne was an important centre for the gathering of Neo-Impressionist artists between 1885 and 1888. Indeed, the young painter Maximilien Luce, a friend of both Camille and Lucien Pissarro, spent long periods at his father's house in Lagny until 1888, and it is likely that Camille Pissarro visited him there during this period (see J. Sutter, *Les Néo-impressionnistes*, Neu-

chatel, 1970, p. 154). For a view of the town, which includes the river and the bridge, see the water-colour by Cavallo-Peduzzi (repr. Sutter, op. cit., p. 189).

Another drawing, apparently from this same sketchbook, of the bridge at Lagny seen from the other side of the river was once with the O'Hana Gallery, London. This other drawing is inscribed *Lagny sur ... du pont en pierre* (no other details known). Yet another is in the Museum Boymans–van Beuningen, Rotterdam (see H. R. Hoetink, *Franse Tekeningen uit de 19e eeuw*, Rotterdam, 1968, p. 130, No. 207 repr., *Study of a street in Lagny*, black chalk, inscribed in black chalk *rue Vacheresse en face No. 28 | Lagny*, 163 × 100). This last sheet, as indeed No. 160D did before being trimmed, shows the original appearance of the pages from this sketchbook.

161 Study of wheelbarrow
Pencil on blue-grey paper
Three small pieces of pigment adhered to the surface after contact with either a gouache or a pastel
Lugt 613e
121 × 164

The first occurrence of a wheelbarrow prominently placed in a composition is P&V 639, *Paysanne poussant une brouette à Eragny*, of 1884. Other paintings in which a wheelbarrow is prominent are slightly later in date: P&V 717, of 1887, P&V 748, of 1890, P&V 822, of 1892, and P&V 1469, of 1892. It is highly likely on the basis of style that No. 161 was drawn in preparation for P&V 639, although in the finished painting the wheelbarrow is seen from the other side.

162 View of a house with a turret seen over a roof
Black chalk on horizontally ruled printed paper
Inscribed in pencil by a later hand *Study for ferme at Osny 1884 (Delteil 51)* along the lower edge
Lugt 613e
219 × 167

Regardless of the inscription prominently placed along the lower edge of No. 162, the correspondence between the drawing and D. 51 (*La Ferme à Nöel,*

Osny), of 1884, is hardly exact. For a drawing that corresponds more closely with D. 51 see No. 285 below.

No. 162 is undoubtedly a sheet from an inexpensive sketching tablet, or notebook, of a type that Pissarro seems to have used a great deal judging from the number of different examples that were once in the possession of Lucien Pissarro (for example, Sketchbook IX (No. 99) and the following drawings, CI negs. 53/8(33a); 52/52(2); 52/52(3); 52/52(1); 53/8(36a); 53/8(35a), all from a notebook of comparable size (186 × 150), with the edges tinted red).

163 Three-quarters length study of a female peasant holding a farming implement
Watercolour over charcoal
Lugt 613e
208 × 164

The pose of this figure corresponds with one occurring in the centre of the tempera *Faneuses à Eragny* (P&V 1394), of 1884. In the tempera the figure is half concealed behind another, who is seen slightly from the back and positioned in the foreground just to the left of centre, but, none the less, the connection seems to be valid. It must be admitted, however, that without this connection the tendency would have been to date No. 163 during the first half of the 1890s on account of the pale palette (pink, mauve and grey-blue), which is remarkably distinctive, and also because the underdrawing in charcoal resembles No. 225E in Sketchbook XXIII.

164 Study of a woman seen from the back milking a cow
Black chalk
Lugt 613e
123 × 140

No. 164 was most probably drawn in connection with P&V 1395, a watercolour with gouache of 1884 entitled *La Traite des vaches, Eragny*, for which there is also a watercolour in this collection (No. 166). It should be observed that in No. 164, the woman faces right, whereas in the two watercolours (No. 166 and P&V 1395) she is posed facing left. A further study, apparently in black chalk, in which Pissarro places the figure as she appears in the two

more finished compositions was once in the possession of Lucien Pissarro (CI neg. 51/53(33), no details known).

165 Study of a woman seen from the back milking a cow in a field
Black chalk
Lugt 613e
154 × 222

It is probable that No. 165 forms part of the preparatory process for P&V 1395, for which see Nos. 164 and 166. Yet, there are considerable compositional differences, to the extent that if the present drawing is not an abandoned idea for the subject, it may be a variant, which Pissarro contemplated using for a print, although this, too, does not seem to have been brought to fruition.

The figure carrying milk churns in the upper right corner of No. 165 was later treated as an independent subject in *Travaux des champs* (see No. 352 below).

166 Compositional study of a milking scene at Eragny-sur-Epte
Watercolour over black chalk
Signed in black chalk *C. Pissarro* lower left
157 × 196

Literature: J. C. Holl, *Camille Pissarro et son œuvre, dessins inédits et peintures*, Paris, 1904, p. 8, repr.
Exhibited: London/Nottingham/Eastbourne 1977–8, No. 20

A larger and more detailed watercolour with gouache highlights of this same composition dating from 1884 is reproduced in the *catalogue raisonné* (P&V 1395). While specific details are left unchanged in P&V 1395, Pissarro has placed the scene itself in the middle distance thereby providing a more spacious foreground. It is highly likely that No. 166 served as a preparatory study for P&V 1395. A further study of the figure milking the cow is also in the collection (No. 164).

The composition was adapted for inclusion in *Travaux des champs* (see No. 367 below). There are undeniable affinities with an engraving entitled *The Milkmaid* by Lucas van Leyden (Hollstein X, p. 177), but whether Pissarro had seen this is not known.

167 Study of a female peasant pushing a wheelbarrow seen from the front
Coloured chalks
Torn in several places, notably in the lower left corner.
Creased diagonally from upper left to lower right. Foxing in lower left corner
Lugt 613e
352 × 218. Framing indicated in black chalk along lower edge, c. 310 × 218.

No. 167 is clearly a compositional study, but it does not appear to have been developed further. The drawing is difficult to date, although the long striations with coloured chalks do suggest the period of the mid 1880s. Pissarro was rarely so explicit, even in his drawings, in his depiction of motion, or of burdensome labour, and it is regrettable that such a distinguished drawing as No. 167 should have been damaged, although it is by no means ruined. For a pastel of the same subject and of approximately the same date see the catalogue of the exhibition *Selection V: French Watercolours and Drawings from the Museum's Collection c. 1800–1900*, Museum of Art, Rhode Island School of Design, May 1975, pp. 135–6, No. 59 repr. where mention is made of another reproduced by G. Lecomte, *Camille Pissarro*, Paris, 1922, opp. p. 22.

The composition may be a reworking of P&V 244, of 1874, for which there is a preparatory study in the collection (No. 85A recto).

168 SKETCHBOOK XV

This sketchbook contains some of Pissarro's finest drawings and the quality is consistently high throughout. The style of drawing combines several aspects of Pissarro's draughtsmanship, successfully resolving a dichotomy between volume and line. The Ashmolean collection has twelve sheets from the sketchbook. It will be observed that two of the sheets (Nos. 168A, 160B, and 168H) are slightly smaller than the others. This is owing to trimming: the texture of the paper, however, is the same, and they are compatible in every other respect. Eight other sheets, all of a similar quality to those catalogued here, have so far been discovered. They may be listed as follows:

(1) *Study of figures at a market stall*, black chalk, 216 × 161, possibly an early study for P&V 1389, of 1884.

(2) *Study of figures standing beneath a bridge*, black chalk, 216 × 161

(3) *Study of figures at a market*, black chalk with watercolour, 216 × 161

These three drawings were all in the possession of Hirschl and Adler, New York, in 1976.

(4) *Study of figures at a market stall*, black chalk with pencil, 210 × 162. Houston, Museum of Fine Arts, inv. 39–90

(5) *Foire St. Martin*, black chalk with grey wash, 165 × 214, Rotterdam, Museum Boysmans-van Beuningen (see H. R. Hoetink, *Franse Tekeningen uit de 19e eeuw*, Rotterdam, 1968, No. 205, p. 130)

(6) *Three-quarters length study of two female peasants*, grey wash over black chalk, 217 × 165 (sight). Exhibited Leicester Galleries 1958, No. 65

(7) *Four studies of a male peasant harvesting*, pencil and grey wash over pencil, 217 × 165 (sight). Exhibited Leicester Galleries 1958, No. 65 (mounted together with the preceding drawing)

(8) *Study of figures at a market*, black chalk with some grey wash, 209 × 169

The last three drawings were formerly in the possession of Lucien Pissarro (CI negs. 52/51(43), 51/36(33) and 52/52(44) respectively).

168A Whole-length study of two female peasants seen from the back
Grey wash over black chalk
Lugt 613e
213 × 160

The two studies have been brought to different degrees of finish: the figure on the left is drawn in black chalk only, whilst that on the right is outlined in black chalk, but modelled with a grey wash. Both figures were clearly observed at a market, a theme that Pissarro began to study seriously in 1881 (P&V 1346–8).

168B Two studies of a turkey
Grey wash over pencil
Lugt 613e
151 × 162
See No. 168C below

168C Six studies of a turkey
Pencil with watercolour
Lugt 613e
164 × 213

Nos. 168B and 168C most probably relate to the painting in tempera, *Gardeuse de dindons* (P&V 1414, Boston, Museum of Fine Arts), dated c. 1887, in the *catalogue raisonné*, but which may have been executed at an earlier date.

168D Study of a seated female figure at a market
Grey wash over black chalk
Lugt 613e
215 × 164

This important compositional study relates in subject to both versions of the gouache entitled, respectively, *Marché aux pommes de terre, boulevard des Fossés, Pontoise* (P&V 1365 c. 1882) and *Le Marché, boulevard des Fossés, Pontoise* (P&V 1402 of 1885). The figures in the right background of No. 168D are virtually identical with those occurring on P&V 1365, whilst the brief indications of the setting confirm the connection with P&V 1402. In both the gouaches, however, Pissarro has omitted the woman seated in the foreground altogether, and it must be concluded that No. 168D was not used by Camille Pissarro for any of his own finished compositions. Yet, as in an earlier drawing in the Ashmolean collection (No. 128), the artist did introduce a seated female figure in the centre foreground of the etching *Marché aux légumes à Pontoise* (D. 97, of 1891), although the pose and the dress are totally different. The closest connection with the composition of No. 168D, however, occurs in a wood-engraving by Lucien Pissarro, *La Marchande de marrons* (Studio Book, I f. 3, No. 3; Fern, No. 3, p. 107 c. 1884), which is manifestly based on the present drawing.

In its stark juxtaposition of foreground and background No. 168D recalls a favourite compositional device employed by Impressionist painters, particularly by Manet and by Degas.

168E Compositional study for 'La Charcutière'
Blue watercolour over black chalk
Lugt 613e
215 × 164

No. 168E is an important compositional study for the painting *La Charcutière* (P&V 615, London, Tate Gallery), of 1883. In this drawing Pissarro explores the distribution of the three main figures within the structural framework of the market stalls. Similar compositional difficulties are explored in Nos. 168F and 168H, and in the sheet in the Museum of Fine Arts, Houston (see the introductory section to Sketchbook XV, 4), to which another drawing, although not from Sketchbook XV, sold at Christie's, 4 December 1973, lot 41 repr., is closely related. The present sheet is notable for the vivid and confident application of the blue wash. The pose of the central figure was adapted for the tempera *L'Etal* (P&V 1389, Glasgow, Burrell Collection), of 1884.

168F Study of a market scene
 Black chalk
 Annotated in black chalk *toile bise, ombre, bleu
 foncé*
 Lugt 613e
 217 × 166

No. 168F is a powerful study, which unites many of the main stylistic features characteristic of Pissarro's draughtsmanship. The strong straight outlines and the vigorous hatching, reminiscent of drawings of the 1870s, are here adapted to suit the curvilinear tendencies developed in the treatment of the human figure at the beginning of the 1880s. There are no directly related market scenes in the painted *œuvre*, but the attention paid to the geometric structure of the wooden stalls may be compared with Nos. 168E and 168H.

A notable stylistic feature of No. 168F is the heavy accent placed upon the middle ground figures. Pissarro thus shows the shifting effects of light by moving from a strongly lit foreground to a darker middle ground, and finally to a light background, which starkly offsets the figures, and gives the composition a striking luminosity.

168G Whole-length studies of two women conversing, one seen from the back and the other in profile facing right
 Grey and brown washes over black chalk
 heightened in places with gouache
 Lugt 613e
 218 × 167

Like Nos. 168A, these two figures were not used in any of the densely populated market scenes executed by Pissarro, but, as in the case of the majority of the sheets in this sketchbook, the handling of the media is masterly. The combination of chalk and wash has again been used, but here Pissarro has rendered the texture of the drapery with broader brush strokes and two tones of wash to which he has applied a white heightening.

168H Study of a female figure examining a market stall
 Black chalk
 Lugt 613e
 215 × 160

While it is apparent that No. 168H is a compositional study of a market scene, it also reflects Pissarro's interest in the confrontation of social groups on such occasions. This is a theme which was further explored later in the decade (see No. 214), and during the 1890s when Pissarro made his overtly political album of drawings known as *Turpitudes sociales* (see Sketchbook XXI No. 210). For a similarly posed bourgeois woman placed in a different context, see P&V 752, *Jeune Femme à la fenêtre, Eragny*, of 1884.

168I Landscape with a distant view of Osny
 Grey wash over pencil
 Signed with the brush in wash with the artist's
 initials and inscribed *Osny* lower right
 163 × 215

No. 168I was used as the basis for the etching *Paysage à Osny* (D. 70), of 1887. The group of buildings on the right of No. 168I occurs in several paintings of 1883 (for example, P&V 584 and 597) where they are seen from different angles. Pissarro lived in Osny between 1882 and 1884, but he continued to incorporate motifs from that area in later works.

168J Study of four cows by a pond seen from above
 Black chalk
 Lugt 613e
 167 × 216

No. 168J is evidently a study for the uncatalogued gouache, *Vaches à la mare; près Osny*, of 1886 (sold Paris, Palais Galliera, 20 June 1968, repr.). A later preparatory drawing, which includes a female figure

and the landscape, was formerly in the possession of Lucien Pissarro (CI neg. 51/56(6), no details known). The elevated viewpoint adopted for this sheet connects it with the drawings of Degas executed in the period 1875–85.

168K Study of three female peasants on a road with buildings and horse-drawn carts in the background
Grey wash and black chalk
Lugt 613e
217 × 168

The scene in the background is clearly a market, and is most probably near the top of the boulevard des Fossés in Pontoise where Pissarro studied the market several times (see No. 168D, as well as P&V 1346, of 1881, and P&V 365, of 1882).

168L Study of a tree
Coloured chalks
Annotated in black chalk *jaune*
Lugt 613e
213 × 163

This marvellously fluid drawing was executed in Osny between 1883–4. The coloured chalks are not applied throughout the sheet. They are restricted to the trunk of the tree, the middle distance, and some of the foliage. In its rigorous structure, No. 168L anticipates the drawings made for P&V 726, *La Cueillette des pommes, Eragny* (Dallas Museum of Fine Arts), of 1888 (see Nos. 180G recto, 181, and 182 below).

169 Study of a farm building
Coloured chalks over pencil with a little watercolour
Stained by rust upper left
Lugt 613e
239 × 293

The watercolour is limited to a single brush stroke in the centre of the drawing to the left of the doorway. The building is most probably one in Eragny, but it cannot be certainly identified in any of the paintings. This type of Norman farm building was painted by Pissarro *c.* 1885 (see P&V 682). The use of coloured chalks suggests a date in the mid 1880s. The effect created by the densely packed series of lines on the roof differs somewhat from that of the

more strictly Neo-Impressionist drawings, as represented in the collection by No. 181, where the handling is tauter and there is a greater range of colour, applied according to the more scientific tenets of Neo-Impressionist theory.

There are, in fact, two landscape studies of the highest quality in the Louvre, both stylistically compatible with No. 169, which reveal a similar delicacy in the handling of coloured chalks; *Landscape at Le Chou* (inv. RF28793, coloured chalks on thick beige paper signed in black chalk *C. Pissarro* lower right, 247 × 317); and *Landscape at Pontoise with a haystack* (inv. RF28801, coloured chalks on thick beige paper, inscribed and signed in black chalk *Pontoise / C. Pissarro* lower left, 250 × 323).

170 Study of the pond at Eragny-sur-Epte
Watercolour over charcoal
Damaged by damp throughout. Marked on the right and along upper edge by the imprint of another sheet of paper
Lugt 613e
Numbered in blue chalk *238* on verso
177 × 210

No. 170 was almost certainly executed at Eragny and the subject appears to be related to two paintings, P&V 643 and 644, entitled *Les Bords de l'Epte à Eragny* and *L'Abreuvoir d'Eragny* respectively, both of which are dated 1884. Pissarro often repeated this subject in the 1890s (for example, P&V 924 and 1003), but No. 170, which is characterized by the use of watercolour used in combination with charcoal, definitely belongs to the 1880s. Another watercolour of the same date and of the same subject seen from a different angle was once in the possession of Lucien Pissarro (CI neg. 52/42(30), no details known). Lucien Pissarro himself made a drawing in pencil of the same view as this second watercolour (Ashmolean Museum inv. 77.612). Indeed, Lucien made several other studies of Eragny and the surrounding countryside, many of which are in the Ashmolean collection and several of which are dated 1884 (for example, inv. 77.676).

On the verso of No. 170 is an offset from No. 209.

171 SKETCHBOOK XVI

Having moved to Osny near Pontoise in 1882, Pissarro continued to live there until 1884

when he found a permanent home at Eragny, a village near Gisors. When looking for a house at this time Pissarro was strongly impressed by the small town of Gisors in which he discovered a number of motifs (*Lettres*, p. 81, dated 1 March 1884) combining those that he had already explored in and around Pontoise with those newly developed in Rouen in 1883. Apart from the drawings in the present sketchbook and that mentioned in the entry for No. 171D, a number of other drawings of Gisors are known and may be mentioned here: (1) *Study of a road in Gisors*, watercolour over black chalk, signed in pencil, inscribed and dated in watercolour *Gisors/84*, Cambridge, Fitzwilliam Museum (see *Selected Works from The Andrew Gow Bequest*, London, Hazlitt, Gooden and Fox, 20 October –10 November, 1978, No. 15 repr. plate 7); (2) *View of Gisors*, formerly in the collection of Lucien Pissarro (CI neg. 52/43 (32), charcoal, inscribed *Gisors* lower right, 228 × 283), of which Lucien Pissarro drew his own version now in the Ashmolean Museum (inv. 77.884), which is dated 1885; (3) *Study of the church at Gisors*, apparently watercolour with black chalk, inscribed in black chalk *Eglise de Gisors* upper left and signed *C. Pissarro* lower right, formerly in the possession of Lucien Pissarro (CI neg. 51/33 (7)), last recorded with the O'Hana Gallery, London; (4) *Group of peasants conversing under an archway*, watercolour over black chalk, inscribed in black chalk *Marché aux blés/Gisors* lower right, 213 × 162, Louvre (inv. RF 31851). These drawings attest Pissarro's interest in Gisors and, in addition, his son, Lucien, made a number of drawings of that town during this same period (Ashmolean Museum).

The dimensions of the sheets in Sketchbook XVI indicate that it was a pocket book, and, judging from the range of subject-matter, it was used intermittently. The inscriptions along the lower edge of each of these sheets reading *Notebook 16, 1884–5* are by a later hand.

171A Study of man and a woman conversing
Pen and indian ink
Lugt 613e
155 × 97

The penwork of No. 171A is reminiscent of the style of Charles Keene, for whose work Pissarro had a profound admiration (*Lettres*, p. 79, 17 February 1884). It is a style characterized by fine pen strokes with dense areas of close cross-hatching of the kind associated with engraving. Pissarro seems to have developed this pen style during the early part of the 1880s. Keene is first mentioned in letters dating from 1883 (*Lettres*, pp. 50 *passim*).

For another drawing in this style see No. 199 recto below.

171B Whole-length study of a female peasant carrying a load of faggots on her back walking to the left
Black chalk
Lugt 613e
156 × 98

A similar figure occurs on the left of two late lithographs (D. 152, *c.* 1896 and D. 153, of 1896), but it is impossible that No. 171B was made directly in connection with either of these two prints at such a late date. It is, therefore, reasonable to assume that Pissarro simply reused this study at the later date. Another drawing connected with these same lithographs is also in the collection (No. 142), but this last is clearly earlier in style than No. 171B, which is invested with an element of caricature, a feature that Pissarro tended to introduce into many of his drawings during the mid 1880s.

The subject of the female peasant carrying faggots is one that J.-F. Millet depicted (Herbert, Nos. 172 and 247, both of which Pissarro could have known).

171C Study of landscape with trees and a bridge
Black chalk
Lugt 613e
97 × 157

Although both the composition and the architecture of the bridge shown in No. 171C bear a striking resemblance to the painting by Cézanne entitled *Le Pont à Maincy* (Paris, Musée du Jeu de Paume), which is now thought to have been painted in 1879 (see *Cézanne dans les musées nationaux*, Orangerie des Tuileries, Paris, 1974, No. 22 pp. 67–8 with full bibliography), there is no evidence that Pissarro ever visited Maincy. No. 171C, however, may be

used to demonstrate the continuing interest shared by the two artists in their approach to landscape after the 1870s and it is perfectly possible that Pissarro had seen Cézanne's painting of the bridge at Maincy. Significantly, Pissarro's earlier rendering of a landscape with a bridge, *Le Petit Pont, Pontoise* (P&V 300, of 1875), was painted during the period of his closest working partnership with Cézanne, and in a style that is distinctly Cézannesque.

171D Study of a tower in the old part of Gisors
Black chalk
Inscribed in black chalk *Gisors* upper left
Lugt 613e
158 × 98

The subject of No. 171D has a kinship with the topographical drawings undertaken in Rouen in 1883 (see No. 158D). Stylistically, No. 171D is also of some interest, for the delicate, almost deft, use of chalk, offset by heavily accented shadows, recalls certain drawings of the Venezuelan period and anticipates sheets in the later sketchbooks (compare particularly Sketchbook XXVI No. 277). Another drawing, not from this sketchbook, but in a comparable loose and confident style, and revealing a similar interest in the topography of Gisors, was exhibited by the Beilin Gallery, New York (*50 Drawings by Camille Pissarro*, March–April 1965, No. 2, black chalk, inscribed in black chalk *Marché au beurre à Gisors*, 222 × 178).

172 Brief study of the head of a woman: study of a window (recto)
Charcoal (study of head) and pen and brown ink (study of window)
Lugt 613e

Two brief studies of heads of male figures (verso)
Black chalk
148 × 60

No. 172 is difficult to date. The handling of the charcoal is similar to that found on No. 168H, a sheet from Sketchbook XV, but the character of the pen work recalls that of No. 85B recto dating from the 1870s, although this alone does not discount it from being later in date, since Pissarro only began to develop his pen style further during the last half of the 1880s. The paper appears to be the same make as that used for Sketchbook XV (No. 168) and it

is conceivable that the sheet is a fragment from that sketchbook.

The studies on the verso are very slight and may not be by Camille Pissarro. They are similar to a certain type of caricatural study drawn with simplified outlines and exaggerated features that were frequently imitated by younger members of the family.

173 Study of the head of a young woman
Black chalk on dark brown paper
Lugt 613e
68 × 69

173 bis Three-quarters-length study of a young woman seen from the back in profile facing left
Black chalk
Horizontal tear across centre of sheet. Stained on right.
144 × 109

174 SKETCHBOOK XVII

Only two sheets from this sketchbook are in the collection, and no others have yet been found. A date of 1885–90 can be posited on the basis of style. Both sheets are of considerable iconographical interest.

174A Study of a seated man drying himself with a towel seen from the back (recto)
Black chalk
Lugt 613a

Four studies of the head of a cow (verso)
Black chalk
Lugt 613e
189 × 113

Stylistically, No. 174A recto with its array of loosely drawn hatched strokes is close to the sheets comprising Sketchbook XVIII (No. 175), with which, as regards the subject-matter, it shares a similar degree of intimacy. The pose and treatment of the figure (possibly a member of the family) suggest knowledge of certain etchings by Rembrandt (especially Bartsch 202). The main study of a cow on the verso of No. 174A resembles that in P&V 1395, *La Traite des vaches, Eragny*, of 1884 (for which see No. 166 above), but it is by no means certain that these studies were drawn specifically for that composition.

174B Study of a man seated in an interior
Black chalk
Lugt 613e
189×112

The figure in No. 174B appears to be seated in an interior, perhaps a café. An alternative suggestion is that he forms part of a market scene and that the table in the foreground is a stall. If the former suggestion is the correct location then, iconographically, it is a setting that Pissarro, in contradistinction to Manet, or Degas, used very infrequently. Indeed, the only other occasion that Pissarro seems to have essayed the theme is in a drawing of a rural café for *Travaux des champs* (see No. 374 below).

175 SKETCHBOOK XVIII

The sketchbook is notable for the variety of subject-matter and for the artist's interest in domestic themes. The use of copying pencil connects the sketchbook with certain sheets made in the mid 1870s (Nos. 85H verso, 87A and B, and 97C), and, while Pissarro often combined black chalk and wash during the 1880s, it is rare to find him resorting to pencil during that decade as he does here (Nos. 175E and 175G). The study of the female bathers on the verso of No. 175C is of particular importance. As regards a date for the sketchbook, it will be seen that three of the drawings (Nos. 175A and 175G, and possibly, No. 175D) relate to compositions dating from the second half of the 1880s.

Two other sheets from Sketchbook XVIII have so far been found: (1) British Museum (inv. 1967. 4. 18), *Study of head and shoulders of Ludovic Rodo Pissarro* (recto), *Slight study of a male peasant hoeing* (verso), copying pencil (recto), black chalk (verso), 211×128; and (2) *Study of head and shoulders of Ludovic Rodo Pissarro* (recto), *Two studies of two peasants making love* (verso), copying pencil and wash (recto), pen and brown ink over pencil (verso), 212×129, JPL Fine Arts, London (formerly collection of Paul-Emile Pissarro).

175A Study for 'Gardeuse de vaches étendue dans l'herbe'
Copying pencil
Lugt 613e
125×208

No. 175A is clearly related to the gouache *Gardeuse de vaches étendue dans l'herbe* (P&V 1398), of 1885. Pissarro has made considerable changes in the landscape, although the pose of the figure has been left almost unaltered. The style of the drawing is characterized by a multiplicity of long rapidly made striations reminiscent of etching.

175B Bust-length portrait of Madame Pissarro seen in three-quarters profile facing right
Copying pencil with a clear wash
Luft 613e
205×125

The even tone in No. 175B results from the application of a clear wash over the copying pencil, but, even allowing for this, the cross-hatching beneath is tighter and more controlled than in the other drawings in this sketchbook. The artist's wife probably served as the model for Nos. 175B, 175C, and 175E, which invests the sheets from this sketchbook with a degree of intimacy that occurs only sporadically in Pissarro's work.

175C Study of a woman dressing (recto)
Copying pencil
Lugt 613e

Study of three female bathers in a wooded landscape (verso)
Copying pencil with a clear wash
205×125

The recto of No. 175C is one of the finest figure studies in the collection. The free handling of line, the monumentality of the figure, and the rhythm induced by the action of the arms are reminiscent of certain prints by Pissarro dating from the end of the 1880s (for example D. 84 and D. 87, both of 1889). The drawing is one of the very few instances when Pissarro depicts a domestic theme in the manner of Degas, or of Renoir. The pose seems to have been developed on another sheet of studies that may, judging from the style and the dimensions, have once been part of this same sketchbook, although

this has yet to be confirmed (see *50 Drawings by Camille Pissarro*, Beilin Gallery, New York, March–April 1965, No. 20 repr., 203 × 124, no other details known). This other sheet comprises numerous nude studies, but, while the figure related to that occurring on No. 175C has the same *controposto*, she is shown holding a large plate, or possibly a sieve, as opposed to dressing.

The verso of No. 175C is also important. Although there are various nude studies dating from the late 1870s and the early 1880s (Nos. 85G recto and 113 recto), the verso is possibly Pissarro's earliest compositional study of a bathing scene. Both the style of the drawing and the treatment of the theme evoke comparison with Cézanne, but no direct relationship between No. 175C and any painting, or drawing, by Cézanne can be established. Pissarro himself does not seem to have returned to this particular motif until the middle of the 1890s when he executed a number of canvases and several prints of bathers set in wooded landscapes.

175D Study of a woman tending a cow with a distant view of Eragny
Pencil
Lugt 613e
125 × 210. Framing briefly indicated in pencil on right, 125 × 152.

No. 175D is the only landscape study in the sketchbook so far as it can be reconstituted in this catalogue. In many respects the composition is a reworking of P&V 509, of 1880, and No. 175D may have been a preliminary idea for *La Vachère à Eragny* (P&V 701), of 1886, although there are notable differences.

175E Two studies of a woman undressing on a bed
Pencil
Signs of charcoal offset from another sheet throughout
Lugt 613e
210 × 125

The drawing is markedly sculptural, a feeling that is induced more by the pose than by the style. Of the two studies on the sheet the lower one is heavily accented, thereby emphasizing the contorted pose. Pissarro seems, however, in general to have exploited such poses more in his series of paintings

and prints of bathers than in a specifically domestic context.

175F Study of a man seated on a step in a doorway playing with a child
Charcoal with grey wash
Lugt 613e (twice)
210 × 125

No. 175F is in a looser style than the other sheets in the sketchbook and the subject-matter is less contrived. In this sense, it is the genre subjects depicted by J.-F. Millet that come to mind, but, as is generally the case with Pissarro during this period, the style owes nothing to that of Millet.

175G Five studies of a turkey
Pencil
Lugt 613e
125 × 205

See No. 175H below

175H Study of a turkey
Pencil
Lugt 613e
125 × 205

No. 175H, together with No. 175G above, should be compared with the similar studies occurring in Sketchbook XV (Nos. 168B and 168C). It may have been made in connection with a fan in the Brooklyn Museum, New York (not in P&V), *Gardeuse de dindons* (inv. 59. 28), of 1885. No. 175H is amongst the freest and strongest drawings made during the 1880s, even though it is in pencil. The heavy accenting of line and the notational style recall the best pencil drawings of the Venezuelan period.

176 SKETCHBOOK XIX

The two following drawings are the only sheets in the collection from a small sketchbook, which appears to have been used towards the very end of the 1880s and possibly into the 1890s.

Both sheets accord well with the subjects essayed in Pissarro's watercolours dating from 1890, many of which have detailed inscriptions recording temporal effects. No other sheets from the sketchbook have yet been found.

176A Study of a landscape with fruit trees
 Black chalk
 Bevelled corners on right
 Annotated in black chalk *orage (2)*, *bleu chaud*
 verdâtre, vert noirâtre (2), vert ombre (2),
 ver de gris
 Lugt 613e
 101 × 160

The annotations in the sky of No. 176A seem to accord well with the treatment of the sky as shown in the following drawing (No. 176B), thus implying that the two sheets were drawn in conjunction on the same day. The landscape is most probably the orchard at Eragny, a subject that occurs frequently in Pissarro's *œuvre* during the last half of the 1880s and during the early 1890s, although No. 176A does not seem to relate to any finished painting. Comparison should be made with No. 99D from Sketchbook IX, an earlier drawing, for an appreciation of Pissarro's more skilful handling of the effect of light.

On the verso are the names and addresses of the following merchants in artists' materials, all of whom are of interest in connection with Pissarro's work as a print-maker, and help to date the drawing: *acierage / Clément / No. 8 rue du Clôtre Notre / Dame / cuivre / Leroux* (crossed through) *Loiseau / 33 rue Descartes / Vernis à remordre / Varé rue Grégoire de Tour 4 / Ribert / 20 rue Demat / planeur de la part de / M. Jacques.*

The mount conceals a small part of these inscriptions at the upper edge and on the right. Janine Bailly-Herzberg was kind enough to check these names in the *Annuaire du Commerce*: A. Clément occurs for the first time in the *Annuaire du Commerce* of 1888, as *imprimeur en taille douce*; Leroux occurs for the first time in the *Annuaire du Commerce* of 1883, as *successeur* of Moreau, and is described as *graveur et planeur à la mécanique*; Varé, or Varré, is also mentioned in the *Annuaire du Commerce* of 1883 and is described as *fabricant de papier à calquer*; Ribert, or Ribeyre, is listed for the first time in the *Annuaire du Commerce* of 1888, as a *planeur sur métaux*. The *Jacques*, at the end of the inscription is, according to Bailly-Herzberg, most probably Charles Jacques, whom Pissarro appears to have met at this time and from whom he may have received this information. On this evidence, therefore, it is possible to date Nos. 176A and 176B in 1887–8.

176B Study of clouds
 Black chalk
 Bevelled corners on right
 Lugt 613e
 101 × 160

Such studies as No. 176B are rare in the context of Impressionism and even in Pissarro's own *œuvre* the present drawing appears to be exceptional. Furthermore, the study is in monochrome and is not concerned with delicate colour changes between cloud and sky. Instead, No. 176B seems to be more concerned with cloud formations, and, inasmuch as the sky is stormy, the drawing may relate directly to the annotated drawing catalogued above (No. 176A).

The sheet may even have been inspired by Constable's series of cloud studies, many of which were on public view in the South Kensington Museum by this date (see G. Reynolds, *Catalogue of the Constable Collection, Victoria and Albert Museum*, London, 1960, pp. 1–5).

177 Sheet of studies: studies of male and female peasants digging and harvesting with a study of the head of an old woman seen in profile facing left
 Pen and indian ink with dark wash on discoloured white paper
 Lugt 613e
 261 × 259

The brief study of the head of an old woman in the lower left corner is on the original sheet of paper, but it has presumably been folded under at some time, since the paper is lighter in tone, and there is a heavy crease to the right of the head. From above this point, however, the sheet has been squared off with an additional strip.

No. 177 is a drawing of high quality exhibiting a wide range of technical skills. Pissarro has used pen and ink outlines for the portrait in the lower left corner and for the two peasants next to this head. The rest of the studies are drawn with the brush and are notable for the powerful chiaroscural style. There is a marvellous fluency and suppleness of hand in each of the studies on this sheet, not one of which can be related to a finished composition.

The elderly woman in the lower left corner is almost certainly a portrait of the artist's mother, Rachel Pissarro (see also Nos. 39, 145, 194), who died in May 1889. No. 177 most probably dates from the period 1885–9.

178 **Compositional study for** *Le Marché de Pontoise*
Brush drawing in grey wash
Signed in pencil with the artist's initials lower left
Numbered in blue chalk *381* on the verso visible through the paper lower right
Lugt 613e (faded)
263 × 205

No. 178 was most probably drawn in connection with P&V 1413, a gouache of 1887 entitled *Le Marché de Pontoise*. Some of the motifs in P&V 1413 are derived form an earlier gouache, *Le Marché de volaille, Gisors* (P&V 1400), of 1885. For instance, the trees, hampers, and the main figures spread across the composition in the middle distance of P&V 1400 are repeated in the foreground of the present drawing and the finished gouache. The format, however, has been changed from the horizontal in P&V 1400 to the vertical.

179 **Study of five peasant figures working in a field**
Pen and ink over black chalk
Lugt 613e
155 × 195

Exhibited: London/Nottingham/Eastbourne 1977–8, No. 29

No. 179 is a preparatory study for the gouache, *La Récolte des pois* (P&V 1408, sold Sotheby's, 22 June 1966, lot 42 repr.), of 1887. In the gouache Pissarro has altered the background by substituting a house for the distant view in No. 179 of St. Ouen-l'Aumône as seen from Le Chou at Pontoise, thereby investing the composition with an unambiguously rural flavour. This alteration of the background may partly be explained by the fact that Pissarro was no longer living in Pontoise in 1887. He did actually paint scenes of the pea harvest at Pontoise in 1880

(P&V 516–19), but both the style of No. 179, and its close relationship with the dated gouache, indicate that Pissarro was seeking to re-create an idealized landscape of Pontoise while living in Eragny. This was a process that he undertook frequently in his market scenes of the later 1880s and 1890s, many of which are set in Pontoise.

There is a study of the two bending figures in the foreground of P&V 1408 seen against the same background as in No. 179 in the Louvre (inv. RF30099, watercolour and black chalk, 213 × 171). The drawing in the Louvre forms part of a sketchbook, from which there are seven sheets in the Cabinet des Dessins, all with studies of peasants working in the fields.

180 **SKETCHBOOK XX**

Both compositionally and stylistically this sketchbook is of considerable importance and dates from 1884–9. Nos. 180E, 180F, and 180G recto explore the possibilities of establishing new landscape formulae. The subjects are not new, and, as such, Pissarro can be seen reworking earlier compositions within a fresh context, one that is characterized by high horizon lines and empty foregrounds. There is less dependence upon the diagonal, and the high curving horizon lines help to unify the disparate elements of the compositions. Stylistically, the softness of touch and the deftness, and speed with which the black chalk, or charcoal, is applied anticipate the drawings of the 1890s.

180A **Study of a man ploughing**
Pencil
Lugt 613e
121 × 200

No. 180A is directly related to a wood-engraving entitled *Le Labour*, which was executed by Lucien Pissarro (Studio Book, I, f. 55 No. 91; Fern, No. 76) after a drawing by his father, and was included as the first print in the portfolio *Travaux des champs*, finally published in 1895. No. 180A appears to be a preliminary study for the ploughing team as seen in reverse direction in the print. There are two

horses in the final wood-engraving, whereas only a single one is shown in No. 180A, although one of the traces leading to another horse is indicated in the drawing. A notable feature is that Pissarro has depicted an old-fashioned wooden plough which is often seen in his paintings (for example, P&V 258). See also No. 144 above.

180B Study of a woman carrying a basket seen from the back in three-quarters profile facing left
Pencil
Lugt 613e
204 × 117

This rapidly executed study, most probably of a figure observed at a local market, does not seem to have been deployed in either a painting, or a print.

180C View of Bazincourt seen from the artist's house at Eragny-sur-Epte
Black chalk
Stained by ink in centre at upper edge
Annotated in black chalk *plus bas* (2)
Lugt 613e
121 × 208

No. 180C is a drawing of the adjacent village of Bazincourt as seen from the artist's house in Eragny. It is a view that is frequently used in Pissarro's paintings of the late 1880s and throughout the 1890s, as well as in several prints. Pissarro depicted the meadows in varying weather conditions and often resorted to such motifs as he became less mobile during old age, and when he began to suffer from an infection of the tear duct that was to cause him considerable inconvenience during the last decade of his life.

180D Study of an unidentified landscape
Black chalk
Lugt 613e
120 × 208

Both the subject and the relatively loose style of No. 180D suggest a date of 1884–5. For similar landscape compositions, see P&V 641 and 644, both of 1884, and No. 272 of the present catalogue. Another drawing of this same landscape, which so far has eluded firm identification, was last recorded with the O'Hana Gallery, London (pencil, signed with the artist's initials lower right corner and dated 1889, 206 × 158). Stylistically, No. 180D is somewhat looser than this other drawing.

180E Study of a landscape with a shepherdess driving her flock
Charcoal
Lugt 713e
119 × 208

Like the two following drawings (Nos. 108F and 180G), No. 180E displays a similar concern with a new type of composition. There is a close correspondence with the pastel entitled *Berger et moutons, Eragny* (P&V 1576, exhibited Marlborough Fine Art, 1968, No. 38 repr.), of 1889, a composition that was repeated much later (P&V 1259) in 1902, but one that depicts a shepherd as opposed to a shepherdess.

180F Study of a field with a distant row of trees
Charcoal
Annotated in charcoal *vert*
Lugt 613e
119 × 208

Nos. 180F and 180G have an unusual stylistic and compositional affinity, and both were drawn at a time when Pissarro seems to have been working towards a broader, more synthesized type of landscape, which is used for the first time in paintings dating from the last half of the 1880s (for example, P&V 726, of 1888, Dallas, Museum of Fine Arts). Two other drawings in the collection, not in the present sketchbook (Nos. 181 and 182), were drawn at the same time as Nos. 180F and 180G, and display similar compositional interests.

180G Study of a field with two trees (recto)
Black chalk
Annotated in black chalk *vert chaud*
Lugt 613e

Slight study of two male figures walking in a farmyard (?); traces of a study of the head of a child (verso)
Black chalk. Pencil (study of head of child only)
119 × 207

See No. 180F above.

**181 Study of the orchard at Eragny-sur-Epte
with a tree in the foreground**
Coloured chalks
Traces of blue watercolour upper centre poss-
ibly offset
Marked by rust along upper left edge and by
stains lower left corner
Lugt 613e
94 × 285

Like No. 182 below (see entry for mention of further studies), No. 181 is a preparatory study for P&V 726, *La Cueillette des pommes*, *Eragny* (Dallas, Museum of Fine Arts), of 1888. Of these, No. 181 is closest to an oil sketch which relates directly to the landscape of the final painting. The oil sketch is entitled *Pommiers en fleurs* and is now in the Musée Faure, Aix-les-Bains. It was first published by Raymond Cogniat (R. Cogniat, *Pissarro*, Naefels, 1974, p. 48 repr.). The oil sketch is, in fact, stylistic-ally compatible with P&V 704 (sold Christie's, 4 April 1978, lot 3 repr.) and P&V 706, both of which are dated *c*. 1886 in the *catalogue raisonné*. No. 181 is of some importance in that it is a direct study drawn in a quasi Neo-Impressionist manner for a picture that is overtly Neo-Impressionist in style. In the finished composition the tree has been moved inwards and placed just to the right of centre.

**182 Study of the orchard at Eragny-sur-Epte
with a tree in the foreground**
Black chalk
Lugt 613e
191 × 305

Exhibited: London/Nottingham/Eastbourne 1977–8, No. 27 repr.

No. 182, one of the most accomplished landscape studies in the collection, is a preliminary drawing for the painting *La Cueillette des pommes*, *Eragny* (P&V 726, Dallas, Museum of Fine Arts), of 1888, which is executed in a Neo-Impressionist technique and for which there is an elaborate study in gouache, P&V 1423. No. 181 is also related to P&V 726 and a further compositional study, developed as part of *Travaux des champs*, is, in turn, derived from that same painting (see Nos. 331 and 332 below). For some discussion of this type of composition see the introductory section to Sketchbook XX in which there are two further related sheets (Nos. 180F and

180G recto). Apart from the essential motifs of the landscape itself, Pissarro fuses the composition together in No. 182 by his skilful technique, charac-terized by the rhythmical lines and broadly hatched strokes used for the spreading tree in the right fore-ground and also for the other trees on the curved horizon line.

183 Study of the orchard at Eragny-sur-Epte
Watercolour and charcoal
Damaged by damp throughout and marked
by the imprint of other sheets of paper
Inscribed in pencil *Eragny-sur-Epte* and
signed *C. Pissarro* lower left
225 × 286

Exhibited: London/Nottingham/Eastbourne 1977–8, No. 23

Pissarro painted a number of views of Eragny dur-ing the mid 1880s, having moved there in 1884 (see P&V 629–635, 647–9, 664–5, and 668). The nearest compositional resemblance with the present draw-ing is P&V 635, of 1884, which Pissarro reused for P&V 765, of 1891. The style of No. 183, where the watercolour has been more loosely combined with the charcoal, is characteristic of the mid 1880s, and is a development of that found in Nos. 91 and 92. A sheet, closely related in composition, but drawn in Pontoise at a slightly earlier date, perhaps 1881–2, is now in a private collection, London (exhibited JPL Fine Arts, London, 1978, No. 23 repr.).

184 Study of a shepherd seen from the back
Black chalk on glazed paper
Pen flourish upper left corner
Lugt 613e
216 × 183

This boldly executed figure study was used for the first time by Pissarro in *Le Troupeau de moutons*, *Eragny* (P&V 723), and in the pastel *Le Départ du berger*, *Eragny* (P&V 1577), both of 1888. The figure recurs later in one of the designs for *Travaux des champs* (see Nos. 369–71 below).

185 Study of a dog seen in profile facing right
(recto)
Black chalk on heavy tracing paper
Faint red stain on left

Study of a dog seen in profile facing left
(verso)
Black chalk on heavy tracing paper
Stained with ink lower left corner.
176 × 252

It is possible that No. 185, like the preceding draw-
ing (No. 184), was drawn in connection with P&V
723, *Le Troupeau de moutons, Eragny*, and P&V
1577, *Le Départ du berger, Eragny*, both of 1888.
Whilst in the case of No. 184 the correspondence
is clear cut, Pissarro has made considerable changes
in the pose of the dog in the finished composition
from that studied in these rather weak drawings
(Nos. 185 and 186), and it may be that they were
made for an unfinished composition.

The outlines of the drawing on the verso of No.
185 are traced through from the study on the recto.
For another possible tracing from the recto of the
present sheet see No. 186 below.

186 Study of a dog seen in profile facing left
 Pencil on beige paper
 Lugt 613e
 215 × 192

See No. 185 above
No. 186 is a weak drawing, and the attribution to
Camille Pissarro has been doubted (see modern in-
scription in lower right corner below stamp). In
fact, it appears that, like the drawing on the verso
of No. 185, the present sheet might have been traced
from the recto of No. 185.

187 Study for Gardeuse de vaches, Eragny
 Black chalk on grey paper
 Extensively damaged. Upper left corner and
 much of the left edge missing
 Stained throughout by damp and offset from
 a watercolour
 Lugt 613e
 292 × 248

No. 187 is severely damaged, but it was once, and
to some extent still is, a drawing of very fine quality.
The study was made in preparation for a large
gouache, *Gardeuse de vaches, Eragny* (P&V 1416),
of 1887. The pose of the figure is almost identical,
although in the gouache she is seen slightly from
above, so that she appears to be looking directly at

the ground, as opposed to staring into the distance,
as in No. 187. Another drawing related to P&V
1416, presumably made at an earlier stage in the
preparatory process than No. 187, is in the British
Museum (inv. 1928. 7. 16. 2, pen and brown ink
with watercolour over brief indications in pencil,
197 × 208).

The subject and the technique of No. 187 are per-
haps closer to J.-F. Millet, whose drawings had
been exhibited at the Ecole des Beaux-Arts in 1887,
than to Seurat. However, Pissarro is here far less
concerned than Millet, with the volume of the
figure, and the modelling with the chalk is far more
even.

188 Study of a field, Eragny-sur-Epte
 Watercolour over pencil
 Damaged throughout by damp
 Inscribed, signed, and dated in pencil *Eragny*
 1888 C. Pissarro lower left
 161 × 238

Although damaged and slightly faded, No. 188 has
retained a great deal of its original luminosity. It is
one of Pissarro's tighter and more controlled water-
colours of these years, given that it is not in the *poin-
tilliste* manner. The technique, which is charac-
terized by large areas of relatively undifferentiated
colour, owes little directly to Neo-Impressionist
colour theory, but, on the other hand, the schematic
composition and the narrow range of tonal values
do relate No. 188 to the contemporary landscapes
of Seurat and Signac. The prominence given to the
cast shadow of the house, which is itself outside the
pictorial area (in this instance the artist's own
house), is a device that Pissarro used during the last
half of the 1880s, notably in those paintings exe-
cuted in a Neo-Impressionist style (see, for
example, P&V 694, *Le Chemin de fer de Dieppe,
Eragny*, of 1886). Interestingly, Pissarro had already
been criticized by Castagnary for using this device
at the time of the first Impressionist exhibition held
in 1874 (see *Centenaire de l'impressionnisme*, Grand
Palais, Paris, 1974, pp. 249–50).

189 Study of a field, Eragny-sur-Epte (recto)
 Watercolour over indications in pencil
 Extensively damaged throughout by damp
 with offset from another watercolour in the
 upper half

Torn horizontally in centre of left edge
Pin marks in corners
Lugt 613e

Study of Camille Pissarro painting
(verso)
Watercolour over pencil
Numbered in blue chalk *135* twice with the
mark \emptyset indicated on left
171 × 250

No. 189 is badly damaged, almost to the point of
ruin. It is compositionally related to P&V 706, *Le
Labour à Eragny*, which is dated *c*. 1886 in the *cata-
logue raisonné*. The present drawing may have been
made in preparation for the painting, which is, how-
ever, in a Neo-Impressionist style, whilst No. 189
is characterized by broadly laid washes.

The verso of No. 189 has been crossed through
in blue chalk, presumably to indicate that it is not
by Camille Pissarro. This may well be the case. It
is in a *pointilliste* style and is possibly by a younger
member of the family. It is of some interest in that
it shows Camille Pissarro at work in front of his
easel, apparently in the garden at Eragny.

**190 Study of the orchard at Eragny-sur-Epte
seen from the artist's house**
Watercolour over black chalk
Lugt 613e
218 × 281

Exhibited: London/Nottingham/Eastbourne 1977–
8, No. 43.

A date of 1886–90 is likely for No. 190 when Pis-
sarro, almost as an antidote to the close technique
necessitated by Neo-Impressionism, adopted a
broader style in his watercolours. Comparison may
be made with a watercolour inscribed *Eragny Sept.
88* exhibited in Paris in 1959 (Galerie Charpentier,
18 March 1959, repr. pl. 1).

The orchard at Eragny seen under different
weather conditions became one of Pissarro's most
frequently depicted motifs during the last half of the
1880s and in the 1890s. The tree in the centre of
No. 190, for instance, occurs in P&V 708 (*c*. 1887)
and P&V 720, of 1888, for which a pastel, P&V 1576,
served as a preparatory study.

**191 Study of a landscape with a ploughed
field, Eragny-sur-Epte**
Watercolour over pencil
Signed in black chalk *C. Pissarro* and
numbered in pencil by the artist *No. 14*
lower right
209 × 276 (sight)
Purchased 1945

Literature: *Ashmolean Museum Annual Report*,
1945, p. 24.
Exhibited: London/Nottingham/Eastbourne 1977–
8, No. 42.

The barren composition of this fine watercolour
recalls J.-F. Millett's *L'Hiver aux corbeaux* (Her-
bert, No. 192), which was included in the large Mil-
let exhibition held at the Ecole des Beaux-Arts in
1887 and was visited by Pissarro (see *Lettres*, pp.
149–51, 16 May 1887). Both compositionally and
technically, No. 191 is closely related to Pissarro's
other Neo-Impressionist landscapes, all of which
date from the final years of the 1880s (notably P&V
706, *c*. 1886, and P&V 730, of 1889). Indeed, the
topography is very close to that of P&V 730, *Les
Moissoneuses*, and there is an undated pastel which
also represents the same field at harvest time (P&V
1605, *Les Moyettes à Eragny*). The closest connec-
tion, however, both stylistically and topographi-
cally, is with another watercolour entitled *Terrain
labouré, Eragny* (exhibited Marlborough Fine Art
1968, p. 29, No. 37 repr. pl. 37), which is dated 1888.

It is interesting to observe that the mood of
Pissarro's treatment of this theme differs consider-
ably from that of J.-F. Millet. Where Millet in his
painting *L'Hiver aux corbeaux* stresses the starkness
of the scene with the abandoned plough and the
wheeling flock of crows, thereby implying the hard-
ship of human labour, Pissarro in No. 191 conveys
a feeling of pantheistic pleasure in the fecundity of
the earth.

**192 View of a house at Eragny-sur-Epte seen
from behind a fence**
Coloured chalks
Cut vertically in the centre and later rejoined
Watermark (cut, top half of a scrolled car-
touche with initials in centre, almost cer-
tainly E. D.&Cie) lower edge left of centre
Lugt 613e (purple ink)
220 × 300

This important drawing dates from the period 1885-90. The style is notable for its neat cross-hatching and is, in some respects, comparable with No. 169, although that sheet itself probably dates from slightly earlier in the decade. Pissarro included the house seen in No. 192, which was situated very near his own home in Eragny, in three paintings; P&V 669, of 1885, P&V 678, of 1885, and P&V 733, of 1889. In these three paintings the house is only partially represented, whereas in No. 192 it forms the centre of the composition.

On the verso there are two previously unrecorded lithographs, which date from the same period as the drawing on the recto. The subjects are *View of the meadows at Eragny-sur-Epte* and *Head of a male peasant wearing a hat seen in profile facing left*.

193 Study of the crowd at the bottom of the Eiffel Tower seen at the Universal Exhibition of 1889
Black chalk
Repaired along lower edge
Lugt 613e
213 × 124

No. 193 was presumably drawn on the occasion of the inauguration of the Eiffel Tower (31 March 1889), which was the central attraction of the Universal Exhibition of 1889 celebrating the centenary of the Revolution. While Seurat, amongst his immediate contemporaries (C. M. de Haucke, *Seurat et son œuvre* i, Paris, No. 196 p. 170 with date 1889), seems to have regarded the erection of the tower as an achievement, for Pissarro it was a symbol of social degradation (*Lettres*, p. 184, 9 September 1889), and it is as such that it is interpreted in the album of drawings *Turpitudes sociales* (see the facsimile edition ed. A. Fermigier, Geneva, 1972, frontispiece and f. 1, and particularly the text of the undated accompanying letter explaining the imagery of the frontispiece). Pissarro's rendering of the tower on No. 193 is of interest for its denial of both the height and the aggressive cast-iron structure of Eiffel's masterpiece.

The style of No. 193 cannot be strictly described as tenebrist, as Pissarro is already revealing his proclivity for the varying values of black chalk, which is one of the main features of his chalk drawings of the 1890s. No. 193, however, is stylistically compatible with the series of drawings of the artist's

mother done in 1888-9, for which see No. 194 below.

There is a drawing by Lucien Pissarro of the same subject as No. 193 with a strikingly similar composition in the Ashmolean collection (see Lucien Pissarro, Sketchbook No. 4, *c*. 1889).

194 Study of the artist's mother lying in her bed seen by candlelight
Charcoal
Signed in charcoal with the artist's initials lower right
Watermark (cut, showing part of a cartouche with initials in centre, almost certainly E. D.&Cie) lower edge left of centre
Remains of another sheet of paper have adhered along the lower edge to right of centre
Lugt 613e (purple ink)
224 × 291

Rachel Pissarro, the artist's mother (for biographical details see No. 39), returned to Paris from St. Thomas in 1856 one year after Camille Pissarro left the island. While in Paris, she kept in close touch with both her sons, Alfred and Camille. The artist made a number of moving studies of his mother during the final years before her death on 30 May 1889. The earliest example, which is in a technique reminiscent of Seurat is in the Museum at Tel Aviv (charcoal, inscribed *à Esther 1887. C. Pissarro*, no dimensions known). These studies culminated in two powerful Rembrandtesque etchings, D. 73 and D. 80 dating from 1888 and 1889 respectively. The drawings made by Pissarro for these two prints reveal a great deal about his preparatory processes. For D. 73 there is a watercolour (Sotheby's, 8 July 1971, lot 5 repr.); a study in pen and ink, formerly in the possession of Lucien Pissarro (CI neg. 52/72(10a), pen and ink, dated *1889*, 189 × 140, exhibited Leicester Galleries, 1955, No. 5, and possibly Leicester Galleries, 1967, No. 48); a study, apparently in conté, in which the back of the armchair is shown, formerly in the possession of Lucien Pissarro (CI neg. 52/58(19), 133 × 95, exhibited Leicester Galleries, 1967, No. 49 repr.); and another study, apparently in conté, also formerly in the possession of Lucien Pissarro (CI neg. 52/58(21), dated *7 mai, 1889*, 152 × 108, exhibited Leicester Galleries, 1967, No. 47).

For D. 80, in addition to No. 194, there is also a watercolour signed and dated *1888* (Sotheby's, 30 November 1967, lot 22 repr. resold Sotheby's, 22 April 1971, lot 28 repr.); a study in pencil on buff paper, exhibited Beilin Gallery, New York, *50 Drawings by Camille Pissarro*, March–April 1965, No. 22 repr. (sold Sotheby Parke Bernet, 18 March 1976, lot 98 repr.), to which another drawing formerly in the possession of Lucien Pissarro (CI neg. 52/58(20), black chalk, 95 × 152 (sight) is closely related. All these studies, as in the final print, show the figure in half-length reclining on a bed illuminated by candlelight. Of these preparatory drawings, No. 194 is the most highly finished, the main stylistic influence being the tenebrist drawings of Seurat (compare Seurat's drawing entitled *Sa tante Anaïs Haumonté-Faivre sur son lit de mort, 5 nov. 1887*, repr. J. Sutter, *Les Néo-impressionnistes*, Neuchâtel, 1970, p. 39). Compositionally, however, as Mr David Alston pointed out, the theme is one that was treated a number of times by Rembrandt in his series of drawings of his wife Saskia in bed (for example, *Saskia asleep in bed*, Ashmolean Museum, Oxford, repr. *Ashmolean Museum Report of the Visitors*, 1954, pl. xiv and O. Benesch, *The Drawings of Rembrandt*, London, 1957, vol. vi, Addenda 4, pp. 424–5, fig. 1711).

195 Study of the head and shoulders of a dead woman lying in her coffin
Black chalk on tracing paper
174 × 133

There can be little doubt that the figure in the coffin is the artist's mother, Rachel Pissarro, who died on 30 May 1889, and whom the painter drew frequently during the last months of her life (see No. 194). Pissarro's group of drawings representing his dying mother, and particularly No. 195, recall Monet's famous picture of his wife Camille on her deathbed painted in 1879 (D. Wildenstein, *Claude Monet. Biographie et catalogue raisonné, i, 1840–1881*, Lausanne–Paris, 1974, No. 543 p. 348 repr.). The subject of death treated in this intimate way is one that Impressionist painters rarely depicted and, in fact, Monet's painting of Camille, the present group of drawings by Pissarro of his mother, and the lithograph of his first daughter Jeanne on her deathbed (D. 129, of 1874) are the only known examples.

The fact that No. 195 is drawn on tracing paper suggests that Pissarro might have intended making

a print of the subject, but no other studies and no such print have so far been found.

196 Copy after an unidentified book illustration, or humorous cartoon
Pen and dark ink with grey wash on tracing paper
136 × 103

The style of the penwork, if the effect of the grey wash is discounted, may be compared with the illustrations of Charles Keene. It is unlikely that No. 196 is an original composition by Camille Pissarro, but an alternative source has not been found. It is, of course, a possibility that Pissarro is here drawing an illustration by another artist in the manner of Keene.

It should be noted that a collection of three hundred and forty-four cuttings of Keene's drawings, as reproduced in copies of *Punch* mainly dating from 1886–90 and sent by Lucien Pissarro to his father, is still in private possession. No. 196 has not been copied from one of these. However, Lucien's own wood-engravings of popular subjects are undeniably similar in style (see, for example, *La Visite*, Studio Book, I, f. 25, No. 34, Fern, No. 34 p. 136).

197 Study of the side of a building with two trees in the foreground
Pen and dark ink
51 × 86

198 Study of the head and shoulders of an old man seen in profile facing left
Pen and dark ink with watercolour
Repaired at upper left corner
Stained
Lugt 613e
50 × 86

199 Half-length study of a female figure seen in profile facing right (recto)
Pen and indian ink
Lugt 613e

Various studies, including a monogram, a whole-length study of a small boy seen

from the back, and a heraldic device (?)
(verso)
Watercolour over pencil
195 × 150

The fine penwork of the study on the recto of No. 199 is of the kind developed by Pissarro during the mid 1880s. It is found, for example, on No. 171A, which forms part of Sketchbook XVI used mainly in Gisors. The pose and the dress of the figure suggest that she is a maid, perhaps the maid who waited upon the artist's mother (see No. 152 below). Such a figure, however, does not recur in any known painting.

The studies on the verso are of no great merit, except for the monogram.

200 Sheet of studies (recto)
Pen and dark ink
Lugt 613e

Sheet of figure studies (verso)
Pen and dark ink and pencil
Three blotches of chinese white in upper half
224 × 176

The principal figure studies (upper left and lower right) on the recto of No. 200 are surely inspired by the work of Charles Keene. The seated figure in the lower right corner appears to be in a railway carriage. The texture of the penwork varies on the page, combining Pissarro's finest pen lines with his thickest, which might have been executed with a reed pen. The landscape composition in the lower left corner is loosely related to P&V 314 (c. 1875), which Pissarro remade in 1880 (P&V 515). The fact that it appears again here on this sheet is difficult to explain unless Pissarro was thinking of transposing the composition into the more schematic manner of a Neo-Impressionist painting.

The studies on the verso of No. 200 confirm a dating during the second half of the 1880s. They are, however, much weaker in quality and are most probably by Lucien Pissarro. All the studies on the verso relate to two wood-engravings by Lucien Pissarro, *La Visite* (Studio Book, I, f. 25 No. 34; Fern, No. 34 p. 136) and *Patron et employé* (Studio Book, I, p. 28 No. 39; Fern, No. 39, p. 140, published in *La Vie Moderne*, 26 February 1887). A half-length study of a male figure lightly drawn in pencil has been sketched on the verso when the sheet was inverted. This study also relates to the wood-engraving *Patron et employé*.

**201 Caricature studies of a group of bour-
geois figures**
Pen and dark ink
Lugt 613e
199 × 150

No. 201 is in Pissarro's broadest pen style. Throughout the 1880s and 1890s the artist concerned himself with class divisions within French society. While this concern is not so evident in his paintings, it is vividly recorded in such drawings as No. 214, which is related in style to those sheets comprising *Turpitudes sociales* (for which see Sketchbook XXI, No. 210).

202 Sheet of figure studies
Pencil
Lugt 613e
188 × 306

Pissarro seems to be principally concerned here with the physiognomy of bourgeois figures, which he used to such devastating effect in *Turpitudes sociales* (for which see Sketchbook XXI, No. 210). No. 202 may be dated c.1885.

Pissarro's interest in caricature first arose in 1883 while on a visit to Rouen (No. 158A), and his studies of physiognomic expression may have been inspired by Degas (see T. Reff, *The Notebooks of Edgar Degas*, i, Oxford, 1976, pp. 25–7 with further bibliography). Pissarro, however, quickly turned this interest to political advantage.

203 Study of a crowd behind a barrier
Pen and indian ink over pencil on squared
paper printed in blue ink
Stained by wash lower right
Lugt 613e
131 × 140

It is difficult to establish where precisely Pissarro witnessed this crowd scene. An inscription by a later hand, presumably faithfully recording a family tradition, has identified it with one at the Universal Exhibition of 1889, but there is no means of verifying this. The penwork is reminiscent of studies found in Sketchbook XIII (No. 158), which was used in Rouen in 1883, but the paper, although similar, is of a different type. It is, however, by no means obvious as to which of the other sketchbooks

with squared paper printed in blue ink No. 203 belongs. Stylistically, a study in pen and ink (sold Galerie Motte, Geneva, 7 December 1973) relating to a composition entitled *La Ronde* (P&V 1392–3 dated *c*.1884 in the *catalogue raisonné*), for which a second study in chalk was sold at Sotheby's, 1 May 1969, lot 284 repr., is comparable.

A date of 1885–90 for No. 203 seems, therefore, the most reasonable until new evidence is found.

204 Sheet of figure studies
Pen and dark ink
Inscribed in ink in Hebrew upper left
Lugt 613e
194 × 309

The inscription in Hebrew is only partly decipherable. The first three characters are not actually recognizable as Hebraic, but the rest has been construed as 'rahegm b', meaning 'have mercy on'. The compilers are grateful to Professor Martin Ostwald of Swarthmore College, Pennsylvania, for his assistance in reading this inscription.

205 Sheet of figure studies
Pen and dark ink
Repaired upper left
Lugt 613e (purple ink)
196 × 299

No. 205 is one of the finest pen and ink drawings in the collection. The figures were almost certainly observed at a local market, but do not seem to have been incorporated into a finished painting, or print. No. 205 and the two following drawings (Nos. 206 and 207) show how narrow the margin is in Pissarro's graphic work between an accurate depiction of the human figure and caricature.

206 Study of a male figure standing behind a seated female figure
Pen and dark ink
165 × 78

The male figure is one of Pissarro's stock male types who often occurs in market scenes (see, for example, No. 128). This same figure, or a closely related one, is the subject of a woodcut by Lucien Pissarro (Studio Book, I, f. 10, No. 15; Fern, No. 18 p. 121 *c*.1885), for which the drawing was apparently made by his father.

207 Three-quarters-length study of male figure seen in profile facing left with other figures behind
Pen and dark ink
Lugt 613e
199 × 120

The group on No. 207 was almost certainly observed at a market. The penwork is of a high quality and the drawing appears to have been made rapidly. As observed in the preceding entry (No. 206), the male figure prominently placed in the foreground wearing a blouse tunic and a hat is a stock figure, who frequently occurs in Pissarro's market scenes.

208 Study of the head and shoulders of an unknown man
Pen and indian ink
Signed in ink with the artist's initials lower right
144 × 73

No. 208 may be compared with a similar portrait drawing of a man wearing a hat now in the British Museum (inv. 1912. 6. 5. 2, pen and indian ink, 132 × 113). The best stylistic references for both of these drawings are a self-portrait drawing dated 1888 in the collection of New York Public Library (Avery Collection, repr. Rewald, p. 57, and *Lettres*, pl. 12), and a drawing of the artist's mother, dated 1889, formerly in the possession of Lucien Pissarro (CI neg. 52/72 (10a), pen and ink, dated '89, 189 × 140, exhibited Leicester Galleries, 1955, No. 5).

The style of these four drawings is characterized by short vigorously drawn lines made with a thick and heavily inked pen. The sheets are also notable for the use of densely drawn parallel lines with areas of cross-hatching, which create a sharp contrast between light and shade.

209 Three-quarters-length study of a bourgeois male figure wearing a hat and a fur-collared coat with a slight study of another male figure on the left
Pen and brown ink with watercolour (main study). Pencil (slight study on left)
Lugt 613e
205 × 129

During the second half of the 1880s, Pissarro's interest in differing social categories increased and he seems to have built up a stock of figures representing the social divisions of contemporary French society that he was later to exploit in such undertakings as *Turpitudes sociales* (for which see Sketchbook XXI, No. 210).

The drawing has been offset on to the verso of No. 170.

210 SKETCHBOOK XXI

The sheets from this sketchbook are of great assistance in the dating of Pissarro's pen drawings of the late 1880s and early 1890s. Essentially, there are two styles: firstly, the closely drawn mesh of lines somewhat resembling the manner of Gustave Doré, and, in fact, only found in this sketchbook on those sheets drawn in connection with the album *Turpitudes sociales*; and, secondly, the broad hatching and ragged pen strokes of varying thickness occasionally used in combination with a wash, a style that had already been developed in the caricature drawings of the mid 1880s, but which here moves closer to the late style of Daumier.

As regards dating, Nos. 210A and 210B are preparatory studies for the album of political drawings known as *Turpitudes sociales*, which was sent to members of the artist's family. The title-page of the album is dated 1890. The drawings are overtly political in tone, and in them Pissarro gives ample evidence of his sympathy with the anarchist movement in France, which became increasingly active during the 1890s. The album was retained by the family during the painter's lifetime, but is now in the possession of the publishing house of Albert Skira. A facsimile edition was published in 1972 with an introduction by André Fermigier (Geneva, 1972).

Two other drawings, both formerly in the possession of Lucien Pissarro and from this same sketchbook, are also directly related to *Turpitudes sociales*: (1) *Study for 'Au café'*, (CI neg. 51/37 (29), pen and ink, inscribed in pencil *No. 11 Au café*, 220 × 175 (sight), exhibited Leicester Galleries, 1955, No. 11), for f. 21 of the album; (2) *Studies for 'Avant*

l'accident' and *'Après l'accident'* (CI neg. 52/51 (41), no details known), for ff. 24–5 of the album. Three other drawings, also once in the possession of Lucien Pissarro, may be included as part of this sketchbook: (1) *Study of a male and female peasant conversing in a field with the sun rising behind them* (CI neg. 51/58(13), no details known), in a style comparable with Nos. 210A and 210B, and, furthermore a subject with anarchist connotations, owing to the imagery of the rising sun, which was frequently used as an anarchist symbol; (2) *Sheet of studies of male figures dressed in overcoats* (CI neg. 51/36(25), pencil with brown wash, 165 × 210 (sight), exhibited Leicester Galleries, 1958, No. 44); (3) *Sheet of studies of male and female figures walking in a street seen from above* (CI neg. 51/37(27), pen and dark ink over pencil with brown wash, 171 × 220 (sight), exhibited Leicester Galleries, 1958, No. 44 (mounted together with the preceding drawing)). One other drawing for *Turpitudes sociales*, but not from Sketchbook XXI, because of its larger dimensions, has recently been acquired by the Denver Art Museum (inv. 1974. 395 (E. 615)), *The New Idolators*, pen and dark ink, 326 × 251.

210A Study for Les boursicatières
Pen and dark ink over pencil on glazed paper
Inscribed in pencil *No. 12. La Bourse* lower left
225 × 180

Literature: K. Roberts, *Painters of Light. The World of Impressionism*, Oxford, 1978, p. 68 repr.
Exhibited: London/Nottingham/Eastbourne 1977–8, No. 32 repr.

No. 210 is a preparatory drawing for *Les boursicatières*, which is f. 3 of the album *Turpitudes sociales*, of 1890. In the final drawing in the album, Pissarro gives far greater emphasis to the flight of steps, which rises dramatically towards the top of the composition, distributes his figures more freely, and fills the foreground with extra figures seen slightly from above, thereby creating a double viewing point. No. 210A is in many ways more traditional in its grouping of small-scale figures than the finished drawing in the album and is clearly related to the illustrations of Doré in France and Keene in England. In the

pen overdrawing in No. 210, Pissarro has omitted the large doorways of the building, which are important elements of the pencil composition beneath.

No. 210 is a fine example of the tightly knit, agitated pen style that is characteristic of those drawings in this sketchbook done for *Turpitudes sociales* (see No. 210B and introductory section above).

210B Study for *L'asphyxie*
Pen and dark ink over pencil on glazed paper
Lugt 613e
231 × 177

No. 210B is a preparatory study for *L'asphyxie*, which is f. 12 of the album *Turpitudes sociales*, of 1890. Although the main features are unchanged, Pissarro has made several alterations, particularly in the lighting of the scene, in the final drawing in the album, where the bed and the three bodies lying on it are more forcefully illuminated by the skylight. The subdued lighting in No. 210B invests the scene with an air of greater mystery, as opposed to the stark horror of the finished drawing.

210C Study of a female peasant carrying a basket moving to the left
Pen and dark ink with brown wash on glazed paper
Lugt 613e
225 × 177

No. 210C was in all probability drawn in connection with *Paysanne portant une manne* (P&V 735, Aix-les-Bains, Musée Faure, repr. in colour by R. Cogniat, *Pissarro*, Naefels, 1974, p. 57), which is dated *c.* 1889 in the *catalogue raisonné*, and is painted on zinc. The main differences between No. 210C and the painting are that in P&V 735 the figure is seen against the side of a house and that she is posed slightly more upright with some minor changes to her dress. There is also a monotype of the same composition (B. Shapiro and M. Melot, 'Catalogue sommaire des monotypes de Camille Pissarro', *Nouvelles de l'estampe*, xix (1975), No. 12, p. 20), which Melot (No. 264 p. 126) dates 1889–90.

The broader penwork and the introduction of a wash are stylistic features which are also found on No. 210C and differentiate these two drawings from those sheets related directly to *Turpitudes sociales* (Nos. 210A and 210B).

210D Study of a half-dressed young woman standing by her bed
Pen and dark ink with brown wash on glazed paper
Lugt 613e
226 × 177

No. 210D is one of several studies connected with the more intimate subjects that Pissarro began to draw with greater frequency during the second half of the 1880s and during the 1890s (see Nos. 174A recto, 175C recto and 175E). The broad pen style and the introduction of a wash is a similar technique to that used for No. 210C.

210E Study of a man carrying a ladder moving to the left
Pen and dark ink over black chalk on glazed paper
Lugt 613e
228 × 178

Although the figure does not recur in any of the finished drawings in the album *Turpitudes sociales*, it seems highly likely that No. 210E was drawn in connection with that series of drawings. Both the style and the treatment of the figure suggest that the artist had a specific illustration in mind.

210F Sheet of studies
Pen and dark ink with brown wash and pencil, and some black chalk on glazed paper
Lugt 613e
223 × 176

The studies of six bourgeois men executed in pen and ink with a brown wash are closely connected with the content of the album of drawings *Turpitudes sociales*. Indeed, the figure in the lower left corner is a type that recurs in the same area of the sheet drawn for *Les boursicatières* (No. 210A), and elsewhere (see No. 201). The compositional study in the upper left corner does not seem to relate directly to any known painting. The head on the left below the compositional drawing is drawn in black chalk unlike the other studies on No. 210F. It is possibly a copy after a piece of sculpture, although the prototype has not yet been identified, and the markings on the face may be indications of pointing for measurement.

211 Sheet of studies: study of a seated woman, study of a female peasant tending a calf, and a study of calf seen from the back (recto)
Brush drawing in grey wash on glazed paper
Numerical annotations in pen and ink, possibly accounts, lower left
Lugt 613e

Study of a group of peasants in conversation (verso)
Brush drawing in grey wash
176 × 227

At first sight the brushwork and the subject-matter appear to be compatible with the drawings belonging to Sketchbook XV (No. 168), but the dimensions and the type of paper are different. In fact, this type of laid paper with a glazed surface resembles that of Sketchbook XXI (No. 210) and the dimensions are similar. Again, while the group of figures on the verso of No. 211 may be compared with that occurring in No. 168D, the firm linear outline of the calf in the centre of the recto, and the more precise application of the wash on the figures are closer in style to drawings made in the early 1890s (see, for example, No. 226). A date of *c.* 1890 may, therefore, be acceptable for No. 211, and inclusion in Sketchbook XXI (No. 210), although the subject-matter differs so greatly from that of the other sheets, is possible.

212 Two studies of a seated man smoking a pipe seen from the back and in three-quarters profile facing left (recto)
Pen and dark ink
Repaired lower right corner
Lugt 613e (twice)

Slight study of a bending male figure (verso)
Pencil
142 × 193

The ink from the recto of No. 212 shows through the paper and is easily visible on the verso, thus rendering the slight pencil study there almost illegible in reproduction.

The loose ragged pen lines of the studies on the recto of No. 212 are comparable with certain drawings done in Sketchbook XXI (Nos. 210C and 210D), although no wash has been applied in this

instance. The recto of No. 212 is a drawing of some skill tending towards caricature.

213 Study of a nude young woman making her bed
Pen and dark ink over pencil on glazed paper
Folded and creased in several places. Vertical tear in centre of lower edge
Lugt 613e
204 × 180 (uneven)

The style of the penwork is very close to that found in the album *Turpitudes sociales* and to several sheets in Sketchbook XXI (Nos. 210A and 210B).

Like 210D, the present drawing attests Pissarro's growing interest in more intimate domestic subjects during this later period. The study must have been made in the Pissarro household, since the same awning over the bed appears in several other works, such as P&V 1404, a gouache of 1885, D. 80, of 1889, P&V 864, of 1894, for which there is a study in gouache (P&V 1599) and of which there is a monotype (B. Shapiro and M. Melot, 'Catalogue sommaire des monotypes de Camille Pissarro', *Nouvelles de l'estampe*, xix (1975), No. 10, p. 20), and P&V 942 *c.* 1896.

214 Compositional study of a market scene
Pen and dark ink over black chalk on glazed paper
Lugt 613e
190 × 113

No. 214 is a drawing of very high quality. The style closely resembles that of the more finished sheets in Sketchbook XXI (compare Nos. 210A and 210B), particularly in the cross-hatching on the female figure to the left behind the stall. The glazed paper is also similar to that of the sheets constituting Sketchbook XXI and it may be the case that No. 214 originally belonged to it, although subsequently it must have been more drastically cut down than the other sheets. Both the character of the composition and the handling of the male figure on the right are strikingly reminiscent of drawings by Charles Keene, whom Pissarro admired so much. The confrontation between two separate social classes, as depicted in No. 214, is a theme that dominated Pissarro's thinking during the 1880s and 1890s, and, therefore, although the treatment of the subject-

matter is not as politically motivated as the drawings in the album entitled *Turpitudes sociales*, the subject of No. 214 is also compatible with Sketchbook XXI.

Another compositional study of a market scene in an identical style to No. 214 is in the Fogg Art Museum, Cambridge, Massachusetts (inv. 1965. 324, pen and brown ink over black chalk, 183 × 107).

215 Study of a male peasant feeding hens observed by a female figure
Pen and dark ink
Lugt 613e
102 × 106

Exhibited: London/Nottingham/Eastbourne 1977–8, No. 33

No. 215 undoubtedly dates from the first part of the 1890s and the penwork has the same quality as the more closely finished studies for *Turpitudes sociales* in Sketchbook XXI (Nos. 210A and 210B). It is possible that Pissarro intended to make a print of this subject, although one does not seem to have been undertaken. Many of the drawings made in this medium during the 1890s are closely related in style to etchings.

The composition of No. 215, albeit unconsciously, is reminiscent of Adriaen, or Isaac, van Ostade.

216 Portrait of Jeanne-Marguerite-Eva Pissarro (known as Cocotte) (1881–1948)
Pencil on card
Inscribed in pencil on the verso by either Lucien, or Esther, Pissarro *Portrait de Jeanne about 1885*
95 × 56

Literature: Lettres, repr. pl. 26; K. Adler, *Camille Pissarro, a biography*, London, 1978, pl. 10

No. 216 is drawn on the back of a visiting card stamped C. Pissarro in blue ink.

Jeanne was the second daughter born to Camille and Julie Pissarro to be so named. She was the sixth child, the only surviving daughter, and married Henri Marie Alexandre Bonin in 1908.

The date inscribed on the verso of No. 216 by a member of the family is slightly too early, and Rewald, for instance, dates No. 216 *c.* 1888 in the various editions of the *Lettres*. No. 216 may be com-

pared with a painting of his sister by Lucien Pissarro (repr. *Lettres*, pl. 30, formerly in the possession of Orovida Pissarro), which is apparently dated 1889, and also with a whole-length study of Jeanne drawn by Lucien now in the Ashmolean collection (inv. 77. 70 annotated by Esther Pissarro and dated by her 1889–92), in both of which the sitter appears to be approximately the same age as in the present drawing. There are two painted portraits by Camille Pissarro of Jeanne (P&V 825 and P&V 827), of 1892 and *c.* 1893 respectively.

217 Study of a young woman seen from the front carrying a basket
Pen and dark ink
Lugt 613e
154 × 192

Exhibited: London/Nottingham/Eastbourne 1977–8, No. 30 repr.

The style of No. 217, like No. 215, is closely related to the etchings of the late 1880s and early 1890s when Pissarro executed his prints with less aquatint, preferring to use pure etching and dry point instead, relying upon cross-hatching for the creation of tonal values. There is, in fact, a stylistic similarity between No. 217 and D. 74, of 1888, as well as D. 84, D. 85, and D. 87, all of 1889. It is, indeed, possible that Pissarro made this beautiful drawing with a view to etching.

218 Shepherd and shepherdess seated beneath a clump of trees
Pen and indian ink with grey wash and chinese white over pencil
Signed and dated in ink *C. Pissarro. 89* lower left
196 (round)

No. 218 is f. 4 of a book of drawings entitled *Old French songs. From Eragny's artists to Miss E. Bensusan*, a volume that was sent to Lucien Pissarro's future wife on the occasion of her birthday shortly before their marriage in 1890 (K. Adler, *Camille Pissarro, a biography*, London, 1978, p. 131). There is only one drawing by Camille Pissarro, the rest being by Lucien and his brothers, Georges, Félix, and Ludovic Rodo. Pissarro reused the composition of No. 218 for P&V 1664, *Pastorale, c.* 1890, which forms a pair with P&V 1663, *Gardeuses de*

vaches, Bazincourt, both executed in pen and gouache. The main difference between No. 218 and P&V 1664 is that the clump of trees on the left has been reduced to a single tree.

219 Rameuses de pois
 Gouache with traces of black chalk on grey-
 brown paper
 Signed and dated in red gouache *C. Pissarro
 1890* lower left
 407 × 641 (Imperial). 390 × 602 (fan-shaped
 composition)

Literature: P&V 1652 repr.
Exhibited: London, The Royal Academy, *Impressionism. Its Masters, its Precursors, and its Influence in Britain,* 1974, No. 92; London/Nottingham/Eastbourne 1977–8, No. 38

No. 219 is one of Pissarro's finest surviving designs for a fan. Its shape with a flat bottom and two notched corners is unique. A painted version of the same subject, once owned by Monet (P&V 772, of 1891) shows that Pissarro chose later to transpose the position of the two background figures in order to achieve a more symmetrical grouping within the vertical format. In both compositions, however, Pissarro has transformed the activity of the peasant women into a natural dance, a rhythmical movement that may have been suggested to him by Gauguin's treatment of peasant subjects in Brittany during the 1880s. Equally, the earlier example of J.-F. Millet, who could turn a circle of flailers in the background of *L'Été, les batteurs de sarrasin* (Herbert, No. 245) into a similar rhythmical pattern, must not be overlooked.

Iconographically, No. 219 belongs to a series of late paintings of peasant life dating from 1886–92 in which Pissarro moved away from the more realistic peasant genre adopted by him between 1874–85 and evoked a rural Arcadia where toil is replaced by graceful labour.

220 La bergère d'Eragny
 Tempera and pastel with traces of water-
 colour and pencil on grey paper
 Signed with the artist's initials in brown pastel
 over which there occurs the signature and
 date in black chalk *C. Pissarro 1890* lower
 right
 425 × 531 (Imperial)

Literature: P&V 1452 repr.
Exhibited: London/Nottingham/Eastbourne 1977–8, No. 37

This dated pastel precedes the painted version of the subject, P&V 819, of 1892. The presence of two forms of signature (not easily made out in the reproduction) might indicate that Pissarro worked on the composition on two separate occasions, the date being left unaltered. Technically, too, No. 220 is notable for its use of mixed media, which again suggests that the drawing might have been reworked.

221 Study of a female peasant picking beans
 Grey/brown wash over pencil
 Lugt 613e
 149 × 191

Exhibited: London/Nottingham/Eastbourne 1977–8, No. 47

Like No. 292, the present drawing is clearly related to D. 103, of 1891. While No. 292 corresponds almost exactly with the etching and must have been made just prior to tracing, No. 221 seems to have been conceived at an earlier stage and could have served as a preliminary study for either of the two figures in the etching. Alternatively, Pissarro might have considered remaking the print with a single figure. A similar figure recurs in the woodcut entitled *Printemps* executed by Lucien Pissarro after a drawing by his father, for which see Nos. 331 and 332.

222 SKETCHBOOK XXII

The drawings from this sketchbook that have so far been identified seem to relate to market scenes in Gisors executed *c.* 1890. As in the case of Sketchbook XIV (No. 160), the squares on this paper, which are also ruled in blue ink, measure 40 mm. Other sheets from the sketchbook are mentioned in the individual entries for Nos. 222A and 222B.

222A Study of a young woman holding a goose at a market
 Grey wash over pencil on squared paper
 printed in blue ink

Lugt 613e
141 × 90

Nos. 222A–C were probably made on the same occasion at the local market in Gisors. Only the figure in the foreground of No. 222A appears to have been used in a finished composition, P&V 1453, *Marché à la volaille à Gisors*, which is dated *c.* 1890 in the *catalogue raisonné*.

Another drawing from this same sketchbook that also relates to P&V 1453 was in the possession of Hirschl and Adler in 1976 (*Study of a market*, watercolour over pencil on faded squared paper printed in blue ink, 152 × 90, untrimmed). In this more detailed compositional drawing the female figure in the centre is similar to that drawn on No. 222A, while the background corresponds with that in P&V 1453. Like No. 222A, this second drawing was clearly done on the spot, but Pissarro made several major changes during the evolution of P&V 1453.

222B Three-quarters-length study of a man seen from the back conversing with two other figures
Black chalk on squared paper printed in blue ink
Lugt 613e
151 × 89

See No. 222A above

An offset from this drawing occurs on the verso of a sheet formerly in the possession of Lucien Pissarro (CI negs. 52/68(37a) and 52/68(38a)), from which it can be deduced that No. 222B was the next page of the sketchbook. The recto of the other drawing is also in black chalk and is a study of a female figure carrying a bag. She is three-quarters length and seen in profile facing left. The study was most probably used for P&V 1453, *c.* 1890, as the figure bears a striking resemblance to the woman in the middle distance of the gouache standing just to the right of centre. The sheet has bevelled corners and measures 146 × 87 (sight). The photograph shows that the inner edge is uneven, probably as a result of the sheet having been loosely torn from the sketchbook, but it does not seem to have been trimmed, and is, therefore, a key piece of evidence for the reconstruction of the sketchbook. The sheet was exhibited at Leicester Galleries 1958, No. 57.

Another sheet from this same sketchbook with a three-quarters-length study of the identical figure

was also once in the possession of Lucien Pissarro (CI neg. 52/68(33a), black chalk, 147 × 87 (sight), exhibited Leicester Galleries 1958, also No. 57).

222C Three-quarters-length study of a male peasant seen from the back conversing with two women
Grey wash over pencil on squared paper printed in blue ink
Lugt 613e
150 × 88

See Nos. 222A and 222B

The grouping of these figures recalls that of the three figures in the lower left corner of P&V 1451, a tempera, *Le Marché à Pontoise*, of 1890, although in the finished work the pose and the identity of each figure have been considerably changed.

223 Nearly whole-length study of a male peasant holding a farming implement
Grey wash over pencil
Lugt 613e
149 × 88

See No. 224 below

224 Nearly whole-length study of a female peasant with hands placed on her hips seen from the back
Grey wash and charcoal
Annotated in charcoal *bleu foncé* (?), *marron* (?)
Lugt 613e
154 × 87

At first sight it is tempting to assert that Nos. 223 and 224 are from the same sketchbook, but, apart from a marginal difference in size, probably due to trimming, there is a basic difference in the texture of the paper. None the less, both drawings are related in style and subject.

Both Nos. 223 and 224 are almost certainly studies of harvesters, but neither recurs in any of the finished compositions of this subject. Stylistically, the neatly executed straight outlines drawn with the point of the brush are closer to drawings made in the early 1890s (see Nos. 225A and 225F) than to the loose flowing curvilinear outlines which characterize the figure studies of the mid 1880s.

225 SKETCHBOOK XXIII

Although there are slight variations in size, it seems highly likely that the six following sheets are from the same sketchbook. The texture of the paper matches perfectly, and it is evident that the drawings have been trimmed. A date of 1889–95 can be advanced on the basis of Nos. 225B and 225C. In addition, there is the possibility of a connection between Nos. 225E and 225F and P&V 862, of 1893. Stylistically, the use of the point of the brush for drawing the outlines is characteristic of Pissarro's small-scale figure studies of the 1890s.

225A Study of two female peasants weeding a field
Grey wash over black chalk
Lugt 613e
102 × 149

No. 225A is directly related to No. 333, which belongs to the group of drawings undertaken for *Travaux des champs*. While the subject of peasant women weeding a field was essayed many times, notably in P&V 301, of 1875, and P&V 563, of 1882, no other version adopts this pairing of figures seen against an empty background.

225B Study of four peasants working in a field
Charcoal with grey wash
Lugt 613e
102 × 143

No. 225B is a preparatory study for the etching, *Paysans dans les champs* (D. 104), of 1891. In the print the group of peasants are placed nearer the centre and the details of the background are more clearly defined. The print is in the reverse direction from No. 225B. The pose of the female peasant, which is reminiscent of that of the reclining figure in P&V 301, has been changed in the print and is closer to that of the kneeling figure on the left of P&V 301.

225C Study of a female peasant walking to the left carrying faggots in a landscape with a cow
Charcoal with grey wash
Stained by rust lower right corner
Lugt 613e
102 × 146

For another drawing of this same composition see No. 228. Both drawings are related to the right section of a fan, P&V 1642, *Paysage avec un arc-en-ciel*, of 1889, now in the Rijksmuseum Vincent Van Gogh, Amsterdam.

225D Study of a small girl walking to the right
Pencil
Lugt 613e
150 × 103

The style of this drawing, particularly the accented pencil outlines, is also characteristic of the figure studies in Sketchbook XXVI (No. 277). Pissarro often included children in his genre compositions, and there are several instances of this in the late 1880s and early 1890s (P&V 755, 822, 856, and 860).

225E Three-quarters-length study of a female peasant seen in profile facing left
Black chalk
Lugt 613e
147 × 102

No. 225E was clearly drawn at a local market. The pose is similar to that of a figure in the middle distance on the right of P&V 862, *Le Marché aux grains à Pontoise*, of 1893, although in the painting she is seen in three-quarters profile facing right.

225F Study of a seated female figure with her hands clasped in front of her seen in profile to left looking over her right shoulder
Grey wash over black chalk
Lugt 613e
147 × 103

It is reasonable to assume that No. 225F was drawn in connection with a market scene, and, indeed, the pose was adapted for the seated figure occurring in the left foreground of P&V 862, *Le Marché aux grains à Pontoise*, of 1893.

226 Sheet of studies of peasants in a field
Brush drawing in grey wash on beige paper
Lugt 613e
88 × 149

The brushwork with its disjointed outlines, together with the tightly controlled sense of form, are features in which No. 226 approaches the style of drawing dating from the early 1890s, such as Nos.

225A and 225F. The reclining male figure in the lower half and the couple conversing in the upper half are reminiscent of similar figures in a gouache of 1887, *Le Repos des moissonneurs* (P&V 1411), which is derived from J.-F. Millet's composition, *La Méridienne*, a pastel now in the Boston Museum of Fine Arts (Herbert, No. 176). The style of the sheet, together with the disposition of several figures on a single page, relate it to Japanese prints and to that in the published portfolio *Travaux des champs* (Leymarie and Melot, P. 204), for which there may also be a Japanese source.

227 Compositional study of a grain market
 Grey wash heightened with pink gouache
 over charcoal
 Signed in charcoal with the artist's initials
 lower left
 134×86

Exhibited: London/Nottingham/Eastbourne 1977–8, No. 57

No. 227 is a brush drawing of high quality dating from the 1890s. It has a stylistic affinity with some of the later drawings done for *Travaux des champs* (see for example Nos. 347 and 355). Pissarro does not seem to have employed this particular composition in any other context, although the horse-drawn carriage in the background is a notable feature in late lithographs of market scenes (D. 145 *c.* 1895 and D. 156 *c.* 1896).

228 Compositional study of a female peasant walking to the left carrying faggots in a landscape with a cow
 Grey wash over charcoal heightened with
 chinese white
 Lugt 613e
 87×163

This subtly controlled wash drawing is closely related to the figure in the right half of the fan P&V 1642, *Paysage avec un arc-en-ciel* (Amsterdam, Rijksmuseum Vincent Van Gogh), of 1889. The connection, both stylistically and compositionally, between the drawing and the fan is close enough to suggest a similarity in date. Another drawing of the same composition is in the collection (No. 225C forming part of Sketchbook XXIII).

229 Three studies of a cow
 Pen and brown ink with the brush over pencil
 Lugt 613e
 127×172

Although not connected with any specific painting, the firm outlines and the tight sense of form are characteristic of drawings of *c.* 1890 when Pissarro also began to use the point of the brush for prescribing outlines. A similar sheet of studies in the same medium, but of larger dimensions, was exhibited in New York in 1965 (*50 Drawings by Camille Pissarro*, Beilin Gallery, New York, March–April, 1965, No. 27, 242×317).

230 Study of a stooping female peasant holding a basket seen slightly from the back
 Watercolour over black chalk
 Signed in pencil *C. Pissarro* lower left
 182×115

No. 230 is difficult to date, although it is reasonable to assume that it was drawn in connection with *Travaux des champs* (compare, for example, the sixth print in the published portfolio, for which see Nos. 325–8). A watercolour close in style to No. 230 is *Study of two female peasants carrying faggots*, formerly with Roland, Browse, and Delbanco (photograph Witt Library) from which Lucien Pissarro made a copy of the figure on the right now in the Ashmolean Museum (*Travaux des Champs* volume of drawings, f. 3), which was eventually incorporated in *La Charrue d'érable* (1912). The association of this last watercolour by Camille Pissarro with *La Charrue d'érable*, which was a reworking of much of the material amassed for the original project of *Travaux des champs*, implies, if the stylistic comparison is also valid, that No. 230 dates from the first half of the 1890s. A similarly posed figure occurs in a fragment of a fan composition (No. 117 verso).

No. 230 has been stamped on the verso *C. Pissarro / à Eragny-sur-Epte / par Gisors*. This is in the same blue ink and by the same stamp as that used on the verso of No. 216.

231 Landscape with the meadows at Eragny-sur-Epte looking towards Bazincourt
 Pen and dark ink
 Lugt 613e
 99×147

Exhibited: London/Nottingham/Eastbourne 1977–8, No. 40

The penwork of No. 231 is characteristic of drawings dating from *c.* 1890. It is controlled and episodic in its terseness, as though the artist was using an etching needle, and, as such, it is in striking contrast with the bolder, freer pen style of the last half of the 1880s, which reached a climax in Sketchbook XXI (No. 210). It is possible that the sheet may have been drawn in preparation for a print. Indeed, an etching of this view was made in 1888 (D. 79) depicting the same view in winter. No. 231 was drawn in the summer and is in reverse direction from D. 79.

232 Landscape with a distant view of trees at Eragny-sur-Epte
Watercolour with pen and ink
Inscribed with the brush in blue watercolour
Matin, Oct. 90 lower left
122 × 172

Exhibited: London/Nottingham/Eastbourne 1977–8, No. 39

The watercolour has been applied initially over indications in pen and ink, but the artist seems to have added a few strokes with the pen afterwards.

This is the same view as that in No. 231, but seen from nearer the trees. The spire over the tops of the trees is that of the church of the nearby village of Bazincourt.

233 Distant view of Eragny-sur-Epte
Watercolour over black chalk
Somewhat damaged by damp throughout. Badly marked by the imprint of other sheets of paper on the right. Stained at the upper edge right of centre
Inscribed, dated, and signed in pencil *Eragny 1890 C. Pissarro* lower left
171 × 248

Although rather washed out as a result of damp, No. 233 is a good example of Pissarro's more meticulous watercolour style evolved towards the end of his life. This style is characterized by the interaction of line and wash and in this recalls that of the 1870s. Here, however, the watercolour is not constrained by the contours, and the overlaid patches of colour flicker

gently and intermingle delicately with the chalk lines. Even allowing for the action of the damp, the tones of Pissarro's watercolours of this period are usually light and pale.

The composition is notable for its close observation of detail within a broad setting, and in these respects is reminiscent of landscape drawings by Netherlandish artists of the late sixteenth and seventeenth centuries.

234 'Gelée blanche'
Watercolour over pencil
Foxed
Inscribed in pencil with the title, signed, and dated *19 Dec. 90 C. Pissarro* lower left
Numbered by the artist in black chalk *No. 1* lower right
208 × 262

Bequeathed by F. Hindley Smith, 1939
Exhibited: London, The Royal Academy, *Impressionism. Its Masters, its Precursors, and its Influence in Britain,* 1974, No. 93; London/Nottingham/Eastbourne 1977–8, No. 41; London, JPL Fine Arts 1978, No. 34

Pissarro frequently painted this motif of the view across the meadows at Eragny looking towards Bazincourt during the last half of the 1880s and he continued to do so intermittently during the 1890s. In fact, the composition of No. 234 is a simplified version of three earlier paintings (P&V 631 and P&V 632, both of 1884, and P&V 707, *c.* 1884). There is also a drawing in chalk (P&V 1586, sold Christie's, 30 June 1967, lot 39 repr.) representing exactly the same view, although in P&V 631 and 632, as well as No. 234, the trees in the orchard, which are such a prominent feature of P&V 707, have been omitted.

During the 1890s Pissarro showed a renewed interest in climatic occurrences such as fog, hoar frost, mist, the changing seasons, and the different effects of the sun, which he had first essayed during the early 1870s. Like Constable, Pissarro often inscribed these watercolours with details of the weather conditions, the time of day, and the date.

235 Soleil couchant avec brouillard, Eragny
Watercolour mixed with tempera on Japanese paper laid on a Japanese vellum

Damaged by damp particularly in the upper half. Stained by damp at top of curved edge. Somewhat rubbed.
Signed and dated with the brush in blue watercolour *C. Pissarro 1890* lower left
351 × 544

No. 235 is a fan, and similar views of the same location are recorded in greater detail in two other fans also dating from 1890 (P&V 1644 and P&V 1650). A letter of 17 November 1890 (*Lettres*, p. 190) from Camille Pissarro to Lucien refers to five fans recently completed by the artist; 'J'ai fait depuis ton départ … cinq éventails dont je suis content. J'ai deux brouillards que tu ne connais pas, qui sont curieux : il y a un sur Japon, c'est féerique, un autre sur l'envers d'une peau, papier pelure d'oignon, celui-là inattendu.' The *brouillard* on Japanese paper is the present drawing, and the other one has been identified as P&V 1644. No. 235 is again mentioned in another letter to Lucien Pissarro dating from 2 January 1891 ; 'Les objets que je t'envoie seront prêts samedi, si Cluzel tient parole il y a un éventail sur Japon un soleil couchant avec brouillard, très simple. Durand n'aime pas ce genre il dit que c'est trop vide!!!' (passage omitted in *Lettres*). Lucien acknowledged this letter as follows : 'Je viens de recevoir la caisse de Cluzel. Je te remercie, c'est très beau. L'eventail que Durand a refusé est épatant. Le mien est aussi tres joli ; les figures sont d'un grand style', and after showing them to Charles Ricketts, Charles Shannon, and Reginald Savage, he adds a postscript; 'Tes éventails leur ont plu extrêmement' (letter dated January 1891).

236 Landscape with a cloudy sky: twilight
Watercolour
Faintly marked by the imprint of another sheet of paper along the upper edge
Signed and dated in pencil *C. Pissarro 1890* lower left
140 × 180

No. 236 is in a looser and more full-bodied technique than most of Pissarro's other watercolours of the 1890s. Like some of the studies of vegetation done much earlier in Venezuela, No. 236 is in pure watercolour. Both the treatment of the subject, as well as the technique, recall the watercolours of such artists as Delacroix, Huet, and Diaz.

237 Soleil couchant
Watercolour and gouache over pencil
Damaged by damp and abraded. Marked by the imprint of another sheet of paper on both sides, and along the lower edge
Inscribed, dated, and signed in pencil *Eragny 1890 C. Pissarro* lower left

The drawing is virtually ruined.

238 Study of the orchard of the artist's house at Eragny-sur-Epte
Watercolour over pencil
Lugt 613e
283 × 225

Exhibited: London/Nottingham/Eastbourne 1977–8, No. 44; London, JPL Fine Arts, 1978, No. 35

No. 238 is one of the best preserved watercolours in the collection. The same view is shown in a pastel P&V 1607, which is dated *c.* 1902 in the *catalogue raisonné*, although No. 238 is undoubtedly earlier, probably 1890. Comparison should be made with another watercolour of the orchard at Eragny in the British Museum (inv. 1920. 10. 18. 1, inscribed, signed, and dated *Eragny 1890 C. Pissarro*, 160 × 238).

239 Study of a woman kneeling on the ground and adjusting her hair
Charcoal on mauve-pink paper
Lugt 613e
279 × 215

The figure is found on the right of a fan, *Le repas champêtre*, of 1891 (not in P&V, sold Sotheby's, 1 July 1975, lot 4 repr.). Although the general attitude of the figure has been retained, the pose in the fan is more upright with the back straighter. The handling of the charcoal is characterized by the varied texture of line and modelling, which is derived from the interaction of the soft crumbly charcoal on laid paper.

No. 239 provides important evidence for Pissarro's style of drawing with the softer media at the beginning of the 1890s.

240 Study of a female peasant seated on the ground
Charcoal highlighted with pastel
Pin marks in corners

There is evidence of an erased inscription in the lower left corner, but it is difficult to tell if it was written by the artist or by a later hand.

231 × 302

No. 240 is a study for a figure on the left of P&V 773, *Faneuses au repos*, of 1891. The painting is not reproduced in the *catalogue raisonné*, but was exhibited by Wildenstein (New York) in 1965 (No. 54 repr.), and is at present in the Marion Koegler McNay Art Institute, San Antonio, Texas (see E. Fahy and Sir Francis Watson, *The Wrightsman Collection, V, Paintings, Drawings, Sculpture*, The Metropolitan Museum of Art, 1973, p. 155, fig. 2).

241 Study of a peasant girl seated on the ground
Pastel with touches of gouache on pink paper
Lugt 613e
339 × 435

No. 241 is a good example of Pissarro's powerfully drawn late figure studies of which there is an outstanding example in the British Museum also on pink paper (inv. 1920. 7. 12. 21, pastel, 457 × 604), relating to P&V 1486–7, *c.* 1896. No 241 is slightly looser in handling than the drawing in the British Museum, but it is similar in the thick broken outlines of brown pastel and the clear divisions of colour (cerise, cobalt, grey, with smaller patches of orange and lime). The pose of the figure in No. 241 is similar to that of the main figure in *Gardeuse d'oies* (P&V 770), of 1891, although in the painting the feet are pulled up under the body, and the positions of the hands and arms have been adjusted accordingly. Aspects of the costume, notably the headscarf, are unchanged.

No. 241 has a prominent pentimento at the right foot.

242 Study of a male figure in three-quarters profile facing left seen from the back
Charcoal
Lugt 613a
291 × 225

No. 242 is one of the few large-scale figure drawings made by Pissarro that does not seem to relate to a finished composition. While the curvilinear quality of the outlines suggest a date some time in the 1880s, the greater sense of volume with which the figure is invested, as well as the handling of the charcoal, imply a date in the early 1890s. It is difficult to establish the identity of the figure. He could be a shepherd (compare P&V 1440, *Berger sous l'averse*, of 1889), or else a dockside figure (compare D. 67, of 1887).

243 SKETCHBOOK XXIV

Both the stylistic and topographical evidence provides a date during the first half of the 1890s for this sketchbook. Pissarro made several trips to England, where his son had been resident since 1883, during this decade, specifically in 1890, 1892, and 1897. The evidence of No. 243D implies that the sketchbook was used on the visit made in 1892. Other sheets from the sketchbook are (1) Sotheby's, 7 April 1976, lot 101 repr., for which see No. 243C, and (2) Louvre, inv. RF28796, for which see No. 243F. Another sheet that may also be from this same sketchbook, similarly inscribed *Kew Gardens* and dated *1892*, was formerly in the possession of Lucien Pissarro (CI neg. 51/38(38), no other details known). It should be noted that No. 243F is slightly larger in size than the other sheets and is in watercolour: the difference in size may simply be a matter of trimming.

243A Study of a male peasant using a winnowing machine
Black chalk
Lugt 613e
173 × 128

See No. 243B below

243B Study of a female peasant turning a wheel
Black chalk
Lugt 613e
173 × 128

Both Nos. 243A and 243B are unusual in Pissarro's *œuvre* on account of the emphasis placed upon mechanized labour. Neither drawing seems to relate to a finished composition.

243C Study of the Thames at Chelsea with the Albert Bridge
Pencil
Inscribed in pencil *Chelsea London* lower left
Lugt 613e
124 × 173

The bridge drawn in No. 243C is undoubtedly the Albert Bridge seen from Chelsea Embankment. Pissarro has included to the left of the bridge the factory and warehouses that still stand on the other side of the river.

A closely related watercolour, variously identified as a view of Albert Bridge, or of Battersea Bridge (Sotheby's, 4 July 1974, lot 326 repr. and Sotheby's, 7 April 1976, lot 101 repr., 125 × 175), is from this same sketchbook. The bridges across the Thames became one of Pissarro's favourite themes during these late visits to England (for example, P&V 745, of 1890, and P&V 805, of 1891, both of Old Charing Cross Bridge), but 243C and the related watercolour do not seem to have been developed further.

243D Study of Kew Gardens
Charcoal
Inscribed in charcoal *Kew Gardens* lower right
Lugt 613e
127 × 172

Exhibited: The Thames in Art, Arts Council exhibition held at Henley-on-Thames and Cheltenham 1967, No. 39; London/Nottingham/Eastbourne 1977–8, No. 49

No. 243D is a drawing of outstanding quality. The landscape is divided into planes, each defined by stronger and bolder strokes as they approach the foreground, thereby reinforcing the diagonals comprising the underlying structure of the composition. No. 243D formed the compositional basis for the etching of Kew Gardens of 1893 (D. 106). Like the bridges across the Thames, Kew Gardens was another motif that Pissarro explored while in England during the 1890s (P&V 793–803, all of 1892).

243E Study of Waterloo Bridge
Charcoal
Inscribed in charcoal *Waterloo Bridge* lower left
Lugt 613e
127 × 171

Exhibited: The Thames in Art, Arts Council exhibition held at Henley-on-Thames and Cheltenham 1967, No. 40; London/Nottingham/Eastbourne 1977–8, No. 45

No. 243E relates almost directly to a lithograph entitled *Le Parlement, à Londres* (D. 186), which is dated *c.* 1897 by Delteil. The title, as given by Delteil, is incorrect, and Leymarie and Melot (P. 190) are also incorrect in calling it Westminster Bridge. The bridge is Old Waterloo Bridge seen from the South Bank, with Old Charing Cross Bridge visible through the two spans on the left. The buildings seen in outline in the background of the left are not the Houses of Parliament. In fact, they are Whitehall Court (built 1886) and the National Liberal Club on the left, while on the right are the government offices comprising Whitehall leading to Charing Cross station. In No. 243E these buildings in the background are silhouetted against the sky, and they possess a tenebrist quality in the tonal shading, which has been achieved not with a wash, but, rather, by smudging the charcoal with the finger.

The date *c.* 1897 suggested by Delteil for the lithograph is questionable for the drawing. Pissarro's paintings in that year are of Bedford Park (P&V 1005–9), and it was while on earlier visits that he appears to have concentrated upon views of Old Charing Cross Bridge (P&V 745, of 1890 and P&V 805, of 1891, not 1892, as stated in the *catalogue raisonné*), both of which are seen from the South Bank and near the place from which No. 243E was drawn.

243F Distant view of the Houses of Parliament seen from Victoria Embankment Gardens
Watercolour over pencil
Lugt 613e
179 × 129

Bequeathed by Francis Falconer Madan, 1962
Literature: Ashmolean Museum Annual Report, 1962, p. 144
Exhibited: London, Leicester Galleries, *Three Generations of Pissarros*, 1943, No. 16

The statue in the middle distance of No. 243F is that of Sir Bartle Frere (1815–84), diplomatist and administrator in India and South Africa. It was unveiled in 1888. Another watercolour from this same sketchbook is in the Louvre (inv. RF28796, inscribed in charcoal *Serpentine*, 128 × 179).

244 View of the Théâtre du Châtelet seen from the Quai Conti
Charcoal
Lugt 613e
166 × 120

No. 244 clearly comes from a late sketchbook, but, as yet, it cannot be determined from which one, for other sheets of the same dimensions have yet to be found. Although Pissarro often painted and drew the *quais* of Rouen, he paid little attention to their better known and traditionally more picturesque counterparts in Paris until the very end of his life when he undertook the famous series of paintings of the banks of the Seine between 1900–3. In No. 244, Pissarro depicts the Théâtre du Châtèlet in the far distance upper left with the Pont Neuf in front. To draw this view Pissarro seems to have been situated on the Quai Conti, near the Institut de France. Interestingly, another view of the Théâtre du Châtelet appears in the left half of an early painting by Renoir *Le Pont des Arts* (Pasadena, Norton Simon Foundation, for a convenient reproduction see A. Callen, *Renoir*, London, 1978, pl. 8).

The drawing was not used for a painting or a print. The style is certainly that of the 1890s, but it is interesting to observe that Pissarro has retained a repoussoir motif in the upper right corner, a stylistic device that he used a great deal during the mid 1870s.

245 Sheet of figure studies: three studies of a man working a cider press, and a brief study of a seated male figure smoking a pipe seen in profile facing left, possibly the artist
Black chalk
Inscribed in black chalk *cidre* at centre of lower edge
The drawing has been stuck down, but there is evidence of a number in blue chalk on the verso, perhaps *289*
296 × 227

The process of making cider was included in *Travaux des champs* (see Nos. 354 and 355), but No. 245 bears no relationship to that particular composition. It is difficult to suggest a specific date for the sheet, which has the vividness and immediacy of a life drawing, and was surely made in Eragny where

the production of cider was an important part of the agricultural economy. The compact forms and the varied texture of the chalk suggest a date sometime during the first half of the 1890s. Another drawing of this subject from the same sketching tablet was formerly in the possession of Lucien Pissarro (CI neg. 51/24(37), black chalk, 235 × 308). The suppleness of line and the strength of form that characterize the figures in both these sheets are close to Daumier and Millet.

246 Study of the left hand of a woman holding a fowl
Charcoal, or conté, on glazed paper
Stained by watercolour right of centre
Lugt 613e
113 × 152

The figure for which No. 246 is a study occurs prominently in the middle distance of two temperas both entitled *Marché à la volaille, Gisors* (P&V 1437 and P&V 1438), the second of which is dated 1889. The composition was also utilized as a print, D. 98, of 1891.

A preparatory drawing concentrating on a small human gesture that is then fitted into a wider context is unusual in Pissarro's *œuvre*, and it must be assumed that the delineation of the hand posed a problem for the artist. Interestingly, a similar motif of a hand holding a fowl also occurs prominently in an unpublished gouache, *Un coin des Halles*, of 1889, now in the Fogg Art Museum, Cambridge, Mass. (inv. 1943. 394). A compositional drawing for D. 98 was formerly in the possession of Lucien Pissarro (CI neg. 51/52(26)(27), no details known).

The paper on which No. 246 is executed has a similar glaze to that found on the sheets from Sketchbook XXI (No. 210), and the possibility exists that this is a fragment from another sheet from the same sketchbook.

247 Study of a group of female peasants harvesting
Black chalk on glazed paper
Repaired in lower left corner
Lugt 613e
224 × 176

No. 247 is a preliminary study for the painting, *Faneuses, le soir, Eragny* (P&V 855), of 1893. The

composition, as drawn on No. 247, is conceived with a vertical format in the manner of P&V 729 and P&V 771, of which P&V 855 is an expanded and totally revised version. The change to a horizontal format adopted for the final painting has allowed the artist to reorganize the figures so that those carrying the bale of hay have been moved to the left side of the composition, while the two centrally placed figures are brought into a closer relationship, and behind them a third harvester has been added. These changes are recorded on No. 248, which represents the next stage in the evolution of P&V 855.

It should be observed that No. 247 is the same size as the sheets included in Sketchbook XXI (No. 210), but the paper has a different glaze.

248 Compositional study of harvesters in a landscape
Pen and dark ink over black chalk
Faintly squared in black chalk (?)
Somewhat stained throughout
Lugt 613e
233 × 304. Framing indicated in pen over black chalk on three sides of composition at extreme edges

No. 248 is clearly related to, and might indeed be a compositional study for P&V 855, *Faneuses, le soir, Eragny*, of 1893. The drawing is a development of the preceding study (No. 247). There are some differences in the finished painting, notably in the landscape and in the placing of the figures, although the poses are essentially the same. The two figures carrying the bale of hay, for instance, are placed nearer to the haystack on the left of the painting. A sheet of rapidly executed *plein-air* figure studies which is closely related to No. 248 was formerly in the possession of Lucien Pissarro (CI negs. 51/56(2) recto, and 51/56(3) verso, charcoal, 250 × 300). The most interesting stylistic aspect of No. 248 is the use made of the reed pen, the thickness of which gives the outlines a slightly wooden effect. In fact, the 'outline' style of the sheet is not at all unlike that of the drawings for the first phase of *Travaux des champs* executed in 1894–5 (see No. 322). It is possible that No. 248 was made after the painting as a projected composition from which Lucien Pissarro could make a print.

249 Female peasant harvesting
Black chalk on tracing paper
Lugt 613e
452 × 300 (sight)

The outlines of the figure on the recto of No. 249 have been redrawn in black chalk on the verso. This figure occurs in the right foreground of the painting *Faneuses, le soir, Eragny* (P&V 855), of 1893. No. 249 is clearly a tracing from the painting, but for what purpose is not known. It is possible that, like No. 250 below, No. 249 was made after the painting was completed for the purposes of producing a print, but no such print has survived, and the dimensions perhaps preclude the sheet from any direct involvement in that process.

250 Study of a female peasant seen in three-quarters profile advancing to the left
Black chalk on tracing paper laid down on card
Lugt 613e
243 × 115

No. 250 was most probably traced from the painting P&V 855, *Faneuses, le soir, Eragny*, of 1893, where this figure occurs on the left of the composition in the middle distance.

Although there are notable differences in the costume, Pissarro used the motif of which this figure forms a part for a later print, D. 126, of 1900 (see No. 304).

251 Study of three stevedores shovelling coal
Black chalk on tracing paper
Backed
The inscription lower left is by a later hand
Lugt 613e
244 × 250

No. 251, as the inscription added by a later hand in the lower corner correctly records, was made in preparation for an illustration drawn by Pissarro for the anarchist publication *La Plume Littéraire, Artistique et Sociale*. The print, which was published in the issue of 1 May 1893, p. 189, is reproduced by R. L. and E. W. Herbert, 'Artists and Anarchism: Unpublished letters of Pissarro, Signac and

Others', *Burlington Magazine*, cii (1960), p. 478 Fig. B. There are a number of other related drawings. One is in the Louvre (inv. RF28799, charcoal, 217 × 168), whilst two others were exhibited at the Beilin Gallery, New York, in 1965 (*50 Drawings by Camille Pissarro*, New York, March–April, 1965, Nos. 18 and 42 repr.). Of these last two, the first, apparently in pen and ink (215 × 249), is a study of three figures very similar to No. 251 and the drawing in the Louvre, except that in the sheet exhibited at the Beilin Gallery the background and the pile of coal on the right is more firmly outlined. The second drawing exhibited in New York in 1965, apparently in pen and ink over black chalk (235 × 305), is compositionally much the closest to the published print and includes the quayside, the harbour, and other figures. No. 251 does not appear to have been traced from any of these sheets, and its role in what was clearly a complex preparatory process is not known.

252 View of the Lac d'amour (Minnewater) Bruges
Watercolour over pencil
Damaged by damp
Lugt 613e
226 × 291

Exhibited: London/Nottingham/Eastbourne 1977–8, No. 54

The subject of No. 252 was first identified by Mrs Lullie Huda in her catalogue of the circulating exhibition of 1977–8. The drawing, which has been rather damaged by damp, must therefore have been made on the occasion of Pissarro's visit to Bruges in June–September, 1894. Indeed, in a letter of 6 July 1894, Pissarro refers to the fact that he has been painting watercolours recently ('Je n'ai encore rien fait que quelques aquarelles ...', *Lettres*, p. 347). There are several other watercolours dating from this same visit to Belgium in the collection (Nos. 253 and 254).

The style of No. 252 shows Pissarro's continuing interest in the English watercolour tradition, for, even when due allowance is made for damage, the breadth with which the washes have been applied recalls the watercolours of J. S. Cotman, David Cox, or Peter de Wint.

253 View of Knokke-sur-Mer
Watercolour with charcoal
Damaged by damp throughout and somewhat faded
Inscribed in charcoal *Knocke s/mer matin* lower left
Lugt 613e
174 × 255

Pissarro visited the small town of Knokke-sur-Mer, a coastal resort in Belgium during the summer of 1894 (July–September). This view forms the background of a painting (P&V 883), which was begun in 1894, but retouched in 1902. No. 253 probably served as a preliminary study for the painting. The technique of No. 253 with isolated patches of colour bounded by lines is more reminiscent of watercolours of the mid 1870s than of the freely executed watercolours of the late 1880s and early 1890s. On the other hand, there is greater freedom in the handling of the trees on the right, which recalls No. 233, and the pale palette is close to No. 252 drawn in nearby Bruges during the same year. Another view in watercolour and charcoal, or black chalk, of a windmill at Knokke-sur-Mer, possibly the same one as in No. 253, but seen from a different angle, was formerly in the possession of Lucien Pissarro (CI neg. 52/42(29), no details known).

254 Study of the church at Knokke-sur-Mer
Watercolour over pencil
Faded by damp and extensively damaged by the imprint of other sheets of paper
Lugt 613e
225 × 290

This is a more detailed study of the same church that occurs in the preceding drawing (No. 253) and was clearly drawn while on the same visit. Although No. 254 is seriously damaged, it appears to be unfinished. It seems that having first drawn the design in pencil, Pissarro then applied one thin layer of wash before abandoning it. The rendering of the church is unusual in Pissarro's œuvre in its concern for architectural detail, and in this respect, recalls the drawings done in Rouen in 1883 (Sketchbook XIII, No. 158). It is probable, for this reason, that No. 254 was made as a topographical *aide-mémoire*, which Pissarro used later in his studio for the execution of a series of paintings in which the same church appears (P&V 889, 890–1).

255 **Study of a landscape with two female peasants working in a field**
> Watercolour over charcoal heightened in places with gouache, or tempera
> Foxed
> 213 × 252

Exhibited: London/Nottingham/Eastbourne 1977–8, No. 52; London, JPL Fine Arts, 1978, No. 40

No. 255 is a watercolour that formed the basis for the coloured etching, *Paysannes à l'herbe* (D. 111), which Delteil dates *c.* 1894. Regarding the dating, it was first pointed out by Leymarie and Melot (P 113) that Pissarro experimented with coloured prints at the beginning of 1895 (*Lettres*, p. 363, 18 January 1895) where, indeed, reference is made to D. 111. Presumably, No. 255 may have been made with the idea of a colour-print in mind.

The composition has been reduced, cut on the left, and slightly extended on the right in the final print, but the essential motifs, as shown in No. 225, have been retained. It should be noted that, as in the print, a third figure is also indicated in No. 255 beyond the second figure, although she is here shown standing upright, as opposed to bending. Pissarro has taken the landscape setting from another watercolour which is dated 1888 (formerly Paul Cassirer collection, Amsterdam, photograph Witt Library).

No. 255 clearly precedes No. 300, the drawing in pencil on which the print is based.

256 **Study of a seated woman seen from the back**
> Charcoal
> Lugt 613e
> 287 × 194

Pissarro used this study for the woman seated in the left foreground of the coloured etching D. 112, of 1895, *Marché de Gisors* (*rue Cappeville*). A similar figure occurs in the centre foreground of the preliminary compositional drawing, which is also in the collection (No. 295), and was retained by Pissarro in the final etching after his rearrangement of the figures. The pose of the figure in No. 256 is closer to that found in the print. Although a similar pose occurs in earlier paintings, such as P&V 567 of 1882, the handling of the charcoal, which is characterized by the strong sense of volume contained within delicately drawn outlines, is wholly characteristic of the

1890s (compare, for example, No. 240). Furthermore, the pose of this figure is directly derived from that of the figure in the centre foreground of Léon Lhermitte's large etching, *La Cathédrale de Rouen*, of 1884 (F. Henriet, *Les Eaux-fortes de Léon Lhermitte*, Paris, 1905, p. 85, No. 41, repr. between pp. 44 and 45).

257 **Study of a nude woman bending seen from the front**
> Charcoal
> Lugt 613e
> 288 × 223

Exhibited: London/Nottingham/Eastbourne 1977–8, No. 50 repr.

No. 257 is a study which was used in several compositions of bathers dating from 1894–5: P&V 898, of 1894, D. 116 and D. 117 (in reverse), both etchings of 1895. A preparatory drawing for D. 116 is also in the Ashmolean collection (No. 294). Two further studies of a female nude closely related in style to No. 257 were exhibited in New York in 1965, (*50 Drawings by Camille Pissarro*, Beilin Gallery, New York, March–April, 1965, No. 11, charcoal, 292 × 209, repr., and No. 36, charcoal, 305 × 241 repr.). Of these, the first is in a pose similar to that of the figure in No. 257 and, therefore, also relates to No. 294, whilst the second is of the same figure seen from the back and relates to D. 114, of 1895.

Pissarro often complained in his letters of the difficulty of finding models in Eragny and of the resulting necessity of having to reuse earlier drawings as the basis for new compositions. His need for nude models was particularly acute during the 1890s especially in view of Pissarro's interest in bathing scenes. Frequently, as is most probably the case for the present drawing, he employed members of his own family as models (see also No. 258).

258 **Study of a nude man climbing a ladder**
> Charcoal on faded blue paper
> Lugt 613e
> 302 × 233

No. 258 is a drawing made from life, the model for which is almost certainly Lucien Pissarro. The study was clearly drawn in connection with the figure climbing the ladder placed against the butt in the upper left section of the composition entitled

Vendange, an illustration to *Daphnis and Chloë* (see Nos. 317–18, of 1895). Such large-scale figure studies for either of the extended projects *Travaux des champs* or *Daphnis and Chloë* are unusual. One other, however, was exhibited at the Beilin Gallery, New York, in 1965 (*50 Drawings by Camille Pissarro*, March–April, 1965, No. 19 repr., black chalk or charcoal, 304 × 197), which relates to the figure of Daphnis seen from the back carrying the basket in the lower left section of the composition. For Pissarro's difficulty in obtaining nude models at this stage of his career, see No. 257 above. Presumably, this included both the male and the female nude, since No. 258 is an isolated example of Pissarro's treatment of the male nude dating from his later years. In fact, No. 258 is the only example so far discovered of this particular subject following upon his early academic exercises, for which see Nos. 36–8 above.

259 Study of a young woman bathing her legs
Coloured chalks highlighted with touches of pastel
531 × 391 (Imperial)

Literature: K. Roberts, *Painters of Light. The World of Impressionism*, Oxford, 1978, p. 72 repr.
Exhibited: London/Nottingham/Eastbourne 1977–8, No. 56 repr.

No. 259 was made in preparation for *Le Bain de pieds* (P&V 903, Cummings collection, New York), of 1895. Pissarro first mentions the theme of female bathers in his correspondence in January 1894 (*Lettres*, pp. 325–6, 14 January 1894, and 21 January 1894), and, by April, he was making drawings and projecting paintings of such subjects (*Lettres*, pp. 339–40, 'Il fait un temps très incertain pour la pauvre peinture; je me contente de triturer à l'intérieur. J'ai fait toute une série de dessins imprimés romantiques qui m'ont paru avoir un aspect assez amusant: des *Baigneuses* en quantitité dans toutes espèces de poses, en des paysages paradisiaques. Des intérieurs aussi, *Paysannes à leur toilette* etc., ce sont des motifs que je me mets à peindre quand je ne puis sortir. C'est très amusant à cause des valeurs — noirs et blancs — qui donnent le ton pour les tableaux'). No. 259 is very closely related to P&V 903 and was probably drawn after an earlier version, P&V 901, *Femme se lavant les pieds à la rivière*, of 1894 (Metropolitan Museum, New York). Another study showing the bather's legs and hands only was

formerly in the possession of Lucien Pissarro (CI neg. 52/49 (31), black chalk, 314 × 238). This last drawing could have been made in connection with either of these two paintings. There is also a monotype of the same composition, for which see B. Shapiro and M. Melot, 'Catalogue sommaire des monotypes de Camille Pissarro', *Nouvelles de l'estampe*, xix (1975), No. 4 repr.

Although the initial impetus for these late bathing scenes must stem from Cézanne, there may also be a desire to emulate the eighteenth-century tradition of the *baigneuse* as it was treated, for instance, by Boucher (see C. Lloyd, 'Camille Pissarro and Hans Holbein the Younger', *Burlington Magazine*, cxvii (1975), p. 725). The style of the sheet owes a great deal to eighteenth-century figure drawing.

260 Compositional study of two women bathing in a wooded landscape
Pencil
Numbered in blue chalk *380* on the verso visible through the paper
Lugt 613e
153 × 196. Framing indicated in pencil on three sides, *c.* 140 × 150

No. 260 is a loosely drawn pencil study that does not seem to have been developed any further. The subject is reminiscent of the paintings and prints of female bathers executed during the 1890s, but the style and format are close to No. 313, which was drawn for one of the illustrations for *Daphnis and Chloë*. However, the inclusion of two female bathers precludes any definite connection with that particular project. As in Pissarro's other drawings of bathers, his treatment of the subject recalls the work of Cézanne.

261 Compositional study of three female bathers in a wooded landscape
Pen and brown ink
Lugt 613e
120 × 138. Framing indicated on three sides in ink, *c.* 113 × 127

Exhibited: London/Nottingham/Eastbourne 1977–8, No. 53

The pen style of No. 261 is close to that of No. 270, as well as to that of the preparatory drawings for *Daphnis and Chloë* (see, particularly, No. 320). The

present study relates to a lithograph, *Femmes nues* (D. 157), which Delteil dates *c*. 1896, but which Leymarie and Melot (P. 145), suggest, on the basis of an indirect reference in a letter, should be dated 1894 (*Lettres*, pp. 332–3, 28 January 1894.) This earlier dating accords well with the pen style of No. 261. The lithograph is considerably larger than No. 261 and measures 285 × 210. In the final composition, the figures are more centrally placed and the specific context of a river bank is thereby eliminated.

262 Study of a female bather in a wooded landscape
Pen and brown ink with brown wash over pencil heightened with chinese white
Pin marks in corners
Lugt 613e
234 × 152

The pose of the figure in No. 262 recalls that of the bather in P&V 937, of 1895, although in the painting the figure is seen in reverse and shows a younger, more slender woman. The subject of a single bather in a sylvan setting is repeated in the lithograph D. 158, *c*. 1896.

Stylistically and technically, No. 262 may be compared with certain drawings done for *Daphnis and Chloë* (see Nos. 314 and 315 below), and is especially close to a drawing of a similar subject, in the British Museum (see entry for No. 301). Presumably, like No. 301, this sheet was also intended as a preparatory drawing for an etching. The figure has been heavily reworked by the artist.

263 Study of three bathers in a wooded landscape
Gouache on silk
Some flaking, particularly from the bodies of the two seated figures
Signed in gouache *C. Pissarro* lower right
207 × 163. The composition does not extend to the edges of the silk except on the left, 199 × 159

Literature: P&V 1483 repr.

No. 263 is dated *c*. 1896 in the *catalogue raisonné*. The two figures seated on the bank are closely related in pose to another gouache (P&V 1482), possibly executed in the same year as No. 263, in

which the third figure is positioned further back on the left beyond her companions.

Although flaking badly in places, the colouring of No. 263 with its subtle blending of blue, green, and yellow over which white highlights have been delicately spread, render it a work of high quality.

264 Study of a female nude seen in profile walking to the right
Pencil with watercolour and some gouache on silk
Extensively damaged by damp, particularly on the right, and marked by the imprint of other sheets of paper. Repaired at lower right corner
Numbered in pencil by the artist *No. 40* in lower margin on left
Lugt 613e
202 × 142. Framing indicated in pencil, 177 × 122

No. 264 is badly damaged. It is closely related to a pastel of the same model similarly posed (P&V 1604), which is classified in the *catalogue raisonné* as a study for the middle figure occurring in a painting entitled *Baigneuses* (P&V 940), of 1896. In P&V 940, however, the figure is half-concealed and the pose has been slightly altered, so that she stands more in three-quarters profile. The grouping in P&V 940 is such that the figure is more statuesque. The pose of the model in No. 264 recalls earlier painted compositions of *The Expulsion from Paradise*, such as that by Masaccio in the Brancacci chapel in the church of S. Maria del Carmine, Florence. Likewise, the triad of figures in P&V 940 recalls the classical grouping of *The Three Graces*.

265 Study of the rue Molière, Rouen
Black chalk
Inscribed in black chalk *rue Molière* upper centre
Lugt 613e
187 × 137

No. 265 could have been drawn in preparation for the etching D. 121, or the lithograph D. 174, both of 1896. In the etching, as in No. 265, the chimney stack of the house in the centre, from behind which the tower of the cathedral emerges, has only two chimney pots, whereas in the lithograph it has three.

Yet, the broader style of No. 265 makes it more likely that the present sheet was made in connection with the lithograph.

Pissarro made a number of prints of various streets in Rouen for which there are several related drawings in the collection (see Nos. 286, 290 and 291). Another drawing made in connection with this late group of lithographs of Rouen was sold at Sotheby's, 9 December 1971, lot 19 repr., which relates to D. 176–9.

266 Study of the Pont Corneille, Rouen
Watercolour over pencil
Lugt 613e
154 × 224

Exhibited: London/Nottingham/Eastbourne 1977–8, No. 58

No. 266 was drawn in 1896 when Pissarro was on the second of his three extended visits to Rouen. The drawing relates quite closely to an etching entitled *Quai de Paris* (D. 123) and to a lithograph entitled *Pont Corneille à Rouen* (D. 170), both of 1896. A preparatory study for the etching D. 123 was in the possession of Hirschl and Adler in 1976 (pen and ink on brown paper, 156 × 168). As regards No. 266, the full-bodied technique and the blue-green palette are characteristic of the watercolours of the 1890s. Interestingly, in No. 266 Pissarro has painted over the industrial features of the landscape, which can be seen in the pencil underdrawing and were retained in both the prints of 1896.

This type of composition with the powerful foreground spatial recession is by no means a novel one in the context of Pissarro's *œuvre*. It was first essayed during the late 1860s in P&V 60, of 1868 (Mannheim, Kunsthalle), and an oil sketch dated 1867 in the Museum at Tel Aviv (not in P&V, repr. Rewald, p. 66), and was reused in 1878 in *Le Pont de Pontoise* (P&V 443), culminating in the late series of paintings done in Rouen and Paris.

267 Study of a landscape with three female peasants and a child working in a field
Pen and brown ink
Lugt 613e
92 × 106

No 267 has been drawn with a reed pen. The style, a Rembrandtesque conflation of short staccato

strokes with broad lined hatching, may be compared with the lithographs D. 188–90 dating from *c.* 1899. Another study, which relates very closely to No. 267 in composition, although it has a vertical format, was formerly in the possession of Lucien Pissarro (CI neg. 52/53(15), no details known). This last sheet was used by Lucien as the basis for a chiaroscuro print executed in 1900 (Studio Book, I, f. 83, No. 168).

268 SKETCHBOOK (?)

268A Study of a male peasant seen from the back leaning on a spade
Pen and indian ink
Lugt 613e
111 × 55

Exhibited: London/Nottingham/Eastbourne 1977–8, No. 36

See No. 268B below.

268B Study of a female peasant carrying a bucket
Pen and indian ink
Lugt 613e
111 × 55

Exhibited: London/Nottingham/Eastbourne 1977–8, No. 35

Both Nos. 268A and 268B have been drawn with a reed pen. Although admittedly the sheets have identical measurements, they were not necessarily conceived as a pair. Like No. 267, however, they both share many graphic and compositional qualities with Pissarro's later lithographs (D. 189–90, *c.* 1899) and were perhaps themselves preparatory studies for prints.

269 Study of a male peasant carrying a pitchfork in conversation with a seated female peasant set in a landscape
Pen and indian ink over pencil
Lugt 613e
89 × 154

Exhibited: London/Nottingham/Eastbourne 1977–8, No. 34

Like Nos. 268A and B, this small anecdotal study was surely drawn in preparation for a print. The

notational quality of the rapidly executed pen lines and the brief indication of the setting suggest a date some time in the late 1890s.

270 Compositional study of a landscape with three female peasants working in a field with two further figure studies below
Pen and indian ink with gouache on beige coloured paper
Lugt 613e (twice)
213 × 263

Exhibited: London/Nottingham/Eastbourne 1977–8, No. 31

The composition of No. 270 does not seem to have been developed further, and it is impossible to tell if Pissarro intended to use it for a painting, or a print. The fine penwork used in combination with another medium is found on drawings of the early 1890s (No. 232), but there is perhaps a closer stylistic connection with the shorter more vigorous lines found in some of the lithographs executed during the second half of the 1890s (D. 167–8, of 1896, D. 188–9 and 190, of 1899). Another drawing close in style to the present sheet was formerly in the possession of Lucien Pissarro (CI neg. 52/59(29), pen and indian ink, 86 × 165, exhibited Leicester Galleries 1958, No. 52).

271 Brief study of a landscape with a woman walking down a path (recto)
Pen and brown ink with some watercolour
Damaged by damp and by offset throughout
Lugt 613e

Portrait of the artist with a slight study of a male figure wearing a top hat (verso)
Pen and ink with brown wash. Pencil (study of a male figure) Badly damaged by damp and by offset, specifically from a study of two female peasants drawn in charcoal with watercolour.
Stained by rust in right half
111 × 127

No. 271 is a puzzling drawing and one that is difficult to date. Possibly the two sides of the sheet were used on two separate occasions. The recto has the

erratic spark-like pen strokes that are associated with some of the pen drawings and lithographs dating from the second half of the 1890s (for example, D. 188 and 189). It is likely that the recto of No. 271 was made in preparation for a print.

The verso of No. 271, which is much damaged by offset, appears to be slightly earlier in style, the hatching resembling that found in drawings of the late 1880s (for example No. 217). It is possible that the verso is not by Camille Pissarro.

272 Study of a landscape at Châtillon-sur-Seine
Black chalk on ruled paper printed in grey-blue ink
Inscribed in pencil *Châtillon-sur-Seine* lower right
Lugt 613e
163 × 220

Châtillon-sur-Seine is a small town near Troyes (see No. 273) and is close to the village of Grancey-sur-Ource (see No. 88) where Julie Pissarro was born. Pissarro records a visit to the town in two letters of 1898 (*Lettres*, pp. 455 and 457, 27 June and 5 July 1898), and No. 272 was probably made while on that trip.

A watercolour, inscribed *rue de Pertuis aux loup* [*sic.*]—*Châtillon-sur-Seine*, was once with the O'Hana Gallery, London (measuring 159 × 216), and, on the evidence of the spire visible above the trees on the right of No. 272, a second watercolour, formerly in the possession of Lucien Pissarro (CI neg. 51/33(4) (5), no details known), is also of Châtillon-sur-Seine. A third watercolour, showing a distant view of the town, was sold in Paris at the Hôtel Drouot, 14 February 1951, lot 86 repr. A *fourth* drawing, entitled *Au parc* and inscribed *Châtillon-sur-Seine*, was sold at Sotheby Parke Bernet, 2 November 1978, lot 108 repr.

273 SKETCHBOOK XXV

The evidence of a letter from Camille Pissarro to Lucien in which mention is made of the town of Troyes provides a date of 1898 for the use of this sketchbook (*Lettres*, p. 455, 27 June 1898). It appears that the sketchbook was used on an extensive journey made in the

summer of 1898 when Pissarro visited Mâcon, Dijon, Châtillon-sur-Seine, Grancey-sur-Ource, and Lyons (*Lettres*, pp. 454–7), and it is highly probable that many other sheets beyond those mentioned here have yet to be discovered. As in the case of Sketchbooks XIII (No. 158), XIV (No. 160), and XXII (No. 222), the paper is squared and printed in blue ink, and, like Sketchbooks XIV (No. 160) and XXII (No. 222), the squares measure 40 mm, although this paper appears to be slightly larger in size. The sheet in the present collection is untrimmed.

Three further sheets from this sketchbook have so far been found: (1) *View of the church of S. Jean Baptiste, Mussy*, formerly in the possession of Lucien Pissarro (CI negs. 51/39(39) recto and 51/39(40) verso), brown crayon, inscribed in brown crayon, *Mussy/Aube*, 108 × 162; (2) *Study of a market scene*, formerly in the possession of Lucien Pissarro, (CI neg. 53/34(9a)), black chalk, inscribed in black chalk *Vente publique à Mussy* (?) (3) *Study of the rue Notre Dame, Troyes*, black chalk, inscribed in black chalk *Rue Notre Dame/Troyes*, 161 × 106, Rotterdam, Museum Boymans-van Beuningen (see H. R. Hoetink, *Franse Tekeningen uit de 19e eeuw*, Rotterdam, 1968, No. 208, p. 131 repr.). Another drawing of Mussy, seemingly dating from this decade, but not apparently from this sketchbook, is in the Museum Boymans-van Beuningen (see Hoetink, op. cit., No. 204, pp. 129–30 repr. black chalk, inscribed in black chalk *Mussy/sur/Seine*, 107 × 161). Pissarro also made several watercolours on this journey (*Study of a street in Troyes*, formerly in the possession of Lucien Pissarro (CI neg. 51/33(8)) inscribed *Troye* [*sic*] lower right, no details known; *View of Troyes*, formerly in the collection of Paul-Emile Pissarro, repr. Rewald, p. 64).

273A Study of St. Urbain, Troyes

Black chalk on squared paper printed in blue ink

Inscribed in black chalk *St. Urbain Troye* [*sic*] upper left and numbered in pencil by the artist *No. 14*

The lower corners are bevelled and the edges tinted in red

Lugt 613e

105 × 161

Literature: Lettres, repr. opp. p. 456

The style of the drawings in Sketchbook XXV differs only slightly from that of the earlier topographical drawings in Sketchbooks XIII (No. 158) and XIV (No. 160). These later sheets are similarly composed, but show a more delicate application of chalk, and the buildings are less geometrical in structure. The style may be compared with that of the sheets from the sketchbook used in Dieppe (Sketchbook XXVI (No. 277)).

274 Study of women laundering clothes in the meadow at Eragny

Coloured chalks heightened with chinese white on faded grey-blue paper

Watermark (visible at the lower edge left of centre, but not fully legible, as the sheet has been cut and stuck down). The edge of a cartouche can be made out and the watermark may be the same as that occurring on Nos. 192 and 194.

236 × 307

No. 274 is a preparatory study for *La Lessive à Eragny* (P&V 1058), which is dated *c.* 1898 in the *catalogue raisonné*. This is the first of two rather elaborate compositions of this subject that Pissarro executed towards the end of his life: the other is P&V 1206. Usually Pissarro's treatment of this motif involved only a single figure, as in P&V 471–2, of 1879, and P&V 1081, of 1899. The principal difference between P&V 1058 and 1206 is that in the former the scene is drawn slightly from above, probably from a window, whereas in the latter the artist has placed himself in the meadow and moved nearer to the figures. The left hand section of No. 274 was used as the basis for a drawing included in *Travaux des champs* (see No. 353).

Although the striations drawn in green and yellow chalks in No. 274 to indicate the ground recall certain of Pissarro's Neo-Impressionist drawings (No. 181), the loose-knit composition and the tentative handling of the figures on the left are very characteristic of drawings dating from the 1890s.

Copies by Lucien Pissarro of Pissarro's prepara-

tory studies for P&V 1206 are in the Ashmolean Museum (inv. 77.818 recto and verso, and 77. 819).

275 Study of a young woman standing with left hand on hip leaning against a window
Orange chalk on blue paper
Numbered in blue chalk 7 lower right
Lugt 613e
441 × 201

See No. 276 below

276 Study of a young woman standing with left hand on hip leaning against a window
Pastel on blue paper
Lugt 613e
451 × 259

Nos. 275 and 276 were both drawn in preparation for the figure on the far right of P&V 1207, *Fenaison à Eragny*, of 1901 (Ottawa, National Gallery of Canada), for which there is also an undated study in gouache (P&V 1495). The composition was first essayed for the second phase of *Travaux des champs* (see Nos 334 and 335) on which Camille and Lucien were working in 1895. Both Nos. 275 and 276 are executed in Pissarro's latest chalk style, which is characterized by a strong sense of form and powerful modelling. No. 275 is a faint study in outline only and is presumably an underdrawing that was discarded. Both the drawings in Oxford, however, were done from a model posed in an interior by a window, but in P&V 1207, for which they were in all probability made, the figure was transferred to a rural setting where she is shown leaning against a tree. There is also a close copy of No. 276 by Lucien Pissarro in the collection (inv. 77. 859, pastel 475 × 305) which again shows the figure in an interior. The style and scale of No. 276 suggest that, like the related drawing in the British Museum (inv. 1920. 7. 12. 2, pastel on pink paper, 457 × 604), the drawing was made in connection with the painting of 1901, as opposed to the initial composition for *Travaux des champs*.

A study for another figure in P&V 1207 was formerly in the possession of Lucien Pissarro (CI neg. 53/32(1a), no details known). Although the pose has been reversed in the painting, the features and dress are similar.

277 SKETCHBOOK XXVI

Pissarro spent several weeks in Dieppe during the summers of both 1901 and 1902 (*Lettres*, pp. 484–5 and 491–3) and it seems, on the basis of Nos. 277C and 277D, that this sketchbook was used on one of these visits to Dieppe, although not exclusively so. For instance, there are two sheets of rural subjects (Nos. 277A and 277F), and also a view of Caudebec, a town near Rouen which Pissarro had visited in 1899 (*Lettres*, p. 469). As regards the date, therefore, the sketchbook spans the years 1899–1902, and it provides a comprehensive survey of Pissarro's style of drawing during his final years. The studies in chalk are of a particularly high quality. In them, Pissarro shows a concern for tonal values rendered by a series of flicks and dots of differing accent, often combined with sudden outbursts of hatching drawn with varying pressure of the hand. One other sheet from the sketchbook has been found, *Study of two sailors seen from the back*, formerly in the possession of Lucien Pissarro (CI neg. 52/22(6), black chalk, 127 × 178), which probably dates from 1902, since this is the year in which Pissarro painted his marine compositions in Dieppe. None of the studies in the sketchbook, however, relates to a finished composition, and it therefore serves as testimony to the artist's habit of drawing continuously. Each of the sheets from this sketchbook has two punched holes ready for insertion into a ring file.

277A Study of a cow seen from the back in three-quarters profile facing right
Charcoal
Lugt 613e
176 × 125

No. 277A is one of the most subtle and delicate drawings of Pissarro's final years.

277B Study of two women at a market
Charcoal
Lugt 613e
177 × 127

These two figures were most probably observed at the local market, or fair, in Dieppe, which Pissarro painted several times in 1902 (P&V 1194–200).

277C Study of the promenade at Dieppe (recto)
Pencil

Five brief studies of standing female figures (verso)
Pencil
Annotated in pencil *noisette chaud | bleue | laine molle | violet et blanc | fondus | fiche chamois | clair | violet blustre | à carre, bleu foncé | avec tache bleu | tablier | vers* (crossed through) | *noisette.*
Lugt 613e
127 × 177

The identification of the promenade drawn on the recto of No. 277C is not absolutely certain. The pairing of street-lamps is similar to that found on the pont Neuf in Paris, which Pissarro painted several times in 1901 and 1902 (for example, P&V 1178–81 and 1210–14), but the street level viewpoint, the buildings to the right and the very brief indication of what appears to be a pier on the far left makes an identification with the promenade at Dieppe more likely. A photograph of the promenade at Dieppe taken in 1890 looking the other way is reproduced in S. Pakenham, *Sixty Miles from England. The English at Dieppe 1814–1914*, London, 1967, opp. p. 164.

The verso is a rare manifestation of Pissarro's interest in the costume of the urban female figure, which he usually, as here, treated in the context of the market. Instead of detailing the intricacies of period dress, Pissarro treats the figure very summarily, concentrating instead on colour notations, which would be useful in the painting of the staffage figures in his late urban views.

277D Study of the cliffs at Dieppe
Black chalk
Annotated in black chalk *bleu verdâtre* (?) | *orangé | soleil | crème | vert clair | ombre*
Lugt 613e
127 × 177

Pissarro first painted a view of these famous cliffs at Dieppe in 1883, P&V 599, *Falaises aux petites-dailles*. In No. 277D, however, he includes figures on the beach, and the technical ability with which he unites the various parts of the composition by varying the texture of line is of the highest order. The episodic quality of No. 277D is wholly charac-

teristic of Pissarro's late chalk style and is foreshadowed, for instance, by No. 243D in Sketchbook XXIV.

277E Two studies of a market scene
Black chalk
Lugt 613e
177 × 127

These studies are undoubtedly of figures grouped in the cathedral market square in Dieppe, which was overlooked by the Hôtel du Commerce in the Place Duquesne where Pissarro stayed in 1901 (*Lettres*, pp. 484–5, 19 July 1901 and 26 July 1901). Pissarro painted the market in the cathedral square several times from the elevated and undisturbed vantage point of his hotel room (P&V 1195, 1197–8, 1200, and the two gouaches, P&V 1502–3, the second of which is now in the Louvre, Cabinet des Dessins, inv. RF28800, all of 1902).

277F Compositional study of a male peasant gathering apples
Brown wash over charcoal with some pen and brown ink
Lugt 613e
176 × 126

Unlike the other studies in this sketchbook, No. 277F is a complete composition in itself. It does not, however, relate to any finished painting, or print. The subject and, indeed, the type of composition are familiar within Pissarro's *œuvre* (compare, for example, D. 166, c. 1896 and P&V 1271, of 1902).

277G Study of Caudebec-en-Caux
Watercolour over charcoal
Marked by the imprint of another sheet of paper at left. Damaged by rust and faded by damp
Lugt 613e
125 × 177

Pissarro visited the town of Caudebec-en-Caux, a town eighteen miles from Rouen on the Seine in June of 1899 (*Lettres*, p. 469, 17 June 1899) when No. 277G was presumably drawn. The watercolour washes are in various shades of purple, blue, and pink.

278 SKETCHBOOK XXVII

Pissarro worked in Le Havre during the final months of his life (July–September 1903) producing a number of paintings of the quayside and the harbour (P&V 1298–315). Many of the motifs—cranes, boats, jetties, flagpoles, signalling towers—used in the series of paintings are rapidly noted in this sketchbook and incorporated into the picture, but there are no detailed compositional studies. The drawings range from densely populated quayside scenes to isolated sketches of single yachts, steamboats, and sailing boats, either seen in the harbour itself, or else out at sea. Pissarro has used pencil for all these sheets adding a wash only on No. 278E. The style, like that of Sketchbook XXVI is notational, characterized by loose episodic outlines joined together by bands of hatching. A letter written in Le Havre indicates that Pissarro was aware of the tradition of painting associated with these northern seaside resorts (*Lettres*, pp. 504–5, 6 and 10 July 1903). To some extent, this accounts for the nature of the subject-matter in this sketchbook, although Pissarro's fascination with the activities of the harbour is in sharp contrast with the beaches, terraces, and promenades that in the main form the basis of the marine subjects painted by Boudin or Monet. It is perhaps fitting that Pissarro, who began his career as an artist by drawing on the dock at Charlotte Amalie, the capital of the island of St. Thomas, should end his working life with these drawings of the harbour and shipping movements observed at Le Havre.

278A Study of figures on the quayside, Le Havre
Pencil
Lugt 613e
107 × 171

278B Study of a three-masted schooner sailing to port seen from the stern
Pencil
170 × 107

No. 278B is possibly a study for the sailing ship in the centre of P&V 1307, *Avant-porte du Havre, après-midi, soleil*, of 1903.

278C Study of a three-masted schooner seen from the port side
Pencil
Lugt 613e
107 × 170

No. 278C is possibly a study for the vessel that occurs in the centre of P&V 1312, *Avant-port du Havre*, of 1903.

278D Study of three sailing boats at the entrance to the harbour, Le Havre
Pencil
Lugt 613e
107 × 171

278E Study of the entrance to the harbour, Le Havre
Pencil with brown wash
Lugt 613e
106 × 170

Exhibited: London/Nottingham/Eastbourne 1977–8, No. 60

278F Study of the quayside, Le Havre
Pencil
Inscribed in pencil *jettée Havre* upper right
Lugt 613e
105 × 169

Exhibited: London/Nottingham/Eastbourne 1977–8, No. 61

The crane on the quayside of the harbour at Le Havre is one of the principal motifs in Pissarro's final series of paintings. It occurs in P&V 1301, 1303–8, and 1315, but only in P&V 1301 and 1308 is the hoist at approximately the same angle and in both of these paintings the shipping tied up alongside the quay is arranged differently. It is, therefore, difficult to say for which of these compositions No. 278F was specifically drawn and it may have formed the basis for them all.

278G Slight study of the entrance to the harbour, Le Havre
Pencil
107 × 171

This motif occurs in the final series of paintings executed at Le Havre (P&V 1309–13), but it is always included as part of a wider, more panoramic view. See also No. 278H below.

278H Study of the entrance to the harbour, Le Havre
Pencil
Lugt 613e
107 × 170

No. 278H might have been used as a preliminary study for P&V 1313, *Avant-port et anse des pilotes, Le Havre*, of 1903.

278I Study of the harbour boom, Le Havre
Pencil
Annotated in pencil *jettée Havre* upper right
Lugt 613e
107 × 170

No. 278I is related to P&V 1299, *Entrée du port, Le Havre*, and to P&V 1314, *Le Havre, la jettée, après-midi, temps gris lumineux, mer haute*, both of 1903. Pissarro has retained the same viewpoint in both paintings, although he has moved further away from the jetty, in order to include the flag-pole on the right, and altered the position of the boats.

278J Slight study of a sailing boat seen from the starboard side
Pencil
171 × 107

278K Study of two steamships
Pencil
Lugt 613e
107 × 171

279 Study of the quayside, Le Havre
Gouache on silk
Signed and dated in gouache *C. Pissarro 1903* lower left
239 × 295

Literaure: P&V 1303 repr.
Exhibited: London/Nottingham/Eastbourne 1977–8, No. 59 repr.

(b) Drawings related to prints

280 *Le Champ de choux*
Pencil
Repaired along all edges. Several tears (lower
 left corner, lower centre, and upper centre)
 also repaired.
Inscribed in pen *épreuve au trait* lower left
Lugt 613e
240 × 162 (uneven)

No. 280 is a transfer drawing for D. 29, *Le Champ
de choux*, dated *c.* 1880 by Delteil. D. 29 is described
as a first state of D. 30, *Femme dans un potager*, also
dated *c.* 1880. A similar preparatory drawing for
D. 29 is in the National Gallery of Art, Washington
(Rosenwald collection), for which see Shapiro, No.
18 repr. Both the drawing in Washington and No.
280 have evidence of soft-ground deposit on the
verso. Another preparatory drawing, most probably
earlier than both of the foregoing and without soft-
ground deposit on the verso, was exhibited at JPL
Fine Arts, London, 1978, No. 14, pencil, 230 × 182.
A freely handled study in pencil with watercolour
entitled *Les Choux* possibly related to D.29 and
D.30 was sold at Sotheby's, 4 July 1968, lot 263
repr.
 For a drawing related to D.30 in the Ashmolean
collection see No. 281 below.

281 *Femme dans un potager*
Pencil on tracing paper
Repaired in lower left corner
Lugt 613e
111 × 170. Indications of plate mark
 reinforced in pencil along upper left edge,
 top edge, and also along right edge (in this
 last case only properly visible on the verso
 owing to over-mounting), *c.* 106 × 169.

No. 281 is a transfer drawing for the upper part of
the second state of D. 30. There are several dif-
ferences in this part of the composition between the
first and second states: the outlines and the shadow
on the house were strengthened, vertical striations
on the wall were added, and one tree, very lightly

indicated on the right of the first state, was removed.
There is evidence of soft-ground deposit on the
verso of No. 281.
 A study for this composition on a sheet from a
sketchbook was once in the possession of Lucien
Pissarro (CI neg. 52/55(4), soft pencil, 90 × 158).

282 *Paysage avec berger et moutons*
Pen and indian ink on tracing paper
Backed with tissue paper
Lugt 613e
107 × 145. Framing indicated in pencil (?)
 visible only on verso, 100 × 140

The nature of the lines on the verso, whether they
are soft-ground deposit or not, cannot be deter-
mined through the backing. No. 282 was un-
doubtedly made in preparation for the fourth state
of D. 40, of 1883. It is in reverse direction from the
print and must therefore have been used for trans-
ferring the design on to the plate. No. 282 shows
only two sheep in the foreground, a feature which
distinguishes the fourth state from those preceding
it.

283 **Study of the port at Rouen**
Pen and indian ink with grey wash over pencil
Lugt 613e
118 × 150

Exhibited: London/Nottingham/Eastbourne 1977–
8, No. 24

Pissarro made two etchings of this subject: D. 43
entitled *Le Port près la douane, à Rouen*, of 1883,
and D. 56 entitled simply *Port de Rouen*, of 1885,
which may justifiably be described as a development
of D. 43. No. 283 is clearly related to the earlier of
the two prints, for which it must have served as a
preparatory drawing, since it is in the reverse direc-
tion. The most obvious change in the etching is the
inclusion of a small boat alongside the sailing vessel
in the foreground. The drawing is also fractionally

larger than the print, which measures 149×118. The extensive underdrawing in pencil suggests that No. 283 was begun on the spot and perhaps finished later in the studio with the pen and the brush.

Pissarro adapted the same composition for a fan, P&V 1633, of 1885, for which a preparatory study in watercolour was last recorded with the O'Hana Gallery, London.

284 Côte Sainte-Catherine, à Rouen
 Pencil
 Stained left of centre
 Lugt 613e
 150×197

Exhibited: London/Nottingham/Eastbourne 1977–8, No. 25

No. 284 is a preparatory study in reverse for the etching D. 48, *Côte Sainte-Catherine, à Rouen*, of 1884. The drawing is of the same dimensions as the print, and the changes made in the final etching are minimal: they include the addition of an extra figure on the barge in the foreground and a straighter line prescribing the quayside with the bollards. There is, however, no indication of the sky in No. 284, as in the etching. The composition was amended for a smaller etching, *Paysage à Rouen (Côte Sainte-Catherine)*, D. 55, made one year later.

No. 284 is executed in a carefully delineated, closely modelled style that is characteristic of drawings made in connection with prints. The fact that No. 284 is in reverse implies that Pissarro used the drawing as an aid in transferring the design on to the plate.

285 La Ferme à Noël à Osny
 Black chalk on tracing paper
 Extensively damaged. Backed with tissue
 paper
 Lugt 613e (cut on left)
 188×143 (uneven)

No. 285 relates to the first state of the etching D. 51, *La Ferme à Noël à Osny*, of 1884, before the introduction of the two figures seated on the wall in the middle distance. The drawing is in the same direction as the print, and, like No. 284, was presumably made so that Pissarro could see how the composition looked in reverse before he undertook to transfer the design properly.

286 La Rue Malpalue à Rouen
 Pen and indian ink over pencil on oiled linen
 Lugt 613e
 207×152

No. 286 is a preparatory drawing for the etching D. 53, of 1885, which is one of a series of views of the streets of Rouen etched in 1884–5 after Pissarro's visit to the city in 1883 (see Sketchbook XIII, particularly No. 158D). The present drawing was evidently not executed on the spot, but appears, rather, to have been drawn in the studio, possibly in preparation for the third state when the sky was added. The sky, however, as it appears in No. 286 differs considerably from the third state, but in all else it agrees exactly.

287 Côte Ste. Catherine, Rouen 83 (recto)
 Pencil
 Inscribed on the verso with the title
 131×179. Plate marks are visible on the
 verso, 131×178

Exhibited: London/Nottingham/Eastbourne 1977–8, No. 26

The verso (repr. below) has ample evidence of soft-ground deposit, from which it can be deduced that No. 287 served as a transfer drawing for an abandoned print of this subject in aquatint, which exists in a single posthumous impression from the plate in the Bibliothèque Nationale, Paris. This important print was not known to Delteil and was first published by Leymarie and Melot (P. 131) and exhibited in 1974 (Melot, No. 250, p. 122). The date and the inscription, which are so prominent on the verso of No. 287, are not easily legible on the surface of the unique impression in the Bibliothèque Nationale, having being obscured by the aquatint. Pissarro made another print of this same subject later in 1883 (D. 69), although Delteil dates it to 1887. However, the single impression of the abandoned print in the Bibliothèque Nationale, together with No. 287, and the annotated impression of D. 69 in the collection of the New York Public Library (Avery collection, repr. Rewald, p. 58) does, as Melot rightly observed, suggest a date of 1883 for this second print.

For another drawing of this subject in the collection see No. 159.

288 *Port de Rouen*
Pen and dark ink on tracing paper
Backed with tissue paper
Much damaged particularly at the corners
 and along the edges
Lugt 613e
172 × 224 (uneven)

No. 288 is related to D. 57, of 1885 and seems to represent an early stage in the working process, the use of tracing paper implying that Pissarro wanted to see how the composition looked in reverse. Indeed, pencil lines are visible on the verso through the backing. Earlier, in 1883, Pissarro had executed a painting of the same motif (P&V 611).

One other drawing directly related to the print is known. This was formerly in the possession of Lucien Pissarro (CI negs. 52/47(12) recto, pen and ink, and 52/47(13) verso, pencil, sold Sotheby's, 8 July 1965, lot 37 repr. (recto only)). The photographs, taken while the drawing was still in private possession, show the sheet before trimming with the plate mark clearly visible, which proves that both recto and verso were made in connection with D. 57 and not with P&V 611, as was suggested in the sale catalogue.

289 *Paysanne dans les choux*
Pencil
Backed with tissue paper
Much damaged, particularly along the left
 edge
Upper right corner cut
Lugt 613e
145 × 110

No. 289 can be connected with D. 61, of 1885. It should be noted that there is no indication in the drawing of the standing figure to the left of the tree trunk that is included in both the recorded states of the print. Evidence of soft-ground on the verso of No. 289 and essential differences between No. 289 and D. 61 suggest that there may have been an unrecorded first state of this etching. Indeed, in the annotated copy of Delteil's catalogue in the Ashmolean Museum (see Abbreviations, p. 91 above), one finds the following note, ('*ler etat No. 2 avec seulement une paysanne, éclairé à droite au lieu de gauche non signée*'). The writers are unaware of any impressions of this first state.

290 *Rue de l'épicerie, Rouen*
Pen and indian ink on tracing paper
Lugt 613e (on verso)
175 × 152. Two indications of size have been
 marked in pen and ink in the corners, outer
 dimensions 172 × 150: inner dimensions
 161 × 144.

No. 290 relates to the etching D. 64, of 1886. The most important aspect of the drawing is the two sets of indications of size marked in each of the corners of No. 290. The inner markings denote the size of the composition, whilst the outer markings indicate the size of the plate. Incised lines join these corner markings together. The impression of D. 64 in the Ashmolean Museum measures 170 × 150 (plate) and 164 × 144 (composition).

There is a great deal of pencil work on the verso, which is visible through the paper, although it looks in reproduction as though it is on the recto. This implies that No. 290 was used to transfer the design on to the plate.

A watercolour of the rue de l'épicerie, Rouen, was exhibited by Marlborough Fine Art Ltd., London, *19th and 20th Century Drawings, Watercolours and Sculpture*, December 1962–January 1963, No. 59 repr.

291 *Place de la République à Rouen*
Pen and indian ink over pencil
Lugt 613e
155 × 175

A painting of this subject (P&V 609) is undated, but was most probably executed in 1883. No. 291, however, is undoubtedly closer to the print of the same subject, D. 65, of 1886. Another drawing in the same medium as No. 291 and of almost exactly the same dimensions (150 × 175), was sold by Parke-Bernet, 4 March 1975, lot 8 repr. It is in the reverse direction from D. 65 and also from No. 291. It is possible that this second drawing may have been traced from No. 291, as there are certain differences in the details of composition which do not occur in No. 291, but do recur in D. 65. Amongst these are the addition of boats at the quayside in the background and the hatching on the backs of the figures in the foreground, which must have come about as Pissarro redrew the composition.

292 Compositional study of two female peasants picking beans
Black chalk
Lugt 613e
183×143. Framing indicated in black chalk, 173×122

Exhibited: London/Nottingham/Eastbourne 1977–8, No. 46

No. 292 is a preparatory study for the etching D. 103, of 1891 (*Paysannes dans un champ de haricots*).

The figure of a bending woman steeply foreshortened and seen slightly from above is a recurring motif in Pissarro's *œuvre* from the early 1880s. Such figures occur in different contexts in P&V 1338, of 1880, P&V 1369, of 1882, P&V 1377, of 1883, P&V 1385, of 1883, P&V 1397, of 1885, P&V 730 of 1889, P&V 1431, of 1891, and P&V 857, of 1893. Pissarro also used a similar composition for a ceramic tile (Sotheby's, 3 July 1969, lot 213 repr. and 14 April 1972, lot 140 repr.).

In D. 103 there is a definite affinity with Van Gogh and Gauguin in the treatment of the figure. See also No. 221 above.

293 Study of a female peasant carrying two buckets walking down a path
Pencil
Faintly squared in pencil
Lugt 613e
123×81

No. 293, made in preparation for the etching D. 102, *La Paysanne*, dating from *c.* 1891, was most probably the first stage in the process of transference. The print without margins measures 120×81 and is in the reverse direction from No. 293. The landscape is unchanged, but the figure is slightly lengthened. Such a change is anticipated by the pentimenti on No. 293, which also occur around the shoulders of the figure. There is an earlier etching, which is more aptly entitled *Paysanne portant des seaux* (D. 85), of 1889. Both prints, particularly the handling of the figure in D. 102, recall J.-F. Millet's composition *Paysanne revenant du puits* (Herbert, No. 158).

294 Compositional study of two female bathers in a wooded landscape
Pen and dark ink with grey wash over pencil

Lugt 613e
192×140. Framing indicated in pencil, 183×130

Exhibited: London/Nottingham/Eastbourne 1977–8, No. 51

No. 294 is a preparatory study for the etching D. 116 (*Les Deux Baigneuses*), of 1895, which appears to have been partly derived from a painted composition executed the year before, namely P&V 898. For a study of the main figure see No. 257. There is also a pastel of the same composition (P&V 1600), which was apparently drawn over an impression of D. 116, a practice that Pissarro occasionally adopted in various media (see No. 299 below). The dimensions of the related etching are 180×127.

295 Compositional study for *Marché de Gisors* (*rue Cappeville*) with a study of a woman's head seen in profile facing left beneath
Pen and indian ink over charcoal and pencil on tracing paper
Lugt 613e
206×255. Framing indicated in charcoal, 173×255 (sight)

No. 295 is a preliminary study for the coloured etching D. 112, *c.* 1894, which is mentioned as being nearly finished in a letter of 18 January 1895 (*Lettres*, p. 363). While No. 295, however, has a horizontal format, that of the final etching is vertical. Pissarro has retained the basic elements of the composition included in No. 295, although in the print he has omitted the figures on the left and raised the horizon line. In these respects, D. 112 returns to the type of composition used in the painting of the same title P&V 690, of 1885, and in the gouache of that same year (P&V 1401), although here the figures have been completely rearranged. It is clear that No. 295 represents an early stage in the genesis of D. 112 and that it precedes all the other known drawings for this print, of which a large number are in the Ashmolean collection (see Nos. 296–9 below). The head redrawn in pen and ink beneath the composition is that of the standing female figure seen in profile facing left in the centre of D. 112, who is positioned just to the right of centre in No. 295.

An important compositional drawing (Fig. 18), with a vertical format and made at an intermediary

stage, was formerly in the possession of Lucien Pissarro (black chalk with pen and ink and grey and brown washes heightened with white on tracing paper, 275 × 109 (size of paper), 250 × 174 (size of composition)). The architectural features at the top, the seated figure lower left, and the standing figure at the right edge have been much worked over and altered. There are also considerable compositional differences, including the retention of the horse-drawn cart in the centre, which strongly suggests that this drawing marks the next stage in the development from No. 295 to the final design.

296 **Whole-length study of a male peasant**
 Pen and indian ink over black chalk on tracing
 paper
 Lugt 613e
 217 × 60

No. 296 is a tracing used in the preparatory stages of the coloured etching D. 112 of 1895. The figure occurs at the extreme right edge of the composition. It is greatly reduced in scale in the final print and serves as a substitute for the figure similarly placed on the right of No. 295.

The fact that No. 296 is a tracing is not easy to explain. Unlike most of the other figures in the composition, this bearded, almost brooding, peasant makes no other appearance in Pissarro's œuvre and, therefore, does not seem to have been traced from any other work of art. Looking mysteriously in from the right edge of the composition, this figure together with the awkwardly posed seated woman in the left foreground, who turns her head towards him, share in a private moment in a public place, which is a unique motif in Pissarro's market scenes. The scale of No. 296 suggests that, like No. 297 below, it was made as a tracing from, or as an overlay for, the second compositional drawing discussed in the entry for No. 295.

297 **Study of the buildings forming the background to** *Marché de Gisors* (*rue' Cappeville*)
 Pen and indian ink on tracing paper
 Lugt 613e
 106 × 162

No. 297 is a tracing for the background of D. 112, of 1895. As in the case of No. 296, above the scale

is greatly reduced in the final print. The outlines of No. 297 have been redrawn in black chalk on the verso. The purpose of No. 297 is unclear. Like No. 296, it is too small to have been traced from either the painting (P&V 690), or from the gouache (P&V 1401), from both of which the print derives. However, it has greater architectural affinities with the painting and the gouache than it does with the print. In the print, Pissarro has added several awnings on the left and removed the smaller gable from the double-gabled house in the centre. Although the size is not exact, it is possible that No. 297 was made to provide an overlay for the second compositional study discussed in the entry for No. 295.

298 **Compositional study for** *Marché de Gisors* (*rue Cappeville*)
 Pencil on tracing paper
 Pin marks in corners
 198 × 143. Framing indicated in pencil, 170 ×
 113

No. 298 corresponds exactly in both size and design with the coloured etching D. 112, of 1895, and must have been made during the final stages of preparation for the purposes of transference. The outlines of No. 298 have been redrawn in pencil on the verso.

It is notable that the tracing was not made from the second compositional drawing discussed in the entry for No. 295 and was presumably executed to enable Pissarro to see this complicated figure composition in reverse. The major changes, which Pissarro effected in this process of selection from, and reduction of, the second compositional drawing are the omission of a thin strip on the left; the alteration of the baskets adjacent to the male figure and seated female figure; the removal of the cart in the middle ground; the rearrangement of background figures; the lowering of the horizon line to include more of the architectural setting; and the alteration in the costume of the standing female figure:

299 *Marché de Gisors* (*rue Cappeville*)
 Coloured chalks over an impression of the
 print D. 112
 196 × 137 (size of plate). 169 × 112 (size of
 composition)
 Inscribed in pencil by the artist in the lower
 margin *No. 8 état No. 1 colourisé au crayon
 de couleur/accompagner les traits en general* (?)

Annotated in pencil by the artist in left margin: *la manche | un peu de | ...à l'essai | au trait assez* [?] | *trop dur;* in upper margin, *éclairer;* in right margin, *n'éclairait | pas endroits, la foule | la foule | travailler la barbe | ... | trop lourd | les noirs*

No. 299 is an impression of the etching D. 112, which the artist has coloured by hand. The practice of colouring prints by hand was possibly inspired by Degas. A passage in a letter of 18 January 1895 (*Lettres*, p. 363) refers to Pissarro's habit of colouring impressions of his prints; 'J'ai reçu mes plaques en couleurs de l'aciérage. J'y enverrai bientôt une jolie épreuve de mes *Petites paysannes à l'herbe* [D. 111] et un Marché [D. 112] en noir, rehaussé de teintes; je crois que l'on peut faire de jolies choses ainsi ... Cela ne ressemble en rien à Miss Cassat; c'est du rehaut, voilà tout. J'ai déjà quelques jolies épreuves, c'est très difficile de trouver juste les couleurs nécessaires.' No. 299 is one of three known impressions of D. 112 so coloured by Pissarro. The others are: (1) Louvre, inv. RF30106, coloured in a blue wash; (2) with Hirschl and Adler, New York, in 1976, retouched with watercolours. Delteil mentions that there are three retouched impressions of the first state alone, but No. 299 is not one of those, and Pissarro must, therefore, have retouched impressions of other states.

Another print known to have been hand coloured by Pissarro is D. 86, for which see Leicester Galleries, 1958, No. 35.

300 Compositional study for *Paysanne à l'herbe*
Pencil
Marked by offset in red chalk
Lugt 613e
183 × 300. Framing indicated twice in pencil: 122 × 164 (outer frame), 101 × 144 (inner frame and size of composition)

No. 300, like No. 255 above, is a study for the coloured etching D. 111, of 1895 (for the dating see No. 255). In some impressions of D. 111, the tree on the hill in the distant background on the left between the house and the copse has been removed. It is generally believed that there was only one state of D. 111 with coloured variants (Leymarie and Melot, P. 113), but the exact details of this print have yet to be recorded.

301 Compositional study for *Baigneuse aux Oies*
Pen and brown ink and grey wash over black chalk heightened with chinese white on beige coloured paper
137 × 187. Framing indicated in pencil, 132 × 181

Exhibited: London/Nottingham/Eastbourne 1977–8, No. 55

No. 301 is a preparatory drawing for D. 115, an etching of 1895, for which there is a tracing in the collection (No. 302). There is also a gouache of this composition from the same year (P&V 1477). A closely related drawing, which appears to have been drawn before No. 301, is in the British Museum (inv. 1912. 6. 5. 1, brush drawing in grey and brown washes over pencil on buff coloured paper, 151 × 178). No. 301 corresponds almost exactly with the etching, although the geese in the middle distance are rather more firmly delineated and given greater emphasis in the print. The drawing in the British Museum, however, differs considerably from D. 115 in the distribution of the geese, only two of which can be seen swimming in the middle distance. Stylistically, the drawing in the Ashmolean is more confidently drawn, both in the strength of the outlines and in the laying in of the washes. The outlines have been drawn with a reed pen.

302 Compositional drawing for *Baigneuse aux Oies*
Black chalk and pencil on tracing paper
Lugt 613e
130 × 182

No. 302 was made during the final stages of preparation for the etching D. 115, *Baigneuse aux Oies*, dating from *c.* 1895. For a preparatory study and for another related drawing, which is in the British Museum, see No. 301 above. No. 302 was clearly used for the transference of the design of an early state of D. 115, perhaps the second, or third. Delteil lists sixteen states in all. No. 302 is in reverse direction from the final print, and the design has been redrawn on the verso in black chalk. Indications of a plate mark are visible along all the edges of No. 302, but the measurements cannot be taken owing to the overmount. The print measures 127 × 173.

303 **Study of a female peasant watching a male peasant haymaking in a farmyard**
Pen and brown ink over pencil
Faintly squared in pencil
Lugt 613e
123 × 84

No. 303 was made in preparation for D. 125, an etching that was apparently only printed posthumously (Leymarie and Melot, P. 126). Delteil, followed by Leymarie and Melot, dates the print to 1899, but this is questionable on two counts: firstly, the similarity in format to No. 293, which was drawn for D. 102 c. 1891, and, secondly, the stylistic affinity in the penwork with No. 261, which was drawn in connection with the lithograph D. 157 dated c. 1896 by Delteil and 1894 by Leymarie and Melot (P. 45). The matter has yet to be settled, but a date some time during the first half of the 1890s is preferable for No. 303, if not for the related etching, D. 125. The size of the print is 120 × 81. According to J. Cailac, 'The Prints of Camille Pissarro. A Supplement to the Catalogue by Loys Delteil', *Print Collector's Quarterly*, xix (1932), p. 83 LD 125, there is also a coloured monotype of this composition (sold Paris, Hôtel Drouot, 8 April 1925, lot 219), which is listed by B. Shapiro and M. Melot, 'Catalogue Sommaire des Monotypes de Camille Pissarro', *Nouvelles de l'estampe*, xix (1975), p. 21, No. 17.

304 **Study of two peasants carrying a bale of hay on a wooden tray** (recto)
Pencil on tracing paper prepared with a ground of red chalk over which a clear wash has been laid
Pin holes in corners
Lugt 613 (on verso only)
123 × 87 (sight)

No. 304 is a transfer drawing for the etching D. 126, of 1900. The design has been redrawn on the verso repr. below in pencil with some lines reinforced in pen and indian ink. Plate marks are clearly visible along all the edges of No. 304, although the measurements do not correspond exactly with those of the finished print probably due to shrinking in the printing process. The plate marks on No. 304 measure 122 × 81 and the dimensions of the impressin of the print in the Ashmolean Museum are 117 × 81 (not 119 × 81 as given in Delteil).

The composition of No. 304 appears to have been evolved out of a painting P&V 855, *Faneuses, le soir, Eragny*, of 1893, for which see Nos. 247–50 below. D. 126 is closely connected in size and style to two other etchings, namely D. 102, and D. 125, for both of which there are preparatory drawings in the collection (Nos. 293 and 303 respectively). The relationship between these three prints, which is in no way denied by the style of the related drawings, suggests that they were either conceived as a series, or are closer in date than Delteil or, more recently, Leymarie and Melot allow.

(c) Drawings for joint projects including *Daphnis and Chloë*

305 Study of a female peasant digging
Pen and indian ink over pencil on tracing
paper
Damaged and repaired along all edges and at
corners
Signed in ink with the artist's initials lower
right corner, the letter *P* in reverse. In-
scribed in pencil by Lucien Pissarro *Reduce
to 4½ ins.* along left edge
237 × 160

The pencil underdrawing of No. 305 is evidently
a tracing from P&V 534, *Dans le potager à Pontoise,
paysanne bêchant* (Oppenheimer Collection, San
Antonio, Texas), of 1881. The outlines of the trac-
ing have then been retouched in pen and ink and
hatching added in the same medium. It is to be pre-
sumed that the tracing, as well as the penwork, were
made by Camille Pissarro. The figure, however, was
engraved by Lucien Pissarro (Studio Book, II, f. 23,
No. 239) and is convincingly dated on stylistic
grounds *c.* 1884 by Fern (No. 4, p. 108). The print
was first used on the cover of the catalogue of the post-
humous exhibition of the work of Camille Pissarro
held at the Galeries Durand-Ruel (7–30 April 1904
and later on the prospectus for *La Charrue d'érable*
(1912), for which see above, Introduction p. 66.
Lucien Pissarro, however, dates the print to 1906 in
his Studio Book. It should be observed that the size
of the image in No. 305 is 235 mm, whereas in the
print the figure measures 115 mm, which is 4½ in-
ches, as indicated in the inscription. For discus-
sion of several related drawings, see No. 306.

306 Study of a female peasant digging
Pen and indian ink over pencil on tracing
paper
Signed in ink with the artist's initials lower
left
153 × 142

Stylistically, No. 306 is closely akin to No. 305 and,
in common with that sheet, the underdrawing
appears to have been traced and then the lines

strengthened with the pen. Although other draw-
ings of this type in the collection (Nos. 249, 250,
and 305) are tracings made from specific paintings,
No. 306 does not seem to fit into that category. The
pose is strikingly close to that of the figure in the
gouache, *Paysanne bêchant* (P&V 1374, *c.* 1883), but
various adjustments have been made: for example,
in the position of the feet, and the angle of the stoop,
as well as in the position of the right arm. Yet, the
costume is identical and the figure in the gouache,
or, alternatively, a preparatory study for it, must
have been the ultimate source for No. 306. The stiff-
ness of the style of drawing may partly have been
due to the fact that it was traced, but it is also an
indication that, like No. 305, it was made for Lucien
Pissarro to engrave on wood. No such print has sur-
vived.

Another tracing of the same figure was exhibited
at JPL Fine Arts, London, 1978, No. 26. Attention
may also be called to two pen and ink drawings of
female figures digging, one virtually identical in
pose to No. 306 and made in connection with P&V
1374, and the other related to P&V 414, *c.* 1877
(Finke Collection, Palm Beach, Florida).

307 Study for *Le Semeur*
Pen and indian ink over pencil on tracing
paper laid down on card
Upper left corner missing and damaged along
all edges
Creased in lower right corner where there is
also a hole to the left of the stamp (Lugt
613e)
Lugt 613e
139 × 192

The image of the sower is one that Pissarro essayed
on three other occasions. There is, firstly, a painting
(P&V 331), of 1875, for which there is an oil study
(P&V 330) and a drawing (Sotheby Parke Bernet,
16 December 1970, lot 7 repr.). This first composi-
tion, in fact, comprises two figures—the sower and
a ploughman in the background on the right. Pis-
sarro then evolved a second composition with a

single figure set in an empty and spacious landscape, which was engraved on wood by Lucien Pissarro (Studio Book, I, f. 28 bis, No. 41, repr. *Lettres*, pl. 176) after a drawing by his father dating from *c.* 1890 (see Fern, No. 47, p. 146), and which was later reused by Camille Pissarro as the basis for a lithograph (D. 155), of 1896. Lucien Pissarro's wood-engraving was published by Goupil-Boussod and Valadon and is in the style of the first prints in the published portfolio, *Travaux des champs* (see No. 322). In spite of the fact that the general composition is similar to No. 307, the design of Lucien Pissarro's print by no means corresponds exactly with the drawing. For instance, the two trees in the middle distance are omitted. Yet, even though the general character of the composition is closer to the lithograph, particularly in the landscape, the style of No. 307 is undeniably related to Lucien Pissarro's wood-engravings. It is, therefore, probable that No. 307 was a rejected study by Camille Pissarro for Lucien's wood-engraving, to which it also corresponds in scale. The subject of the sower is included in the unpublished section of *Travaux des champs* (see Nos. 358–60) with a new composition, in which the figure is no longer placed parallel to the picture plane, but seen from the front.

The theme of *Le Semeur* occurs frequently in French nineteenth-century painting and was essayed several times by Millet, Van Gogh, and Pissarro. The exact relationship between these various groups of works, together with the political connotations attached to the theme, which would undoubtedly have attracted Pissarro to undertake it, has still to be properly examined.

It should be noted that an inscription added by a later hand along the lower edge of No. 307 refers to Prince Kropotkin and *Les Temps Nouveaux*, the anarchist newspaper edited by Jean Grave. The compilers have been unable to establish any specific connections.

308 Study of figures picking apples
Black chalk on tracing paper laid down on card
Lugt 613e
113 × 263. Framing indicated in black chalk, 88 × 260

See No. 309 below.

309 Study of figures picking grapes
Red chalk over black chalk on tracing paper
Lugt 613e
74 × 268. Framing indicated in red chalk, 57 × 244

Nos. 308 and 309 both have in common a long horizontal format and it is likely that they were drawn in connection with the same project, possibly with one or other of the two joint projects that Camille and Lucien Pissarro undertook together, namely *Travaux des champs* and *Daphnis and Chloë*. Yet there can be no certainty about this, since the format is totally different from the drawings made for either *Travaux des champs*, or *Daphnis and Chloë*.

As regards the subjects of these two drawings, there can be little doubt that they are more suited to *Travaux des champs* than to *Daphnis and Chloë*. There is also a stylistic similarity between Nos. 308 and 309 and the earlier studies for *Travaux des champs* (particularly Nos. 324 and 326). The horizontal emphasis in both these compositions is suggestive of the large decorative schemes painted by Puvis de Chavannes, *Le Bois sacré* (part of the decorations in the Musée des Beaux-Arts, Lyons) and *Inter Artes et Naturam* (part of the decorations of the Musée des Beaux-Arts, Rouen), both of which Pissarro admired (see *Lettres*, pp. 455–7 and 377 respectively). For the paintings by Puvis de Chavannes see the exhibition catalogue, *Puvis de Chavannes 1824–1898*, Paris and Ottawa, February–May 1977, Nos. 174–7, pp. 193–9 and No. 190, pp. 210–12. Pissarro, however, does not appear to have intended any allegorical significance to be attached to his designs. Another tracing of the composition on No. 308 was formerly in the possession of Lucien Pissarro (CI neg. 51/70(21a), no details known), as was an elaborate compositional study for the cart and surrounding figures in No. 309 (CI neg. 52/71(4a), no details known). This last study included four additional figures in front of the cart which were omitted in the larger composition.

310 Compositional study of two peasants in a field
Pencil with watercolour on beige paper printed with ruled horizontal lines in vertical column's following the laid lines between the chains
Flourishes with the brush in the margins of the sheet

Lugt 613e
173 × 113. Framing indicated in pencil, 57 ×
48, extended by 7 mm at upper edge.

No. 310 was used as the basis for a chiaroscuro wood-
cut entitled *Paysans* printed from two blocks by
Lucien Pissarro (Studio Book, I, No. 12, f. 9, Fern,
No. 15, p. 120). Fern dates this print *c*. 1884–5,
which is far too early. Lucien Pissarro did not begin
to experiment with chiaroscuro woodcuts until
c. 1900 in connection with *Travaux des champs* and,
in fact, the style and composition of No. 310 are not
all that far removed from the later drawings for the
third phase of *Travaux des champs* (for which see
Nos. 352–6). Indeed, the compact, tautly controlled
composition recalls certain prints made by Pissarro
himself during the 1890s (for example, D. 102 and
125–6).

The paper on which No. 310 is drawn is unusual.
Pissarro did, however, sometimes use it for his cor-
respondence, and it is likely that the drawing was
enclosed in a letter from Camille to Lucien Pissarro
as part of the consultative process for the making
of the print.

311 Tracing of a compositional study of Ruth gleaning
Pencil on tracing paper
109 × 75. Framing indicated in pencil, 76 × 65

No. 311 is a tracing by Camille Pissarro of a drawing
by Lucien Pissarro which served as the basis for a
wood-engraving for a print in *The Book of Ruth and
the Book of Esther*. This was Lucien Pissarro's
second published book and was issued by the Vale
Press in 1896. The illustration differs considerably
from the others in the project in that the composi-
tion is less complicated and lacks the figures dressed
in vaguely Oriental costumes. In fact, No. 311 is
much closer to Camille Pissarro's own peasant genre
subjects of the early 1890s, such as those adapted
for *Daphnis and Chloë* and *Travaux des champs*. The
final print appears on p. x of the publication, and
No. 311 is of interest because of the corrections
marked on it by Camille Pissarro. The tracing was
enclosed in a letter from Camille to Lucien Pissarro
dated 23 May 1895, 'Je te disais que j'avais trouvé
ton bois fort bien et te conseillais même de refaire
les deux premiers en faisant du trait-blanc après
correction de ton bras et du bas de la robe et les
valeurs de l'autre. Je t'envoie un décalque indiquant

les points critiquables de la moisson' (passage
omitted in *Lettres*).

312 *Nicolette*
Pen and indian ink over pencil with brown
 wash heightened with touches of gouache
 (partly oxidized)
125 × 100

No. 312 is a copy by Camille Pissarro of a print
designed and executed by Lucien Pissarro as the
frontispiece for a publication entitled *C'est d'Aucas-
sin et de Nicolette* (Studio Book, I, ff. 94 and 95, Nos.
219 and 219 bis; Fern, Nos. 140–1, pp. 233–4), dat-
ing from 1903. There are, in fact, two prints by
Lucien Pissarro of this composition dating from
1903. The first was printed with three blocks and
the second with five. No. 312 is clearly after the
earlier of the two prints and was drawn by Camille
Pissarro on a separate sheet inserted in a letter (21
July 1891, passage omitted in *Lettres*) illustrating his
comments on the proof of the print that he had re-
ceived from his son, 'Je n'ai pas pu faire le terrain
assez blanc, mais il faudrait avoir dans les contours
des teintes qui débordent, en un mot tu graves trop
bien ou plutôt tu ne graves pas dans le but d'obtenir
de la souplesse. Ta figure ne devrait pas être aussi
claire dans les blanc. Rappelles-toi la gravure de
l'exposition du livre? Tu n'est pas fou[?] de faire
noir ... je n'ai pas pu obtenir l'effet de l'imprimerie
mais c'est très possible il me semble. Tu devrais
essayer avec des traits tirés très *clairs noyés?* pour
ainsi dire. Il aurait fallu peut-être que les traits
fussent plus larges.'

313 Compositional study for an illustration to *Daphnis and Chloë* (*Chloë washing Daphnis at a stream*)
Pencil
Creased horizontally just above the centre
Lugt 613e
145 × 191. Framing indicated in pencil, 134 ×
 177

No. 313 is the first of four related studies drawn in
connection with an illustration for the scene of *Chloë
washing Daphnis at a stream* described by Longus
in Book I. 13. More preparatory studies survive for
this first scene of the series illustrating *Daphnis and
Chloë* than for any other. This must partly be due

to the unfamiliarity of the technique and to the fact that Pissarro had great difficulty in finding nude models to pose for him, a problem that affected not only his work on *Daphnis and Chloë*, but also his painting. Two quotations from letters written by Camille Pissarro to his son dating from 1895 testify to this point, 'Je ne sais comment je me tirerai du nud pour le Daphnis et Chloé il en faut' (*Lettres*, p. 363, 18 January 1895); 'Je cherche les nuds en ce moment' (*Lettres*, p. 384, 11 October 1895). No. 313 is tentatively drawn and Pissarro has concentrated upon the attitudes and gestures of the figures, as opposed to the details of the composition. For the other drawings for this composition see Nos. 314–16 below.

314 Compositional study for an illustration to *Daphnis and Chloë* (*Chloë washing Daphnis at a stream*)

Brown wash over pencil with some black chalk

Lugt 613e

152 × 199. Framing indicated three times in pencil and black chalk, 131 × 179 (outer frame); 118 × 134 (inner frame); 100 × 134 (off centre frame)

No. 314 is a development from the previous drawing (No. 313). Pissarro has here changed the position of the figures and paid closer attention to the flock of sheep and the setting. The numerous indications of the framing show a gradual reduction in scale. No. 314 has many stylistic affinities with Pissarro's contemporary drawings of bathers (see No. 262 above) and in some ways anticipates the chiaroscuro technique developed for the third phase of *Travaux des champs* (Nos. 343–78).

315 Compositional study for an illustration to *Daphnis and Chloë* (*Chloë washing Daphnis at a stream*)

Brown wash over pencil

Lugt 613e

139 × 156. Framing indicated in pencil, 119 × 135

No. 315 represents a resolution of the compositional difficulties that Pissarro encountered in No. 314. As such, No. 315 is the final composition. The present drawing is commented upon in a letter written by

Lucien Pissarro to his father dated October 1895: 'Ricketts et Shannon aiment le jeune gars dans le Daphnis et Chloé mais ils n'aiment pas la femme! R. trouve que le retroussis de la jupe n'était pas porté par les gens de la campagne, mais la vraie raison est probablement qu'ils sentent que les plis etc. sont faits un peu de chic et les gens qui connaissent si bien les grecs doivent s'apercevoir de cela tout de suite.' Camille Pissarro's reply to this, written on 6 October 1895 (*Lettres*, p. 383), is quoted above in the Introduction (p. 60).

316 Compositional study for an illustration to *Daphnis and Chloë* (*Chloë washing Daphnis at a stream*)

Pen and indian ink over pencil with chinese white on tracing paper

Lower right corner missing

Pin marks in corners

Signed in chinese white with the artist's initials lower left corner of composition

174 × 191. Framing indicated in indian ink, 121 × 136

There are some brief studies in pencil of sheep in the left margin of the drawing and pen flourishes in the right margin.

No. 316 is a drawing done for Lucien Pissarro, who then proceeded to engrave it (Fern, No. 115, p. 208). The engraving, which is also reproduced in Leymarie and Melot (P. 206), is dated 1899 by Lucien Pissarro in his Studio Book (I, f. 79, No. 162).

317 Compositional study for an illustration to *Daphnis and Chloë* (*Vendange*)

Pen and indian ink over pencil with chinese white on tracing paper laid down on card

135 × 146. Framing indicated in indian ink, 124 × 139

There is an overlaid correction upper right extending horizontally just over half-way across the drawing and at its furthest reaching vertically for 135 mm down the drawing. There are pen flourishes in the right margin.

No. 317 illustrates the scene described by Longus in *Daphnis and Chloë*, Book II. 1. Like No. 316, the present sheet is a drawing done by Camille Pissarro

for Lucien, who then engraved it (Fern, No. 116, p. 209). The print is dated 1899 in Lucien Pissarro's Studio Book (I, f. 80, No. 163), although already in a letter of 14 October 1895 to his father he reports 'La Vendange est presque gravé, mais je l'ai laissé en plan pour faire une bordure pour Ruth. Je vais ajouter à Ruth le Livre d'Esther...' It was this design that formed the basis of Lucien Pissarro's attempt to create a *mise-en-page*, for which see the Introduction (pp. 63–5). For related drawings see Nos. 258 and 318.

The composition is somewhat reminiscent of the right section of the allegorical painting by Puvis de Chavannes, *Ave Picardia Nutrix*, dating from 1861–5, which forms part of the decorations in the Musée des Beaux-Arts at Amiens (see the exhibition catalogue, *Puvis de Chavannes 1824–1898*, Paris and Ottawa, February–May 1977, pp. 60–7 where the relevant section is reproduced on p. 65). There is, however, an even closer connection with an allegorical rendering of *Autumn* (Cologne, Wallraf-Richartz Museum), which is derived from the right half of *Ave Picardia Nutrix* (op. cit., No. 50, pp. 71–2), but it cannot be proved that Pissarro knew this last composition, although he was a keen admirer of Puvis de Chavannes.

318 Sheet of studies for an illustration to *Daphnis and Chloë* (*Vendange*): figures picking grapes; an old man scything with evidence of a further study of the same figure (?) on right

Pen and indian ink on tracing paper. Pencil (fragmentary study upper right corner only)

122 × 240

No. 318 is a partial tracing of the preceding compositional drawing (No. 317) with those figures occurring there in the upper left section omitted. The allegorical figure of an old man representing Father Time is an adaptation of *Le Moissonneur*, for which see No. 341. Pissarro possibly intended to include such a figure in one of his illustrations to *Daphnis and Chloë*.

319 Compositional study for an illustration to *Daphnis and Chloë* (*Daphnis meeting Chloë in the snow*)

Pen and indian ink over pencil with chinese white on tracing paper

Signed in pen and ink with the artist's initials lower right corner

130 × 193. Framing indicated in indian ink, 124 × 141

There are pen flourishes in the right margin.

No. 319 illustrates the passage described by Longus in *Daphnis and Chloë* (Book III. 5) when the lovers suffer a period of long separation as a result of a severe winter, only occasionally contriving to meet. The passage is one of the most vividly written sections in the pastoral romance.

A preparatory study in a much looser style and showing more of the house on the right was formerly in the possession of Lucien Pissarro (CI neg. 42/41(23), grey wash over charcoal, 213 × 229, exhibited Leicester Galleries 1958, No. 26). In this preparatory study, the house in the background bears a striking resemblance to Ludovic Piette's farm, Montfoucault (see P&V 287, Sterling and Francine Clark Institute, Williamstown). Interestingly, No. 319 is the only design in the series of drawings made by Camille Pissarro that is derived from the comparable scene in the *Daphnis and Chloë* illustrated by Ricketts and Shannon and published by the Vale Press in 1893 (p. 61).

320 Compositional study for an illustration to *Daphnis and Chloë* (*The Feast of Dionysophanes at Mytilene*) (recto)

Pen and indian ink over pencil

Pin marks in upper corners

Lugt 613e

125 × 144 (sight). Framing indicated in pencil, 118 × 134

Compositional study for an illustration to *Daphnis and Chloë* (*The Nuptials of Daphnis and Chloë*) (verso)

Pen and indian ink over pencil with a dark wash highlighted in chinese white

Lugt 613e

Framing indicated in pencil, 117 × 134

There are pen flourishes in the right margin of the verso of No. 320.

The recto is an early idea for the scene described by Longus in *Daphnis and Chloë* (Book IV. 34–6)

in which the true parentage of Chloë is revealed. In the previous section of Book IV, it is narrated how Dionysophanes and Clearista were revealed as the real parents of Daphnis. Pissarro has here shown the servants at the celebration held by Dionysophanes carrying in Chloë's jewellery, which was then immediately identified by her true father, Megacles, who is, perhaps, the figure seated at the head of the table to whom most of the other figures point.

The verso of No. 320 relates to the final incident in the text (Book IV. 40), *The Nuptials of Daphnis and Chloë*.

321 Compositional study for an illustration to *Daphnis and Chloë* (*The Nuptials of Daphnis and Chloë*)
Pen and indian ink over pencil with chinese white on tracing paper laid down on card,

134 × 195. Framing indicated twice in pencil and indian ink, 125 × 169 (outer frame) 122 × 139 (inner frame)

There are pen flourishes in the margins at left and right. The sheet is also notable for the extensive overlaid correction in the upper right corner and in both the lower corners.

The incident is described by Longus in *Daphnis and Chloë*, Book IV. 40. It is the closing scene of the pastoral. For another compositional study, probably drawn before No. 321, see the verso of the preceding drawing (No. 320). No. 321 is a drawing done by Camille Pissarro for Lucien who, however, engraved the composition much later (Fern, No. 258, p. 313), according to the Studio Book (II, f. 151, No. 344), in 1920. It is notable that *The Nuptials* is the only scene chosen by Camille and Lucien Pissarro that was not illustrated by Ricketts and Shannon.

(d) Drawings for *Travaux des Champs*

322 Compositional study of a female peasant feeding hens
Pen and brown ink over chalk with corrections in chinese white on tracing paper
Lugt 613e
164 × 113. Framing indicated in black chalk, 145 × 88

No. 322 was made in preparation for the fourth print in the published portfolio *Travaux des champs*. There are, however, several differences between No. 322 and the final print involving changes to the tree on the left and the omission of the building on the right. In the print the tree reinforces the vertical format, and the figure, more upright and slender, is enclosed beneath its spreading branches. The dimensions of the print are smaller, 130 × 70. These differences between No. 322 and the final print may be accounted for by the fact that there were at least two preparatory drawings for the print, as can be surmised from the letter of 22 October 1894 written by Lucien Pissarro to his father quoted above in the Introduction (p. 70). Presumably, the passage from the fragmentary undated letter also quoted there might refer to the second drawing, which can tentatively be identified as No. 322, finally rejected in favour of the first design.

In the portfolio *La Femme aux poules* marks a transition from the pure wood-engraving style of Nos. 1–3 to the coloured engravings with which it closes (Nos. 5–6), and we know from the correspondence that, in this instance, the complicated printing procedure of a wood block with two zinc plates in relief used for the colours created difficulties for Lucien Pissarro. In many ways, therefore, particularly on the basis of style and technique, *La Femme aux poutes* anticipates the chiaroscuro prints executed later in the project, and it is significant that it is in this context that Camille Pissarro refers back to the print (see letter to Lucien Pissarro dated 18 December 1901, quoted above in the Introduction, p. 73).

323 Compositional study for *Les Sarcleuses*
Pen and indian ink with brown ink and red chalk over pencil
Inscribed in ink on the verso, possibly by Lucien Pissarro, *Réduire de moitië*
Pin marks in corners
Lugt 613e
223 × 149. Framing indicated in black chalk, 175 × 119

Literature: J. C. Holl, *Camille Pissarro et son œuvre, dessins inédits et peintures*, Paris, 1904, p. 3. repr.

See No. 324 below.

324 Compositional study for *Les Sarcleuses*
Red chalk on tracing paper
Lugt 613e
227 × 150. Framing indicated in red chalk, 174 × 118

Nos. 323 and 324 form part of the concluding stages of the preparatory process for the fifth print included in the published portfolio *Travaux des champs*. The dimensions and composition of each of the drawings correspond almost exactly with those of the print and, as a result, the instructions inscribed on the verso of No. 323 do not seem to have been carried out.

The last two prints in the portfolio were executed contemporaneously (see No. 327), and each needed a large number of wood blocks. *Les Sarcleuses*, for example, used five (Studio Book I, f. 58, No. 94).

325 Compositional study for *Femmes faisant de l'herbe*
Pen and indian ink with watercolour over charcoal
Pin marks in corners
Lugt 613e

232 × 150. Framing indicated in pencil and grey wash, 178 × 120

There are pen flourishes in the upper margin

See No. 327 below.

326 Compositional study for *Femmes faisant de l'herbe*
Red chalk on tracing paper
Torn in upper left corner
Lugt 613e
238 × 166. Framing indicated in black chalk, 229 × 156, and again in red chalk, 175 × 112

See No. 327 below.

327 Compositional study for *Femmes faisant de l'herbe*
Drawn with the stylus in red powdered pigment on perspex
187 × 130. Framing indicated with the stylus in red powdered pigment, 113 × 170

Nos. 325, 326, and 327 form part of the concluding stages of the preparatory process for the sixth and last print in the published portfolio *Travaux des champs*. The dimensions and composition of each of the drawings correspond almost exactly with the final print. *Femmes faisant de l'herbe* is mentioned in the letter from Lucien Pissarro to his father dated 22 October 1894, in which Lucien reports that he is working on the block, and in a subsequent letter (written in reply to one of 4 November 1894 from Camille) he states that he has just finished pulling twenty-five impressions of the print (both passages quoted above in the Introduction p. 70). No. 325 was probably drawn in connection with the selection of colours, whilst Nos. 326 and 327 were surely used for transferring the design on to the block.

328 *Femmes faisant de l'herbe*
Woodcut coloured in watercolour by hand
Pin marks near upper corners
Enumerations in pen and ink lower right corner
212 × 178. Size of block, 175 × 118

The annotations in pencil in the right margin read, '*3e femme | coiffe blanche | ensoleille avec solide*

(crossed through) *caraco | orange rouge | Tablier | vert bleu. 2e femme coiffe | rouge et | jaune | caraco (?) | rayé vermilion | Tablier | vert bleu | jupons | bleu et violet. Ière femme | coiffe | Points vermilion | caraco | rayé bleu | Tablier | orangé | jupon marron*. In the lower margin there occurs in pencil *Lumière de soleil couchant orangé rouge | effet intense de soleil couchant avec ombres | profondes et lumière vive et orangée*.

The recto of No. 328 is an impression pulled from an outline block, which Camille Pissarro then coloured by hand. It represents a more complex colour system than that propounded on No. 325, and it is the one that was adopted in the final print. According to a note in Lucien Pissarro's Studio Book (I, f. 59, No. 95), the print was made from six blocks. For Camille Pissarro's practice of colouring his prints by hand, see No. 299 above. The most important change from No. 325 is that the light has been altered to suit the tones of a *soleil couchant*. There is some discussion of the finished print in the correspondence between Camille and Lucien Pissarro, namely in a letter of 31 December 1901 from Camille Pissarro to his son and in Lucien Pissarro's reply date 2 January 1902 (both passages quoted above in the Introduction, pp. 73–4).

On the verso there is the study of a dead cat drawn in pen and indian ink over black chalk. It does not appear to be by Camille Pissarro.

329 Compositional study of three female peasants in an orchard
Brown-red ink and grey-blue wash over pencil highlighted with gouache
Badly damaged by damp and marked by offset in the upper and left margins
Lugt 613e
238 × 308. Framing indicated in pencil, 177 × 240, and divided vertically into two halves.

No. 329 is manifestly a study for a projected engraving on wood, although none of this composition has survived. The division of the composition into two vertical halves indicates the use of two separate blocks and a reference to this problem is made in a letter written by Lucien Pissarro to his father towards the end of November 1894, some time between 17 and 22 of that month (quoted above in the Introduction, pp. 72–3). The fact that no print of this composition was ever made may have been because it is too detailed for translation on to a wood block. It appears that on being aware of this

Camille Pissarro then redesigned the composition with simpler outlines and one less figure (see No. 330 below), since the subjects and the stylistic context of the two drawings are virtually the same. For a discussion of the purpose of Nos. 329, 330, 331, and 332 see the following entry (No. 330).

### 330	Compositional study of two female peasants conversing in an orchard

Red-brown and indian inks over charcoal highlighted with gouache on blue paper
Signed in indian ink with the brush with the artist's initials in lower left corner
Pin marks in corners
223 × 295. Framing indicated in indian ink, 176 × 241. Pencil lines indicate a reduced composition comprising a section of the right half of No. 330, 150 × 120

No. 330 is clearly a study made for a projected engraving on wood, but, as in the case of No. 329, none has survived, either of the whole composition, or of the reduced composition indicated in pencil in the right half of the drawing. Inasmuch as the lines of the composition are simpler than those in No. 329, and therefore more suitable for cutting on wood, it is possible that the present sheet represents a reworking of No. 329.

The question arises as to when and why these two drawings were made. It is significant that the compositions are the same size as No. 332, which was definitely drawn in connection with the projected second series of prints for *Travaux des champs* (see Nos. 332 below). Furthermore, after the successful printing of Nos. 5 and 6 (*Femmes faisant de l'herbe* and *Les Sarcleuses*) in the first portfolio of *Travaux des champs*, it was intended to include other colour wood-engravings of different subjects in the second series, as stated in the letter written by Lucien Pissarro to his father some time between 17 and 22 November, 1894 (quoted above in the Introduction, pp. 72–3). It is feasible, therefore, to argue that Nos. 329 and 330 are earlier versions of the composition referred to in that letter as *Printemps*, which then had to be entirely redesigned, owing to the difficulty of cutting this design on wood.

### 331	Compositional study of four female peasants working in an orchard (*Printemps*)

Red chalk with touches of gouache on tracing paper
Signed in red chalk with the artist's initials lower right corner
195 × 258. Framing indicated in red chalk, 177 × 239, and the composition divided vertically into two halves

See No. 332 below.

### 332	Compositional study of four female peasants working in an orchard (*Printemps*)

Red-brown and indian ink over charcoal on blue paper
Lugt 613e
236 × 299. Framing indicated in charcoal, 178 × 240, and the composition divided vertically into two halves

Exhibited: London/Nottingham/Eastbourne 1977–8, No. 48

Nos. 331 and 332 are preparatory drawings for a wood-engraving executed by Lucien Pissarro (Fern, No. 12, p. 118, where it is incorrectly dated *c.* 1884–5). Both are in reverse direction from the wood-engraving. No. 331 is on tracing paper and presumably served as a transfer drawing. The evidence of the letter written by Lucien Pissarro to his father sometime between 17 and 22 November, 1894, refers to a colour wood-engraving entitled *Printemps*, which was to form part of the projected second portfolio of prints for *Travaux des champs* (letter quoted in the Introduction pp. 72–3). In another letter from Lucien Pissarro to his father, dated 14 January 1895, he writes, 'nous avons en main la gravure du Printemps pr. les Travaux des champs'. It appears, however, that no colour impressions were ever made, and the impression in the Studio Book is in outline only. According to Lucien Pissarro's annotation in his Studio Book (I, f. 82, No. 166), where it is entitled *Printemps*, the print is placed in chronological order at 1900, and it is recorded that three proof impressions were pulled before an edition of twenty was printed. Indeed, there are direct references to the printing of *Printemps* in two letters written by Lucien Pissarro to his father in October–November of 1899 (both quoted above in the Introduction, p. 73), when Lucien sent proof impressions of the print to Camille Pissarro to obtain his advice on the colours.

From this evidence, it appears that Camille Pissarro's drawings and at least one impression of *Printemps* date from the period November 1894 to January 1895, but that the complete edition was not printed until late 1899, or early 1900.

The stooping figure in the foreground of Nos. 321 and 322 recalls the composition of D. 103, of 1891, and the whole composition was reduced in scale and adapted for a lithograph of *c.* 1896 (D. 166). The landscape, however, is one that occurs in Pissarro's compositions of the last half of the 1880s (see Nos. 181 and 182), epitomized by the painting P&V 726, *La Cueillette des pommes, Eragny*, of 1888 (Dallas Museum of Fine Arts). Presumably, on finding that he had to clarify his design for the wood-engraving, *Printemps*, Pissarro returned to the simplified structure of his Neo-Impressionist period.

See also Nos. 329 and 330 above.

333 Compositional study of two female peasants weeding in a field

Pen and indian ink with chinese white over pencil on tracing paper
Repaired at upper right corner
Signed in indian ink with the artist's initials lower right
120 × 165. Size of composition, 120 × 135

There are pen flourishes in the right margin.

The subject of No. 333 is ultimately derived from two earlier paintings, namely P&V 301, of 1875 and P&V 563, of 1883. There is also a close relationship with No. 225A, where, however, there is no specific setting for the figures.

No. 333 is not referred to in the correspondence.

334 Compositional study of a harvesting scene .

Pen and brown ink with brown wash over pencil heightened with chinese white
Foxed
Pin marks in corners
Lugt 613e
125 × 197. Framing indicated in pencil, 118 × 134

Literature: J. C. Holl, *Camille Pissarro et son œuvre, dessins inédits et peintures*, Paris, 1904, p. 22 repr.

There are pen flourishes in the right margin.

No. 334 is executed in brown ink with a brown wash, which differentiates the sheet from the rest of the drawings in this group associated with the second phase of *Travaux des champs*. However, although slightly looser in handling, the style of No. 334 is compatible with that of the other drawings, and it seems that the sheet is a preliminary study in the manner recounted in a letter from Camille Pissarro to Lucien dating from 26 September 1895, 'Il me semble que la mesure que tu m'as envoyée n'est pas celle de Daphnis et Chloë, c'est notablement plus grand que celles que j'ai en carton. J'ai fait deux dessins pour les Travaux des Champs mais avec les mesures que j'ai, le dernier que je viens de terminer est sur la mesure que tu m'as envoyée. Faut-il te les envoyer tout de même? Le dernier dessin est fait sur du vieux papier gris blanchis. Je suppose que cela pourra servir, C'était l'esquisse, mais comme il m'a paru bien, je ne l'ai pas recommencé sur le papier à décalquer. Réponds moi à ce sujet. C'est un faucheur.' (*Lettres*, p. 383 in part only.) Pissarro redrew the design in indian ink with chinese white in order to make it correspond with the other sheets prepared for engraving (see No. 335 below).

The composition of Nos. 334 and 335 was later reused by Pissarro for a painting, P&V 1207, of 1901, *Fenaison à Eragny* (Ottawa, National Gallery of Canada), for which see also No. 276. It is interesting that this highly complex composition seems to have been devised initially for *Travaux des champs* and later revived for the painting. It was more usual for Pissarro, when making drawings for Lucien Pissarro's prints, to turn to already established compositions, rather than to invent new ones, as seems to have been the case with Nos. 334–5.

335 Compositional study of a harvesting scene

Pen and indian ink with chinese white over pencil on tracing paper laid on card
Damaged along the edges and at the corners
Signed in indian ink with the artist's initials lower left
Inscribed in ink on a label attached below the drawing *Fenaison*
Inscribed in ink by another hand, perhaps that of Esther Pissaro, *increase to* $5\frac{1}{2}$ *inches* in upper margin
141 × 149. Framing indicated in ink, 117 × 134

There are pen flourishes in the upper and right margins, and overlaid corrections near the upper right corner and in the centre by the lower edge.

The composition of No. 335 is basically the same as that of the previous drawing (see No. 334), but it is executed in the media more suitable for the translation of a drawing into an engraving. Furthermore, the artist has simplified various parts of the background by eliminating the two figures seen in the distance in the upper right corner of No. 334.

336 Compositional study of a *Gardeuse de vaches*

> Pen and indian ink with dark wash over indications in black chalk heightened with chinese white
> Lugt 613e
> 143 × 160. Framing indicated in black chalk and indian ink, 128 × 143

Literature: J. C. Holl, *Camille Pissarro et son œuvre, dessins inédits et peintures*, Paris, 1904, p. 16 repr.

No. 336 was clearly drawn before the related drawing, No. 337, and both, therefore, serve as a useful demonstration of how Pissarro moved from a broad, strongly chiaroscural style to the neat close penwork of the finished drawings sent to Lucien Pissarro to be cut on wood. In his Studio Book (II, f. 31, No. 244) Lucien Pissarro records that the block was engraved in 1902, but that an edition was not printed until 1907 (see Fern, No. 139, p. 232). The print is reproduced in *Lettres*, p. 493. The composition is based on that of an undated gouache of this subject located in a more spacious setting (P&V 1472, sold Sotheby Parke Bernet, 26–7 April 1972, lot 23 repr.). The gouache was painted before March 1894, when it was exhibited at Durand-Ruel's gallery in Paris (No. 84).

337 Compositional study of a *Gardeuse de vaches*

> Pen and indian ink with chinese white over pencil on tracing paper
> Signed in indian ink with the artist's initials lower right corner
> Inscribed in ink on a label attached below the drawing *Gardeuse de vaches*
> Pin marks in corners
> 143 × 174. Framing indicated in pencil, 125 × 143

There are pen flourishes in the upper and right margins. In addition, there are several overlaid corrections; lower right corner, centre of the lower edge, the face of the cow on the left with the head raised, upper right corner, and the landscape upper centre.

See No. 336 above.

338 Compositional study of female peasants harvesting apples

> Pen and indian ink over pencil on grey paper prepared with a chinese white ground
> Signed with the artist's initials lower right
> Foxed, visible mainly in the margins
> Pin marks in corners
> 157 × 203. Framing indicated in pencil, 126 × 142

There are pen flourishes in the right margin.

In the light of the extensive discussions in the correspondence between Camille and Lucien Pissarro on the desirability of maintaining a careful balance between the tonal values of the text and the illustrations for this phase of *Travaux des champs* (see the Introduction, particularly pp. 75–7), No. 338 is of some interest. The drawing has been made on grey paper prepared with a white ground. The effect of the white background was to make the composition too pale and it had eventually to be redrawn. Interestingly, the same technique is described in a letter from Camille Pissarro to Lucien dated 26 September 1895, *Lettres*, p. 383 in part only) in the context of No. 334 (quoted in the relevant entry). Nos. 338 and 339 can be dated to 1895, and there is a direct reference to them in a letter from Camille Pissarro to Lucien dated 19 May 1895, 'Ta dernière gravure est fort remarquable, beaucoup mieux que les autres si cette manière au trait blanc fait bien avec la typographie tu feras bien de l'adopter, on dirait que tu sens mieux les valeurs. Je crois que tu feras bien de recommencer les deux premières, la récolte et la chaumière, qu'en penses-tu?' (not in *Lettres*). Presumably, No. 338 was drawn first. It is somewhat freer in style and minor changes have been made in the composition of No. 339, mainly in the heavily laden branches of the apple trees.

Although possibly cut at an earlier date, Lucien Pissarro does not seem to have pulled any prints of this subject until 1925, which is the date that occurs in his Studio Book (II, f. 169, No. 354; Fern, No. 268, p. 323).

The composition is an amalgam of motifs found in a number of works, for instance, P&V 695, of 1886, which may, in turn, be compared with an earlier painting, P&V 545, of 1881. In addition, there are two related gouaches, P&V 1422 and 1423, and a ceramic tile that Pissarro painted for the decoration of the family house at Eragny (P&V 1665). However, the composition of Nos. 338 and 339 differ markedly from all of these and, like the other drawings for the second phase of *Travaux des champs*, appears to have been designed specifically for the project.

339 Compositional study of female peasants harvesting apples
Pen and indian ink with chinese white over pencil on tracing paper
Signed in indian ink with the artist's initials lower right
Inscribed in ink by another hand, possibly that of Lucien Pissarro, *Reduce to 5½ ins* in lower margin
Numbered in ink *4* in lower right corner
154 × 195. Framing indicated in indian ink, 126 × 144

There are pen flourishes in the margins.

The numeration may signify that No. 339 was one of the five drawings which Camille Pissarro mentions in a letter to Lucien (11 October 1895, *Lettres*, p. 384) as having been finished, although they are not itemized.

See No. 338 above.

340 Compositional study for *Porteuses de fagots*
Pen and indian ink with chinese white over pencil on tracing paper laid down on card
Inscribed in ink on a label attached below the drawing *Porteuses de fagots*
Pin marks in corners
Inscribed twice in ink by two other hands, the first possibly that of Lucien Pissarro, the second possibly that of Esther Pissarro, *without reduction* in the upper and lower margins respectively
Lugt 613e (purple ink)
152 × 174. Framing indicated in indian ink, 118 × 140

There are pen flourishes in the upper and right margins, and an overlaid correction in the lower right corner.

The instructions inscribed in the upper and lower margins are possibly connected with the fact that the right half only of this composition was used as an illustration for the English edition of Théodore Duret, *Manet and the French Impressionists*, London, 1910, opp. p. 134. In his Studio Book (II, f. 39, No. 250; Fern, No. 173, p. 262), Lucien Pissarro provides a date of 1908 for the print of the whole composition, the block for which had been jointly cut by Lucien and Esther Pissarro.

No. 340 is referred to in a letter from Camille Pissarro to Lucien dated 9 September 1895 (not 11 September 1895 as given in *Lettres*, pp. 382–3), 'J'ai à peu près terminé un dessin pour les Travaux des champs, des ramasseuses de bois mort revenant du bois' (quoted by Melot, No. 268, p. 128, but mistakenly associated with the published portfolio of *Travaux des champs*). The composition of No. 340 was also used for two lithographs, D. 152 and D. 153, dating from *c.* 1896 and 1896 respectively, for which there are related drawings in the collection (see Nos. 142 and 171B).

341 Compositional study of a male peasant scything
Black chalk on tracing paper
Inscribed in black chalk *La Moisson* in left margin
Lugt 613e
130 × 177. Framing indicated in black chalk, 130 × 145

Both the size and the format of No. 341 suggest that the tracing was made at the time of the second phase of *Travaux des champs*. This is supported by documentary evidence, since references to such a composition occur in three letters dating from 1895; firstly, in a letter from Camille Pissarro to Lucien dated 11 April 1895: 'Les deux gravures sont d'un très joli arrangement—la moisson me paraît bien, le bras qui s'étend ne serait-il pas un peu long, c'est peu de chose. L'autre est peut-être un peu confus les figures ne se détachent peut-être pas assez, ce serait plutôt la chaumière qui en serait cause, c'est cependant bien d'arrangement. Le fond gagnerait peut-être à être plus simple' (passage omitted in *Lettres*, pp. 376–7); secondly, in a letter from Camille Pissarro to Lucien dated 26 September

1895 quoted above in the entry for No. 334; and, thirdly, in a letter from Camille Pissarro to Lucien dated 16 October 1895 quoted above in the Introduction (p. 75). It might be inferred from the reference in the letter of 11 April 1895 that Lucien Pissarro did cut the composition on wood, but no impression exists in the Studio Book, or has yet been found elsewhere. It is reasonable to assume, although it is by no means absolutely certain, that the passages in these three letters, where the drawing seems to have been given a different title on each occasion ('la moisson', 'le faucheur', and 'le moissonneur', respectively), do, in fact, refer to the same composition. The inscriptions occurring on No. 366 would seem to confirm this. The loose style of No. 341, albeit only a tracing, indicates that it may have been made hurriedly to correct the error to which Camille Pissarro had called attention in his letter of 11 April 1895. The original drawing from which No. 341 was traced has not yet been found.

The composition of No. 341 is closely related to the gouache, P&V 1474, *c.* 1894, and to the lithograph, *Faucheur*, D. 141, *c.* 1894. The figure of the female harvester on the left of No. 341 is derived from the tempera P&V 1358, of 1881, for which there are a number of important drawings in the Ashmolean collection (Nos. 118–23 below).

No. 341 was adapted for inclusion in the final phase of *Travaux des champs* (see Nos. 365 and 366 below).

342 Compositional study of harvesters—*La batterie mécanique*
Pencil with some pen and brown ink
Badly torn and damaged at edges
Lugt 613e
150 × 200. Framing indicated, 126 × 172

The size, format and composition of No. 342 indicate that the drawing might have been made in connection with the second phase of *Travaux des champs*, although it does not seem to have been mentioned in the correspondence. The outlines of No. 342 have initially been traced and then redrawn in pencil. Pissarro has restricted the use of the pen to the two bending female figures in the foreground.

The composition is repeated almost exactly from P&V 367, of 1876. The only modification is to the background upper right. The design was reused for the final phase of *Travaux des champs* (Nos. 376–8).

343 Compositional study of three female peasants with a child weeding in a field
Grey wash and chinese white over black chalk on tracing paper
Damaged at edges
Signed in grey wash with the brush with the artist's initials lower right
Inscribed in ink on a separate label attached below the drawing, *No. 1 printemps / sarcleuses*
Purchased 1976 (inv. 1976. 43, f. 1)

It follows from the inscription that No. 343 is the first drawing made in connection with the first scheme for the final phase of *Travaux des champs* (for the outline of the relevant scheme see p. 78 above).

The subject of female peasants weeding is one that Pissarro utilized in two famous paintings, P&V 301, of 1875, and P&V 563, of 1882, but the composition of No. 343 is not derived from either of these. Rather, it is of a type often employed by Pissarro in his prints dating from the 1890s (D. 165 *c.* 1896 and D. 188–9 *c.* 1889) characterized by a figure standing behind two others kneeling in the foreground. Compositionally, No. 343 is very far removed from the print of this same subject included in the published portfolio of 1895 (for which see Nos. 323 and 324), and comparison between the two designs illustrates the basic differences between Pissarro's works of the 1880s and 1890s.

No. 343 is the only drawing from amongst those made for the first scheme of the final phase of *Travaux des champs* that was printed. Two states of the woodcut are in the Ashmolean Museum, one pulled from three colour blocks printed in violet-brown tones (inv. 1976, 43, f. 2), and the other pulled from two colour blocks, one impression of which is printed in dark grey tones and the other in lighter grey-green tones (inv. 1976. 43, f. 3 and 4, and Studio Book I, f. 83, No. 168 where an annotation by Lucien Pissarro dates the print to 1900).

344 Compositional study of harvesters working in a field
Pen and indian ink over black chalk
Lugt 613e
Inscribed in ink on the verso, *No. 2 printemps, faneuses* 146 × 102. Framing indicated twice, firstly, in black chalk on three sides

(136×85), and secondly, in ink over black chalk (106×41)

See No. 345 below.

345 **Compositional study of harvesters working in a field**
 Grey wash with chinese white over black chalk on tracing paper
 Inscribed in ink on a separate label attached below the drawing *No. 2 faneuses—Printemps*
 103×61

It follows from the inscription that Nos. 344 and 345 relate to the second subject of the first scheme of the final phase of *Travaux des champs* (for the outline of the relevant scheme see p. 78 above). It seems reasonable to assume, as in the case of No. 346, that No. 344 drawn in outline was executed before No. 345.

The composition is not markedly similar to any particular painting, although the subject recalls P&V 855, of 1893, and P&V 1207, of 1901.

346 **Compositional study of female peasants picking peas**
 Black chalk
 Inscribed in ink on the verso *No. 3 l'été cueillette / de petit pois*
 Lugt 613e
 110×61. Framing indicated, 107×61

See No. 347 below.

347 **Compositional study of female peasants picking peas**
 Grey wash with chinese white over black chalk on tracing paper
 Pin marks in corners
 Inscribed in ink on a separate label attached below the drawing, *No. 3 l'été / La Cueillette de petit pois*
 Lugt 613e
 118×70. Framing indicated in black chalk, 106×63

It follows from the inscription that Nos. 346 and 347 were drawn in connection with the third subject of the first scheme of the final phase of *Travaux des champs* (for the outline of the relevant scheme see

p. 78 above). It seems that No. 346 was drawn first as the underdrawing which would then most probably have been worked over with the brush.

The figures are derived from the central group of the gouache P&V 1408, of 1887, which is of the same subject, and for which there is a drawing in the collection (No. 179). As is often the case with the drawings for the final phase of *Travaux des champs*, where earlier compositions were exploited, Pissarro has given greater emphasis to the figures and reduced the significance of the setting.

348 **Compositional study of a female peasant digging**
 Grey wash and chinese white over pencil on tracing paper
 Repaired in corners. Stained lower left
 Signed in grey wash with the brush with the artist's initials lower left
 Inscribed in ink on a separate label attached below the drawing, *No. 4 l'automne / paysanne bêchant la terre*
 171×104. Framing indicated in pencil, 171×95

It follows from the inscription that No. 348 relates to the fourth subject of the first scheme for the final phase of *Travaux des champs* (for the outline of the relevant scheme see p. 78 above). No. 349 is also related, although there is a slight compositional difference in the background and a change in medium. The background of No. 349 includes a tree, which serves both to anchor the figure and to counteract her gesture. It is reasonable to assume that No. 348 precedes the related sheet where the chiaroscural appearance of the drawing is more pronounced and is more in accordance with the finished prints made from *Les Sarcleuses*, which was the only composition amongst those from the first scheme of the final phase to have been printed (see No. 343). Two other studies for the figure occurring in Nos. 348 and 349 were once in the possession of Lucien Pissarro (CI negs. 51/71(23) and 52/57(16), no details known).

The subject of a female peasant digging had been treated in several paintings by Pissarro: P&V 534, of 1881, P&V 573, of 1882, P&V 618, of 1883, and P&V 1374 c. 1883. The composition, however, is perhaps closer to the print D. 95, of 1890. The subject is one that is ultimately derived from Millet, *Les Deux Bêcheurs* (Herbert, Nos. 115–24, of which there is an etching, Herbert, No. 128).

References to the drawings occur in the following letters: 23 December 1900 (L.P. to C.P.); 3 January 1901 (L.P. to C.P.); 7 January 1901, 'Je t'envoie la femme bêchant corrigé je t'envoie aussi un autre dessin de bêcheuse qui me semble mieux, qu'en dis-tu? ...' (C.P. to L.P., passage omitted in *Lettres*), probably a reference to No. 349; 11 January 1901, 'J'ai reçu la femme qui bêche le nouveau est épatant c'est celui-la que je choisis' (L.P. to C.P.); 14 January 1901, 'Moi aussi j'aime mieux la femme qui bêche vue de trois quarts elle a bien plus de carac-tère' (C.P. to L.P., passage omitted in *Lettres*).

It should be noted that some of these references overlap with those made to drawings undertaken for the second scheme for the final phase of *Travaux des champs* (for an outline of the second scheme see p. 79 above), and it can only be concluded from this that No. 348 was somehow to have been inter-polated, regardless of the fact that it was not in-cluded in the listed titles for the scheme.

349 Compositional study of a female peasant digging
Gouache with grey wash over pencil
Signed in ink with the artist's initials lower right
140 × 93

See No. 348 above.

It should be observed that the dimensions of Nos. 348 and 349 are similar to those of Nos. 350 and 351, but that they differ from those of the other drawings in this series for the first scheme, which are much smaller.

350 Compositional study of a male peasant placing a bean pole in the ground
Grey wash with chinese white over black chalk heightened with a very pale pink wash
Stained with ink along lower left edge and on left
Pin marks in corners
Signed in grey wash with the brush with the artist's initials lower left
Inscribed in ink on the verso, *No. 5 l'été, pay-san mettant | des rames aux haricots*
152 × 92. Framing indicated in pencil on two sides only, 152 × 88

It follows from the inscription that No. 350 was drawn in connection with the fifth subject of the first scheme of the final phase of *Travaux des champs* (for the outline of the relevant scheme see p. 78 above). No. 351 is also related. In size, format, treatment of subject, technique, and, to a lesser extent, in style, Nos. 350 and 351 are comparable with Nos. 348 and 349. The size, in particular, dif-ferentiates these four sheets from the drawings done for the rest of the subjects in the first scheme (see Nos. 343–7 and 352–6). Indeed, Nos. 348 and 351 may have been conceived as pendants. In both com-positions Pissarro shows an interest in the close de-scription of a precise activity, as opposed to the more diffuse generalized compositions used for the other scenes.

The composition of Nos. 350 and 351 is derived from two paintings, P&V 1269 and P&V 1270, both *c.* 1892. As in the case of Nos. 348 and 349, the sub-ject evokes comparison with a famous picture by Millet, *Un paysan greffant un arbre*, Herbert, No. 63), where there is a similar balance between the treatment of the large-scale figure and the delicacy of the activity.

351 Compositional study of a male peasant placing a bean pole in the ground
Grey wash with chinese white over black chalk on tracing paper
Repaired in lower left corner. Stained in places by spots of chinese white
Pin marks in three remaining corners
Signed in grey wash with the brush with the artist's initials lower left
Inscribed in ink on a separate label attached below the drawing *L'été | 5ᵉ | paysan mett-ant des | rames aux haricots*

See No. 350 above

A drawing executed in the same medium as Nos. 350 and 351 and showing the same subject, but with a different composition, was once in the possession of Lucien Pissarro (CI neg. 51/50(9a), no details known). In this last drawing the male peasant is depicted standing upright seen in three-quarters profile in the act of pushing a pole into the ground. It is possible that this composition was rejected, although, visually, it balances the figure in Nos. 348 and 349 more effectively than Nos. 350 and 351.

352 **Compositional study of a female peasant carrying two milk churns**
Grey wash with chinese white over black chalk on tracing paper
Stained with spots of chinese white
Signed in grey wash with the brush with the artist's initials lower left
Inscribed in ink on a separate label attached below the drawing *6 La Laitière*

It follows from the inscription that No. 352 was drawn in connection with the sixth subject of the first scheme of the final phase of *Travaux des champs* (for the outline of the relevant scheme see p. 78 above).

The composition of No. 352 is conceived in the manner of the 1870s, as, for instance, in P&V 438, *La Carrière à l'Hermitage*, of 1878, where the figure is carefully integrated into the background, but, on the other hand, the curving road and the placing of the figure to one side is more reminiscent of compositions of the 1880s (see No. 167 below). The subject is again derived from Millet (Herbert, No. 158, repr. in Alfred Sensier's monograph on Millet, *La Vie et l'œuvre de J.-F. Millet*, Paris, 1881, p. 207).

A preparatory drawing in a looser style, apparently executed in black chalk, was formerly in the possession of Lucien Pissarro (CI neg. 52/66(24a), no details known).

353 **Compositional study of two women washing clothes in a tub**
Grey wash with chinese white over black chalk on tracing paper
Repaired at right corners and also at lower left edge
Signed in grey wash with the brush with the artist's initials lower left
117 × 85. Framing indicated in black chalk, 108 × 61

Although there is no inscription, No. 353 surely relates to the seventh subject of the first scheme of the final phase of *Travaux des champs* (for the outline of the relevant scheme see p. 78 above).

The composition is derived from P&V 1058, *c.* 1898, for which there is a preparatory drawing in the collection (No. 274).

354 **Compositional study of a male peasant with a horse operating a cider press**
Grey wash with chinese white over black chalk on tracing paper
Signed in grey wash with the brush with the artist's initials lower left
Repaired lower left corner
Inscribed in grey wash with the brush *Cidre* in lower margin
123 × 91. Framing indicated in black chalk, 107 × 64

See No. 355 below.

355 **Compositional study of a male peasant with a horse operating a cider press**
Grey wash over black chalk
Pin marks in upper corners
Inscribed in ink on the verso *No. 8 Le Cidre*
Lugt 613e
113 × 70. Framing indicated in black chalk, 107 × 62

It follows from the inscription that Nos. 355 and 356 were drawn for the eighth and last subject of the first scheme of the final phase of *Travaux des champs* (for the outline of the relevant scheme see p. 78 above). Unlike many of the other drawings for this part of *Travaux des champs*, the composition of Nos. 355 and 356 is not derived from a specific painting. Neither does there appear to be any connection with Millet. The choice of subject is of some interest, because of the substitution in Normandy at this time of cider-making for wine-growing.

It is possible that No. 245, which is in Pissarro's late chalk style, relates to the development of this composition. Where Pissarro has not been able to adapt an earlier composition it is reasonable to expect a more elaborate and considered approach to the subject-matter, perhaps necessitating additional studies.

356 **Compositional study of a peasant family walking along a road**
Grey wash and chinese white over black chalk on tracing paper with some heightening in pure chinese white
Repaired at upper right edge
Signed in grey wash with the brush with the artist's initials lower right

120 × 74. Framing indicated in black chalk and grey wash, 120 × 69

No. 356 is not a subject included in the first scheme for the final phase of *Travaux des champs* (for the outline of the relevant scheme see p. 78 above), but both the size and the medium suggest that the drawing belongs with that group. The subject, however, is one that does not treat a specific activity, but, rather, illustrates a more general aspect of rural life. In this respect it anticipates the second scheme for this final phase of *Travaux des champs*, for which see also Nos. 374 and 375 below. It is, therefore, possible that No. 356 was drawn for the revised scheme before any change in format was effected, and there is some documentary evidence that work on both schemes did overlap: see the references to 'La femme qui bêche' in the letters of 23 December 1900, and 3 January 1901, from Lucien Pissarro to his father, and in the letter from Camille Pissarro to his son dated 14 January 1901 (passage omitted in *Lettres*), where there are also references to 'Le laboureur'.

The composition is strongly reminiscent of Millet's *La Famille du paysan* (Herbert, No. 231, National Museum of Wales, Cardiff), which Pissarro could have seen in the Millet sale of 1875. There are also overtones of the composition by Daumier entitled *Femmes et enfants* (K. E. Maison, *Honoré Daumier. Catalogue Raisonné of the Paintings, Watercolours and Drawings*, i, London, 1968, No. 1–52, p. 80), now in the Rijksmuseum Mesdag, The Hague.

357 Compositional study of a peasant ploughing a field

Pen and indian ink with grey wash over black chalk

Pin marks in corners

Lugt 613e

149 × 114. Framing indicated in black chalk, 111 × 91

No. 357 was drawn as the first subject for the first category of the second scheme for the final phase of *Travaux des champs* (for the outline of the relevant scheme see p. 79 above). The drawing was used as the basis for the print appearing in *La Charrue d'érable*, Paris, 1912, opp. p. 62. Although the transfer drawing has not been rediscovered, it is apparent, on comparison with the drawings executed in connection with the first scheme for the

final phase, that the working process was virtually the same.

Regarding the composition, it may be observed that in Pissarro's earliest treatment of the subject (P&V 340, of 1876) the ploughman is positioned parallel to the picture plane. In the later renderings of the theme, a gouache P&V 1493, *c.* 1901, and a coloured lithograph D. 194 of 1901, first published as the frontispece to the lecture by Prince Kropotkin entitled *Les Temps Nouveaux*, to both of which No. 357 is closely related, the ploughman is placed on a diagonal. These later compositions are all vertical in format. In No. 357, however, Pissarro has cut off part of the figure and used a shallower diagonal.

There are several references to both the drawing and the print in the correspondence between Camille and Lucien Pissarro. They are as follows: letter from Lucien Pissarro to his father written between 1 and 4 November 1900, 'J'ai bien reçu les dessins, il y en de charmants! Je vois bien la façon de les faire. J'aime surtout le semeur d'un dessin concis. Le labour est aussi fort bien quoique je ne voie pas le moyen de faire les brides ...'; letter from Lucien Pissarro to his father dated 3 December 1900, 'Je t'envoie le dessin du laboureur pour que tu y ajoutes des lumières blanches comme dans la baratteuse, que je joins à l'envoi pour que tu comprennes bien ce que je veux dire. Le laboureur sera donc fait en 3 planches: 1. une planche de fond qui est représenté dans le dessin par le papier à décalquer sur laquelle on coupe les lignes blanches, d'accent lumineux que tu vas y mettre. 2. une planche de gris clair 3. une planche d'accent foncé. Je suis presque sûr que cela fera très bien. Tu comprends bien que le ton du papier qui est jaunâtre doit jouer le rôle de la teinte clair d'encre de chine que tu as mise dans la baratteuse. Ne change pas trop le dessin du laboureur car il est déjà photographié, ce que je veux est seulement pour savoir quels sont les accents lumineux nécessaires'; letter from Lucien Pissarro à his father dated 23 December 1900, 'J'ai bien reçu le dessin corrigé du 'laboureur'.' Other references occur on 3 January 1901 (L.P. to C.P.); 4 January 1901 (C.P. to L.P., not in *Lettres*); 7 January 1901 (C.P. to L.P., passage omitted in *Lettres*); 11 January 1901 (L.P. to C.P.); 14 January 1901 (C.P. to L.P., passage omitted in *Lettres*); undated letter from Lucien Pissarro to his father in reply to one dated 14 January 1901; 19 January 1901 (C.P. to L.P., passage omitted in *Lettres*).

For some observations on the iconography of this composition, see C. Lloyd, 'Camille Pissarro and Hans Holbein the Younger', *Burlington Magazine*, cxvii (1975), 722–6.

358 Compositional study of a sower in a field
Grey wash over black chalk
Pin marks in corners
Lugt 613e
125 × 101. Framing indicated in black chalk, 110 × 90

See No. 360 below.

359 Compositional study of a sower in a field
Grey wash with chinese white over black chalk on tracing paper
Lugt 613e
131 × 104. Framing indicated in black chalk, 111 × 91

See No. 360 below.

360 Compositional study of a sower in a field
Grey wash with chinese white over black chalk on tracing paper
Lugt 613e
130 × 103. Framing indicated in black chalk, 111 × 90

The subject is the second in the first category of the second scheme for the final phase of *Travaux des champs* (see the outline of the relevant scheme on p. 79 above). The working process is still the same as that used for the first scheme of the final phase. No. 358 is drawn on ordinary paper and includes an extra figure on the right in the middle distance. Nos. 359 and 360 are on tracing paper, and, apart from the exclusion of the figure, have small changes in the sky and in the ploughed furrows in the foreground. The drawing served as the basis for the print appearing in *La Charrue d'érable*, Paris, 1912, opp. p. 32.

As in the case of No. 358, Pissarro has rethought his standard composition for this subject so that the figure is no longer moving in a direction parallel to the picture plane set within a horizontal format, as in P&V 330–1, of 1875, D. 155, or a wood-engraving by Lucien Pissarro after a drawing by his father, for

which see No. 307, but is intead seen from the front. In this respect, although the correspondence is by no means exact, Pissarro's composition recalls Millet's famous painting of 1850 (Herbert, No. 56), and, in fact, in a drawing by Millet in the Ashmolean Museum dating from 1850–1 (Herbert, No. 186) the sower is seen directly from the front.

There are several references to the drawings and the print of this composition in the correspondence between Camille and Lucien Pissarro. They are as follows: 'J'aime surtout le semeur d'un dessin concis' (L.P. to C.P. written between 1 and 4 November 1900); 4 January 1901, 'Je te renvoie les dessins retouchés le Semeur auquel j'ai ajouté du blanc avec discrétion, tu verras au tirage òu il en manque, il vaut mieux ajouter au besoin' (C.P. to L.P., not in *Lettres*); 19 January 1901, 'Je vais m'occuper de la fenaison et du moissonneur et je mettrai du blanc au Semeur' (C.P. to L.P., passage omitted in *Lettres*).

361 Compositional study of harvesters working in a field (I)
Grey wash with chinese white over black chalk on tracing paper
Stained by blotches of chinese white
Lugt 613e
134 × 105. Framing indicated in black chalk, 112 × 92

See No. 364 below.

362 Compositional study of harvesters working in a field (II)
Grey wash with chinese white over black chalk on tracing paper
Stained upper left corner and also by blotches of chinese white
Inscribed in ink on a separate label attached below the drawing, *Ière division, Ière catég/ 3 fenaison*
Lugt 613e
134 × 108. Framing indicated in black chalk, 111 × 89

See No. 364 below.

363 Compositional study of harvesters working in a field (I and II)
Pen and indian ink with grey wash over black chalk

Pin marks in corners
Stained on right
Inscribed in black chalk in upper margin *No.
3 la fenaison* and in ink on verso *1ère division
1ère catégori* (sic) / *3 fenaison*
Lugt 613e (twice)
152 × 230. Framing indicated in black chalk
separately for each composition, 111 × 91
(I), and 111 × 88 (II)

See No. 364 below.

**364 Compositional study of harvesters work-
ing in a field (I)**
Brush drawing in indian ink with gouache and
chinese white over traces of black chalk on
prepared paper
Signed in indian ink with the artist's initials
lower left
157 × 155. Framing indicated in indian ink,
112 × 94

There are several flourishes with the brush in the
margins on either side.

Nos. 361–4 relate to the third subject of the first
category of the second scheme of the final phase of
Travaux des champs (for the outline of the relevant
scheme see p. 79 above). As far as the initial draw-
ings are concerned (Nos. 361–3), Pissarro has here
followed the same working process as for the first
scheme and also for the first drawings of the second
scheme, but No. 364 represents a new development
with regard to technique. Lucien Pissarro did ulti-
mately engrave two separate versions of the com-
position for inclusion in *La Charrue d'érable*, Paris,
1912, opp. pp. 52 and 56 respectively. The second
of these illustrations only (opp. p. 56) corresponds
with No. 364.

The original intention was to make a double-page
illustration for *La Fenaison*. 'J'ai commencé sur la
nouvelle mesure, une fenaison en deux parties, je
le fais sur papier à décalquer collé sur bristol.
J'espère que cela ira ainsi, si c'est bon j'aurai bientôt
fait de faire les trois autres' (letter from Camille Pis-
sarro to Lucien dated 21 October 1900, not in
Lettres). The idea, however, was rejected by Lucien
Pissarro on technical grounds; firstly, 'quant à la
fenaison en 2 planches je te demanderai de n'en faire
qu'une car cela m'entraînerait peut-être un peu loin
d'en faire 2 en 2 couleurs cela fait un supplément
de 2 bois c'est beaucoup de travail, surtout qu'il faut

que je fasse tout moi-même, impossible de me faire
aider ayant continuellement à choisir ce qui
appartient à l'un ou l'autre block. Pour la fenaison
au lieu d'avoir une double planche ce qui fait 4
gravures, ne vaudrait-il pas mieux en avoir qu'une
simple en 3 tons ce qui ferait une économie d'une
gravure et ferait une variété. Si tu as le temps ne
pourrais-tu pas en faire un autre dans le genre de
la noce ou du berger?' (letter written by Lucien Pis-
sarro to his father between 1 and 4 November 1900);
and secondly, 'Comme je fais les gravures en 3 tons
cela me mènerait trop loin de faire des doubles pages
aussi je voudrais la composition en une seule page
je te la retourne pour que tu décides si une moitié
est assez complète en elle-même et aussi cela a l'air
tâché quand on le compare au semeur ou au labour.
Cela fait bien pour un dessin mais la rigidité de la
gravure se prête mal aux choses trop évoluées' (let-
ter from Lucien Pissarro to his father dated January
1901). The revision of the double-page project is
referred to in two letters from Camille Pissarro to
his son. Thus, Camille Pissarro writes on 4 January
1901, 'J'ai refait les faneurs à nouveau. Je crains
qu'il n'y ait du blanc trop à profusion je crois que
tu feras bien d'y aller avec quelque précaution,
puisque nous pouvons toujours en ajouter. Il n'y a
d'accent que dans les premiers plans' (passage
omitted in *Lettres*), and again on 19 January 1901,
'Je vais m'occuper de la fenaison et du moissonneur
et je mettrai du blanc au Semeur (passage omitted
in *Lettres*.)

It seems that while working on this particular
composition a new working process was introduced
involving a middle tone to which lights and darks
were added. At the beginning of November, 1900
Lucien Pissarro had written to his father, 'Je suis
en train de graver un des petits dessins c'est joliment
difficile. Je veux dire par une teinte plate avec des
lignes blanches quelque chose dans le genre du cro-
quis ci-joint un papier de couleur qui fait le fond un
dessin (plume ou pinceau) et des lignes blanches de
gouache dans les lumières dans certain cas on peut
ajouter une planche demi-teinte un peu plus foncé
que le fond du papier' (letter written in reply to
those from Camille Pissarro dated 24, 31 October,
and 1 November, 1900). Drawings in this technique
are also found for other subjects from the final
scheme (Nos. 371 and 372), but not throughout,
possibly because they have not survived, or were,
perhaps, not begun. These gouache drawings
approximate far more closely than any others to the

prints published by Lucien Pissarro in *La Charrue
d'érable*.

The composition on the right of No. 363, which
is drawn again in No. 362, is a reworking of No.
345, which forms part of the first scheme of the final
phase of *Travaux des champs*. As such, it is the only
composition in purely visual terms that is common
to both schemes.

365 Compositional study of a male peasant scything

Pen and indian ink with grey wash over pencil
Pin marks in corners
148 × 113. Framing indicated in black chalk,
 112 × 91

See No. 366 below.

366 Compositional study of a male peasant scything

Grey wash and chinese white over black chalk
 on tracing paper with some highlighting in
 pure chinese white
Repaired at upper right corner
Pin marks in corners
Inscribed in ink in upper margin, *4e moisson*,
 and in ink on a separate label attached
 above the drawing *1ère division* [abraded]
 1ère catégori (sic) / *4 faucheurs*, and again in
 pencil on a second separate label attached
 below the drawing *1ère catégorie*
129 × 101. Framing indicated in black chalk,
 113 × 92

The white highlighting is limited to the male figure.

It follows from the inscription that Nos. 365 and
366 were drawn in connection with the fourth sub-
ject of the first category of the second scheme of the
final phase of *Travaux des champs* (for the outline
of the relevant scheme see p. 79 above). The draw-
ing formed the basis for the print published in *La
Charrue d'érable*, Paris, 1912, opp. p. 82.

The composition appears to be a reworking of a
gouache. (P&V 1474, *c.* 1874), a lithograph (D. 141,
c. 1894), and of the same subject in Phase II of *Tra-
vaux des champs* (No. 341). In No. 365, Pissarro has
made some changes in the background and in the
pose of the female harvester on the left, in addition
to transforming the composition into a vertical for-
mat.

There are several references to both the drawing
and the print in the correspondence between
Camille and Lucien Pissarro. They are as follows:
L.P. to C.P., 'Je trouve que ton faucheur en chapeau
melon n'a pas autant de style que le semeur, par
exemple' (written between 1 and 4 November
1900); 14 November 1900, 'Je referai le faucheur
tu me diras quels sont les autres dessins qu'il faut
refaire' (C.P. to L.P., not in *Lettres*); 4 January
1901, 'J'ai refait le faucheur, je crois qu'il aura plus
de caractère (C.P. to L.P., not in *Lettres*); 7 January
1901, 'Je t'avais dit de me renvoyer le dessin du fau-
cheur que je l'en fasse un autre, car en effet le bon-
homme manque de caractère' (C.P. to L.P., passage
omitted in *Lettres*); 11 January 1901, 'J'enverrai le
faucheur avec les épreuves du laboureur (L.P. to
C.P.); 19 January 1901, 'Je vais m'occuper de la
fenaison et du moissonneur et je mettrai du blanc
au semeur (C.P. to L.P., passage omitted in
Lettres).

367 Compositional study of a milking scene

Pen and indian ink with grey wash and
 chinese white over black chalk
Pin marks in corners
Inscribed in black chalk in upper margin, *tous
 les fonds le tons gris clair*
151 × 113. Framing indicated in black chalk,
 111 × 88

No. 367 was the first subject of the second category
of the second scheme for the final phase for *Travaux
des champs* (for the outline of the relevant scheme
see p. 79 above). The subject was originally
entitled *L'Etable et la traite des vaches* implying per-
haps an interior. The drawing served as the basis
for the print published in *La Charrue d'érable*, Paris,
1912, opp. p. 92.

The composition is directly related to a gouache,
P&V 1395, of 1884, and to a watercolour catalogued
above (No. 166). Pissarro has rearranged the com-
position slightly, in order to make it tighter, but the
salient features have been retained. Milking scenes
are comparatively rare in French nineteenth-cen-
tury painting of rural life. It was not, for instance,
a theme favoured by Millet, although a woman
milking a cow is depicted in the background of the
pastel *La baratteuse*, of 1866–8 (Herbert, No. 179).

No. 367 is not mentioned in the correspondence
between Camille and Lucien Pissarro.

**368 Compositional study of a female peasant
making butter**
 Grey wash and chinese white over black chalk
 Pin marks in corners
 Inscribed in ink on the verso *2e catégori* (sic)
 2e division | no. 3 la barateuse (sic)
 152 × 117. Framing indicated in black chalk,
 110 × 88

There are several flourishes with the brush in the
right margin.

It follows from the inscription that No. 368 was
drawn in connection with the third subject of the
second category of the second scheme for the final
phase of *Travaux des champs* (for the outline of the
relevant scheme see p. 79 above). The drawing
served as the basis for the print published in *La
Charrue d'érable*, Paris, 1912, opp, p. 12.

Pissarro also made a lithograph of this subject,
D. 162, *c*. 1896. Both the lithograph and No. 368
recall the composition that recurs frequently in Mil-
let's *œuvre* (Herbert, No. 170, a painting of 1869–
70, No. 179, a pastel of 1866–8, No. 125, an etching
of 1855).

There are references to the drawing and to the
print in the correspondence between Camille and
Lucien Pissarro. These are as follows: 'J'aime
beaucoup la barateuse mais c'est un bois en 3
planches. Enfin de temps en temps on peut se per-
mettre cela quand tu emploies la ligne blanche tu
te sers quand même d'un ton d'accent et d'un trait
ce qui fait 3 tons' (letter from L.P. to C.P. written
between 1 and 4 November 1900); 3 December
1900, 'Je t'envoie le dessin du laboureur pour que
tu y ajoutes des lumières blanches comme dans la
barateuse, que je joins à l'envoi pour que tu com-
prennes bien ce que je veux dire' (L.P. to C.P.).

**369 Compositional study of a shepherd and
his flock**
 Grey wash and chinese white over pencil
 Pin marks in corners
 152 × 115. Framing indicated in black chalk,
 110 × 87

See No. 371 below.

**370 Compositional study of a shepherd and
his flock**
 Grey wash and chinese white over pencil
 Pin marks in upper corners

 Annotated in black chalk in margins, *blanc |
 avec taches du ton gris* (upper margin),
 blanc | avec tache du ton gris (right margin)
 Inscribed in ink on the verso *le berger*
 125 × 104. Framing indicated in black chalk,
 111 × 87

See No. 371 below.

**371 Compositional study of a shepherd and
his flock**
 Brush drawing in indian ink with gouache and
 chinese white on tracing paper
 Inscribed in ink on a separate label attached
 below the drawing, *2e catigori* (sic) *le berger |
 2e division | No. 2*
 Lugt 613e (purple ink)
 125 × 104. Framing indicated in black chalk,
 110 × 88

It follows from the inscription that No. 371 was
drawn in connection with the third subject of the
second category of the second scheme for the final
phase of *Travaux des champs* (for the outline of the
relevant scheme see p. 79 above). Nos. 369 and 370
are also related and were most probably drawn
before No. 371. The sequence suggests that Pissarro
has used the same working process as for Nos. 361–
4. It seems that No. 369, in which the scale of the
figure is much larger and the shadows cast by the
buildings are much more pronounced, may have
been drawn first. It was followed by No. 370 in
which the architecture has been changed and trees
omitted. The more finished drawing, namely No.
371, served as the basis for the print published in
La Charrue d'érable, Paris, 1912, opp. p. 42.

There is a reference to No. 371 in a letter written
by Lucien Pissarro to his father between 1 and 4
November 1900, 'Le berger gris bleu est le plus
compris au point de vue que je veux dire on peut
le faire en 2 planches tandis le même dessin décalqué
ne pourrait se faire qu'avec 3 planches quoique
moins riche d'effet'.

The composition occurs frequently in Pissarro's
œuvre, notably as a painting, P&V 723, of 1888, and
as a gouache P&V 1577, of 1888, for which there
are three related drawings in the collection (Nos.
184–6). It is interesting to observe the changes in
architecture in the present sequence of drawings. In
No. 369, as in P&V 723 and P&V 1577, the scene
is depicted with modern rural architecture of the

type much in evidence both in Pontoise and Eragny, but in Nos. 370 and 371 Pissarro has preferred the traditional *chaumières* seen in Auvers-sur-Oise, or Osny, and this was the solution adopted for the final print.

372 Compositional study of a market

Grey wash with chinese white heightened with pure chinese white partly redrawn in pencil on paper prepared with a grey/green wash

Pin marks in corners

Inscribed in ink on the verso *3e catégori (sic) 3e division/No. 2 marché aux legumes*

158 × 113. Framing indicated in pencil, 111 × 92

It follows from the inscription that No. 372 was drawn for the second subject of the third category of the second scheme for the final phase of *Travaux des champs* (for the outline of the relevant scheme see p. 79 above). The subject was originally entitled *Un marché blé ou autre*. Pissarro selected a vegetable market. The drawing served as the basis for the print published in *La Charrue d'érable*, Paris, 1912, opp. p. 72.

The figures in the foreground of No. 372 are freely adapted from two gouaches of market scenes, P&V 1365, of 1882, and P&V 1402, of 1885. The background, however, does not relate to any earlier work.

There are no references to No. 372 in the correspondence between Camille and Lucien Pissarro. While the technique to some extent resembles that of Nos. 364 and 371, there is no gouache and the tone is somewhat lighter. In fact, the tone is closer to the finished prints published in *La Charrue d'érable* than to that found on any of the other drawings.

373 Compositional study of a market

Pen and dark ink with grey wash and chinese white over black chalk

Pin marks in upper corners

Inscribed in black chalk in the lower margin, *Marché aux bestiaux* and in black chalk on the verso *3e catigori (sic) 3e division No. Marché aux bestiaux.*

204 × 171. Framing indicated in black chalk, 113 × 91

It follows from the inscription that No. 373 was drawn for the third category of the second scheme for the final phase of *Travaux des champs* (for the outline of the relevant scheme see p. 79 above). Although Pissarro has not filled in the number of the subject in the inscription on the verso, it is, in fact, the first subject of the third category (*Un marché aux bestiaux*). The drawing served as the basis for the print published in *La Charrue d'érable*, Paris, 1912, opp. p. 76.

The background and the setting of No. 373 resemble the composition of a gouache, P&V 1447, c. 1890 (exhibited Marlborough Fine Art Ltd. 1955, No. 55, and by the same gallery *19th and 20th Century Drawings, Watercolours and Sculpture*, December 1962–January 1963, No. 61 repr.), although the figures have been freshly distributed.

There are no references to No. 373 in the correspondence between Camille and Lucien Pissarro, but an annotation by Lucien Pissarro in his Studio Book (II, f. 99, No. 303) records that the block was 'engraved before 1903'.

374 Compositional study of the interior of a rural café

Grey wash with chinese white over black chalk heightened with pure chinese white on tracing paper

Inscribed in pencil on a separate label attached above the drawing, *3e catigori (sic) 3e division/No. 3 au café* and again in black chalk on a separate label attached below the drawing *En un ton gris avec trait et blanc*

134 × 106. Framing indicated in black chalk, 113 × 91

It follows from the inscription that No. 374 was drawn in connection with the third subject of the third category of the second scheme for the final phase of *Travaux des champs* (for the outline of the relevant scheme see p. 79 above). There are no references to No. 374 in the correspondence between Camille and Lucien Pissarro, and no print appears to have been made from the drawing. The subject is not included in *La Charrue d'érable*.

Iconographically, however, No. 374 is of great interest, for while the café in an urban context, and to a much lesser extent in a rural context, is a major theme for Impressionist painters, Pissarro eschewed it. The café, as an institution, had only recently been introduced into French rural society,

and it is, therefore, highly significant that Pissarro's single depiction of a café should have been in *Travaux des champs*.

There is a similar innovative quality about the following composition, No. 375.

375 Compositional study of a marriage ceremony

Grey wash with chinese white over pencil heightened with pure chinese white on tracing paper

Inscribed in ink on a separate label attached below the drawing, *3e categori* (*sic*) *3e division/No. 4 la noce*

Lugt 613e

125×104. Framing indicated in black chalk, 112×92

It follows from the inscription that No. 375 was drawn in connection with the fourth subject of the third category of the second scheme for the final phase of *Travaux des champs* (for the outline of the relevant scheme see p. 79 above). The drawing was used as the basis for the print published in *La Charrue d'érable*, Paris, 1912, opp. p. 102, where it illustrates the chapter entitled *La Noce normande*.

Like No. 374, the subject is unique in Pissarro's *œuvre*. The novelty of having to treat this theme is amply borne out by the references to it in Camille Pissarro's letters to Lucien: 'J'approuve entièrement les trois catégories dont tu parles, ainsi divisé ce sera clair et pratique, seulement il y a une noce à faire? Il faudra que je fasse une composition que je n'ai jamais osé faire! enfin on fera le possible' (24 October 1900, not in *Lettres*), and 'Je ne suis pas satisfait du dessin de la noce qui manque de caractère, je n'ai aucun document et n'ai jamais étudié cette scène de la vie de campagne, il me faudrait en faire un autre et même une série, jusqu'à présent je n'en ai pas le sentiment' (4 November 1900, not in *Lettres*). Since, in a letter written between 1 and 4 November 1900 to his father, Lucien Pissarro had already acknowledged the receipt of one drawing of this subject, describing it as 'La petite noce sur papier vert se ferait en 3 planches', No. 375 may represent the second attempt at the subject alluded to in Camille Pissarro's letter of 4 November 1900, as the present drawing is not on green paper.

Clearly, the singularity of the subject in Pissarro's *œuvre* suggests that his drawing was made from fresh observation of a particular marriage ceremony, but it should be noted that there is a painting of this same subject by Pieter Breughel the Elder, both in Brussels (Musée Communal de la Ville, for which see G. Arpino and P. Bianconi, *L'Opera completa di Breughel*, Milan, 1967, No. 67), and also in Paris (Musée du Petit Palais).

376 Compositional study of harvesters—*la batterie mécanique* (I)

Grey wash with chinese white over black chalk

Pin marks in corners and centre of lower edge

Inscribed in ink on the verso, *2e division 2e catigori* (*sic*)/*No. 4 Batterie mécanique*

153×115. Framing indicated in black chalk, 111×88

It follows from the inscription that No. 376 was drawn in connection with the fourth subject of the second category of the second scheme for the final phase of *Travaux des champs* (for the outline of the relevant scheme see p. 79 above). The composition is, in fact, a reworking of the left half of No. 342, which may originally have been drawn for the second phase of *Travaux des champs*, and was itself derived from P&V 367, of 1876. For the reworking of the right half of No. 342 see No. 377 below. No. 376 served as the basis for the print published in *La Charrue d'érable*, Paris, 1912, opp. p. 22.

By including Nos. 376–8 together with Nos. 361–4 from the first category of this second scheme for the final phase, Pissarro draws a clear-cut distinction between mechanical and manual labour. Indeed, it is unusual for Pissarro to include scenes of mechanized labour in his work, although it readily suited the context of *Travaux des champs*. P&V 367 is also one of the very few instances in Pissarro's painted *œuvre* that makes allowances for the recent developments in the mechanization of rural life in France during the second half of the nineteenth century.

There appear to be no references to No. 376 in the correspondence between Camille and Lucien Pissarro, and, unlike No. 377, no drawing of this subject on tracing paper has survived.

377 Compositional study of harvesters—*la batterie mécanique* (II)

Grey wash and chinese white over black chalk

Pin marks in corners and centre of lower edge

Inscribed in ink on the verso *2e division 2e categori (sic)/No. la batterie mécanique*

152 × 116. Framing indicated in black chalk, 111 × 87

See No. 378 below.

378 Compositional study of harvesters—*la batterie mécanique* (II)

Grey wash and chinese white over black chalk heightened with pure chinese white on tracing paper

Inscribed in pencil in upper margin *lumière* and in ink on a separate label attached below the drawing *2e division 2 / No. 4 la batteri...* (cut on right)

Lugt 613e

133 × 106. Framing indicated in black chalk, 111 × 88

It follows from the inscription that No. 377 was the fourth subject of the second category of the second scheme for the final phase of *Travaux des champs* (for the outline of the relevant scheme see p. 79 above). No. 378 is also related. It appears that there were two compositions of 'la batterie mécanique', of which only No. 376 was used in *La Charrue d'érable*. The present drawing is a reworking of the right half of No. 342, which is from the second phase of *Travaux des champs* and was itself derived from P&V 367, of 1876. The fact that No. 378 is on tracing paper implies that Camille and Lucien Pissarro had every intention of using it as the basis for a print.

Indexes

Compiled according to catalogue numbers

1

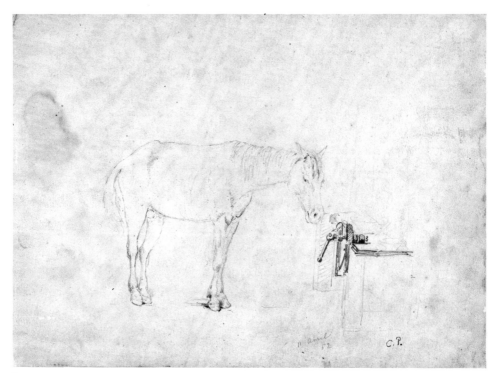

2 recto

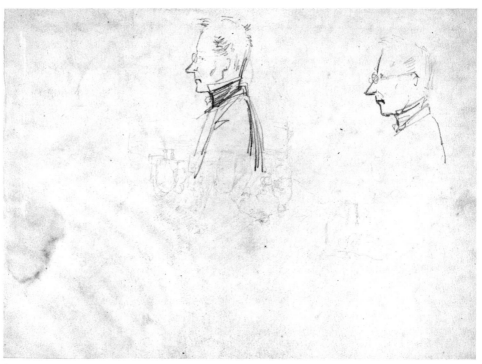

2 verso

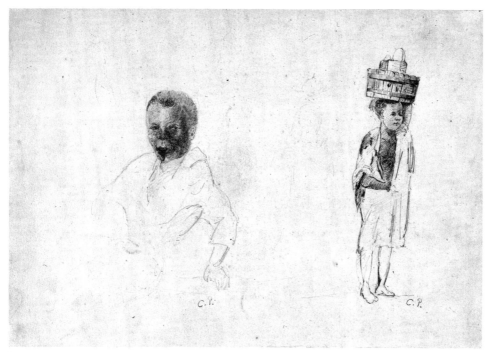

3 *recto*

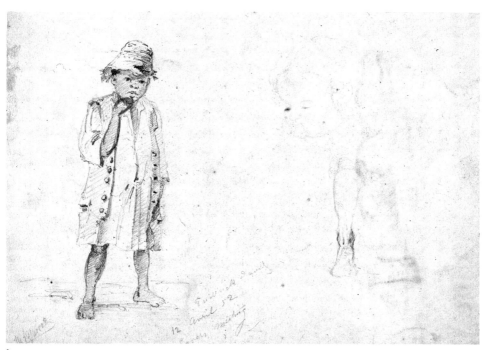

3 *verso*

4 *recto*

4 *verso*

5

6

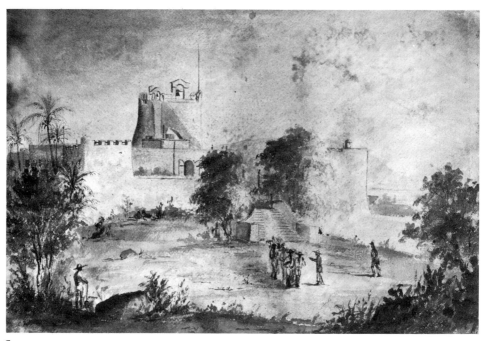

7

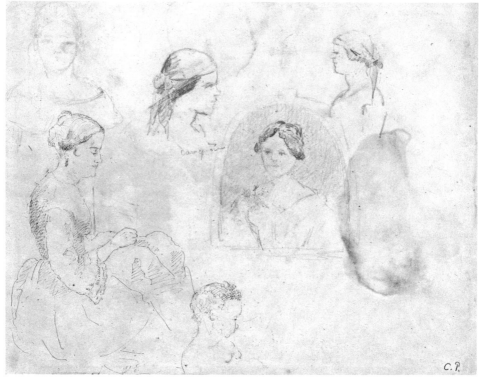

8 recto

8 *verso*

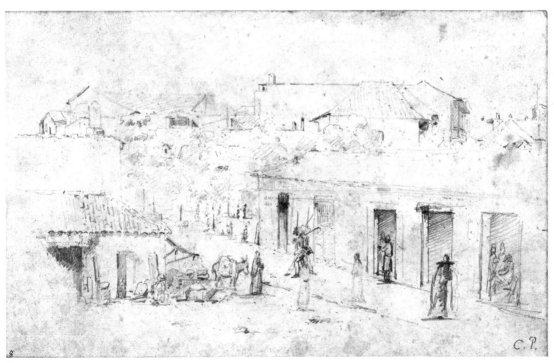

9 *recto*

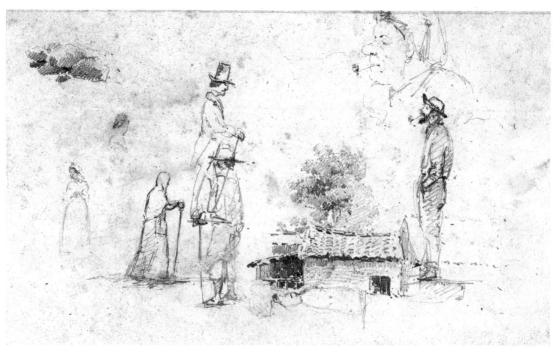

9 *verso*

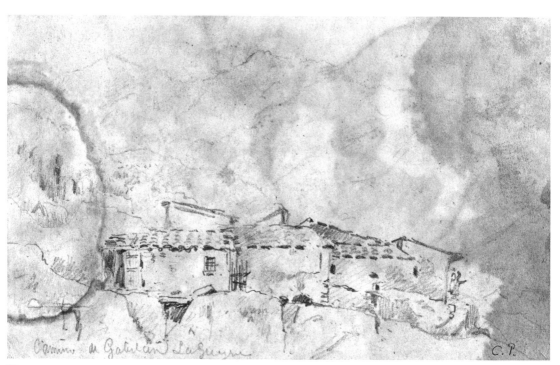

Camin de Gatulãn Laguayn C. P.

10 *recto*

12 *recto*

12 *verso*

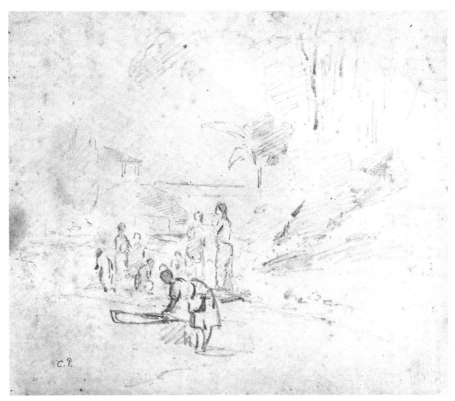

13

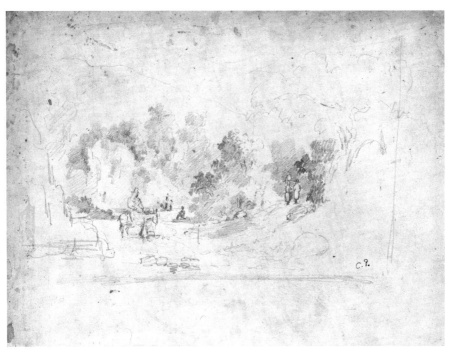

14

15 *recto*

15 *verso*

16

17 *recto*

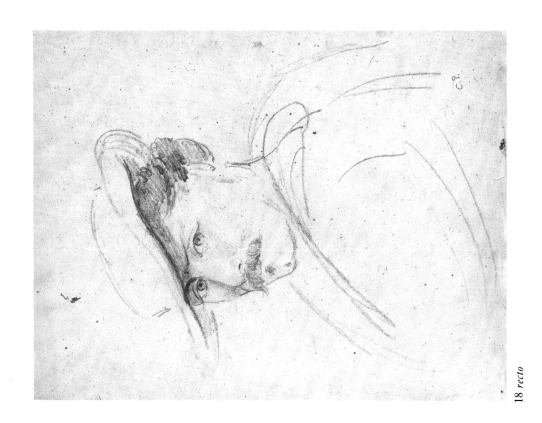

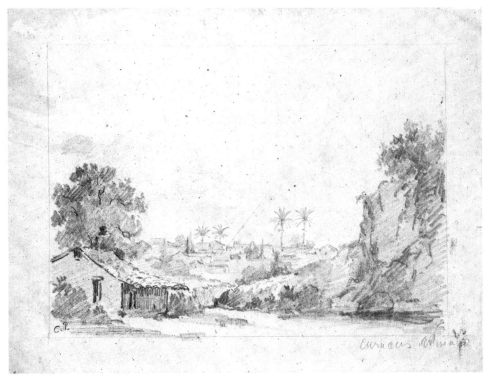

18 *verso*

19

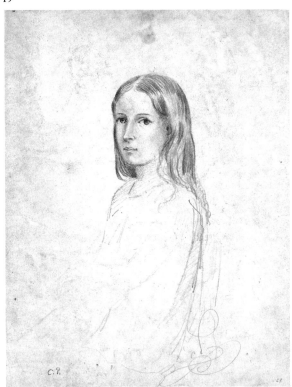

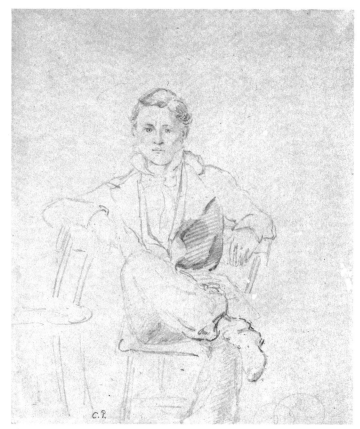

20 *recto*

20 *verso*

C.P.

27

22 recto

21

C.P.

22 verso

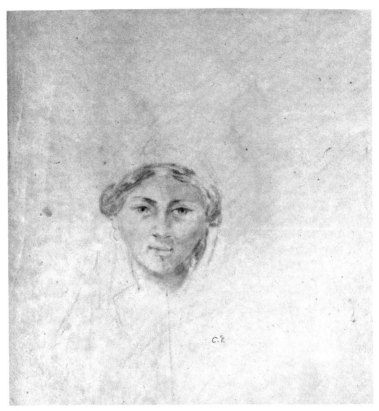

23 *recto*

23 *verso*

24 *recto*

24 *verso*

25

26 *recto*

26 *verso*

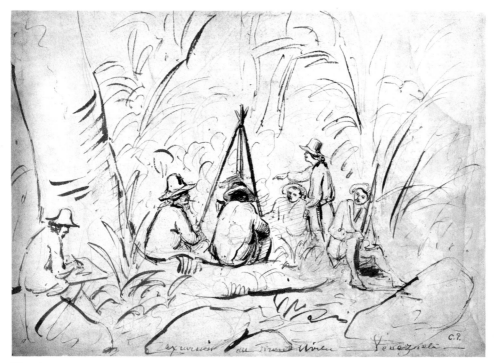

27 *recto*

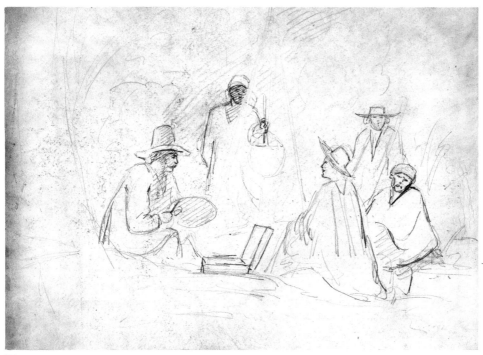

27 *verso*

28

29 *recto*

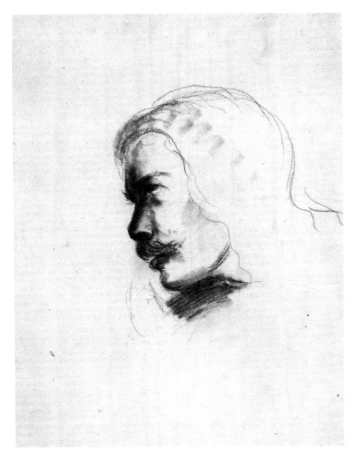

29 *verso*

30

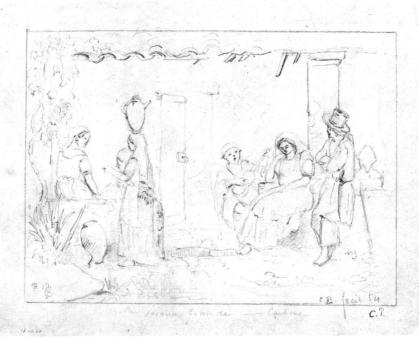

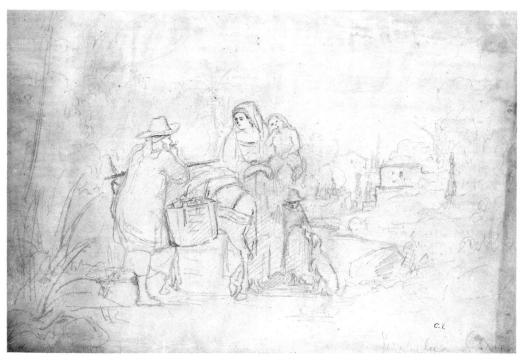

31 *recto*

31 *verso*

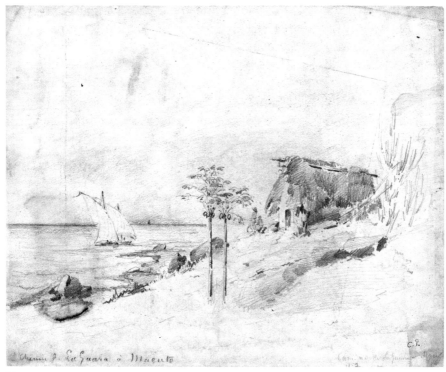

Chemin d. La Guaira à Macuto

Camino de La Guaira á Macuto
181

C. P.

32 *recto*

32 *verso*

33

34

35 *recto*

35 *verso*

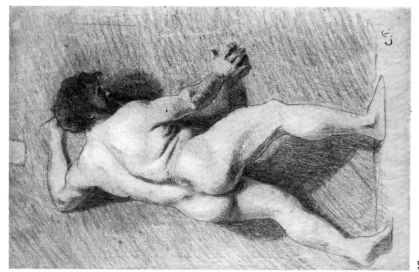

37

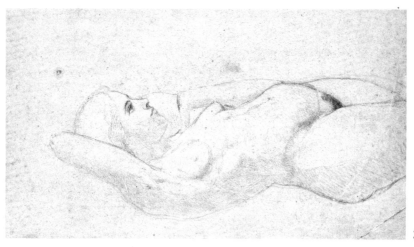

36 verso

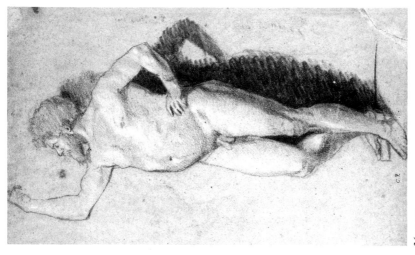

36 recto

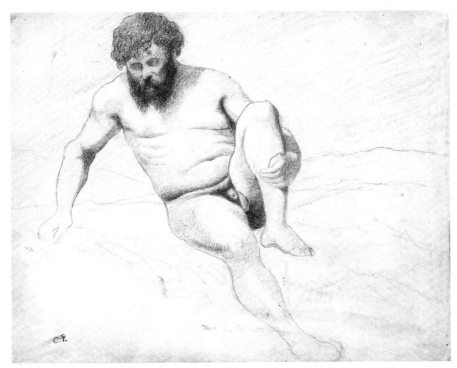

38 *recto*

38 *verso*

39

40 *recto*

40 *verso*

41

42 *recto*

42 *verso*

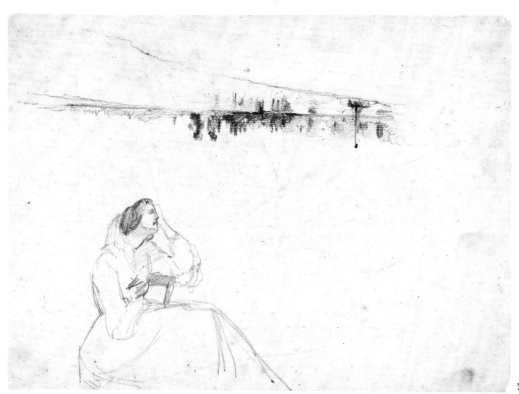

44

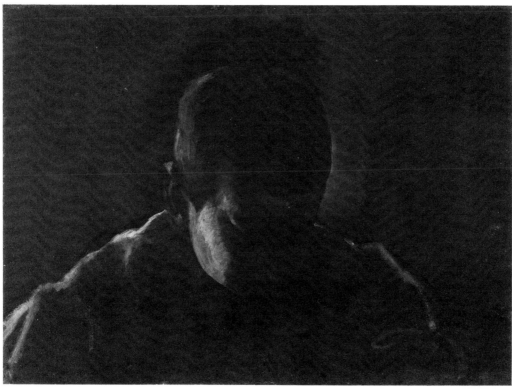

45

C.R.

47

c.2

48

46

49A

49B

49C

50

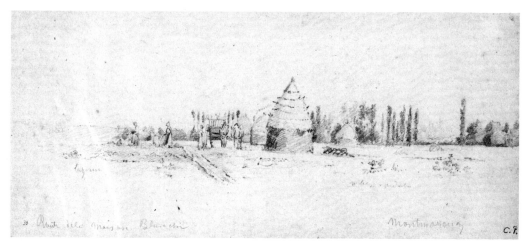

51

52

53

54

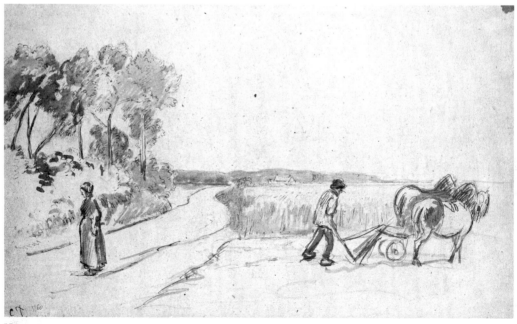

55

56 *verso*

C. P.

56 *recto*

57

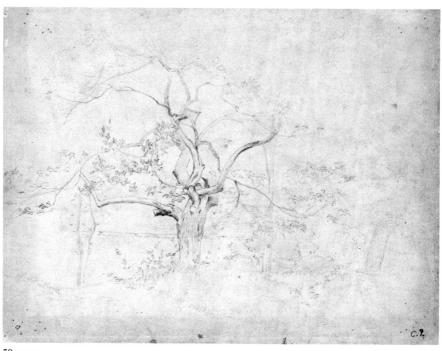

58 *recto*

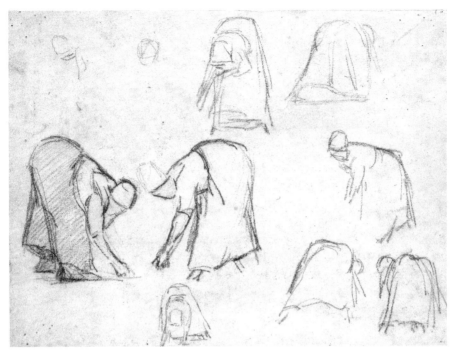

58 *verso*

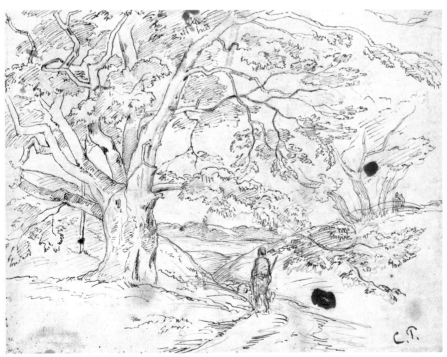

59

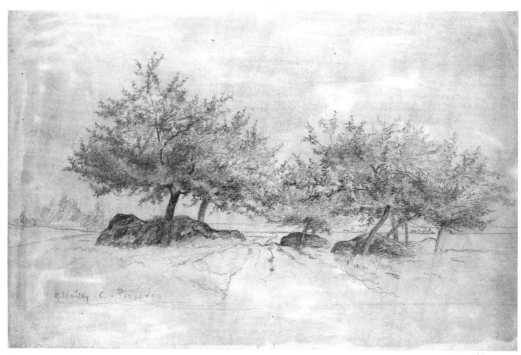

60 *recto*

60 *verso*

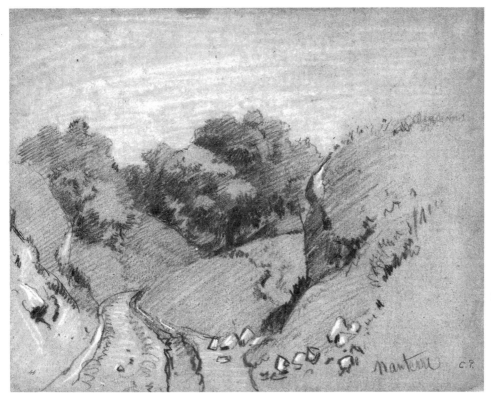

61

62

63

64 *recto*

64 *verso*

65 *recto*, 1

65 *recto*, ii

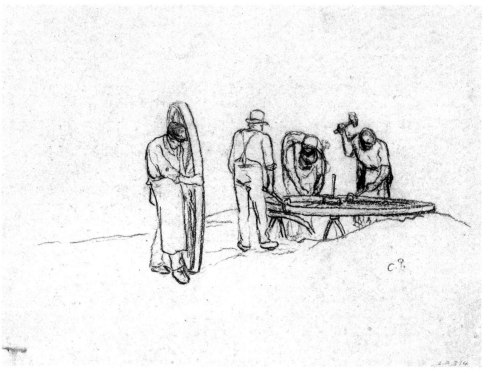

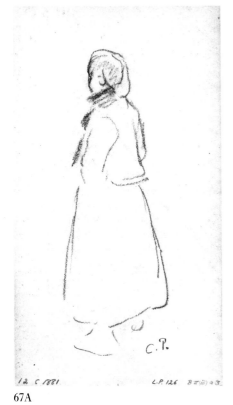

12 C 1881 L.P. 126 B π (iii) a 3

67A

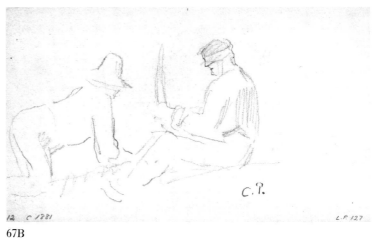

12 C 1881 L.P. 127

67B

64 , 1871, A8v. 95 C.P. 65 B.π a 29

68A *recto*

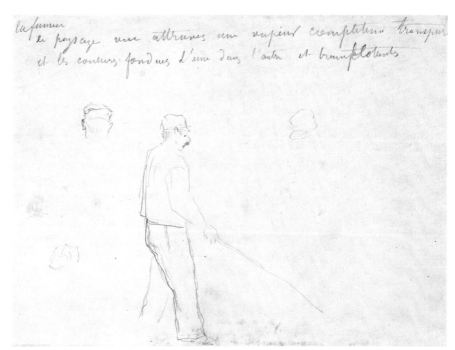

68A *verso*

68B

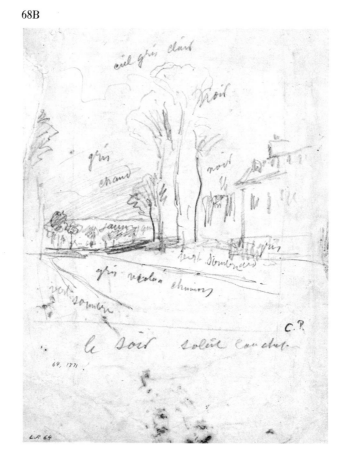

68C *recto*

68C *verso*

68D *recto*

68D *verso*

68E *recto*

68E *verso*

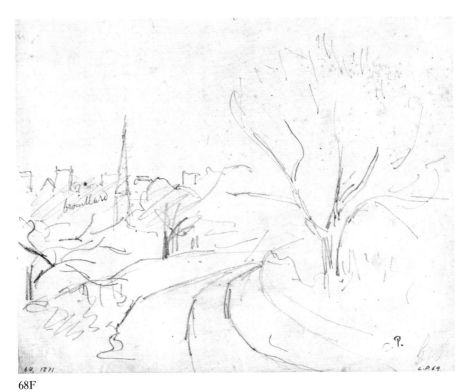

68F

69

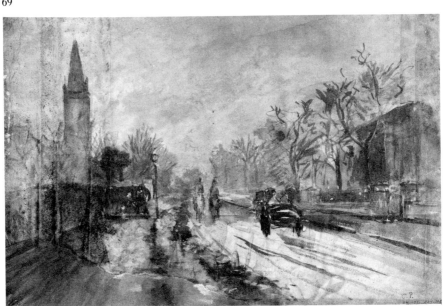

72

71

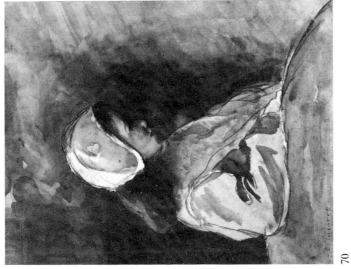

70

73A *recto*

73A *verso*

73B *recto*

73B *verso*

73C *recto*

73C *verso*

73D *recto*

73D *verso*

73E *recto*

73E *verso*

74

75 *recto*

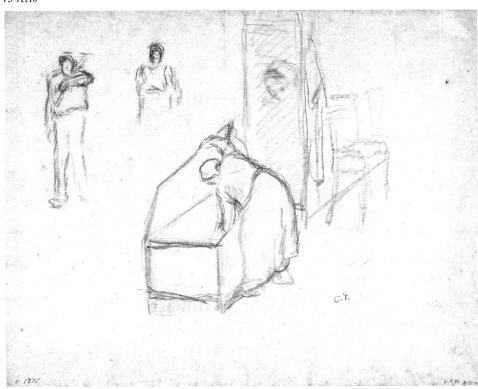

75 *verso*

76

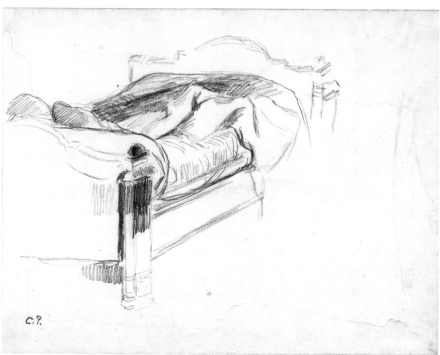

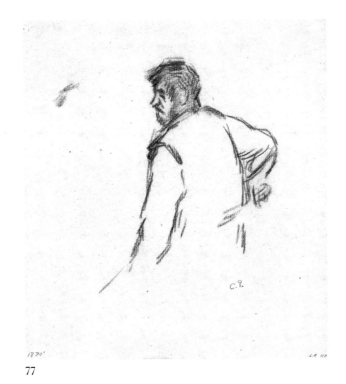

77

78 *recto*

78 *verso*

79

80

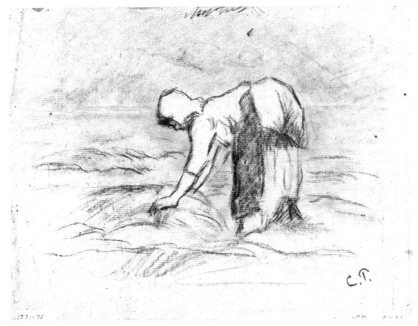

81 *recto*

81 *verso*

82

83 *recto*

83 *verso*

84

85A *recto*

85B *recto*

85A *verso*

85B *verso*

85C *recto*

85C *verso*

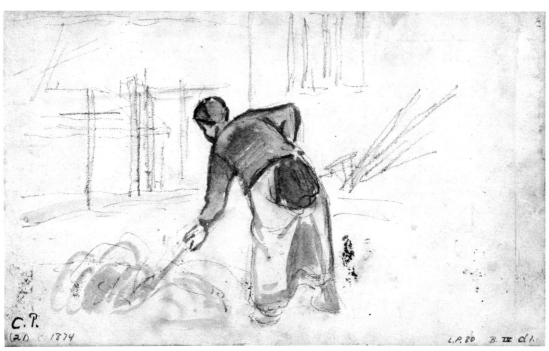

C.P.
(20) 1874

L.P. 80 B. IX ch.

85D *recto*

85D *verso*

85E

85F *recto*

85F *verso*

N (21) 01874

85G *recto*

85G *verso*

85H *recto*

85H *verso*

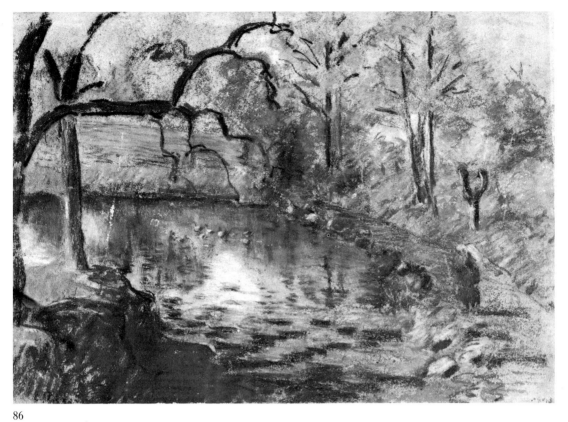

86

87A *recto*

87B *recto*

87A *verso*

87B *verso*

88

89

90

91

92

93

94

95 *recto*

basse cour toile de 8

C.P.

relate) E 472 à Pissarh. 1878

95 *verso*

96

vieux?

trop gras

C.P.

about 1875

ZE a 22 CP.89

97A *recto*

97A *verso*

97B *recto*

97B *verso*

30 1877 Studies (o. P.D.V. 432 C.P.101 B.III.a.16

97C *recto*

97C *verso*

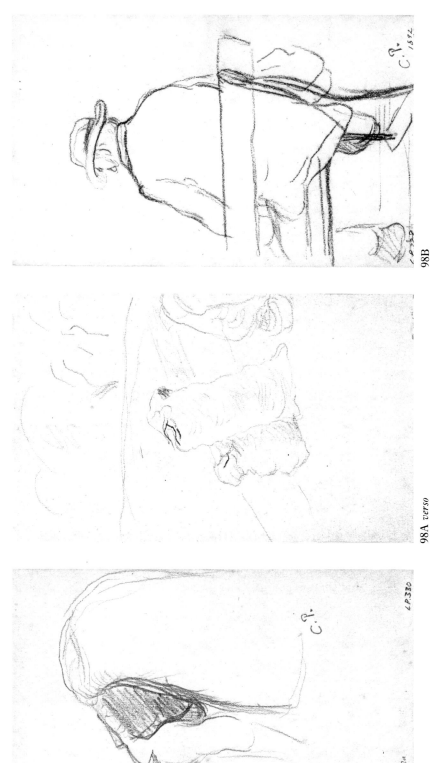

98A *recto*

98A *verso*

98B

99A *recto*

99A *verso*

99B

99C *recto*

99C *verso*

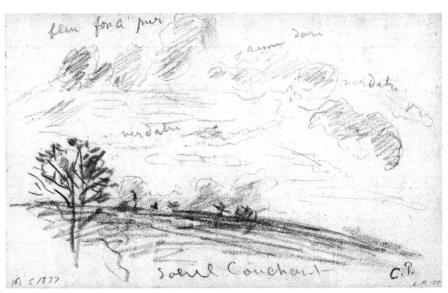

99D

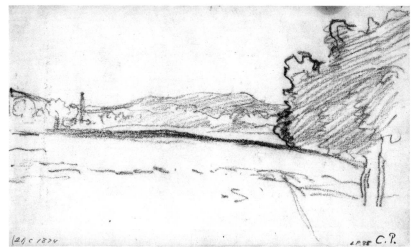

100A *recto*

100A *verso*

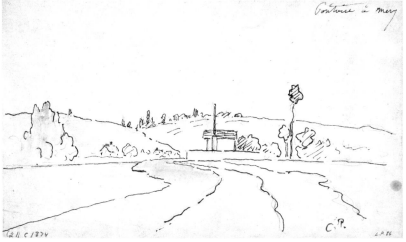

100B

101

102

103

104

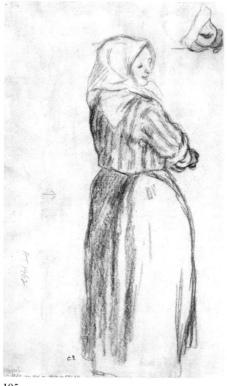

105

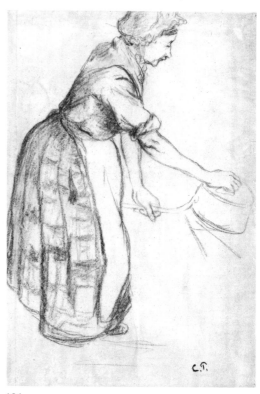

106

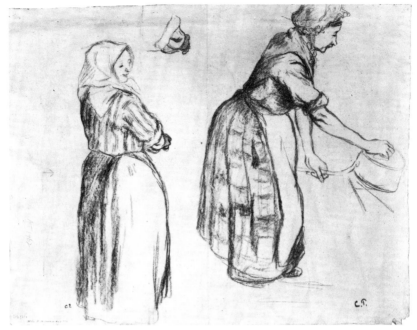

105–6

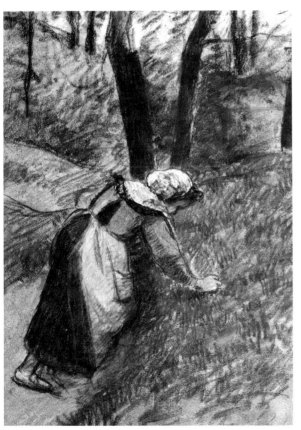

107

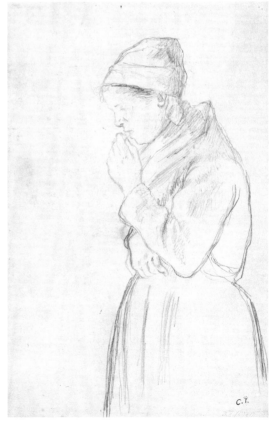

108

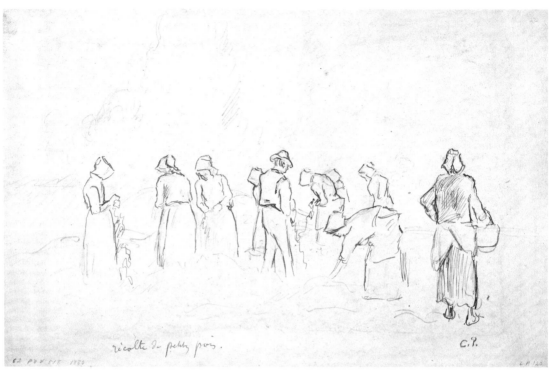

récolte de petits pois.

C.P.

62 POV S18 1880

C.P. 120

109

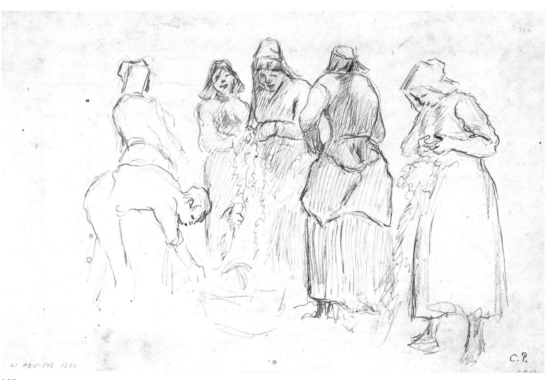

62 POV S18 1880

C.P.

110

111

112

113 *recto*

113 *verso*

114

115

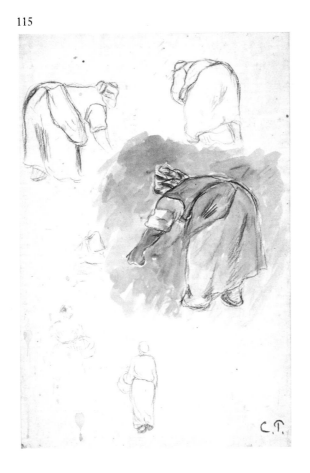

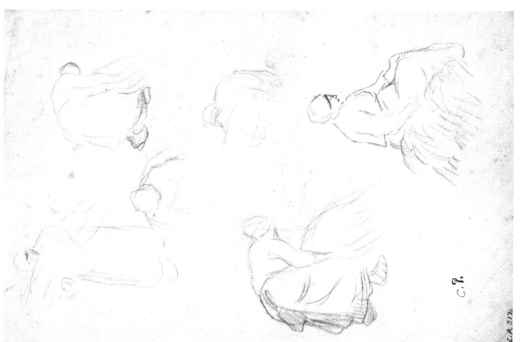

117 *recto*

117 *verso*

118

119 *recto*

119 *verso*

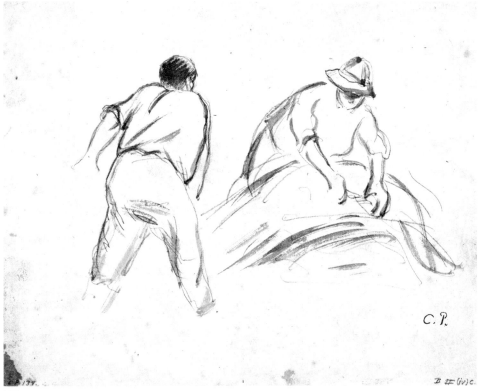

C.P.

120 *recto*

120 *verso*

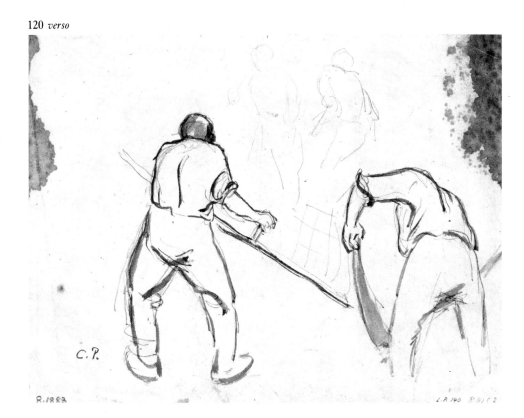

C.P.

122

123

124

125

126

127

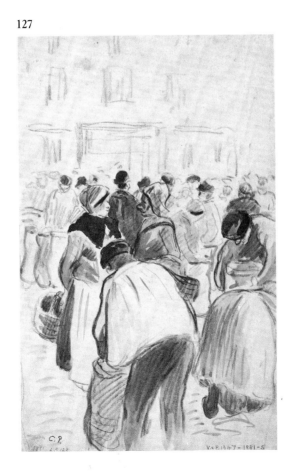

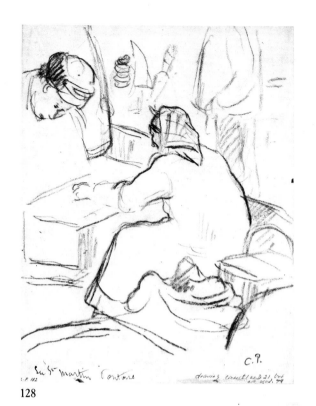

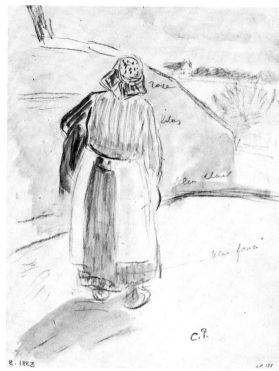

128

129

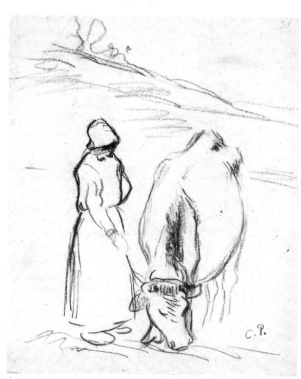

130

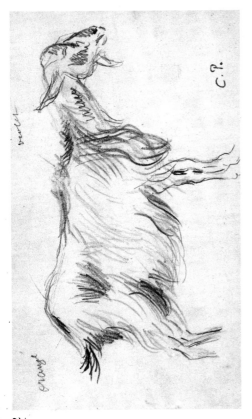

vert

orange

132

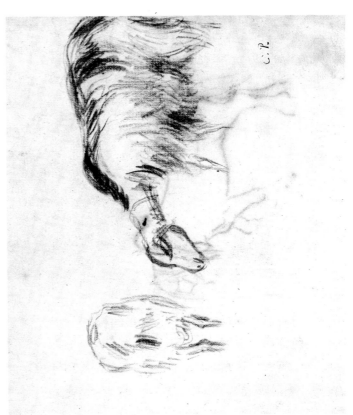

C.P.

133

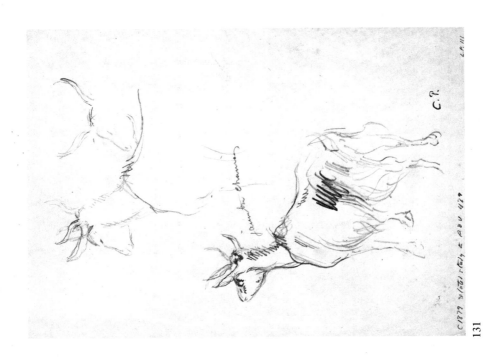

peau des chevaux

C.P.

C1879 (voir catalog de 1880 &?

L.P. III

131

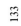

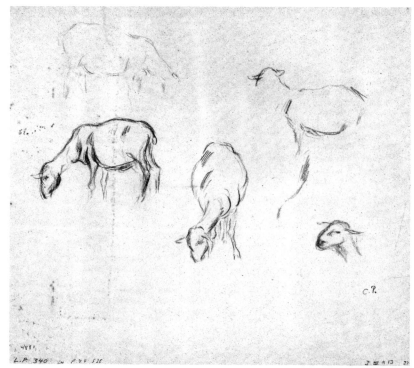

134

135

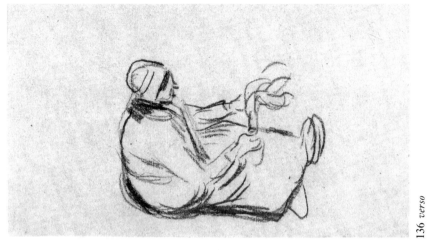

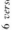

140

141A

141B *recto*

141B *verso*

C.P.

C.P. 437

143

Grand Mère 1870s

145

C.P.

(1) 1886/89

C.P. 386

142

C.V.

144

C. P.
L.P.382

146B

n.1886/9 (ii)

C. P.
L.P.383

146C

IIA 1886/9

C. P.
L.P.384

(I) 1886/9

146A

147

146D

148

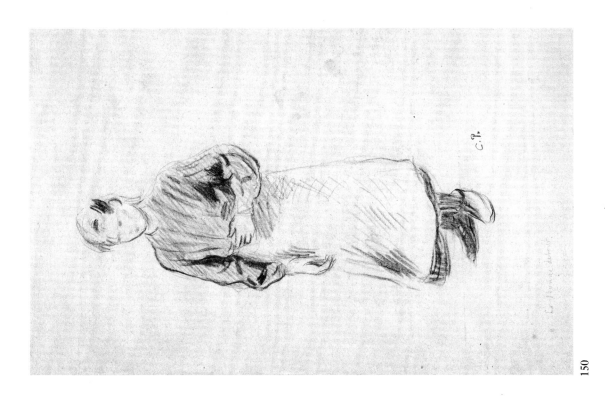

149

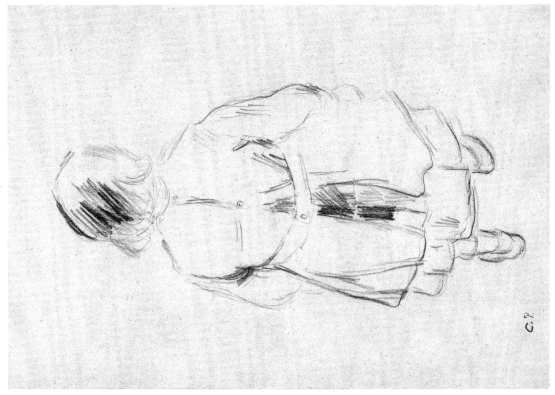

150

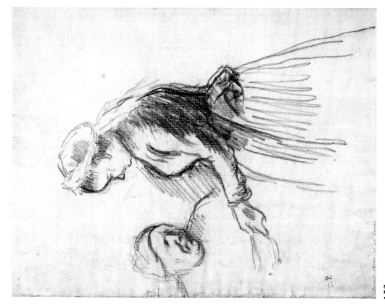

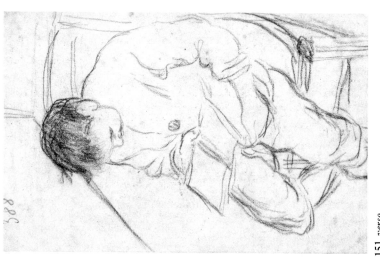

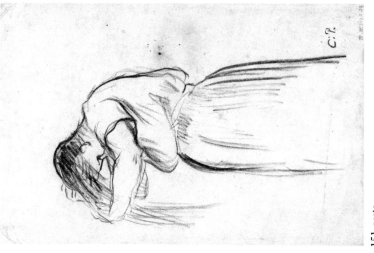

151 *recto*

151 *verso*

152

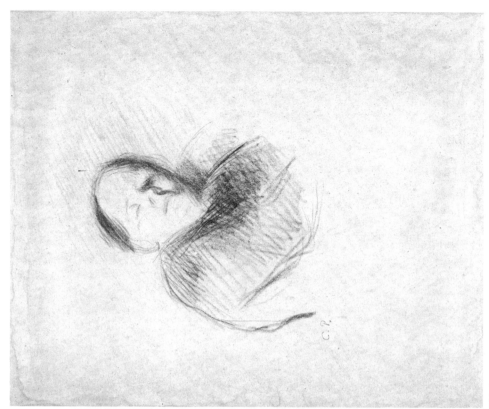

154

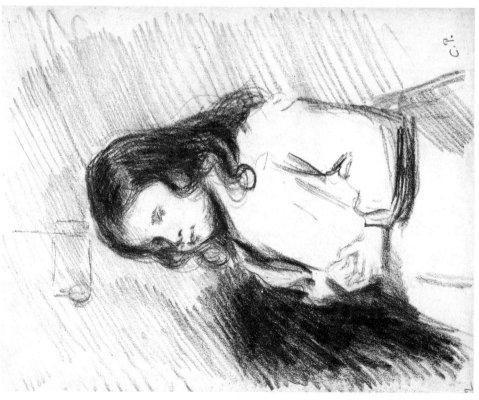

153

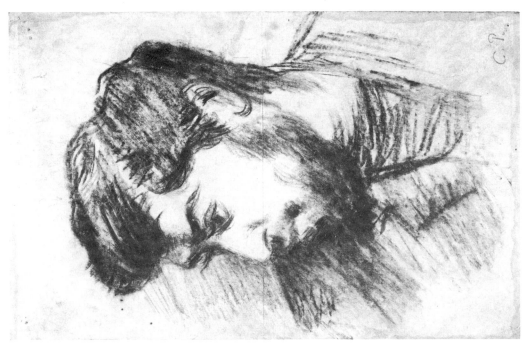

155B

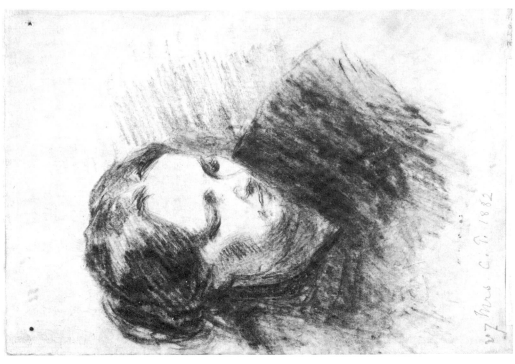

155A

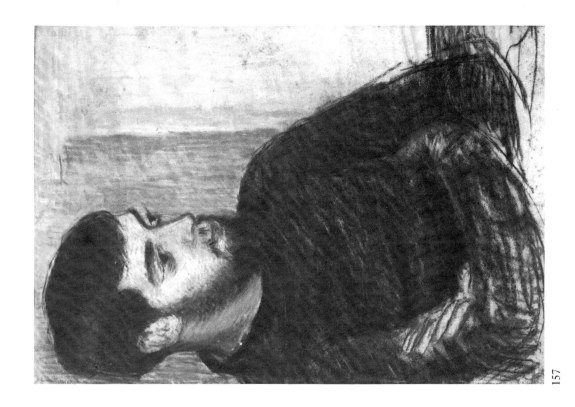

157

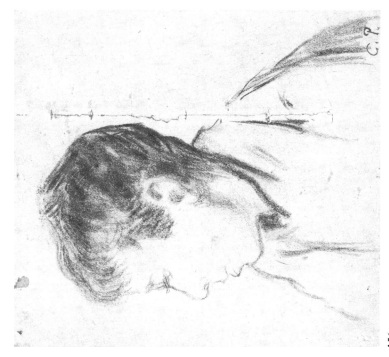

156

3. 1883-1884 L.P. 128

158A

158B

3. 1883-1884 L.P. 129

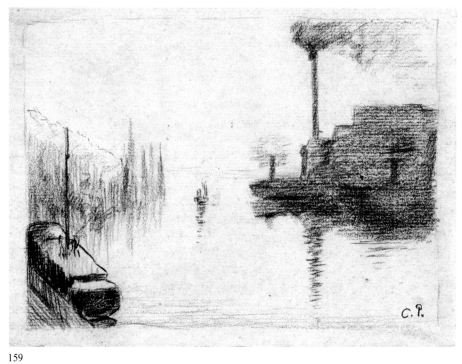

159

160A

160B

160C

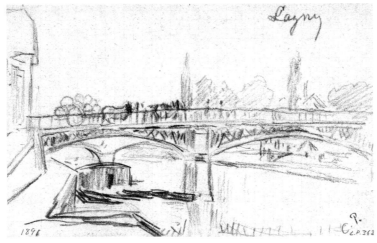

160D

161

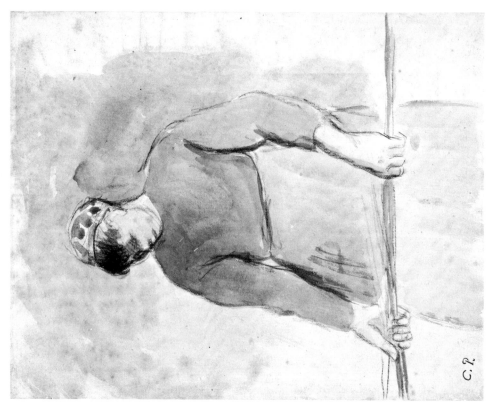

C.P.

163

C.P.

study for ferme at Orny 1884 (Delteil 51)

L.P. 156

B IV 43

162

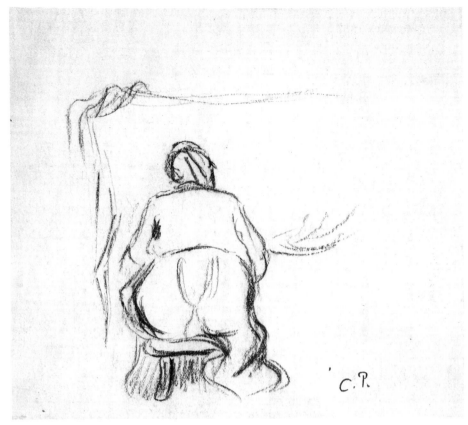

164

165

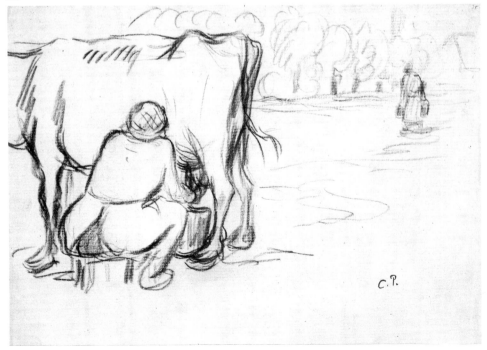

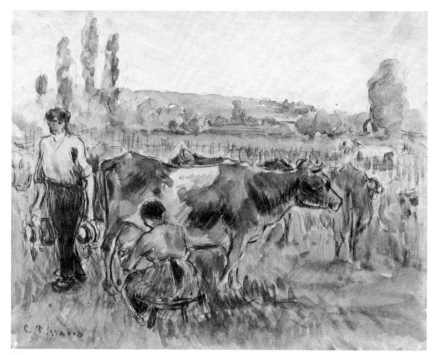

166

167

168A

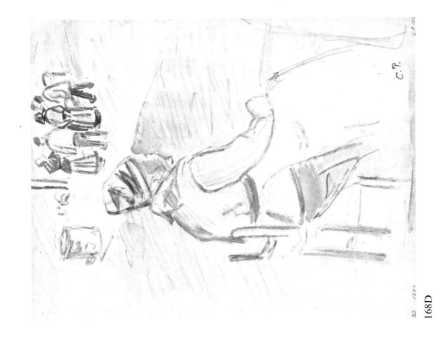

168D

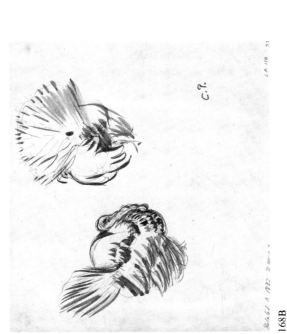

168B

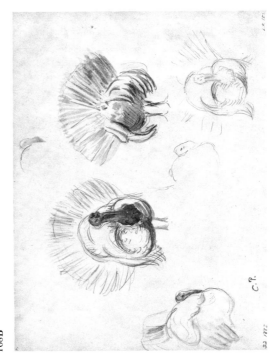

168C

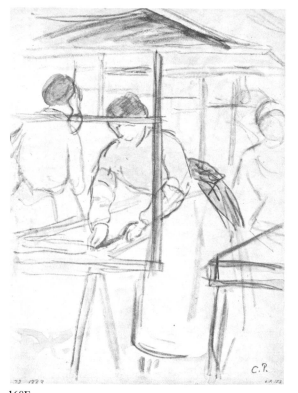

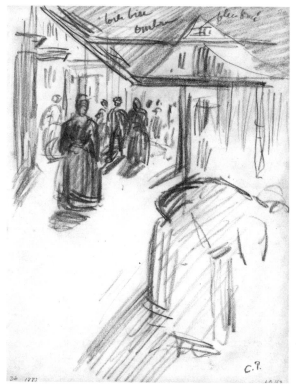

168E

168F

168G

168H

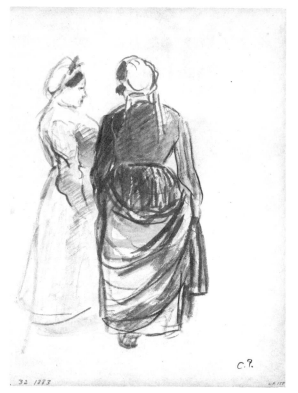

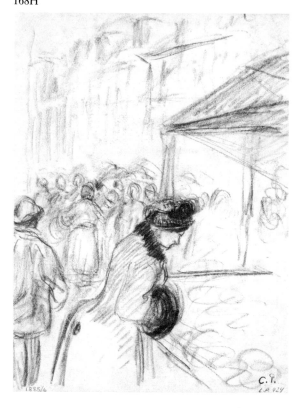

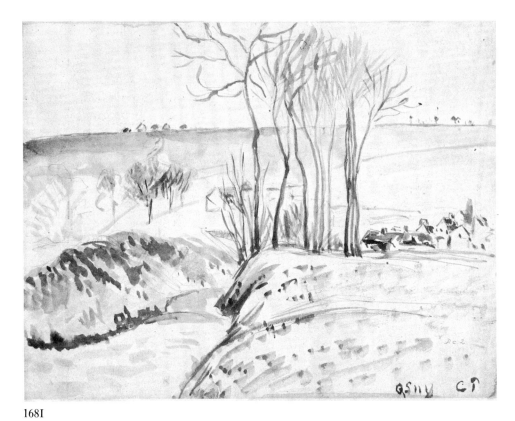

168I

168J

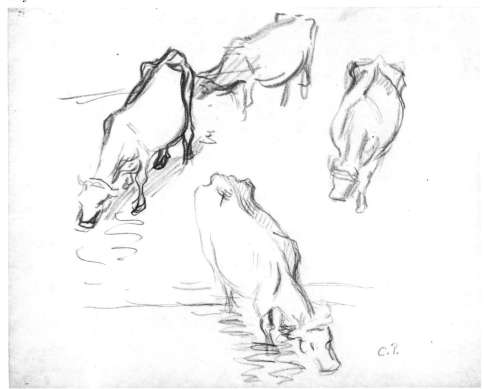

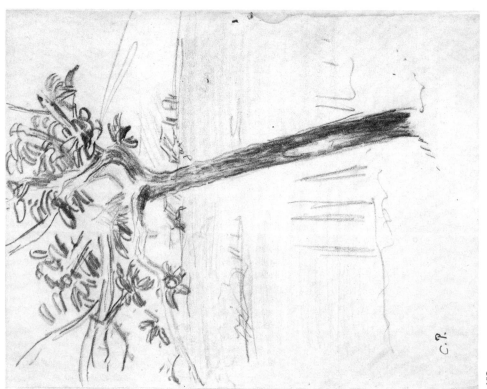

168L

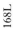

168K

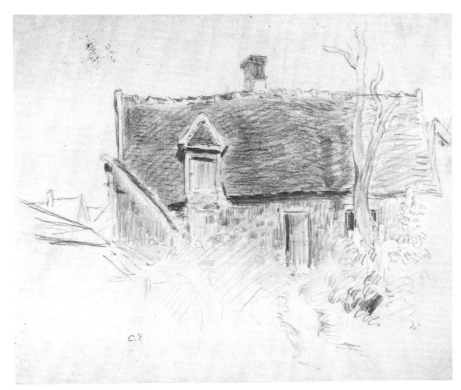

169

170

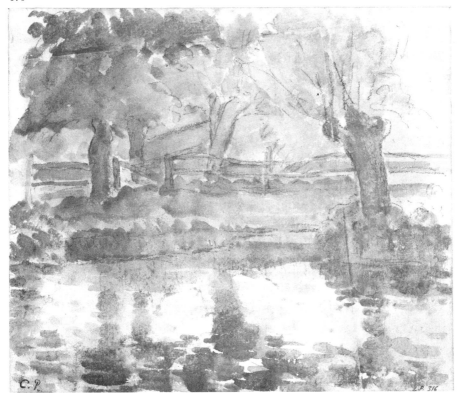

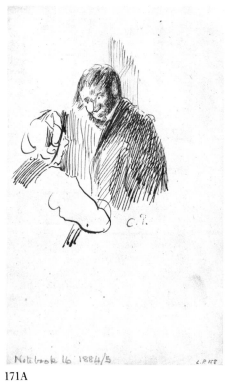

Notebook 16 1884/5 L.P.158

171A

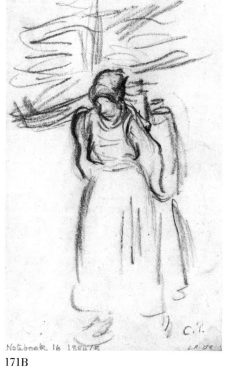

Notebook 16 1884/5 L.P.159

171B

Notebook 16 1884/5

C.P. L.P.160

171C

Gisors

Notebook 16 1884/5 L.P.161

171D

172 *recto*

172 *verso*

173

173 *bis*

L.P. 334 r. B.E.bh?

174A *recto*

L.P. 335

174B

174A *verso*

C.P.

175A

175B

175C *recto*

175C *verso*

175E

(22) 1885~.1887) L.P. 418 B.II.(1) az

175D

(22) 1885~1887) C.P. L.P. 417

C.P.

175G

C.P.

175H

C.P.

175F

176A

176B

177

178

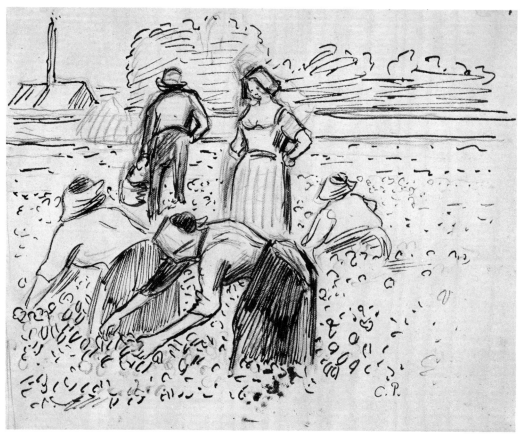

179

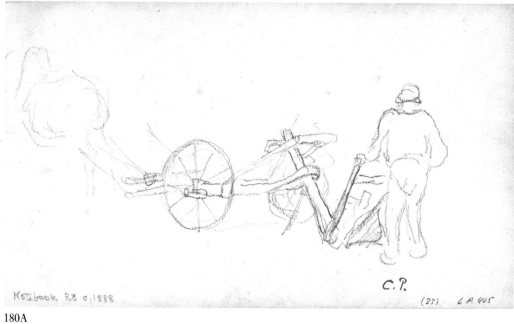

Ketchbook R3 c.1888

(23) C.P. 405

180A

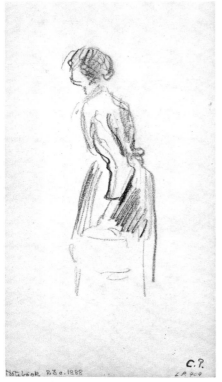

180B

180C

180D

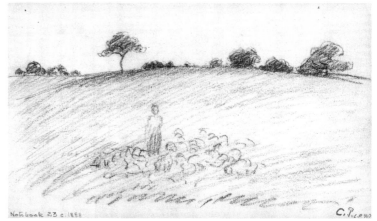

180E

180G *verso*

180G *recto*

180G *recto*

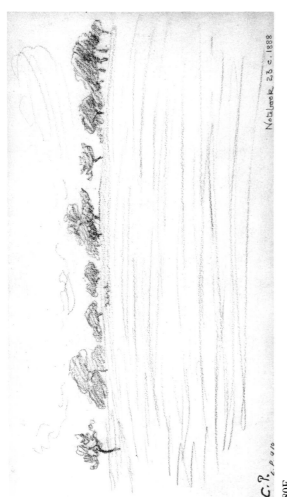

Notebook 23 c. 1888

C.P.

180F

(23)

181

182

183

L.P. 412 C.P. P.V 723 1888 184

185 *recto* L.P.338.

185 *verso*

186 L.P.337

187

188

189 *recto*

189 *verso*

190

191

192 *recto*

192 *verso*

193

194

195

1889

L.R. 401

197

198

196

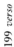

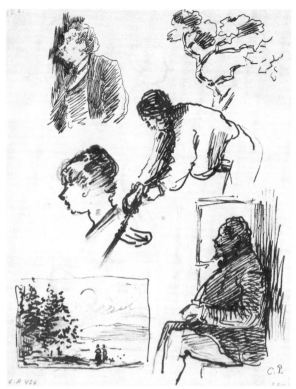

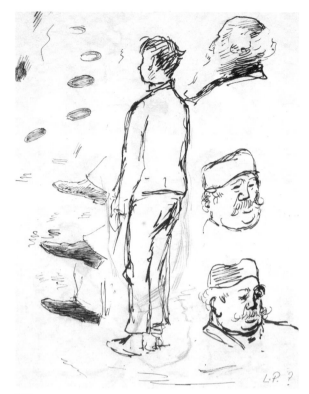

200 *recto*

200 *verso*

201

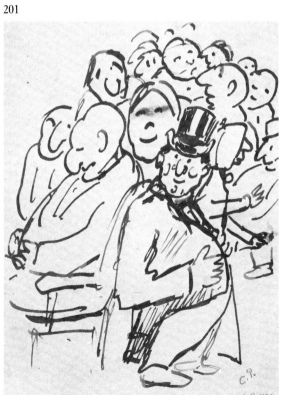

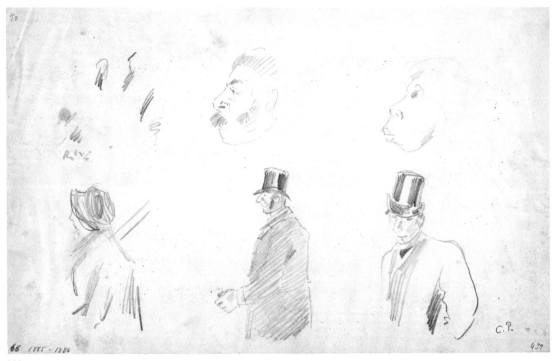

202

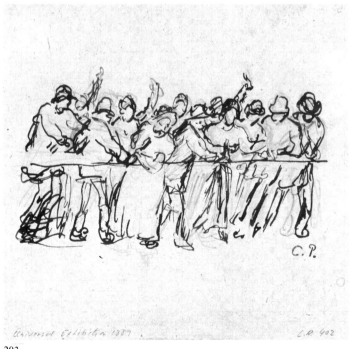

203

206

205

204

209

208

207

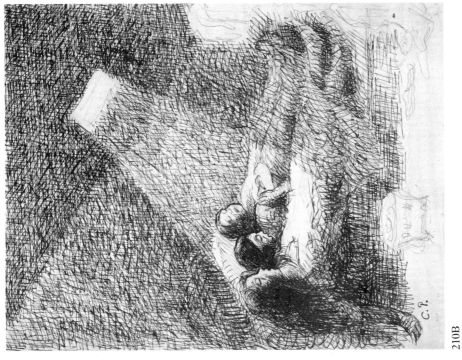

210A

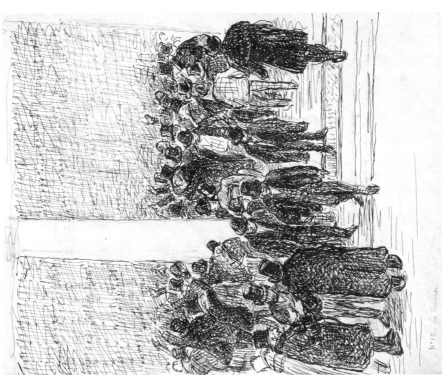

210B

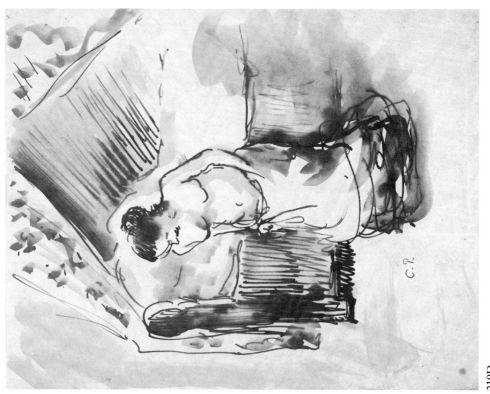

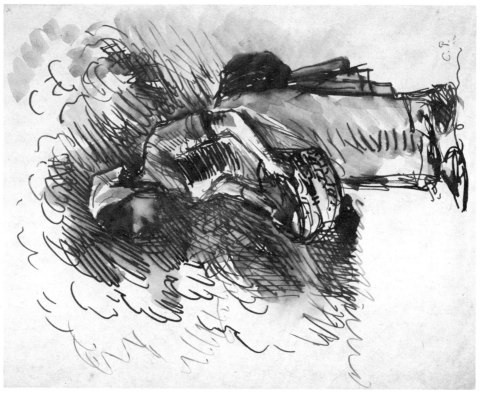

210D

210C

C.R.

Upps Liebelekten 201 1892

GR 135

210F

C.R.

GR 424

abril 18977

210E

211 *recto*

211 *verso*

212 *recto*

212 *verso*

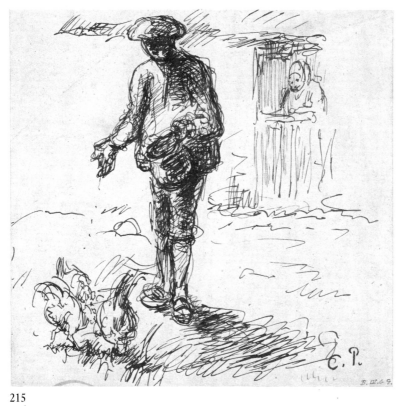

215

216

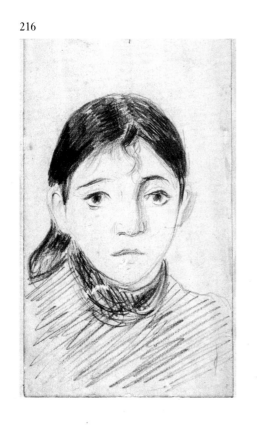

217

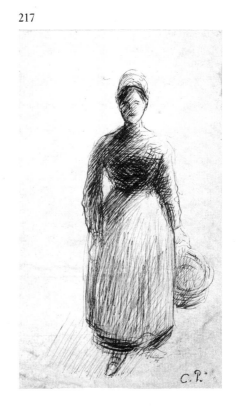

218

219

220

221

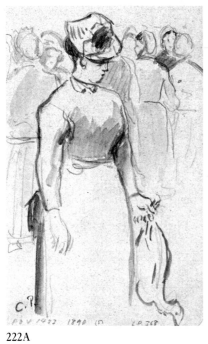

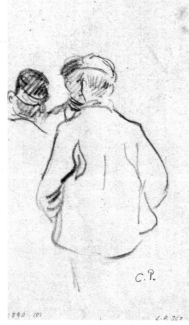

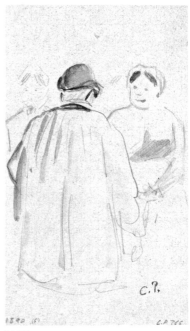

222A 222B 222C

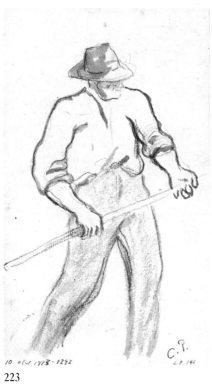

223 224

225A L.P. 398 C.P. (15)

225B D.104 L.P. 396 C.P. (15)

225C L.P. 395 C.P. (15)

225D

225E

225F

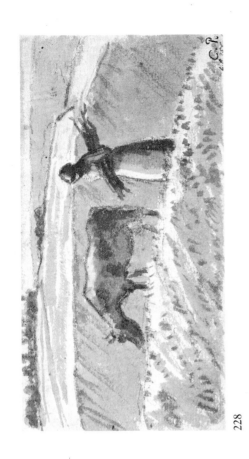

228

229

226

227

230

231

232

233

234

235

236

237

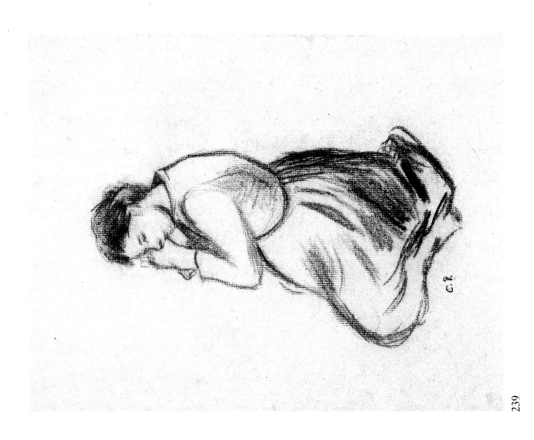

239

238

240

241

242

243A

243B

243C

243D

Waterloo Bridge

C.P.

243E

C.P.

243F

C.P. 198

244

cidre C.P.

245

C.P.

246

C.P.

C.P. 341 1893

247

248

249

250

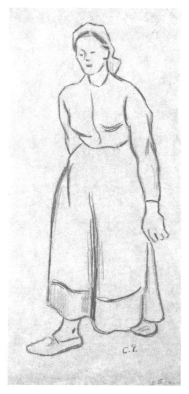

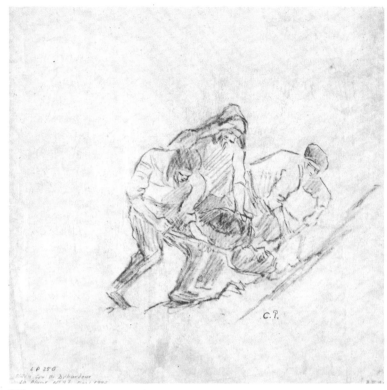

251

252

253

254

255

256

257

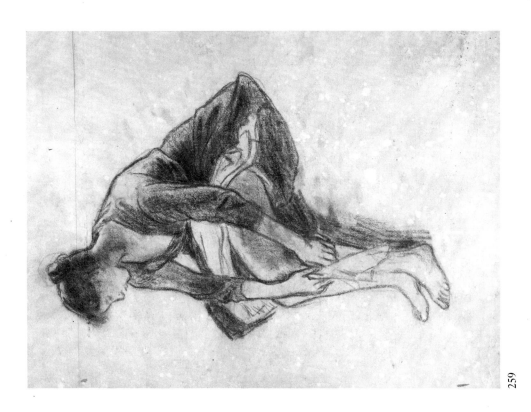

259

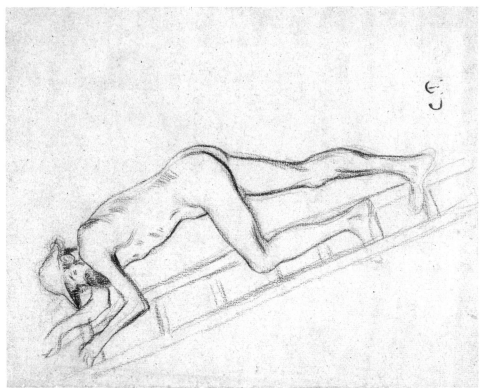

258

C. P.

L.P. 353 1896

260

261

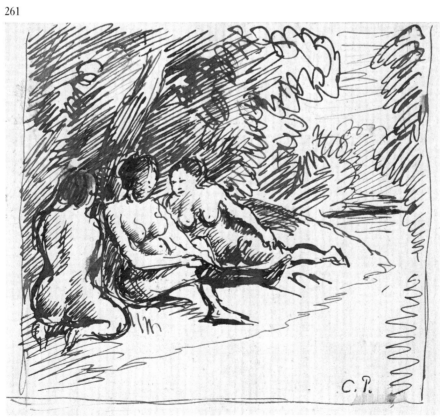

C. P.

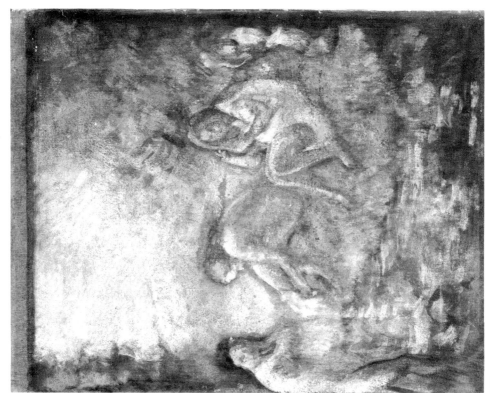

263

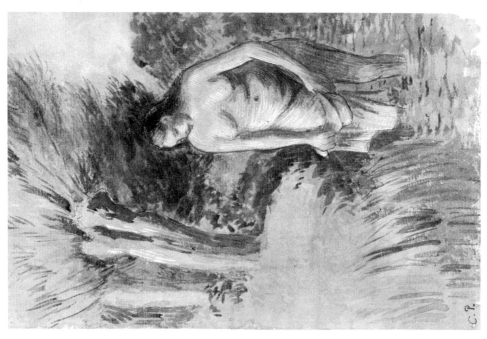

262

265

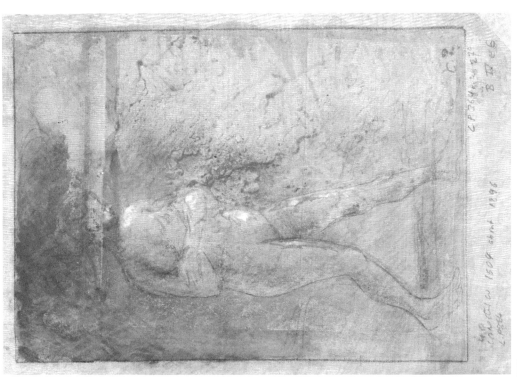

264

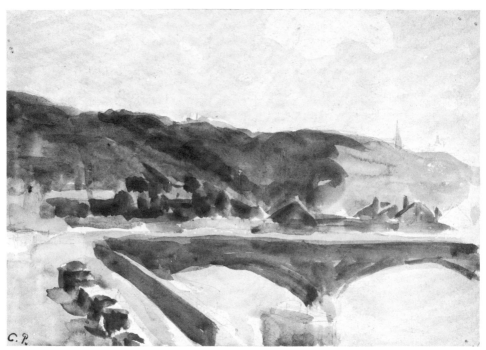

266

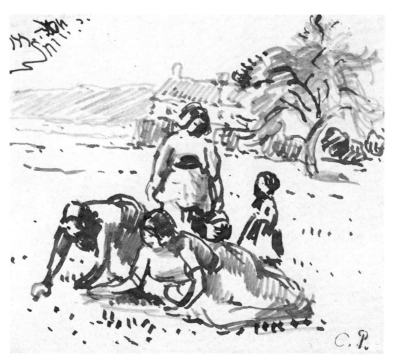

267

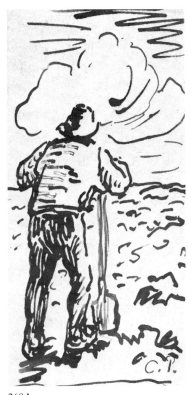

268A

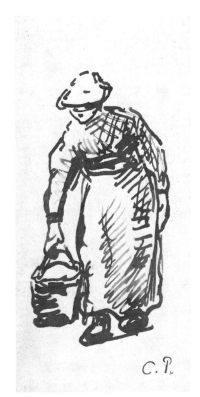

268B

269

270

271 *recto*

271 *verso*

272

273A

274

275
276

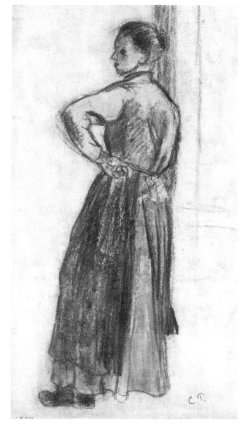

277A

277B

277C *recto*

277C *verso*

277D

277E

277F

277G

278A

278B

278C

278D 128e. M.L. (69) C.P.

278E

278F

278G L.P. 376 (69) I.X.a 86.

278H (69) C. P.
 L.P. 378

278I (69) C. P.
 L.P. 373

278J

278K

279

281

282

280

283

284

285

286

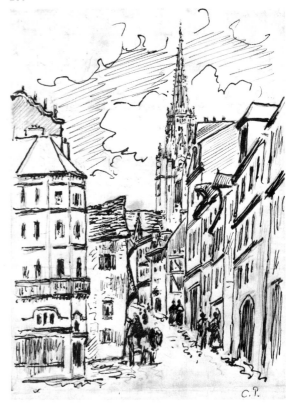

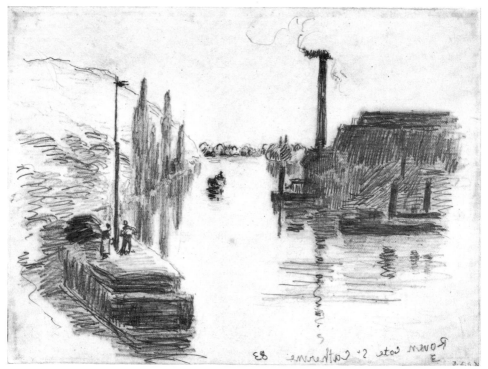

287 *recto*

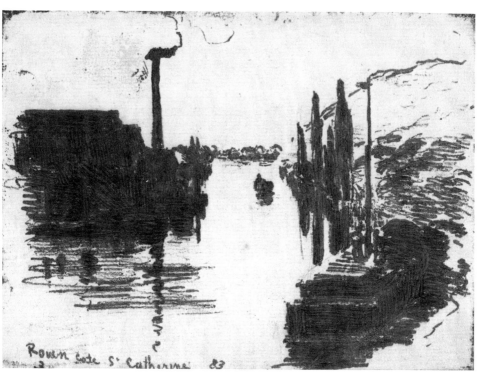

Rouen côte St Catherine 83

287 *verso*

288

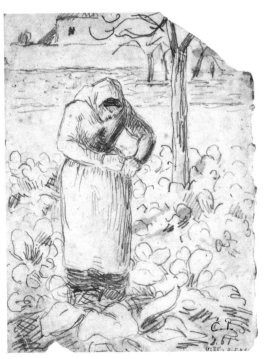

289

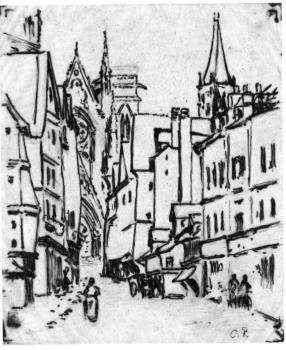

290

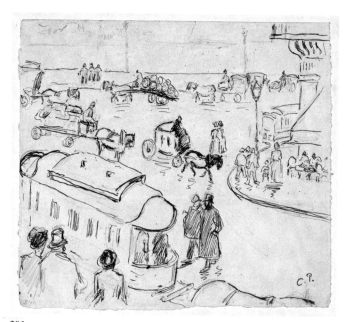

291

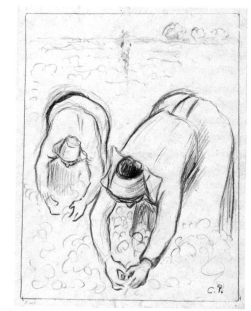

292

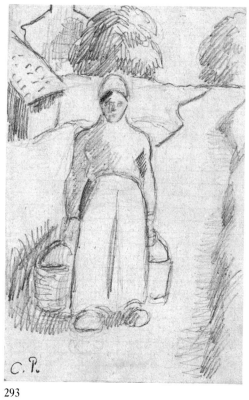

293

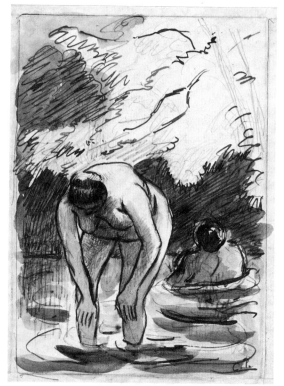

294

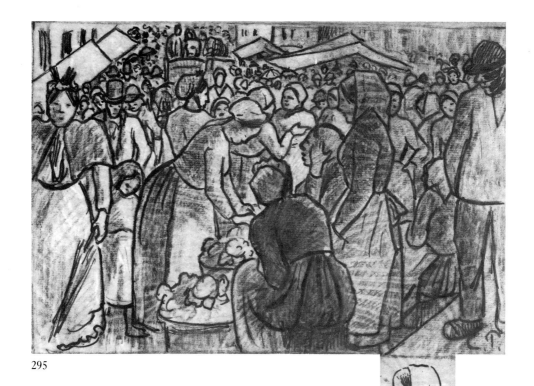

295

296

297

299

443

298

300

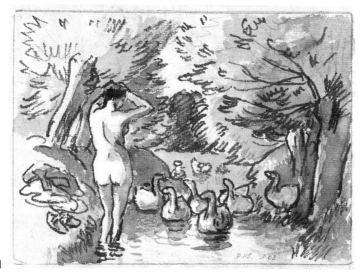

301

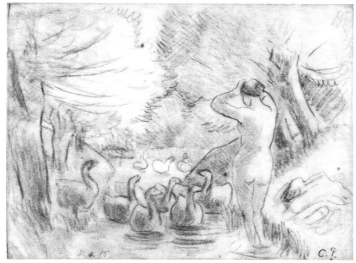

302

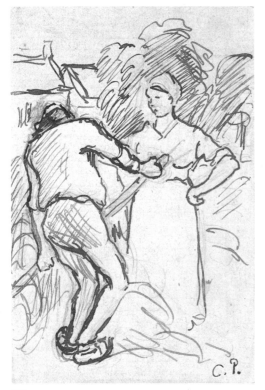

303

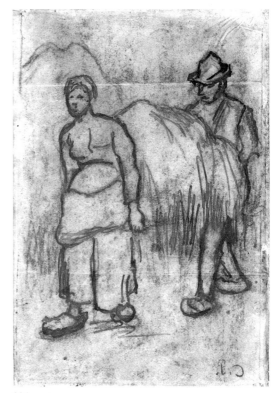

304 *recto*

304 *verso*

305

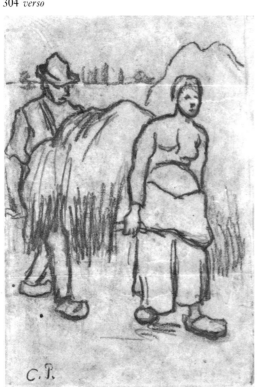

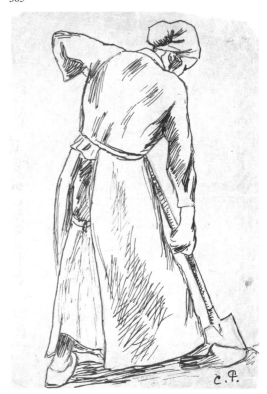

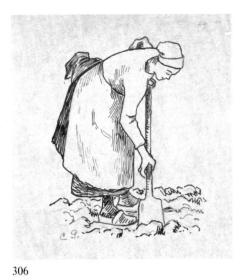

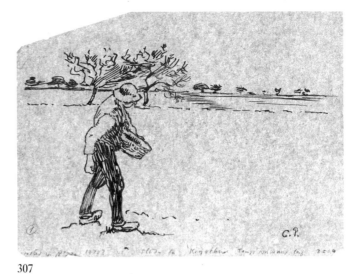

306

307

308

309

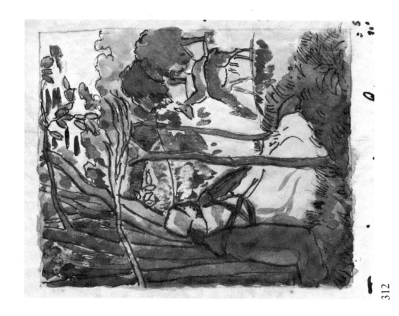

312

311

310

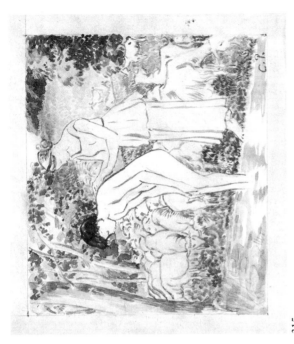

315

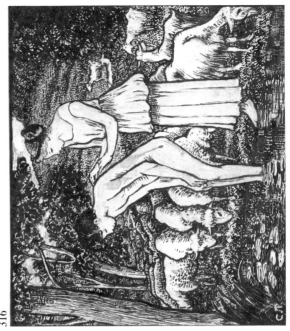

316

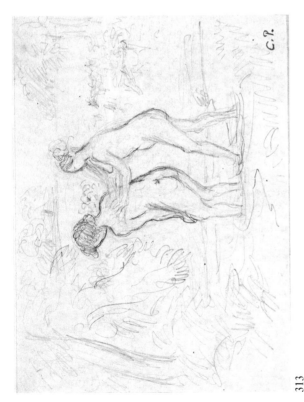

313

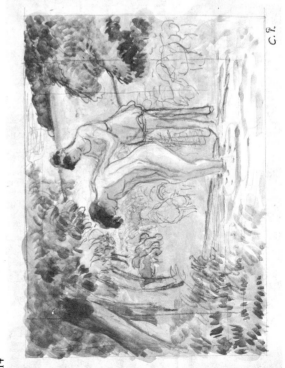

314

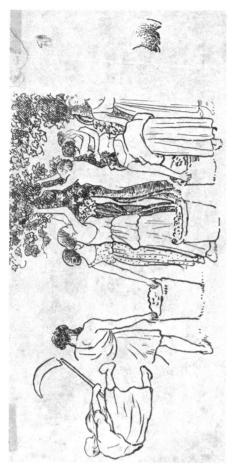

318

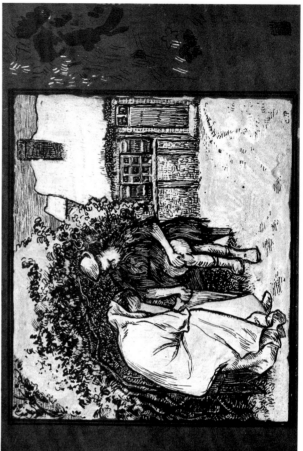

319

317

321

320 recto

320 verso

322

L.P. 255 C.P. E.II.01

323

L.P. 25 c C.P.

324

L.P. 257 C.P.

325

C.P. E.II.1

326

327

328

330

332

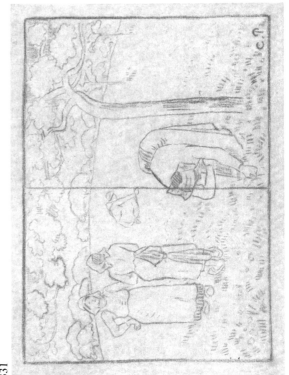

329

331

335

333

334

338

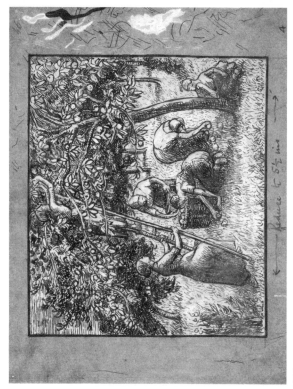

339

336

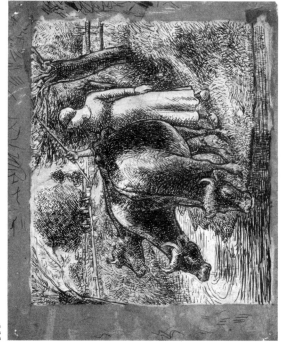

337

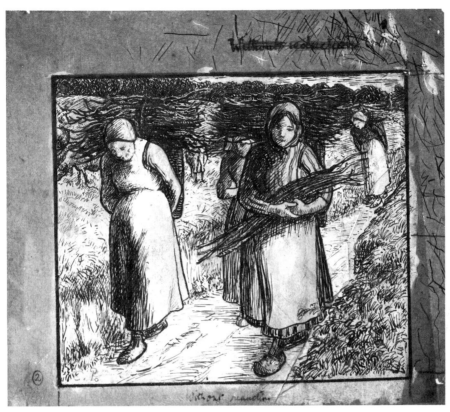

340

341

342

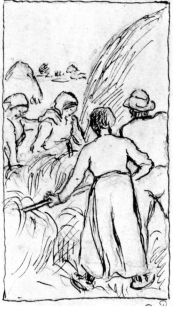

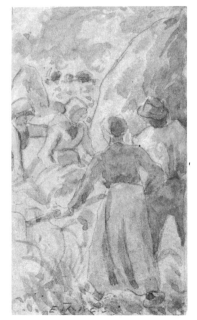

343 344 345

346

347

348

349

350

351

352

353

354

355

356

357

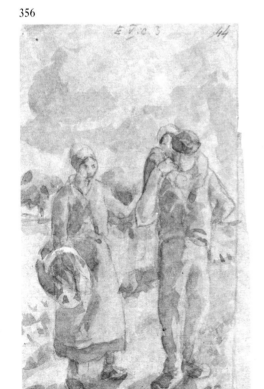

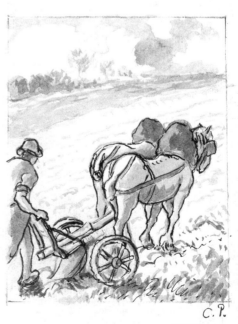

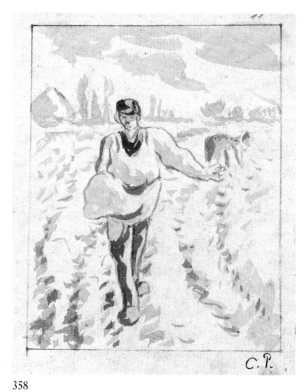

358

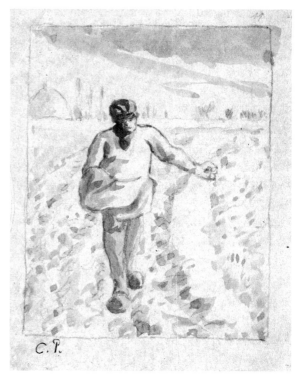

359

360

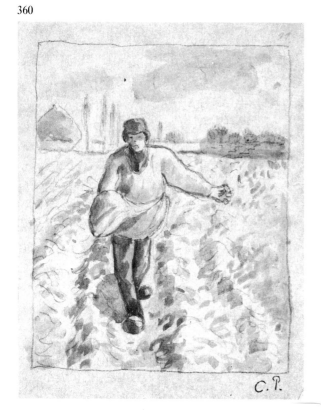

361

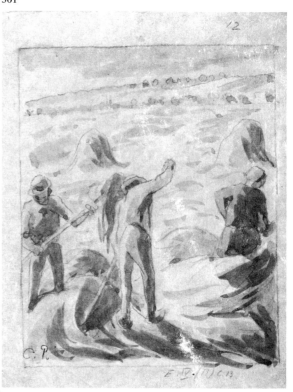

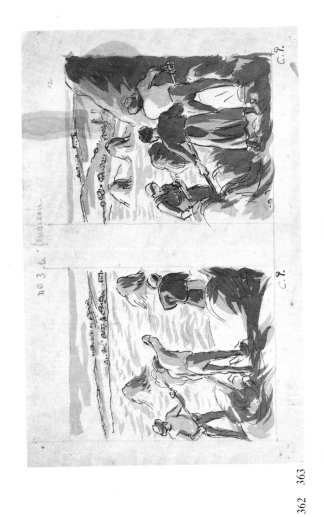

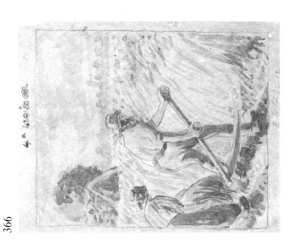

362 363

364

365

366

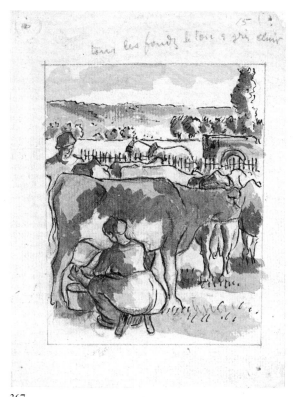

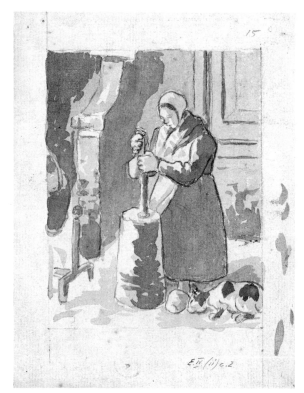

367

368

369

370

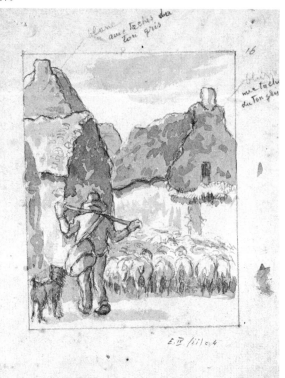

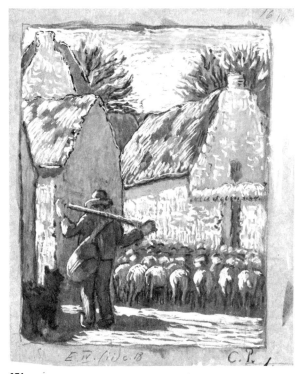

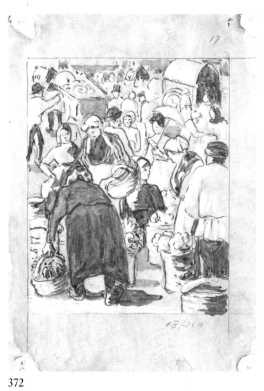

371

372

373

374

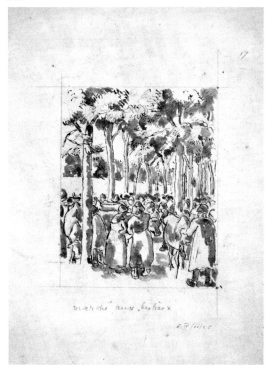

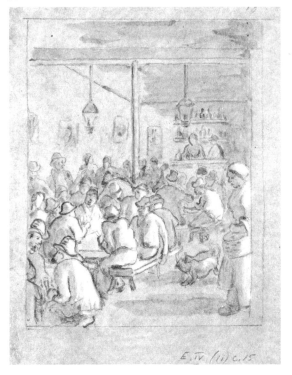

375

376

377

378